ANXIOUS CINEPHILIA

Film and Culture

FILM AND CULTURE

A series of Columbia University Press

Edited by John Belton

For a complete list of titles, see page 303

Anxious Cinephilia

Pleasure and Peril at the Movies

Sarah Keller

Columbia University Press New York

Columbia University Press
Publishers Since 1893
New York Chichester, West Sussex
cup.columbia.edu
Copyright © 2020 Columbia University Press
All rights reserved

Library of Congress Cataloging-in-Publication Data
Names: Keller, Sarah (Sarah K.), author.
Title: Anxious cinephilia : pleasure and peril at the movies / Sarah Keller.
Description: New York : Columbia University Press, [2020] | Series: Film and culture |
 Includes bibliographical references and index.
Identifiers: LCCN 2019043044 (print) | LCCN 2019043045 (ebook) | ISBN 9780231180863
 (hardback) | ISBN 9780231180870 (trade paperback) | ISBN 9780231543309 (ebook)
Subjects: LCSH: Motion pictures—Appreciation. | Motion pictures—Psychological aspects. |
 Motion pictures—History.
Classification: LCC PN1995 .K397 2020 (print) | LCC PN1995 (ebook) |
 DDC 791.4301/5—dc23
LC record available at https://lccn.loc.gov/2019043044
LC ebook record available at https://lccn.loc.gov/2019043045

Columbia University Press books are printed on permanent and durable acid-free paper.
Printed in the United States of America

Cover image: *The Lady from Shanghai.* © 1948, renewed 1975 Columbia Pictures Industries, Inc.
All Rights Reserved. Courtesy of Columbia Pictures.
Cover design: Lisa Hamm

Contents

Acknowledgments

I have profited from many conversations with all the smart, engaged, anxious cinelovers I know over the years I have worked on this project. I am deeply grateful to be part of that community. The conferences, panels, seminars, and individual invitations to present my work allowed me to air parts of this project. Thanks in particular to the organizers and audiences who offered thoughts at presentations for Domitor, Michigan State University, the Modernist Studies Association, New York University, Northwestern University, the Society for Cinema and Media Studies, the Screen conference, and the University of Minnesota.

Thanks as well to the staff at the Margaret Herrick Library of the Academy of Motion Picture Arts and Sciences in Beverly Hills, California, who assisted me in finding and copying materials in their collection about colorization and the impact of movies on youth.

I owe a special thanks to colleagues at New York University's graduate program in cinema studies during the time I spent visiting in 2013, especially Dan Streible, who set me up for success while there. That year, I taught a graduate seminar, "Cinephilia/Cinephobia," where the spark of ideas related to this book began to catch fire. The students in that seminar influenced my thinking about cinephilia in highly productive ways, and I thank them for a great semester.

Colleagues from the University of Massachusetts at Boston—especially in the College of Liberal Arts Dean's Office, the Art Department, the Cinema Studies Program, and Healey Library—also provided a great deal of support as this project came into being. None did so more than Katharina Loew, who is the very best of interlocutors, writing partners, co-conspirators, and friends.

A special thanks, too, to Ariel Rogers, who at more than one point while I was writing this manuscript lent her calm, brilliant, incisive skills as a reader and editor. I would have been lost without her generous willingness to help. I deeply appreciate her kind encouragement and keen eye.

Others who also offered an ear, advice, suggestions for interesting things to look into further, a forum for presenting work, or general encouragement at crucial moments include Dudley Andrew, Nico Baumbach, Francesco Casetti, Don Crafton, Noam Elcott, Jennifer Fay, Ally Field, David Gerstner, Tom Gunning, Barbara Hammer, Maggie Hennefeld, Brian Jacobson, Daria Khitrova, Antonia Lant, Adrian Martin, Dan Morgan, Justus Nieland, Tasha Oren, Kate Rennebohm, Theresa Scandiffio, Girish Shambu, Tess Takahashi, Yuri Tsivian, Julie Turnock, Malcolm Turvey, Christophe Wall-Romana, Haidee Wasson, Patricia White, Jennifer Wild, and Josh Yumibe.

The Film and Culture series editor John Belton as well as Jennifer Crewe and Philip Leventhal at Columbia University Press provided guidance and thoughtful insights at key moments: I am grateful for their steadfast support. They expertly shepherded this project to its resolution, in part by also finding excellent, anonymous outside reviewers, whose comments sharpened this manuscript in important ways.

Thanks to cinema—it has been a long-standing love that has sustained me for my whole life.

And first and last, thanks to my extended family and especially to my fellow cinephiles J, G, and H—for simply everything. You made the time during which I worked on this book not only worthwhile but wonderful. I wouldn't have done it without you.

ANXIOUS CINEPHILIA

Introduction

THE POWER AND PERILS OF CINEMA

Simply put, cinephilia is the love of cinema. However, like all kinds of love, there is in fact nothing simple about it. An affectively driven response to the cinema—itself a fleeting, ever-changing phenomenon based on movement—cinephilia is characterized, like love, by an attitude of volatility. Just as for love and cinema, cinephilia is not one thing for all people. So: how to fix this wave upon the sand?

What follows here pursues elusive objects and affects. It takes as its starting point the notion that the foundation of cinema upon which cinephilia builds has been laid with a fluid cornerstone: although it has enduring, sturdy elements that cohere into a system we call cinema, that system is an oceanic phenomenon in constant motion. Predicated on constant change in its ontological bases, its technological realities, and its position as part of cultural, historical, theoretical, aesthetic, economic, and social networks, cinema is naught if not on the move. And cinema's shifting circumstances will undoubtedly change yet again in wholly unforeseen ways in the future. The volatile nature of cinema leads naturally to volatile *relationships* with cinema. That is, cinema is a mercurial medium, and its magic, such as it is, depends on fickle spectators who watch and obsess in different ways.

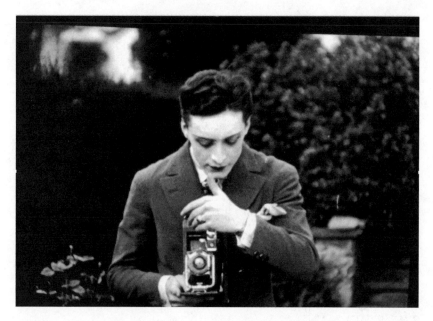

FIGURE. 0.1 *Six et demi, onze* / *6½ × 11* (Jean Epstein, 1927).

Cinephilia has often been treated as a specifically historical phenom-
enon, albeit one with threads that reach into earlier and later moments.
Fixated in particular on French postwar, *Cahiers du cinéma*, New Wave,
auteurist milieus, this model of cinephilia has had a lasting impact far
beyond that time and place. Historical notions of cinephilia persist, and
they have indelibly and intensely shaped the way we understand film his-
tory, the role of directors, the notion of masterpieces, and the appropri-
ate manner of appreciation for engaging with moving images. Indeed,
these historical notions—often not altogether unfairly charged with
being elitist (the very word *cinephilia* may need to be defined to the
layperson)—have defined for better or worse hegemonic modalities of
film style, production, and critical spectatorship. As a result of the way
we tend to value certain films and filmmakers over others, the power to
produce work has remained in certain demographics, and critical and
theoretical ideas about cinema have been formulated from a certain kind
of cinephilia. Cinephilia carries a political charge whether it originally
meant to or not. Acknowledging cinema's fundamental mutability on the
ontological level as well as on the phenomenological level sharpens the

acuity of one's love—and one's love helpfully sustains and sharpens notions about what the cinema comprises and why it deserves love.

Querying the nature of cinephilia begets as many fraught and individual answers as the question of what cinema is. Like the cinema, there are certain aspects of cinephilia that are fairly stable, such that one can meaningfully call it by its name, but there are also aspects that vary. I adopt a capacious sense of cinephilia here, one that allows for change and does not attempt to limit the idea to one that everyone, including me, can share. After all, who am I to tell another cinephile how to love? Cinephilia may focus its attentions on the cinema's unique and remarkable qualities, on its ability to stun an audience or make an audience lose itself in the lives of others, or on any of its many attractions. All the same, a few things may be said of this rather larger cinephilia. It fixates, of course, on cinema, and it denotes a set of strong responses akin to love that express this fixation: wonder, astonishment, longing, devotion, possessiveness—in short, powerful feelings attached to the cinema. Cinephilia invokes many of the most powerfully positive connotations of love as they are invested in aspects of cinema. But one remarkably stable facet of cinephilia—and one of its defining characteristics—is notably less positive: its inherent anxiety. Anxiety underscores cinephilia in crucial ways. It has proven to be a productive, galvanizing force for cinephiles: it goads one to articulate and stand up for what matters most in an appreciation of a film, a way of filmmaking, or a mode of watching films. Anxious feeling haunts the cinema that people love more broadly, too, and figures in their ways of relating to what they see onscreen—from the way cinema ritualizes cultural memory of historical traumas to its ability to startle and scare its audiences to its revitalization of lost places and people, marking the passage of time and carrying the reminder of mortality.

In fact, the astonishingly wide range of examples of the way love and anxiety are entwined at and in relation to cinema offers glimpses of a new way of approaching a number of issues in cinema studies. Throughout this book, I offer a set of examples without exhausting the possibilities for further exploration of the connections among moving images, love, and anxiety. Examples present themselves over the whole course of the cinema's history, up to recent instances where closer examination of anxiety yields a better understanding of the complex nature of cinema's

purchase on its lovers. In March 2013, for instance, the *New York Times* ran a discussion column that invited four writers to address the question of whether computer-generated imagery (CGI) is "ruining the magic of cinema or enhancing it."[1] At issue for those who weighed in is the state of cinephilic wonder inspired by such effects—and whether digital effects weaken or strengthen that wonder as well as whether that wonder is sufficient to bring people into cinemas. A couple of the writers and dozens of the people who offered comments in each thread excoriated or dismissed the digital effects of contemporary movies, simultaneously valorizing the possibility of cinema's world-creating wonders and worrying over the lack of the human factor in such effects.

One of the four writers, Natalie Wolchover, focused on the "uncanny valley" effect as a factor in the danger of digital effects. This term describes the experience of something feeling off when a spectator observes a digital character. An eerie feeling arises in the differential between the digital character's familiar lifelikeness and its digital provenance. For a recent set of films that give a "digital makeover" to older actors (e.g., Johnny Depp in the fifth entry in the *Pirates of the Caribbean* franchise [Espen Sandberg and Joachim Rønning, 2017], Kurt Russell in *Guardians of the Galaxy Vol. 2* [James Gunn, 2017]), digital artists have struggled against this effect: Trent Claus, the visual effects supervisor for Lola VFX, the company responsible for several of these makeovers, has remarked on the human/technological divide: "Working on the human face is one of the, if not the most challenging thing to do. . . . People can tell when there is something amiss. Even if they can't put their finger on what is wrong, they can tell that something is wrong. . . . The characters seem at once human and alien, causing cognitive dissonance that settles into a feeling of fear or repulsion."[2] As writers from Béla Balázs to Jacques Aumont and Noa Steimatsky have emphasized, the human face is a fertile site for the cinephilic imaginary, for exploring the essence of cinema as well as its technology.[3] The human element figures in important ways in digital debates and makes new again some of the oldest questions that have riled and vitalized studies of the cinema. It figures, too, in the tendency to describe celluloid as kindly, warm, and human but digital cinema elements as cold and inhuman, connected to machines and not people. The effect of this tendency shapes the way media are received and perceived: as David Bordwell has pointed out in *Pandora's Digital Box:*

Films, Files, and the Future of Movies, a film projector "chatter[s]," but the digital projector silently and mechanically decodes its file.[4] One is more human than the other. Celluloid connects to the shape of the world it films, whereas the digital translates the world into numbers. Made-up characters, faces, and places have the power to undermine the worlds of the cinematic imaginary that showcase such ersatz wares even while they allow entry into fantastical realms—Pandora, Middle-Earth, and so on—strongly associated with cinephilic obsessions. Tracing these connections allows a look below the surface into the undercurrents that connect diverse aspects of the way people have described how they look at and experience moving images.

By attending to the ways people have been anxious in relation to the object of their love, this book provides a way to begin thinking about the nature of cinema and the cinematic experience. Anxiety in, through, or about cinema is not limited to cinephiles but may be most legible in relation to them because their responses are frequently and intensely articulated. I offer a view into the workings of cinephilia that takes into consideration its own and the cinema's volatility. The present moment demands such an account because it, too, seems rather anxious, and cinema in such times has served as both a conduit for and a respite from particular anxieties. Moreover, mergers between love and fear in and through cinema occur most forcefully at moments of profound technological change, such as that currently represented by the so-called digital turn. Bordwell rightly notes that the ability to reflect on a moment of massive technological change from *within* that very moment is an opportunity not to be neglected.[5] That goes as well for changes that arrive alongside the technological shifts—changes in how movies are made, consumed, and reflected upon. These transformations deserve our full attention so that we might not just observe their parameters in the moment but situate them in the continuum of transformations of cinema over the course of its history. By looking at such changes through the lens of an anxious cinephilia, we gain perspective on the driving cultural, psychological, economic, and aesthetic factors that have shaped and are shaping the cinema. Exploring love and fear together in this context, we discover both a way to describe deeply engaged spectatorship and a means for coming to terms with the contradictory, dynamic nature of that engagement.

Cinephilia began early and continues to the present. It may be discovered equally in testimonies by reviewers who saw the first films ever made, by filmmakers of the cinematic avant-garde of the 1920s, in writings in *Cahiers du cinéma* from the 1950s and 1960s, and in cinephile blogs in the 2010s. These sources document cinephilia as foundational to the cinema experience and to the writing of cinema's history. In the current decade, reverence for films has thrived and discovered new outlets—for instance, in videographic essays, which attest to an adaptive cinephilic practice using the medium to illustrate and to valorize cinema.[6] A spate of recent scholarship about cinephilia has attempted in a variety of ways to describe and proscribe its nature and history. Associating the pleasurable, often intensely personal experience of being "at" the movies with the specific kinds of images encountered there, these studies of cinephilia offer points of entry to a slippery concept.

Looking at some recent and influential studies of cinephilia, one finds a few trends: particularly in the past two decades, writing about cinephilia has considered its own history. Several studies compare older cinephilia with present cinephilia or trace the changes in cinephilia from its earliest manifestations to its manifestations in the present. The idea that the present moment has prompted a revitalization of cinephilia may well come from a pivotal source, Susan Sontag's pronouncement of the death of cinephilia in 1996: "If cinephilia is dead, then movies are dead too . . . no matter how many movies, even very good ones, go on being made." She concludes her death knell, however, with what she may not have intended as a ray of hope but has been often taken as one by writers of cinephilic histories: "If cinema can be resurrected," she concludes, "it will only be through the birth of a new kind of cine-love."[7] That cinephilia has been seen as experiencing a renaissance in the 2000s may come from exactly this birth of a new kind of cine-love forged from a different way of experiencing movies, one grounded in the vicissitudes of technological changes as well as in cultural shifts rising to greater consciousness in the past two decades. But, importantly, this cinephilia emerges in the wake of losses and an irrecoverable past.

In addition to the sense that both the cinema and cinephilia of the past have broken down and are in need of renewal, one notion that has emerged in the literature is that the old cinephilia is singular—elite, grounded in and simultaneously giving legitimacy to a canon of films and

filmmakers, asserting limits to the idea of what cinema is—whereas the new cinephilia is multiple—democratic, transnational, transgenerational, mixed in its gendering, more at home with various technologies and platforms and screening situations. These characterizations of cinephilia underlie constituent points of engagement over its history, including the importance of writing, the tension between subjective and collective configurations of preoccupation with cinema, the relationship between appreciation and theorization, and the role of anxiety in all of these areas.

Those who have grappled with the relationship between historical cinephilia and the media realities of the present moment often do so in a nostalgic vein. The difficulty of theorizing a concept that is perceived as fundamentally subjective prompts many writers who have dealt with cinephilia to counter this objection by laying their biases bare and foregrounding their own cinephilic investments. Antoine de Baecque and Thierry Frémaux, who focus on what one must do to forge a contemporary cinephilia in the wake of being left behind by the old cinephilia, provide such a case.[8] Because their own cinephilia first emerged in what they think of as the "belated" moment of cine-love in the 1970s (by necessity because "everything had happened already"), they developed a strategy of personal compensations. They turn to "creative act[s] of substitution" that they think of as equal in importance to the films. Critical writing and preserving a notion of the past become all-encompassing forms of self-perpetuating cinephilia: "For us, the pleasure of being a reader often replaced that of being a spectator. . . . We regret the disappearance of cinemas and the cinephile passions experienced by our elders. Since then, everything has changed: it is no longer a matter of sacralizing only cineastes, but also critics; not only the films themselves but also texts; not only the cinema but also cinephilia."[9]

De Baecque and Frémaux exhibit the nostalgia found in many writings about cinephilia when they remark that the expansion of cinephilia is necessary because it is manifested in the generation that "discovered cinema by closing cinemas."[10] It took loss to bring the love to the fore. In their view, the period of postwar cinephilia is in the past, and its most important act was to create and establish auteurs. However, in the present, cinephilia finds purchase through other more extensive means, as it must needs do because it is found among the ruins, the shells of old movie theaters turning into garages and boutiques. Consequently, de Baecque

and Frémaux's description of cinephilia's nature proves historical, deeply personal, and ultimately anxious about having missed something before they even began their own cinephilic quests.

The personal element on display here is key to the trouble with theorizing cinephilia. Perhaps more than any other scholar of cinephilia, Christian Keathley acknowledges and builds upon such individual valences of cinephilia, confronting its subjective aspects by bringing his own specific cinephilia—fixed, for instance, on an indelible moment in *The Searchers* (John Ford, 1956)—to bear upon his full-length study *Cinephilia and History, or The Wind in the Trees*. Keathley's work adopts a personal yet expansive view of what cinephilia is and how it finds a place in the longer history of moving images. As a call for new approaches to the affective aspects of cinephilia, he adopts "cinephiliac anecdotes," both his own and those of others in the history of cinephilia (for instance, the ubiquitous anecdote of where and how the *Cahiers du cinéma* critic Jean Douchet sat in the cinema). As such, he heeds Thomas Elsaesser's call to derive a more inclusive sense of film history from "counterfactual histories," or those parts of experiences with moving images that don't neatly fit into an apparent teleological progression.[11]

Like several other scholars, including Laura Mulvey and Rashna Wadia Richards, Keathley advocates for multiple points of entry to cinematic objects and experiences as part of cinephilia.[12] He marshals personal and anecdotal information in the hopes of mapping relevant but overlooked experiences such that "the resulting discourse maintains and even extends the initial experience, and at the same time constitutes part of a history in that it imparts information, knowledge, insight."[13] By tracing such experiential moments and attempting to connect them to a variety of bases and approaches to knowledge—from the sinuous resources of the affective domain and self-knowledge to film and cultural history and theory—Keathley offers subjective answers informed by knowledge about the ways cinema has been understood over its history. He legitimizes individual experience as a point of ingress to a wider range of knowing about (and appreciating) films.

Other scholars have also contributed methods that combine notions of film theory and history connected to cinephilia to square the theoretical and the personal. In their collection *Cinephilia: Movies, Love, and Memory*, Marijke de Valck and Malte Hagener provide a compass for

navigating elements of history *within* cinephilia; for instance, they demonstrate how cinephilia merges present and past, making full use of "history as a limitless warehouse that can be plundered for tropes, objects, expressions, styles, and images from former works."[14] This quality, the sense of nostalgia and of the past (especially a past that seems to be receding in the too-present present), is a feature of cinephilia that shifts times and places and brings new life to cinema and media of the past.

Nostalgia in the form of allusions and creative reworkings is even more pertinent to the *filmmaker* as cinephile. For instance, Jean-Luc Godard's early films pay homage to Hollywood films from the immediate postwar period; his *Histoire(s) du cinéma* (1988–1998) puts into relief the relationship among images from different times, mediums, and contexts.[15] For *Histoire(s)*, Godard builds his own film history, an act Alifeleti Brown has called "the ultimate labour of cinephilic love, an intensive audio-visual retrospective ruminating on the multiple incarnations of cinema, its vital intersections with 20th century history and ultimately, its immanent death, as projected by the medium's most studied, critically devoted and playfully intellectual independent figure."[16] Many films cite or allude to other films out of a desire to reshape beloved images according to new visions or times. Christian Petzold's *Phoenix* (2015) represents a perfect example of this phenomenon: for one thing, the character of Johnny was modeled on the atmosphere surrounding the defeated postwar men from several film noirs. Moreover, Petzold borrows themes, images, and character developments from Alfred Hitchcock's *Vertigo* (1958), reimagining what it means to occupy Madeline/Judy's perspective, and (just as within that film) remakes (along with his male protagonist) the image of his female lead/muse while accessing a new subjective position that includes her.[17] Several filmmakers, in addition to making visual rhymes or references to earlier films or genres they have appreciated, directly include footage from earlier films as homage, as Olivier Assayas does in *Irma Vep* (1996) and *The Clouds of Sils Maria* (2014), both of which manifest his love of silent cinema. On an even more personal level, filmmakers such as Laurie Anderson or Barbara Hammer use footage from their own earlier films (Anderson using home movies for *Heart of a Dog* [2015]; Hammer using several of her films from the 1970s for *Tender Fictions* [1995]) as material for reflection and re-creation based on an attraction to their own pasts and filmic images of it. Filmmakers may also

appeal to earlier models, references, and genres in order to court, as Elena Gorfinkel puts it, "a more earnest mode of film reception"—that is, films such as *Far from Heaven* (Todd Haynes, 2002) might consciously invoke earlier films and film historical moments in an effort to tap into reserves of audience nostalgia, cultivating "the poignancy of the irrecoverable gap between past and present" as part of their subject matter and aesthetics.[18] As this wealth of occasions for repurposing material suggests, cinephilia's wistful anachronisms, allusions, and recycling of past glories described in de Valck and Hagener's account applies in abundance across cinema history.

The suspension of past and present similarly arises in Thomas Elsaesser's essay "Cinephilia, or the Uses of Disenchantment," which puts cinephilia's enduring qualities in conversation with its changeability over time based on intellectual fashions, subjective moods, and local circumstances. Like others in first tracing cinephilia's "originary" moment to the postwar French love of cinema, Elsaesser introduces the clash between cinephilia and theory in the 1970s. While the "first" cinephilia—"a discourse braided around love, in all the richly self-contradictory, narcissistic, altruistic, communicative and autistic forms that this emotion or state of mind afflicts us with"—thrived for some time unchecked, it came to be supplanted by the second cinephilia—a "post-auteur, post-theory cinephilia."[19] Elsaesser's consideration of theory as formative for contemporary cinephilia reverberates with a set of essays on cinephilia by Nico Baumbach in *Film Comment*. Addressing an apparent rift between different kinds of cinephiles (critics versus academics) as posited by David Bordwell, Baumbach scrutinizes Bordwell's claim that the rise of "Grand theory" in fact provided "a 'weapon' against the pleasure derived from classical Hollywood films," a weapon capable of killing that pleasure.[20] Baumbach questions the old saw about the cinephile's naive pleasure at the movies being ruined by the knowledge given by the sober theorist, who shows the claims of moving images on innocent cine-slumberers. Tracing its course over history, Baumbach debunks this theory-as-adversary narrative commonly attributed to cinephilia and its failure to endure within the confines of the academy. In the process, he demonstrates cinephilia's complex, resilient nature, showing how it has always drawn on tensions between passivity and consciousness about the object of one's love.

Elsaesser likewise questions theory's role as a foil, arguing that it is instead a force that reveals otherwise elusive aspects of cinephilia. He claims a second version of cinephilia arrived in the aftermath of the insistence by authors writing for *Screen* and other vehicles for film theory in the 1970s that the illusionist qualities of cinema must be overcome, that the spectator must be "dis-enchanted away from its spell." Elsaesser characterizes the second cinephilia primarily according to its complexities, consonant with what theory afforded the cinematic medium. A more knowing cinephilia allows lovers of cinema to take control of their own "libidinal economy." The lovers of cinema can (and do) "[turn] the images around, making them mean something" for themselves as cinema lovers and for their community of kindred cinephiles. Technological developments allow cinephiles to capitalize on "the mobility and malleability of [cinephilia's] objects, the instability of the images put into circulation."[21] For Elsaesser, the first cinephilia is fixed and unidirectional, whereas the second has greater flexibility with the objects of its obsession.

Elsaesser's most revealing insight for my purposes derives from these observations: he argues that cinephilia early and late is tinged with *anxiety*. Expanding the provenance of a sense of loss, like the one inspiring de Baecque and Frémaux's nostalgic cinephilia, Elsaesser recognizes that it begins with the nature of intense cinematic encounters and the ephemeral qualities of cinema: "Cinephiles were always ready to give in to the anxiety of possible loss, to mourn the once sensuous-sensory plenitude of the celluloid image, and to insist on the irrecoverably fleeting nature of a film's experience."[22] In this view, cinephilia is anxious because it comes to full flower within the gap between possible loss and actual loss and because it undergirds the very nature of the cinema experience cinephiles hold dear. Thus, Elsaesser proposes a "darker side" to how a cinephile is displaced and deferred through love. The cinephile seeks the "plenitude, envelopment and enclosure" that characterizes, painfully, "a search for lost time," making cinephilia hinge on something longed for that cannot be obtained and dooming it to a repetition that never brings it any closer to the object of its love:

> Looking back from cinephilia take two to cinephilia take one, it once more becomes evident just how anxious a love it has always been, not only because we held on to the uniqueness of time and

place, in the teeth of cinema's technological change and altered demographics that did away with those very movie houses which were home to the film lover's longings. It was an anxious love, because it was love in deferral and denial. By the 1960s, we already preferred the Hollywood films of the 1940s to the films made in the 1960s, cultivating the myth of a golden age that some cinephiles themselves have since transferred to the 1960s, and it was anxious in that it could access this plenitude only through the reflexiveness of writing, an act of distancing in the hope of getting closer.[23]

Elsaesser connects the new cinephilia with earlier forms of cinephilia—in its dependence on writing and in its shared quality of both deferral and expansion of the cinematic experience into the after-experience of remembering it—in terms of anxiety. As I show in the chapters that follow, Elsaesser's essay is a crucial starting point for my own sense of cinephilia. I extend his argument to show that anxiety is a necessary condition of cinephilia, and it may be most readily found in a changing media environment (as in most things, change is the only constant here). Indeed, without anxiety, cinephilia loses power.

Recent writing on cinephilia has especially focused on the transformations of cinephilia in the wake of the digital turn. Belén Vidal has succinctly sketched the parameters and stakes of these transformations through the many contributions to cinephilic scholarship in the past decades. She underscores the political mandate this body of work has inspired, noting that the "seismic shift provoked by medium (r)evolution" has led to the need "to take into account the twin factors of unprecedented technological development, and the diversity of cross-cultural film experience that it has enabled—factors that challenge the Eurocentric underpinnings of cinephilia's narrative in the twenty-first century."[24] Undoubtedly, cinephilia of the present moment is troubled in many ways by its past manifestations, not the least of which means reckoning with loves that reflect historical blind spots. In the contemporary context, we find the democratizing ethos of online cinephilic communities as well as the connection of kindred cinephilic spirits across distances. Regarding the latter, as Nicole Brenez attests, "one might even say that geographical distance favors mental closeness, for it smooths the personality quirks or territorial conflicts that often characterize local

chapels/congregations."[25] The most ardent and eloquent advocate for this position is Girish Shambu, whose contribution to contemporary cinephilia comes wrapped in a tiny, elegant book, *The New Cinephilia*, as well as in a sprawling, prolific project of communicating with other contemporary cinephiles through his blog, social media, and other online sources.[26] Shambu captures the energetic and creative spirit of "the new cinephilia" in word and in deed, arguing for the redirection of his own cinephilia through engagement with a community of cinephiles who post information, reactions, and fragments of their cine-love in fits and starts in online communities. In one internet post for Project: New Cinephilia,[27] he writes: "I cherish the plentiful opportunities for learning and discovery, for the proliferation and growth of film discourse, made possible by the Internet and the countless mediators it makes available to us each day."[28] Discourse takes a place of pride in this cinephilia, as it did for Frémaux and de Baecque in the relative dearth of cinemas, in part because it extends cinephilic experience and in part because it extends cinephilic territory: now one can participate in discourse with like-minded cinephiles or contrarians around the world, both of whom bolster or inspire cinephilic engagement.

In light of the further rise of the digital and of a panoply of alternative sites for cinema spectatorship, Elsaesser's claims should be extended. Much of the writing on cinephilia from recent years grapples with the "death" of cinema and the subsequent death of cinephilia, following Sontag's account. However, while Sontag's lament hits at the heart of nostalgia for the disappearing cinema community and identity of an earlier cinephilia, for many recent cinephilia commentators the affirmative reinvention of cinema and its audiences' commitment to finding in it a pathway to love have happened already. As de Valck and Hagener have commented, Sontag's proclamation "in effect declared the incompatibility of the cinephile archetype with the contemporary situation."[29] Indeed, the contemporary situation is ripe for other cinematic pleasures, which may explain why so many people are still thinking about cinephilia. However, although the new cinephilia rings more utopian, we should keep in mind that it, too, tends to be anxious. One of its forms is a frantic effort to keep up with keeping up: the wild proliferation of possibilities for connection with many others, the aim of being exposed to everything everyone is talking about, and therefore the conundrum of

needing to spend time—for a deep love takes time—with objects that are too dispersed and too many to keep track of.

The new cinephilia is nothing if not self-reflective: while the first waves of cinephilia tended to wax rhapsodic about the *cinema*, current writing is just as invested in the well-being of *cinephilia*, whether it argues that cinephilia has never been better or is indeed dying or is something in between. For my own part, I contend that we need a way of conceptualizing cinephilia across cinema's history that will take into account its ongoing, underlying anxieties as they relate to a volatile cinema. This conceptualization will help us better understand not only the spectatorial, economic, aesthetic, and historical dynamics of a *love* for cinema but also the nature of cinema.

WHAT IS CINEPHILIA, AND WHY IS IT SO ANXIOUS?

> What is proposed, then, is a portrait—but not a psychological portrait; instead, a structural one which offers the reader a discursive site: the site of someone speaking within himself, *amorously*, confronting the other (the loved object), who does not speak.
>
> —ROLAND BARTHES, *A LOVER'S DISCOURSE: FRAGMENTS*

The cinema does not betray love for its admirers. It is the indifferent recipient of or vehicle to express love. As object of a one-way exchange, cinephilia would seem to tell us more about the lovers than about the beloved. But the ways cinema has been loved demonstrates some of cinema's own qualities, too: not least of all its inconstancy. As it is for the elusive ingénue, this is part of its vitality and charm and necessary to it. The cinephile must seek out her own ways of loving, which lead to a range of cinephilic engagements. Or, as Lucas Hilderbrand has put it, "if there is such a thing as the politics of contemporary cinephilia—and I don't think there is any dominant or coherent political position in cinephilia today—it may be the breakdown of a strict conception of the term. Cinephilia has splintered from a rarefied specialist milieu to include more everyday practices. There are many ways to love movies."[30]

Without forgetting the breadth of these ways, lest its diffusion render cinephilia invisible, let us pin down a few of the qualities that are nonetheless typical of cinephilia. Several inhere across its history in

various forms. For instance, cinephilia often depends on a sense of other movies (it is relational); inspires a drive to connect to other things and products (it is communal as well as commercially exploitable); is interested in the material, technological, aesthetic, social, or other qualities specific to itself (it is metacinematic); and fixates on strong feelings, frequently mixed between good and bad (it is intense, complex, and contradictory). In short, it tends to cover a range of the powers and perils involved in a confrontation with moving images. In more senses than have yet to be allowed, we can discover in the cinephile's engagements a means for understanding the cinema as the complicated phenomenon it is.

Several of these elements come into play in adumbrating the contours of a volatile, contemporary cinephilia. First, *cinephilia is an affect*, something that derives from feeling and is therefore personal and subjective. Second, *cinephilia is an extension of affect into actions*: it manifests itself (makes itself visible) in such actions, especially through but not limited to writing. Third, *cinephilia depends on displacements in time and space*. As a partial result of this dependence, it tends to be nostalgic. Another result is that it is interested in relationships between past and present. Finally—the thing that undergirds the three previous categories—*cinephilia is fundamentally anxious*.

Cinephilia Is an Affect

When love is involved, things get complicated quickly. Lauren Berlant chides the analyst of love, warning against whole-cloth accounts of its nature and reminding us that "the minute an object comes under analytic scrutiny, it bobs and weaves, becomes unstable, mysterious, and recalcitrant, seeming more like a fantasy than the palpable object it had seemed to be when the thinker/lover first risked engagement."[31] This caution is suitable for studies of cinephilia. Constituted by the vicissitudes of subjectivity and affects that stem from a phenomenon based on feelings, cinephilia necessarily includes individual responses that have been tricky territory for theory. Theoretical positions that foreground the theorist's personal experience may prompt intellectual gymnastics to avoid the taint with which subjectivity, individuality, and contingency have been charged in intellectual fields. Whereas some cinephiles avoid the

problem by not acknowledging their subjectivity as formative for their pronouncements about the films, directors, or any aspects of cinema they love, others, as we have seen, foreground the impossibility of getting away from questions of personal taste or their predisposition to certain targets of cinephilia, and they build their ideas by showing the intersections between their subjective stance and their film-historical/theoretical knowledge.

Some, such as Eugenie Brinkema in *The Forms of the Affects*, take still another approach. Arguing that theory's recent affective turn is a response to the evacuation of specificity (and a consideration of content) and, further, that the tendency to lump all affects together is detrimental to understanding any of them, Brinkema advocates applying oneself to the formal specificities of affect. Affective theory has gotten lost in individual responses, she argues, charging theorists who allow personal experience to drive their writing about affects with solipsism and insisting that such an approach "shut[s] down critical inquiry instead of opening up avenues for thought and investigation." For Brinkema, affect is not "a matter of spectatorship at all" but is produced or revealed through the process of attentive reading of film texts.[32] She argues that intense attention to formal dimensions might open up avenues that the theorist does not have already mapped out. The close formal reading she therefore endorses

> allows not only for specificity but for the wild and many fecundities of specificity: difference, change, the particular, the contingent (and) the essential, the definite, the distinct, all dense details, and ... the minor, inconsequential, secret, atomic. Treating affect in such a way deforms any coherence to "affect" in the singular, general, universal and transforms it into something not given in advance, not apprehendable except through the thickets of formalist analysis.[33]

Brinkema's position puts the intricate act of reading at the center of theorization. While texts take precedence over effects and despite her suspicions about privileging the body of the spectator/theorist, her strategy fixes on determining the text's intensity, vitality, contingency, and unpredictability as it is illuminated by a particularly careful spectator.

As such, although cinephilia proper is not her focus, one detects in such attentive individual acts of reading an alternatively obsessive cinephilic approach predicated on the way the detours and diversions of reading texts might feed a passion for formal analysis of the sort at which Brinkema excels. Indeed, as she suggests, "arguing for affect as having form and reading for affect as it inheres in form . . . [do] not deflate or de-passify passion or weaken its kinetic lure[;] . . . *it is only because one must read for it that affect has any force at all*."[34]

Brinkema echoes the call for including openness and the incidental in certain studies of cinema, including Laura Mulvey's argument that cinephilic spaces open up through comparison of a still image against and in relation to the narrative of which it is taken.[35] Like Jacques Rancière's pensive image, such dislocation of an image from its source allows a productive contingency that opens both images (in context and out of it) to new meaning, generated by the spectator's interaction with the text and its intertexts.[36] Both of these approaches are subjective, and their emphasis on form (narrative and otherwise) mitigates the question of personal taste that dogs other approaches. Relatedly, Roland Barthes's conception of the discourse of love (which he deems a structural, discursive site) may be applied to the affective terrain of cinephilia: it denotes a space into which individuals may enter to apply the specifics of their amorous attention to the beloved object.[37] These perspectives similarly incorporate affect into the conceptualization of cinephilia via formal investments.

However one approaches cinephilia, the personal, subjective, and affective are part of its foundations, which for better or worse have been erected through often deeply personal accounts. Compiling a portrait of one's own cinephilia within a larger theoretical project risks not only getting lost on the way to generalization from the particular but also revealing the private and intimate details of one's attachments. Sharing one's personal history as an individual spectator, however, does not mean that one must lose sight of the objective aspects constituting the cinema. Indeed, some of the most compelling tributes to cinema, including early entries such as Jean Epstein's *Bonjour, Cinema* (1921) and "The Cinema Seen from Etna" (1926), do not limit themselves to rhapsodies about their object but seek to understand something about cinema's specific dynamics *through* their personal cinephilia. In addition to the hazards to

further theorization spelled out by Brinkema, processing one's peculiar attachments to cinema means opening oneself easily to derision or the judgments of others as well as risking being misunderstood—for instance, a reader might conclude that in telling more about my personal cinephilia, which I confess I am about to do, I am suggesting it is universal, which is not at all the case. Nevertheless, at whatever risk, I concur with Keathley's observation that presenting cinephilic anecdotes is a productive step toward building a living, breathing history of cinephilia. Not acknowledging subjectivity does not mean that subjectivity is not informing everything that flows from a cinephilic predisposition anyway. So: some moments at the Music Box Cinema in Chicago, Illinois . . .

The Music Box! The ceiling had a thousand, blinking stars.[38] The large auditorium was decorated with a moving night sky, statues along the walls, a deep-red curtain that often closed before the credits started. (It has been years now, so all of these details are filtered through the lens of memory. That is important, too.) It was there that I saw *Bob le flambeur* (Jean-Pierre Melville, 1956). The print got caught in the gate, and it melted. For a long time! The projectionist must have stepped out. The audience began to shout. The film burned during a scene where Bob is driving in a convertible, the top down, and so it was like Bob's head was on fire. *Bob le flambé.* When I saw *Jeanne Dielmann 23, quai du Commerce, 1080 Bruxelles* (Chantal Akerman, 1975), I realized movies could be longer than I thought possible—and also patient and perfect. I also saw 70mm prints for the first time in this theater: they made my eyes feel as if they were sparkling. Likewise for the landscapes in *The Good, the Bad, and the Ugly* (Sergio Leone, 1966), which I also first witnessed at the Music Box. It is not on the list of my favorite films. But when "the Ugly" runs around the cemetery just before the three-way shootout, I was so affected that I had to go stand at the back of the theater. I sometimes show this sequence in classes. And I still have to go stand at the back of the room. As Keathley notes in his own foundational cinephilic anecdote, this is the moment I am waiting for whenever I see the film. While I watch it, I am running, but not actually. That's what movies can do: it is an experience that feels like experience. I tend not to want to think about it. I am fearful of losing it if I train my scholar's eye on it. Love is complicated: it becomes part of a person and her experience.

These small sketches of a handful of moments over the course of a cinephilic history are emblematic of several aspects of both a personal history and the history of cinephilia. Cinephilia is not just *a* feeling but *a way of* feeling, and, as Elsaesser suggests, it is inflected by memory and nostalgia. The now rather old-fashioned experience of seeing a film print projected before an audience of well-behaved cinephiles gives me great pleasure, making me not far fallen from the Sontag tree of nostalgia for an earlier kind of cinephilia. Several scholars echo this thought—including Laura Marks, who seems to echo Seth Feldman's intuition that cinema does not exist anymore because new digital screening conditions render films already "half-disappeared." Marks laments screening conditions for her students that make it so that they "never *really see* a film in class" because it is often "a projected video that just teases us, with its stripes of pastel color, that there might be an image in there somewhere."[39] One of the issues at stake in this attitude is often the very question of what cinema is and whether one can brook its changing to encompass other conditions.

However important or insignificant my own observations may be, I want to underscore the fact that I consider cinephilia a phenomenon that includes the knowledge that I can tell you where I sat (or stood) within the theater on each of these screening occasions, despite the lapse of years and the fact that I must have attended films at the Music Box hundreds of times. These kinds of formative cinephilic moments enhance the placeness of spectatorship and my sense of self as an embodied, present spectator: cinephilia has the ability to wake up a body to being at the movies. Anecdotal or personal information is both the blessing and the bane of cinephilic discourse. Is there any part of our experience that we can take to be universal? How much is exceedingly peculiar to our own case? Although these experiences are my own, nostalgia for specific moments at the movies and experienced through the movies does not belong to me alone. It connects, for example, with Germaine Dulac's film-clip-illustrated lectures reprinted in *Cinémagazine* or with cinephile colleagues blogging about moments at the movies.[40] You see, I shared it with you. That is part of cinephilia, too: the urge to act (here, to speak out and to write) out of one's cinephilic predisposition and to connect with other (potential) cinephiles. Together we represent the living presence of cinephilia on the proverbial shifting sands of time. We apply and produce

cinephilic theory and history through such affective, sensuous, subjective experience, grounded in many individual bodies.

Cinephilia necessarily generates tension between the personal and the universal. However individual these manifestations of love for cinema may be, they seek out like minds. The search for cinephilic communities—kindred spirits in one's love of a film or star or cinema site or festival—is one of the decisive factors in the second aspect of cinephilia.

Cinephilia Is an Extension of Affect Into Actions

You can't see the wind, save when it moves the trees or fills the sleeves of a shirt on a clothesline; similarly, you can't see cinephilia or any kind of love save when it compels you to do something with it or even just to confess it. Just as it is necessary for a wholly private form of it to exist, cinephilia is also manifested in a set of specific external practices that make it visible and betray its form. As Michael Cowan has noted, it is "both individual passion and shared practice."[41] Along these lines, one central action of the cinephile is writing and seeking a meaningful conversation about cinema. Consider how Girish Shambu distinguishes a cinephile from any other moviegoer: "What sets a cinephile apart from any other person who loves films? Yes, both likely enjoy watching films in good numbers. But beyond that, I would draw a line and assert: cinephilia involves an active interest in the *discourse* surrounding films. Not just watching but also thinking, reading, talking, and writing about films in some form, no matter how non-standard: these activities are important to the cinephile."[42] The cinephile is an *active* viewer of films who thinks of them according to both a global, shared notion of cinema as well as her own cinephilic experience. This definition recalls de Baecque and Frémaux's observation that they came of age as cinephiles at a moment when writing and reading about films were as important to them as seeing films. Many cinephiles in various contexts court a community in print and online media.

To the act of writing with words, in the present media environment we may well add writing with images. Making videographic essays, GIFs, and supercuts, for instance, provides outlets for cinephiles to process their passions and to reproduce them in fragments, rearrangements, and

other creative reimaginings of the various objects of their cinephilia. Christian Marclay's masterwork, *The Clock*, may be the ultimate example of this creative, image-based writing in cinema as cinephilic act.[43] As Cristina Álvarez López and Adrian Martin have remarked of their own video essays, the practice of drawing connections among films through such essays expands and prolongs the experience of cinephilia. As they put it, they are "*forging* that connection in the cut, making the channel flow on and forward a little more."[44] Extending the cinephilic experience also motivates the short cinephilic essay film *50 Years On*, in which Keathley compiles brief snippets of footage from some of his favorite films and excerpts from writers about film, accompanied by John Coltrane's recording of "My Favorite Things." The soundtrack prompts fellow cinephile and video-essay connoisseur Catherine Grant to remark on the way the essay film draws on the original song from *The Sound of Music* to generate new layers of meaning about the films and the experience of seeing them:

> [*Fifty Years On* is] a hymn to, and performance of, the powerful effect of distraction, and the reassurance of immersion in (memories of) comforting objects when faced with anxiety. In using Coltrane's improvised version [of "My Favorite Things"] . . . *50 Years On* becomes an exploration of how cinema does *and doesn't* comfort us. How the contract we buy into when we begin to watch a film involves us sort of knowing where it will take us, and of not knowing at all, but going (or not) with the flow, relying on our curiosity and our senses to make our way. . . . The video and its music (like the cinema) create a *reflexive* container, or frame, for this experiential process, for its anxieties as well as its pleasures—a *more or less* safe, but usually exciting ride.[45]

That is, Keathley's film both exercises and comments on its author's cinephilia: it is a perfectly packaged expression of the cinephilic impulse. And it acknowledges the affective, experiential, and rather anxious character of that cinephilia.

Another action common to cinephiles is financial transaction. Cinephiles not infrequently become collectors of DVDs, 16mm prints, movie posters, and other movie artifacts and memorabilia. There are those who

pay to travel far afield to attend the Giornate del Cinema Muto in Pordenone, the Toronto International Film Festival, the Nitrate Film Festival in Rochester, New York, or some other gathering point for lovers of various aspects of cinema. They demonstrate their cinephilia through the action of travel and the collection of new cinephile experiences with a community of others doing the same thing. They go to see (or stay at home or go to the gym or take a plane or ride the train to see) a lot of movies. They subscribe to special streaming services. They accumulate cinephilic experiences, often shared by others of a similar disposition.

The difference between those activities considered part of a *fan* discourse and those that belong to cinephilia is not as wide as has sometimes been considered the case, at least not in the most recent iterations of global, "postmodern" cinephilia. Indeed, the difference between a fan and a cinephile may well be only one of degree rather than of kind. Whereas the *cinephile* has been traditionally associated with elite, intellectual, and often privileged circles of aesthetes, the *fan* takes cine-love down a notch: the term *fan* is used for nonintellectual or marginal groups and focuses on popular or, conversely, esoteric (cult, camp, trash, otherwise specialized) material. But the activities of both groups are not dissimilar—perhaps fans get dressed up like Harry Potter and bring their friends to a midnight screening, while cinephiles go to an eight-hour screening of a Warhol film—and both center their activities on a passion for cinema that leads to certain extremes. Part of the point here is that the specific focus on one's love should not be the defining factor for cinephilia: the act of loving is sufficient. Rather than signaling an indiscriminate attitude toward loves of the cinema, I hope this shift in emphasis (from what is loved to who loves and how) provides greater access for a more democratic and potentially emancipatory version of cinephilia such as that proposed by Codruța Morari through her reading of Jacques Rancière. In its acknowledgment of cinema's way of bridging appearances and a foundation in reality, spectators' activity and passivity, and the ivory tower and the masses, she argues, Rancière's cinephilia mitigates the "strained relationship between art and democracy" that has plagued debates about the proper objects of aesthetic appreciation.[46] Why debate matters of taste and the worthiest objects for praise among fickle and diverse admirers of cinema? After all, one person's trash is another's treasure. By allowing for cinephilia's many kinds of love, we instead emphasize

the dynamics of engagement with moving images instead of building canons that may not even apply to many people after all.

All the same, a couple of issues arise in the differences between someone who identifies as a cinephile and someone who is a fan, which deserve mention and a few provisional thoughts. First, the relationship to the marketplace for fans tends to upset top-down/bottom-up distinctions, such that fans are simultaneously the target of as well as the drivers of widespread marketing strategies.[47] Cinephiles tend to think of themselves as having a bottom-up relationship to the market (even if they are being marketed to, possibly in a niche market). Cinephiles salvage the things that they fear will become obsolete; they shore their cinephilia against the buffeting winds of change by collecting experiences that cohere with their notions of a beloved cinema.[48] The connotations of elitism, rarity, and specialization that still stick to cinephilia in contrast to fandom's collectivity and mass appeal lead to slightly different relationships to market forces and activities of collection and community. Second, the fan's actions, I think, are not as marked by anxiety as the cinephile's actions are. Fans do not have something to lose in dressing up as Hermione Granger on the eve of a release of a new *Harry Potter* film: they seek an extension of the film experience, fun, and community. Cinephiles worry that the eight-hour showing may be the only chance to see the Warhol in the proper format. They may be thrilled by the opportunity and find it fun, but there is a trace of angst in the action, too. In both cases, though, through such activities both cinephiles and fans outwardly affirm the objects of their love in an intentional way.

Tensions between collective interests—a cinephilia marked by a sense of belonging to a film community—and individual interests—a cinephilia centered in a single body and channeling personal predilections—make the location of cinephilia difficult to map. However, "building bridges" is frequently used, especially recently, as a metaphor for what a contemporary cinephile does (perhaps versus burning them, as in cinephile collectives of the 1950s, where pointedly polemical critical writing was often the rule rather than the exception).[49] The *practices* and actions of cinephilia, geared toward the expression of both a singular and a communal sensibility about cinephilic objects, are the outward signs of the affect that drives cinephilia as well as part and parcel of the phenomenon.

Cinephilia Depends on Displacements in Time and Space

As we have seen, memory plays a role in cinephilia; Laura Mulvey conceives of its function in terms of how it both inspires nostalgia for the lost object of cinema and how it lives through a present attachment: "As its original conditions of being have receded (along with the cigarette smoke that had fueled them) into the past, the idea of loving the cinema becomes a conscious stance that stretches back into the twentieth century so that the contemporary cinephile lives the problem of the continuities and discontinuities of time."[50] The copresence of older and newer media in the current media environment also enables connections between cinema's past and future that elicit cinephilic play as we see in the reuse of older media (e.g., updating parts of cinema's past for the present moment in GIFs) or in attendance at screenings on film, reliving a media past in the media present. A love of cinema frequently depends on the displacement or rearrangement of experience(s) in time and space.

Such displacements are complemented by the way the nature of cinema has been conceptualized. Cinema's complex relationship with time prompts elements that characterize cinephilic experience.[51] "Cinephilia is also a quest for memory and pastness," Jenna Ng observes. Its pleasure lies in the desire to roll back time, "a gesture toward recovering an unbroken window, invoking a time before corruption and hence a return to prelapsarian innocence."[52] Moreover, the foundations of an anxious love of cinema are often tied to a perception of an inherent memento mori within cinematic time. Moving images have been perceived as a way of freezing time, of preserving a version of time and of people intact, an embalmment of what is immediately an earlier self, place, and situation in a period of duration and in perpetuity. As André Bazin has suggested, to be able to preserve the body—"to snatch it from the flow of time," "to have the last word in the argument with death"—is a long-standing urge, which art, the cinema in particular, has worked to fulfill.[53] Through a description of family albums that preserve "the disturbing presence of lives halted at a set moment in their duration, freed from their destiny," Bazin describes moving images as having the additional power to create "the image of their duration, change mummified as it were."[54] Such images have both a "charm" and "disturbing presence": the flow of people's lives is mummified as well. This aspect might well recall the beholders to

themselves through this "halted" ultimate destiny. Like Hamlet's poor Yorick, it reminds a body of its ultimate destination as an inanimate object (i.e., a future corpse, from which the "self" has departed), even while that body is still animated and fully (for the moment) a subject. Drawing on Bazin's postulation, Phil Rosen notes that although a subject may be aware of temporality and duration in the cinematic experience, her position is "essentially defensive" since she must "disavow . . . [t]ime passing, duration, and change" to obviate "the problem of death."[55] Rosen underlines the way the simultaneous awareness and disavowal of time subtly but distinctly inflects the experience of duration with moving images. The moving/stasis binary undergirding motion pictures pits a feeling of stability against the variability of the future—and against the feeling of progress that nonetheless necessarily ends with stasis or death.[56]

Laura Mulvey, too, expatiates on the implications that nuances of death hold for the medium of cinema even as its technologies change. The temporal shifts of the cinema underline the way that cinematic images, "necessarily embedded in passing time[,] . . . come to be more redolent of death than of life."[57] For Mulvey, this connection to death has to do with film's capacity to preserve both the stillness and the movement of a gesture within its frames and to reanimate past gestures by playing the film forward. But the nature of the reanimation, Mulvey remarks, is different for the digital age. Because the spectator can fragment the film to fixate on favorite moments, she "is able to hold on to, to possess, the previously elusive image," which produces a "fetishistic spectator, driven by a desire to stop, to hold and to repeat" images that are special to her.[58] Thus, the cinephile who longs to possess the object of her love finds assistance in digital platforms. But her victory is pyrrhic because the mastery she might wield over the image is limited to its single, original registration of the world and because it constantly if subtly reminds us of what Mulvey calls the "secret, the hidden past that might or might not find its way to the surface" in moving images—that is, its inherent stillness (twenty-four absolutely still frames per second).[59] Mulvey associates this ontological stillness with an existential stillness in the ultimate stoppage of movement in death. A little bit of imagination recalls to us that everyone imaged in the cinema is dead or is closer now to death than before, even while brightly animated for the moment: the moving image makes them living specters, ghosts in advance. Mulvey's

chilling reminder of the abyss below the moving image's surface leads to the final quality under consideration—the one that binds all the earlier qualities together.

Cinephilia Is Fundamentally Anxious

Just as I allow for many kinds of love as constitutive of cinephilia, I have chosen the term *anxious* as a more general affective container than *dread, horror, angst, loathing,* or other similar terms because it fits a range of cases prompted by different spectators and cinematic situations.[60] Moreover, cinephilia betrays an array of *nonspecified* or *nonspecifiable* anxious feelings. Part of the power of anxiety is that its causes are ambiguous; this quality suits such feelings in the cinema, grounded in reality while also mysteriously akin to memory, imagination, hypnosis, or dreaming. Furthermore, with a debt to Neta Alexander's exploration of the anxiety invoked by digital buffering,[61] I call it *anxiety* because that term seems best suited to an affect that persists—indeed, is perpetual—despite (or perhaps because of) the difficulty of identifying its precise sources. And anxiety's appearance in cinephilic discourse is pervasive.

Anxiety shapes the cinema from the inside and outside. Audiences, for instance, have struck a number of positions antagonistic to cinema based on a wide range of anxieties: some have entertained misgivings about photography's soul-stealing potential, while others have worried over cinema's portrayal of violence. Moving images have served as a vehicle to assuage or redirect uneasiness about real events, differing viewpoints, or technology. The long history of apocalyptic narratives or movies about robots taking over the planet or historical dramas that replay national traumas speaks to the way cinema envisions and channels fears. Some filmmakers have focused on unpleasant, even ugly feelings (e.g., torture porn), and certain moviegoers have been more cinephobes than cinephiles, fearing the cinema and what it does to vulnerable audiences. These cinephobes have boycotted, banned, and otherwise censured or censored such films. All the same, reactions of this sort, however extreme, tend to underline the powerful effects of cinema—aligning them obliquely or directly with cinephilia's operations.[62]

Anxiety and the cinema have long been closely intertwined. Films that capitalize on fear and provoke it in their audiences—such as those

in the horror genre—often also give a giddy, sometimes perverse plea-sure. Strong responses to the cinema simultaneously betray a sense of its many allures and its underlying or transparent anxiety-inducing qual-ities. Even within what may seem to be euphoric cinephilic accounts of cinema, anxieties shadow the object of love. Ardent tributes to cinema, for example, often surface at the moment of forfeiture of some salient fea-ture of the medium (e.g., the transition to sound or color or widescreen or digital): they express a love provoked by a sense of loss or passing. Many such tributes are contentious, with critics, scholars, and audiences delineating the boundaries of cinema, arguing that one thing is cinema and another thing is not.[63] These seemingly opposite responses to cine-matic experience—love and anxiety—are wedded to each other in a fraught but not unhappy marriage. Investigating that marriage, one observes that recognizing the anxiety that undergirds cinephilia leads to a more nuanced understanding of the arc of film history and theories of cinema spectatorship within and beyond that history.

CINEPHILIA: A "DECLARATION OF LOVE"

An open "declaration of love," cinephilia lays bare the dynamics of cin-ema. Even as a one-sided romance, a singular, obsessive, or addictive rela-tionship to the cinema, cinephilia offers a point of entry for a collective engagement with the cinema. Cinephilia suffers the same complications as any love that derives from an insatiable need for repeated encounters with the object of desire (the compulsion to repeat is also constitutive in Freud's conception of the death drive[64]). One returns to the sites of cinema to get a "dose," to fulfill "a sort of need, like tobacco or coffee," as one well-known cinephile has put it.[65] Desire of this sort suggests dis-tance, a longing for something just out of reach. Further, it suggests the formation of a core part of identity: what you want more or less shapes who you are. As Berlant has noted, the nature of desire entwines with issues of identity and its boundaries in complex ways: "Desire is memo-rable only when it reaches toward something to which it can attach itself; and the scene of this aspiration must be in a relation of repetition to another scene. Repetition is what enables you to recognize, even uncon-sciously, your desire as a quality of yours. Desire's formalism—its drive to be embodied and reiterated—opens it up to anxiety, fantasy, and

discipline."[66] Yearning for the repetition of pleasurable experiences occasions the possibility of disappointment. All the more so when the object of desire—here, cinema—is ever changing, temporally fleeting, and hard to possess. Further, the plenitude and fulfillment sometimes associated with experiences of (especially narrative) cinema potentially disperse or disappear altogether once the specific film has ended. That is, feelings of immersion and spatial presence that often accompany narrative engrossment turn into a feeling of loss when at the end of the movie a spectator snaps out of the spell it has cast.[67]

Difficulty in holding on to cinematic experience is unmitigated by the availability of material and commercial goods related to cinema, whether actual reels of celluloid, the sleek packaging of DVDs, tie-in products such as the *Star Wars: The Empire Strikes Back* glass that came with your hamburger at a fast-food joint in the 1980s, or the moving image in whatever format playing before your very eyes. In its temporal, aesthetic, and technological dimensions, cinema is a moving target. Even pausing an image is no way to possess it truly. *Star Wars* is not yours. The image of one of its stars is not yours. Moving images are highly fickle love objects: they have many admirers who are not you (as well as many detractors against whom they must be defended), and they change over one's lifetime (literally in the case of *Star Wars*,[68] but also in terms of your reception of certain beloved films as a child and then later as an adult).

Furthermore, cinema is unique in being perfectly suited for *envisioning* unfulfilled desire and the infusion of feeling that desire involves: movie images of people touching a screen as a dead loved one, a distant city, or a missing friend is briefly reanimated on it could serve as an emblem for the distance embedded in cinematic desire. The screen (and time) separates the experiences within and outside of the film, and the film's spectator participates in these separations (see figs. 0.2–0.5).

It is in just this way that Pedro Almodóvar's film *Los abrazos rotos / Broken Embraces* (2009) articulates the kinds of desire that drive cinephilia. In flashbacks, the film tells the story of a film director, Mateo Blanco, now living under the name "Harry Caine" (Lluís Homar), who in a car accident loses both his sight and his lead actress, lover, and muse, Lena (Penélope Cruz). When Mateo/Harry receives a copy of footage taken during the final moments before he and Lena are in the accident, he lingers over the image of their kiss, trying to close the gap between

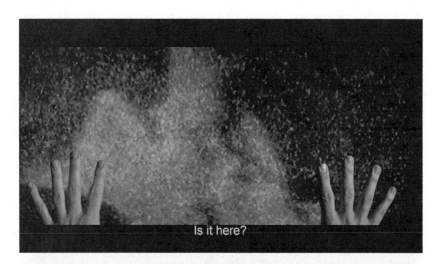

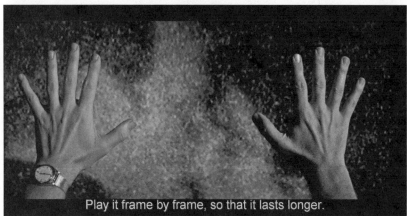

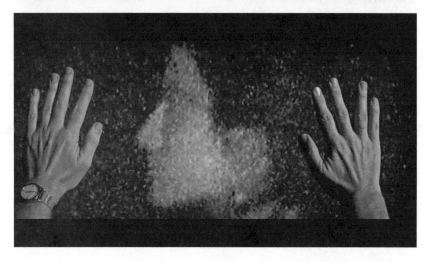

FIGURES. 0.2–0.5. *Los abrazos rotos / Broken Embraces* (Pedro Almodóvar, 2009).

FIGURES. 0.2–0.5. (*continued*)

the past and the present and between the image of his lover and his long-ing for her. No matter that he is now blind: he moves his hands over their faces, asking his young companion, Diego (Tamar Novas), to slow down the playback to stretch out the moment, attempting to make tac-tile contact with a person who is now an impossible image. His effort brings him no closer to anything but the screen. However, the memory is reactivated through the image, so in some important but unverifiable way the image briefly flickers to life again in a new moment beyond the bounds of its original context.

Broken Embraces is centrally concerned with these impossible images of desire and serves as a case study for articulating the ways a film might engage several cinephilic levels at once. First, it underlines the director's own cinephilia. As theme and topic of the film, cinephilia inspires Almodóvar's image making. From the perspective of his intermediary within the film, the director Mateo/Harry, he "views" the footage, fram-ing Lena between his hands as the camera pans slightly to the right so that she is in the center. In this moment, we become aware of other layers of framing: there is slippage between Mateo/Harry as director/writer of Lena (framing her image with his hands but not in control of it, not direct-ing it) and Almodóvar; their roles collide with each other as well with that of Ernesto Jr./Ray X (Rubén Ochandiano) as director of his own film

about Mateo and Lena within the film, which he is in the act of filming at the moment depicted. One shot registers these layers at once: Ernesto Jr. is shown clearly and unpixelated in a shot that is intercut with the grainy footage he has taken of Mateo and Lena: the purpose of the clear shot is ambiguous in terms of the layers of direction embedded in the whole film (Is Harry Caine imagining how he got the footage while driving, or is Almodóvar showing us how he got it?). Each of these layers signals the overarching cinematic direction of all that we see: Almodóvar framing the shot of Lena/Cruz via the attenuated view of his two stand-in director figures within the film.[69] He articulates his own cinephilia via a tripling of desire (for Lena within the film footage within the film, for Cruz's image within the film, and for cinema as a vehicle for imaging this desire). The objects of his love—his character, the actual actress, and cinema's history and devices—motivate these shots and their function in the film.

However much the film emphasizes the role of the director in forming images of unbridgeable distances, *Broken Embraces* also points to the way the spectator should understand the nature of such images. The grainy quality of the movie within the movie signals the difference between longed-for real people and their reproductions in an image beheld by the spectator, who is embodied and real, while whatever is depicted in the image is presently not. This happens especially when the image within the image betrays its own technology's fallibility: it gets less sharp the closer Mateo/Harry gets to it. And no matter how sharply the image is rendered, distance inheres in it. As it must. Or as Roland Barthes has put it, "Here then, at last, is the definition of the image, of any image: that from which I am excluded."[70] The screen is an impassable barrier: no one and nothing will cross that boundary to occupy the world in which the images are observed. The fantasy of permeability—of immersion in the movie, of the "aesthetics of proximity,"[71] of moving from outside the screen toward within the screen or vice versa, of the three-dimensional merger between spaces onscreen and the space of the theater or virtual-reality glasses, of really any technological, aesthetic, or other effort to tighten the gap between the two—holds to the rule of asymptotes. Until reaching infinity, those lines will not meet.

Almodóvar also embraces cinephilia outside of the film. Recently, for instance, as chair of the film jury at the Cannes Film Festival 2017, he sparred with fellow jury member Will Smith and others who argued that

films released only on Netflix should still be allowed consideration in the competition for the Palme d'or award. Almodóvar vigorously disagreed, issuing a statement at a press conference on the first day of deliberations that laid out a cinephilic argument against naysayers to the rule that a film must be shown in theaters before it can be entered for an award: "All this doesn't mean I'm not open, or don't celebrate the new technology and the possibilities they offer to us, but while I'm alive, I will be fighting for the one thing the new generation is not aware of—the capacity of hypnosis of a large screen for a viewer."[72] (Interestingly, however, within his own film, his most urgent expression of cinephilia happens on a small screen.)

Broken Embraces also meditates on the act of filmmaking as a cinephilic practice. It is a film that lavishes attention on color and the various landscapes (both natural and artificial) it images. Moreover, it pays overt homage to memory and to several specific films, citing them visually, narratively, and thematically. When Harry Caine and Diego sit down to watch a movie, Harry asks to hear Jeanne Moreau's voice and directs Diego to find *Ascenseur pour l'échafaud / Elevator to the Gallows* (Louis Malle, 1958) on his shelf. As Diego searches for the video, he names other things on the shelf: "Fritz Lang, Jules Dassin, Nicholas Ray, *Fanny and Alexander* [Ingmar Bergman, 1982], *8½* [Federico Fellini, 1963], *Magnificent Obsession* [Douglas Sirk, 1954]." Several of these directors and movies have had an influence on Almodóvar and on *Broken Embraces*; almost all of them are central to the legacy of postwar French cinephilia, putting Almodóvar squarely in the midst of that tradition. Of all of Almodóvar's films, *Broken Embraces* may be the most blatant "declaration of love" to the cinema, which is precisely what he calls the film in his press-kit notes. In this two-hour nostalgic encomium to cinema history, Almodóvar includes references to these same films and directors as well as a clip from Roberto Rossellini's *Viaggio in Italia / Voyage to Italy* (1954); nods to *Sabrina* (Billy Wilder, 1954) and *Breakfast at Tiffany's* (Blake Edwards, 1961); homages to actresses such as Audrey Hepburn, Marilyn Monroe, Sophia Loren, and others; citations of several films featuring staircase scenes (e.g., *Written on the Wind* [Douglas Sirk, 1956], *Leave Her to Heaven* [John M. Stahl, 1945], and *Killer's Kiss* [Stanley Kubrick, 1955]); and allusions to films about the nature of photographic

evidence as laced with anxiety (Almodóvar mentions Michelangelo Antonioni's *Blow-Up* [1966] in the press materials, and Mateo mentions *Peeping Tom* [Michael Powell, 1960] to Ray X). Finally, throughout *Broken Embraces*, Almodóvar makes lengthy reference to his own earlier film *Mujeres al borde de un ataque de nervios / Women on the Verge of a Nervous Breakdown* (1988). In that reference point, he makes transparent the desire not to leave behind the beloved images of the past but to fidget with and revivify them according to new contexts and themes. As Javier Herrera has argued, Almodóvar's "thefts" of existing films are a sign of his cinephilia, which demonstrates what Herrera calls his "intertextual transvestism," a signature aspect of "the Almodóvar style."[73] Almodóvar's status as an auteur (a term he courts in his publicity) also links him to French postwar cinephilia. Multiple, complex reference to other films transpose key components of the films constituting his oeuvre into the mode of earlier genres and idioms, in particular the New Wave and the classical Hollywood genre films (melodrama in particular) extolled by the postwar French cinephiles.

In toto, *Broken Embraces* mobilizes several of the features of cinephilia that the chapters in this book outline: it emphasizes the distances, small or large, between the image and the perceiver; it calls attention to the way directors and audiences engage with images in an obsessive way, seeking to create impossible bridges for temporal distances (for example, between images of memory and of the past and the present); it underlines the simultaneously amorous and unsettling sides of longing both in the themes narrated and in how it makes and displays images; it reminds the spectator of the cinema's technological fallibility; it dwells in exquisite landscapes and accesses their moods; and it cites in complex ways a rich cinephilic history. Further, in Almodóvar's worrying about how audiences will receive what he insists are not homages, in his filming of a landscape that reminds him of his own grief and its maternal source, and in the characters' and spectators' inability to cross to the loved one because of the firm boundary between image and spectator, *Broken Embraces* exposes the anxious foundations of cinephilia. Finally, steeped in a specific, historical cinephilia centered on the French postwar context, it perpetuates an older cinephilia that some feel the need to protect, others to explode, in the wake of the present moment.

THE CHAPTERS: FIXING A WAVE

In the following chapters, I address anxious cinephilia by tracing the historic, aesthetic, cultural, and technological aspects of cinema through which it becomes visible. Delving into discourses about cinephilic encounters with moving images, I focus on anxieties related to these encounters to illuminate the multiple ways in which intense and anxious engagement with cinema over the whole course of its history shapes that history. The dynamics of cinephilia depend on oscillation between love and anxiety, such that they are like the proton and electron that attract each other and give it energy.

For an affective concept such as cinephilia that likes to parry, dodge, and spin out of range when confronted, it is necessary to take a variety of approaches. Although this book charts different reactions to cinema, what binds them together is their source in both love and anxiety—coupled with a desire to see more, know more, and possess more. Having a sense of the common ground these experiences share lends cohesion to the long history of cinephilia. Meanwhile, the diversity of occasions for which cinephilia serves as a useful explanatory concept for what cinema is and does for an intensely engaged spectator shows how fundamental and pervasive the concept is for thinking about cinema. Its diversity and ubiquity help broker a notion of the past and present moments of cinema at its most fully realized and most fully engaged instances—as well as set us on the path of understanding the cinema(s) to come.

In pursuit of cinephilia's common qualities as well as its changes across times and places, I begin in chapter 1 by outlining the long history of anxious cinephilia and expanding the geographical and conceptual boundaries of a love of cinema. Cinephilia has existed across cinema's history, from its very beginning and up to the present, and it has always (sometimes somewhat precariously) bridged fascination and anxiety in spectators' responses to the cinema. Cinephilia invites obsessive engagements with motion pictures—their images, stars, and modes of consumption—that derive from the slippery object of their desire, an object that changes from time to time, audience to audience, and over broad trends and innovations in filmmaking.

Perhaps the very intangibility and elusive qualities of moving images prompt special fixation on their material supports, from the

brick-and-mortar sites that gather films and cinephiles to the film on reels and running through the projector and to DVDs or other graspable and collectable items that offer at least an oblique tangibility, a point of entry to the objectless object of cinema. From the focus on the institutions of cinephilia in the first chapter, in chapter 2 I turn to phenomenological aspects of cinephilia in order to address the spectator's relationship to that elusive, immaterial object. As the funhouse-mirror sequence near the end of Orson Welles's *The Lady from Shanghai* (1948) suggests, cinematic images hold unique potential for being deceptive, threatening, or elusive. Images that reflect and refract a notion of an identifying self embody cinema's foundational mutability. Moreover, the pleasure that comes from an investment in the image and its plenitude and allure as well as from all the (narrative, aesthetic, etc.) meanings it bears comes at a cost because the image also carries anxiety about its constant disappearance and unreality. To this end, I trace issues related, first, to a peculiar but pervasive aspect of cine-love—that of being in thrall to one's self-image—and, second, to images more generally. For the first, I consider the notion of identification in terms of how one relates to a version of oneself onscreen and query how the cinema's ability to capture images of witting or unwitting people can be simultaneously wondrous and dangerous to those people. For the second, I turn to ways of addressing oneself to images that are pleasing without their being a reflection of the self. In tracing both of these kinds of identification, this chapter maps the significance of cinephilia for understanding how a spectator confronts the cinematic image.

The third chapter examines the relationship between technology and cinephilia. Using three case studies, it outlines a set of examples detailing the force that certain changes in technology have had on shaping discourses about the cinema: the emergence of sound cinema in the late 1920s, the controversy over colorizing black-and-white movies in the 1980s, and the conversion of independent movie theaters from film to digital projection in the early 2000s. The chapter adumbrates a complicated, conflicted cinephilia: the embrace or rejection of technology (both in narrative frameworks and as part of the cinematic *dispositif*) offers insight into the way that audiences and makers of moving images respond to the cinema as a technology and vehicle for entertainment.

In chapter 4, I apply the anxious cinephilia related to cinematic technology outlined in chapter 3 to a specific genre: the postmillennial apocalyptic film. This genre emblematically demonstrates how digital technology used in these films illustrates and parallels the anxieties undergirding cinephilia. Films such as *Melancholia* (Lars von Trier, 2011) and *Snowpiercer* (Bong Joon-ho, 2013) depict landscapes and survivors in environments not so much ruined as returning or longing to return to a more natural state. In marking apocalyptic spaces as both visually and sonically intense and undeniably generated through spectacular special effects, these films point to the usefulness of thinking about the intersection of cinephilia with anxiety through their longing for a not-yet-come-to-pass simplicity and an exquisite, vivid present. They imagine uneasy and uncertain futures through and for cinema that allow us to be nostalgic, overwhelmed, both technologically stymied and enhanced, and struck by simplicity, nature, and beauty at the same time.

Cinephilia derives from the commingling of a love for the object of cinema and a disconcerting sense that that object is shifting beneath one's feet. The need to reassess the nature of cinema is an understandable reaction in the wake of change, and examining it through the lens of an anxious cinephilia provides a productive outlet for doing so just at a point when it seems there may be something (again) to lose. Cinephilia has frequently been marshaled to cope with a changing cinema culture, aesthetic, or experience. Embracing the peculiar and shifting set of relationships between fear and love provides a resilient foundation for thinking about the cinematic experience in a climate of constant change.

Ardor and Anxiety

The History of Cinephilia

But film is hated by so many idiots, in such an idiotic way, that any reasonable person must not provide film's haters with any of his reasons [for loving cinema]. Thus, I will take mine to the grave.

—WILLY HAAS, "WHY WE LOVE FILM"

The qualities associated with cinephilia described in the introduction correspond to the full spectrum of cinema's history. Going back to a time even before cinema came into being and continuing through the present moment, this anxious cinephilia emerges and then reemerges, transformed to fit different times and different places, reflecting those times and places even while it transcends nation and history.

There is not a catch-all cinephilia; my love of cinema will never quite be yours, even if we regularly see each other across a darkened auditorium, and the forms of cinephilia of the 1920s, say, differ in important ways from the cinephilia of the present moment. As we shall see, however, a dominant cinephilia particular to a period and place (postwar France) has enjoyed enormous influence. Emerging out of *Cahiers du cinéma* enthusiasms, auteurist in perspective and predominantly straight, white, and male in its orientation, this cinephilia exerts a fascination that persists and shapes the way we have been pressed to think about earlier and later cinephilia (that it is not quite "cinephilia" because it is not *this* cinephilia). The many less-considered types of heterogeneous, inclusive, volatile cinephilias both resemble the dominant version and challenge our contemporary understanding of its dominance. For cinephilia, as for

many things, the more things change, the more they stay the same—which is only fitting, anyway, for a medium predicated on flux and movement.

Although French postwar cinema occupies a privileged position in debates about cinephilia, the many ways, times, and places in which a love of cinema has flourished demands that we look beyond its parameters. As Girish Shambu argues in *The New Cinephilia*, "It is far more likely that the globe has seen multiple and geographically dispersed cinephilias since the invention of cinema."[1] Disagreement between one version of cinephilia and another in fact underlies certain anxieties that I argue are a fundamental part of cinephilia *tout court*. Tensions arising in arguments over the nature of cinephilia's objects—over the powers and ontology of cinema, over what cinema does to its audiences, over whether it belongs only to those who pay careful attention to it or also to those who are content to let it simply entertain them, over how it seems to change just when it seemed perfect, as well as over the relative quality and provenance of its products—drive deep investments in and anxieties about cinema. Like Shambu's "new cinephilia," such a cinephilia is by necessity not confined to a single period, group, or location: it is expansive, inclusive, and pervasive. Its affective responses—wonder, astonishment, obsession, defensiveness, attraction, delight—relate to an intense engagement with and acknowledgment of the power of cinema. To call it new, however, is in fact not wholly accurate.

Indeed, cinephilia arrived early and has stayed late. When we see that it has always been in flux, too, adapting and resisting changes in the mediascape and cultural landscapes in which it takes root, we must recognize that it has flourished throughout cinema's history and up to the present instant. As Christian Metz argues, film history has been indelibly shaped by cinephilia, such that the impulse to love moving images is the foundation for how we understand that history overall: designating the merits of this or that film, style, or filmmaker is "really a plea, a claim for legitimacy and an appeal for recognition."[2] That is, any theoretical discourse about moving images is still predicated on "the film *such as it has pleased*," and theorization is rather anxiously pitched in order to protect that beloved object, which has also become internalized by the theorist/spectator:

Thus a simultaneously internal and external love object is constituted, at once comforted by a justificatory theory which only goes beyond it (occasionally even silently ignoring it) the better to surround and protect it, according to the cocoon principle. The general discourse is a kind of advanced structure of the phobic (and also counter-phobic) type, a proleptic reparation of any harm which might come to the film, a depressive procedure occasionally breached by persecutory returns, an unconscious protection against a possible change in the taste of the lover himself, a defense more or less intermingled with pre-emptive counter-attack. To adopt the outward marks of theoretical discourse is to occupy a strip of territory *around* the adored film, all that really counts, in order to bar all the roads by which it might be attacked.[3]

Metz's cinephilic impulse is one that erects ramparts even while going on the offensive. The beloved film must be protected against those who would attack, disparage, or dismiss it, and a key strategy for offering such protection is to fill the territory around the film with unyielding discourse. This description of a defensive offense against potential assailants of one's cine-loves correlates with several moments of cinephilia in history, none more so than the mode of French postwar cinephilia, to which I return later. But cinephilic love has also been full of fascination with moving images—for example, from early cinema's "attractions" mode to last year's blockbuster full of slow- or fast-motion explosions or rhythmic walking. Supported, nuanced, and complicated by a range of anxieties that shift over time and circumstances, the history of fascinations with moving images demonstrates a thick spectrum of cinephilic engagements.

CINEPHILIA AND EARLY CINEMA

At first glance, early cinema seems in some important ways *not* to inspire the same set of cinephilic practices I outlined in the introductory chapter: writing about cinema as an object worthy of study does not emerge until some years later; there are no specialized central locations where fellow obsessives intentionally gather as a body; the connoisseurship of the potential cinephile does not seem pertinent: in short, a collective

accounting of moviegoing doesn't exist in film's early years in the way it will later. We might well be prompted to ask a number of questions: Do earlier ways of engaging with cinema resemble the conditions of later cinephilia? Do they lead to that version? Does the birth of cinema and then the explosion of interest in cinema in the 1920s demand to be seen as a challenge to claims that postwar French cinema is the "first" or "classic" moment of cinephilia? At a minimum, we can discern evidence of a protocinephilia that emerges from the beginning of cinema's invention, which contains seeds of the later version. And not much later, we see develop a cinephilia that richly deserves stronger consideration in historical accounts. In these early forms of cinema love—characterized by enthrallment with the cinema's moving (in both senses) images and mechanisms and engaged with the ways it was able to express and work with the raw material of modern and universal anxieties—we see the building blocks for the establishment of cinephilia in its more familiar, later manifestations.

As such, we should not only think about earlier cinema's *relation* to cinephilia but also include early cinema in the swath of practices, affects, and dynamics that *are part of* a broader notion of cinephilia. The earliest encounters with cinema encompass a wide range of strong responses to moving images, de-particularizing the account of a coherent cinephilia experienced by a specific kind of person at a specific moment in cinema's history. Whereas some elements of early cinephilia are continuous with later versions, others are quite different. For instance, early cinema inspired a "cinemaniac" who haunted the picture shows,[4] and early cinephilic expressions of astonishment were entwined with anxiety in grappling with new, mediating technologies; at the same time, early cinephilia's relationship to moviegoing trends looks different than later relationships, and the types of writing about it are more fragmentary. Accounting for both the disjunctions and continuity among earlier and later cinephilias points to what drives the rage for moving images more generally. Looking more closely at forms of cinephilia from the beginning emphasizes how there has always been an impetus for cinema's dynamics to change in order to sustain a novelty that may be necessary to keep love fresh for fickle cinema lovers waiting to be seduced by something new. In these ways, an examination of early cinephilia challenges a singular model of cine-love.

Audiences for early cinema had the opportunity to experience the uncanny and marvelous realism of photography long before the images moved, and they were offered access to the illusion of movement in toys, devices, and other technologies, such as flip books, the phenakistoscope, and the zoetrope.[5] Early film spectators were also likely to have encountered magic lantern shows or phantasmagoria, which played on spectators' curiosity and delight in tandem with their spectral anxieties.[6] These shows were frequently presented in a protocinematic, narrative context with motion effects and often with beautifully colored slides meant to please if also, at times, to chill.[7] An experience of precinema was designed to be engaging and encompassing. Wonder at early cinema proliferated despite the familiarity of some of its aspects. Although early cinema developed in tandem with these several overlapping technologies and social practices, the novelty of its invention and its powerful impressions nonetheless had a strong impact on its first observers and earned it both ardent admirers and detractors.

Very early on, the potency of the medium was recognized. Several of the first encounters with cinema were described (by the people who were there) in terms of wonder, delight, astonishment, and shock and sometimes a combination of these reactions, so much so that the aesthetics of early cinema have been provocatively defined as drawing on these qualities.[8] Tom Gunning has dubbed the cinema of this early period "the cinema of attractions," which "directly solicits spectator attention, inciting visual curiosity, and supplying pleasure through an exciting spectacle." The audience was treated to titillating content: "a unique event, whether fictional or documentary, that is of interest in itself," including "recreations of shocking or curious incidents (executions, current events)."[9]

To be sure, the cinema of attractions, though predicated more on circus rather than love attractions, corresponds to aspects of cinephilia. The idea of showing an audience something delightful, surprising, or titillating draws on a range of delights as well as on anxieties and depends on activating an audience's desire—to see, to engage, to feel. Cinematic phenomena such as the "magical" qualities of Alice Guy-Blaché's or Georges Méliès's trick films play on apprehensions and delight about appearance and disappearance, presence and absence, control and chaos, and animation/life and stasis/death within both the new medium of

cinema and the world it images.[10] Guy-Blaché's *La fée aux choux / The Cabbage Patch Fairy* (1896) makes babies magically appear in a field of cabbages; a woman presents them to the spectator at the front of the frame (fig. 1.1). In Méliès's films, things that appear to be fixed, drawn, inanimate, or human size come to life, dance around, and grow to Brobdingnagian or shrink to Lilliputian proportions—and vice versa (the life given to objects is frozen). Both filmmakers highlight the role of the spectator as one courted by the image, as one to be bowled over by such marvels. Méliès's *The Marvelous Living Fan* (1904) makes that courtship of the audience its focus. An enormous fan is brought out to the middle of the space where an important gentleman sits down to have it shown to him. It unfolds as another man waves his arms about, conjuring it to move on its own. Open, it reveals seven marvelous panels, each framing the image of a woman who seems to come to life. The panels and the framing arches of the fan panels disappear, the women's costumes magically change, and the film ends with them freezing briefly after blowing more kisses. More than half of the film is the set up: the act of

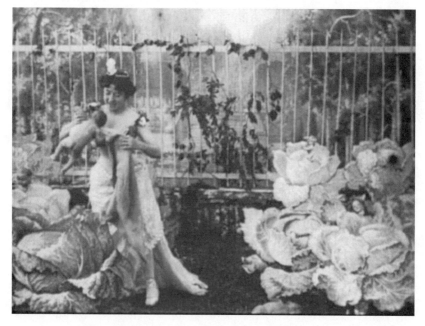

FIGURE. 1.1. *La fée aux choux / The Cabbage Patch Fairy* (Alice Guy-Blaché, 1896).

showing and of whetting the spectator's anticipation. Once the women appear, they perform their affection for the gentlemen at the front of the frame but also for the film's audience. The power of cinema to conjure women or make them disappear, as Karen Beckman argues, also plays on a range of anxieties, including a "profound ambivalence about female presence" on the screen and stage and in the public sphere. Here, their insubstantiality is underlined in much the same way that, as Beckman argues, cinematic spectators must be able to dissolve in order to immerse themselves in narrative films—this is another fearful gift of cinema, its dis-integrating powers hinted at from an early moment in its history forward.[11]

Moving images elicit a powerful response from many spectators, a response that serves as a lure for the return to see more. A very wide range of loves and anxieties affiliated with cinema's powers—and, perhaps even more importantly, a very wide range of the kinds of people who are drawn to the cinema in particular ways from the first moment of its long history—should be recognized. The way audiences responded to early film suggests a mode of spectatorship that shares foundations with cinephilia. The tale of spectators leaping out of the way at the spectacle of *L'arrivée d'un train en gare de la ciotat / Arrival of a Train at the Station* (Lumière Brothers, 1896), for instance, bears witness to the way that this anecdote highlights something deeply impressive and unnerving about moving images. Whether apocryphal (probably) or not, the story speaks to the sense that cinema carries this capacity to so affect spectators that they are literally moved—out of the way of the image bearing down on them. Tom Gunning has explicated the dynamics of such myth-making accounts of encounters with early films, arguing that the extreme reactions reported by audiences of the train-arrival film (leaping out of the way, gasping, or fainting as the train came toward the foreground of the shot) convey the effects of "astonishment" over the "magical metamorphosis" on screen.[12] Aiming to surprise audiences and to show them the almost occult magic of revivification and animation inherent in the medium, early film exhibitors initially projected a still image on the screen, which, when they cranked the projector, would leap to life. They transformed the still photograph, which audiences had encountered many times before, into moving images, which was something new.[13] Gunning connects the early technology of the cinema with

its stirring impact on spectators and the swift popularity of cinematic events capable of simultaneously unnerving and delighting them.

It is exactly this kind of reaction that characterizes one of the earliest accounts of motion pictures. Having witnessed *Arrival of a Train* and a selection of other films in a screening in 1896, Maxim Gorky wrote of the experience in a way that corresponds to the simultaneous wonder and uneasiness of interest here, dubbing the cinema "a kingdom of shadows." Gorky betrayed anxiety about the images that sprang to life before him: they bore a disarming allure. His account hinges on wonder at the lifelike quality of the movement coupled with the eerie fact that it was drained of sound and color—the films were both a technological wonder and a disappointment. The result was "terrifying to watch," but "it [was] the movement of shadows, mere shadows" that frightened him, not the notion that the train was real and capable of hitting him.[14]

As films became increasingly popular over the next decade, a subset of spectators responded to the lure of cinema by going to the cinema as frequently as possible. Early cinema exhibitors counted on these patrons who came to the movies repeatedly.[15] As reported in *Moving Picture World* in 1908, in Grand Rapids, Michigan, "the theatres depend upon 'repeaters' for the bulk of their receipts," so much so that exhibitors were obliged to change their programs regularly to serve them and keep their business. Exhibitors courted regular patrons to keep traffic up in their cinemas, and some audience members were characterized as having "moving picturitis" because they "visit the theatres day after day."[16] In such reports, we see the prototype of a cinephile, a "cinema maniac" of the sort who would emerge in the next decade or so as cinema took purchase as an industry worldwide. Early cinema thus provides a call to expand the territory for the consideration of how cinephilic practices emerged, found a foothold, and thrived.

LIFE AND DEATH, DELIGHT AND DREAD IN THE TRANSITION TO FEATURE-LENGTH NARRATIVE CINEMA

As cinema moved out of the attractions mode and into longer and narrative forms, tensions between delight and dread such as those in early cinema continued, both in and outside of exhibition spaces. During the

period of transition to narrative feature films, circa 1907–1913, films' content focused in many cases on sensational, risqué, and grisly material; at the same time, campaigns to protect vulnerable audiences from salacious content, to educate the masses, and to gentrify cinema spaces began to gain steam. Reviews and editorials from this moment—often highly attuned to then current censorship debates—shed light on how the direction of cinematic storytelling was forged by the pressure to mitigate sensation (an attractions-based concern) with a dramatic/narrative arc.[17] An increasing sense of cinema's power to revivify beings and moments from the past and in the present came to preoccupy people paying attention to cinema. This marshaling of life-and-death concerns on both the narrative and the ontological levels would shape cinephilia—and a sense of the almost occult powers of cinema—for years to come.

The early years of narrative cinema were banner years for bodily harm and danger in the movies, with bodies hurled from trains and cars, plummeting off cliffs and bridges or falling out of buildings and boats, being stabbed or blown up or strangled, and generally being subjected to every kind of mortal threat. Much of the fare on offer contained violent material. In descriptions of movies reviewed in *Moving Picture World* on January 18, 1908, an old man is killed, and the deed pinned on an innocent woman;[18] a child's life (and then his rescuer-father's life) is imperiled by an eagle;[19] a captive boy is in danger of being eaten by the Bogey Man; and a man mistakenly kills his daughter instead of her clandestine lover. The omnipresent intersection of death and life offers a productive site for reckoning with issues relevant for developments in early cinema and cinephilia. In both narrative and theoretical terms, the cinema trades in vital presence onscreen even while it grapples with the terms of mortality that inhibit its bodies on and in front of the screen. Like the still image springing to life in the earliest cinema exhibitions, several of these films play out the animate/inanimate dialectic of cinema, such that people mistaken for dead spring to life or such that death itself seems undone by cinema's transformative capacities. Through André Bazin's essay "Death Every Afternoon," C. Scott Combs reads cinema's moments depicting death as a sensational feature of its nature: cinema has the power to reverse "the ultimate irreversible experience," to undo death. For Combs, cinema's focus on death as a process, like that of Topsy in *Electrocuting an Elephant* (Thomas Edison, 1903), reveals its ontological

uncertainty onscreen.[20] Topsy keeps returning to the platform, and her death is paradoxically both inevitable and completely undone each time the film rewinds. Meanwhile, on the narrative and thematic level, early observers of the cinema saw the popularity of life-and-death scenes as differently ambivalent. On the one hand, such scenes are cathartic, a release from the stresses of modern life. On the other, they unnecessarily court sensation for shock effect. Each side of the publicly debated question of whether cinema is a balm or a stressor drew on the same material for evidence.

Censorship debates from this time demonstrate that people were dealing with the impact of social mores related to bodies and their behavior in cinemas as well as on their screens. These debates developed out of anxieties about the power of moving images. Governmental agencies got involved to respond to the pressures of citizens complaining about the sensational content of the moving images: the city of Chicago flexed its presumptive right to ban or monitor the content of moving images in 1907; the mayor of New York City closed down 550 nickelodeons on Christmas Eve in 1908; the U.S. National Board of Censorship was formed in 1909; and in that same year the London Cinematograph Act was passed to make theaters safer for audiences but was taken up by non-literal-minded conservatives as an occasion to "[stretch] the definition of 'inflammable films' to cover not just their physical nature but also the images they contained."[21] In *Policing Cinema: Movies and Censorship in Early Twentieth-Century America*, Lee Grieveson makes the connection between popular fears and the way the movies as a medium came to develop in terms of both style and their social function at this key moment:

> Linked closely to anxieties about social dislocation and the governance of populations, the regulatory response to cinema had considerable effects on the shaping of the medium. . . . Legal decisions, combined with those internal to the mainstream film industry in this period, gradually established a consensus that mainstream cinema should principally offer harmless and culturally affirmative entertainment and not pretend to the loftier purposes of the press or to the purpose of cultural negation that postromantic cultural theory accorded the category of "art."[22]

The films of this moment were caught up in navigating how to tell a legible story, entertain, hold attention, draw people into theaters, and stay out of trouble with the censors. Walking the lines among these concerns proved to be a balancing act. In the end, tensions between sensationalism and staunch moral (and, interestingly, aesthetic) values were expressed and worked out through these films. While audiences clamored for sensation, the censors worried about moral degradation, and business interests worried about the health of the movie industry (being shut down for having too dark a theater, too spicy a collection of films, too overstimulating a set of posters in the vitrines, etc.).[23]

In the process of becoming, as Grieveson suggests, the entertainment (not educational, not artistic) medium par excellence in the early years of the development of narrative codes, cinema grappled with social and aesthetic anxieties. That is, within this emerging cinematic system of storytelling, films also suppressed or conversely (and often simultaneously) exploited anxieties about modern life, social issues, and especially destruction and death. In addition, debates about the role of the movies as entertainment built upon what needed be done to mitigate potential damage inflicted on the frequent moviegoer. The censors directed their attention primarily at audience members, who were seen as sensitive to sensations—to an attractions mode of soliciting attention through spectacles most thrilling and titillating. Unsophisticated rubes, corruptible youth, women of any description, immigrants, and other members of the audience deemed susceptible motivated the hand-wringing of the arbiters of society and culture and become the focus of uplift efforts.[24]

These same audiences were some of the first to embrace the cinema yet are discounted in most accounts of cinephilia, both in this early period and later. As Miriam Bratu Hansen has demonstrated, in the 1910s the cinema in both its literal space in the theater as part of the public sphere and in the "phantasmagoric space on the screen" offered an important point of convergence for women, immigrants, and the "urbanized working class of all sexes and ages," including children. It provided "a site for the imaginative negotiation of the gaps between family, school, and workplace, between traditional standards of sexual behavior and modern dreams of romance and sexual expression, between freedom and anxiety."[25] Although writing from the perspective of these audiences did not find an outlet in the press, the things that brought them into the theaters

and kept them coming—their own amorous encounters with the cinema—were no less strong for being unreflected upon in a cohesive way. Several scholars have introduced important insights about the obsessions, habits, and loves of these audiences via letters, scrapbooks, memoirs, and ephemera collected in archives and elsewhere.[26] Through such materials from this period, Paula Amad has shown how the conventions often attributed to male versus female cinephilia—which usually afford a higher status to the former—might actually intertwine in complex ways.[27] Further, as Hansen argues, the appeal to women in particular as audiences can be discerned in many forms, including the studios' investment in serials with "adventurous, physically active heroines" and virtuous heroines across the broad swath of American film scenarios and genres as well as emerging fan discourses surrounding female stars. In response to women's "craving for the cinema," the emerging film industry offered a complex set of enticements that would appeal specifically to that hunger.[28] Within the next decade, fan culture tapped into and built a commercial juggernaut in response to these moviegoers' habits and predispositions.

Films of this period negotiated life-and-death stakes in order to fulfill dramatic *and* social, cultural, and artistic purposes. Life's tribulations, felt as a burden on the bodies of spectators, might be lessened by a movie fix—but it was not just the "cheerful" movies urged by editorials at the time that might offer benefits.[29] The attention paid to the life-and-death consequences of transitional films suggests there was something in them that afforded relief as well. While the film plots of this period are populated by those who perish, the life-giving qualities that cinema conferred on the bodies onscreen and off were equally prevalent and persuasive as part of what made the aesthetic, narrative, realistic codes that constituted the cinema of this time irresistible to vulnerable and calloused spectators alike. Side by side, life-giving and death-dealing qualities shaped the draw and drawbacks of the cinema for its audiences, molding their cinephilic and cinephobic responses. Within another decade or so, although entertainment values were still of enormous importance, cinema all over the world also took a conscious turn toward fulfilling specifically artistic ambitions. Through the turn to film art, the cinephilia of the 1920s in many countries began to look a great deal more similar to the postwar French example, and several scholars identify in these years the first wave

of cinephilic thought. We may thus conclude that the later version of cinephilia is not original or necessarily the center point of cinephilic histories but rather an extension of earlier interests and investments specific to different moments and different kinds of cinema.

PREWAR CINEPHILIA IN THE 1920s AND 1930s

The starting point of cinephilia arguably coincides with the starting point of cinema. But if the somewhat disjointed manifestations of the love of cinema in its earliest years leave this issue in some doubt, the 1920s definitively affirm that cinephilia began well before the mid–twentieth century. As Christian Keathley has observed, there is much to compare between cinephilic networks of the 1920s and those of the postwar period.[30] Although cinephiles of the 1920s were more enthusiastic specifically about the medium of cinema and its artistic potential than about its history, their focus on the embodied and communal experience of cinema as well as their ways of expressing cinephilia coincided. The emergence of cine-clubs and outlets in print media for film criticism and discussion of ideas parallels later cinephilia. And the gush of filmmakers who exercised their own cinephilia not only in making moving images but also in writing and lecturing publicly about cinema—for example, Jean Epstein and Germaine Dulac[31]—contributed to a sense of a cinephilia in configurations strikingly similar to the postwar variety. By the 1920s, writing about cinema took on broader terrain, and nascent theories of cinema's nature, powers, and best practices emerged. A portrayal of this period in even a limited survey of locations demonstrates the poverty of a notion of cinephilia restricted to one time and place.

Although there has not yet been a collective accounting across the 1920s globally, several scholars have considered elements of this earlier moment of cinephilia in specific locations, from France to Germany, Italy, Scandinavia, Japan, China, and elsewhere. In her dissertation, Annie Fee examines the heterogeneous publics of film fandom in France circa 1920, arguing for the importance of working-class female moviegoers as well as of audiences whose political affiliations shaped the way films were shown. Aiming to demonstrate how the use of the term *photogénie* offered a "negotiation between high-brow and low-brow film culture," Fee also tracks the way this word divided the sophisticated, elite art-cinema

audience from popular moviegoers. Her work encompasses a wide range of cinephilic engagements by nonelite audiences while arguing that in fact cinephiles in the elite sense sought to distance the ordinary filmgoer from discourses about film as an emerging art.[32] By scrutinizing accounts in fan letters and daily newspapers, she demonstrates capacious, complex notions of love in early observers of the cinema. Her line of questioning for this material (e.g., whether early appreciation of the cinema was democratic or specialized, whether it was the province of the elite, what its intellectual and situational exigencies were) ought to apply equally to postwar cinephilia as well as to the most recent forms of cinephilia.

Echoes between these pre- and postwar French cinephilias in particular are numerous, especially if one focuses on a set of cinephiles who were well positioned to help define the role of cinema in the years to come. Many of them wrote a great deal about the cinema, several made films or helped to establish venues for cinephilic activities in the forms of journals and clubs, and in these activities they were articulate both about making cinema and about being addressed by the cinema as one of its spectators.[33] This elite, top-down cinephilia was based on elevating cinema to the realm of art. In its interest in the intersection of art and cinema, it strongly resembled several of the postwar French cinephiles' efforts to reclaim the cinema (even popular cinema) for art: it focused its amorous attention on cinema's expressive, image-oriented (rather than literary) abilities, its unique purview, and its untapped potential. In a search for the components that would constitute a cinematic art, this form of cinephilia, wrought for the most part by professional critics and filmmakers rather than by laypersons, attempted to define the nature and capacities of cinema. Compared with the mobs at Rudolph Valentino's funeral or outpourings of letters to popular actors and actresses written by young fans the world over—a very passionate set of vernacular cinephiles—these critics and filmmakers were specialists of the cinema rather than its stars. They concentrated on its medium-specific gifts, noting that even while it drew on elements of the other arts (rhythm and pictorial qualities, for example), it stood alone as an art in its own right. Meanwhile, fans asserted their cinephilia through a different set of practices, including keeping diaries, subscribing to fan magazines, writing fan letters, entering contests, and participating in other networks that courted like-minded film fans.[34]

What is interesting is how these two branches of cine-love have attempted to remain separate and even antagonistic to each other when in actuality they can and do balance each other out. On the fandom side of the equation, there is a sheer mass of people, while on the other side there are specialists articulating and circumscribing the spaces and objects of cinephilia. One tends to excess and gush, the other to restraint but also to a confidence deriving from a sense of artistic, intellectual, and social status that makes a member of the cinephile elite feel her taste counts more. Cinephiles have been criticized for their lack of inclusivity; meanwhile, rough-and-ready fans denigrate fussy words such as *cinephilia* and the critic's superior attitude. As a result of these two groups' seeing past each other, the more popular cinephilia has languished as an underrecognized form of cinephilia, frequently disparaged by those who wield the tools of the already-powerful masters of discourse. No matter: an animosity between approaches to the object of cinephilic passion may actually be one of the primary sources of sustenance for each side. Having a sense of opposition against one's object or way of love can be galvanizing to that love ("The course of true love never did run smooth"). Moreover, each group's activity is remarkably similar, even if the status of its acts is coded differently. One obsessively pursues the object: one writes, goes out to the movies, reads magazines or journals in which one may find out more about one's obsessions. One looks for others with whom one shares a taste for this or that aspect of the cinema (one might, of course, also be inclined to hide the true private passion of one's heart). One tries to convince others. Whether one is writing a theory or a fan letter, the need to express and wax rhapsodic on the traits of the beloved object derives from a similar place, an approach to the cinema in which the urge to experience and then to describe that experience further ends in the (possibly pleasant) comingling of the object and the discourse.

Writers and filmmakers connected to a more elite post–World War I cinephilia did not lack for discourse. These early cinephiles, who shared "an almost religious devotion to film,"[35] include Louis Delluc, Ricciotto Canudo, Marcel L'Herbier, Jean Epstein, and Germaine Dulac, with the latter two ranking among the most prolific and articulate about their cinephilic investments over film history. Jean Epstein's writing and work have often been situated within a cinephilic frame of reference, in part

because of his ecstatic descriptions of cinema's powers and his films' exploratory fixations with specific objects, faces, landscapes, and movement.[36] His first exposure to cinema seems to have been especially rapturous. What makes him unique is that, particularly in his early writing about cinema, he was a film fan cut from the same cloth as a popular moviegoer *just as much as* he was an elite intellectual in a culture driving the movement toward thinking of film as an art form in its own right. Not unlike the soon-to-be filmmakers writing for *Cahiers du cinéma* in the postwar period, Epstein equally appreciated popular cinema and films that aspired to art. Also like them, he began his career not by making films but first by writing about cinema: in 1921, he published two volumes that explore his cinephilic propensities. (He made his first film—a documentary on Louis Pasteur—the following year.) The first of his two books from 1921, *La poésie d'aujourd'hui: Un nouvel état d'intelligence*, focuses near the end on qualities inherent in filmmaking relative to modern life and poetry. For instance, he discerns an "aesthetic of mental quickness" expressed through the pace of cinematic editing and an "aesthetic of metaphors," akin to poetic expression, which he sees expressed visually in Abel Gance's films.[37] Likewise, in the second book, *Bonjour cinéma*, an exuberant and experimental tribute to cinema, Epstein describes the enchantment of cinematic devices, the close view among others: "I will never find the way to say how much I love American close-ups. Point blank. A head suddenly appears on screen and drama, now face to face, seems to address me personally and swells with an extraordinary intensity. I am hypnotized."[38] The qualities he observed in the films he had seen became foundations for his own practice. For instance, absorption in close-ups manifested in Epstein's films, especially in *Coeur fidèle* (1923), several significant moments of which are beholden to the power of the close-up to create particular narrative and extranarrative effects, such as close identification with the heroine (whose contempt for her seducer is palpable in extreme close-ups) or the rhythm and unnerving excitement of being thrust into the components of an impending fight (fist, bottle, threatening face, withdrawing face, etc.) by means of a series of close-ups. Epstein's writing about cinema continued for the duration of his career as a filmmaker, and the self-reflexive and cinephilic aspects of his practice underscored his engagement both with

intellectual circles and with the moviegoing population more broadly. Working in several popular genres (historical dramas, melodramas, comedies, etc.) and engaging with a number of mainstream fan discourses (*Bonjour cinéma* includes tributes to the international stars of cinema, such as Alla Nazimova, Charlie Chaplin, and Sessue Hayakawa), Epstein bridged the gap between elite and popular passions for the cinema, standing in as a figure for the blend of both cinephilic impulses that inheres in the whole of film history.

Moreover, Epstein's thoughts on and practice of cinema melded his love of the medium with certain anxieties that it produces or harnesses for expressive purposes. In Epstein's view, cinema's constitutive capacities allow it both to exacerbate and to alleviate such anxieties. Throughout the 1920s, he commented on cinema's ability to disrupt how one imagines one's position in the world—for instance, by offering jarring reflections of oneself on film or by unsettling Euclidean notions of space and time.[39] Further, he questioned the role cinema plays in addressing modern fatigue, arguing contrary to some of his contemporaries that cinema offers a positive respite to its beleaguered modern spectator. As Stuart Liebman has suggested, Epstein condoned the cinema's tonic effects: it refashioned the world through novel, cinematic devices, "yield[ing] works that helped to relax and soothe jangled brains, affording compensation to them for their extraordinary exertions."[40] Epstein crafted films that used novel devices to elaborate cinema's unique and changing gifts and to envision the weary world anew, as in the triple superimpositions of *L'or des mers* (1933) showing the resonance of multiple events and objects simultaneously and in dizzying movement. In later films, especially *Le tempestaire* (1947), Epstein mobilized experiments with cinema's changing technological foundations. For that film, he recorded the sound of the wind and sea at variable speeds, allowing "acoustic vibrations stretched in time" to create a "genuine, sonorous score."[41] This manipulation allows the ear to hear newly the full drama of sounds it might otherwise miss because they happen too quickly for the mind to unpack all of its components. As Tom Gunning has observed of the film, it puts us in the midst of "defamiliarized sonority" while simultaneously "allowing us to dwell within an extended soundscape filled with the uncanny echoes of nature."[42] It taps into cinema's potential

using new technologies—indeed, a key theme of the film is the tension between the old and new ways of reading the land- and seascape—to uncover an eerie effect of the nature it records.

In a different way, Germaine Dulac also proleptically introduced many of the characteristic features of postwar cinephilia. For her work, this included its political charge, commitment to experimenting with the expressive capacities of cinema, and engagement with a body of films outside of her own. Dulac toured and lectured, traveling with her own films and those of others to illustrate her ideas about the cinema and to expose audiences to a wider range of films in the realm of cinema as an art form with unique means of expressing ideas, feelings, and subjectivities. She was one of the first to advocate for the development of an organized system of film clubs in France: in addition to her contributions to the early Club des amis du septième art,[43] Dulac cofounded and served as secretary for the Club français du cinéma in 1922; later that year, she attended the first Congress du cinéma-éducateur, where she lectured and shared her work; in 1924 she cofounded and acted as treasurer for the Ciné club de France; in 1926 she began work as a film critic, writing a byline for Marguerite Durand's feminist journal *La fronde*; and in 1929–1930 she cofounded what became the Fédération française des ciné-clubs.[44] As a spokesperson for the "seventh art," Dulac helped to advocate for cinema's legitimacy as a site of French culture and art. She was also a voice for a particular kind of art cinema that hewed to the cultural elite.

In the 1920s, Dulac published several articles (many were based on her lectures) and contributed to ongoing debates about cinema. Filmmakers and writers such as Louis Delluc and Marcel L'Herbier, among others, were initiating such debates in the many journals with a page or more devoted to coverage of the cinema—and thus inviting discussions about the nature of people's engagement with the cinema and current discussions about *cinéphiles, cinéphobes,* and *cinéclasts*.[45] One especially prescient exchange occurs in *L'echo de Paris*. Beginning on April 7, 1922, in his column "Le cinéma" Gaston Tournier proposed new vocabulary for describing cinema, including shortening some commonly used terms (e.g., from *cinématographie* to *cinégraphie*), replacing other terms with new ones (e.g., *cinégramme* for *scénario*), and adding new vocabulary to the cinematic lexicon. For the latter category, he proposed the terms

cinémanie (excessive passion for the cinema), *cinéphobie* (hatred of the cinema), and *cinéphilie* (love of the cinema). Among the writers who weighed in on these matters was Dulac, who argued her perspective about the importance of what sounds remarkably like a proto-auteur of cinema:

> The survey at *L'echo de Paris* marks a great worry about writing in the cinema [*cinégraphie*], aiming to reform the vocabulary of coarse and often unsuitable terms used by the cinema specialist [*le cinélogue*].
>
> I ardently wish for the abolition of the qualifying term *"metteur en scène."* The artist who, based on a theme, composes and gives rhythm to the image—the verb of the film—is not simply an organizer of movements: he sees, he feels, he expresses, he creates perceptible thought: he visualizes the work.... The written work is nothing without the vision that materializes it. If the *"scénariste"* indicates action through gestures, in lights, movements, and cadence, he writes a *cinégramme.*[46]

Dulac recognized that the "worry" underneath the desire to make a new vocabulary was prompted by a need for precision about what cinema was and did in relation to its makers and spectators—its purview and hold on the public—at just this moment in its history. Perhaps this explanation helps account for the fact that the column on cinematic vocabulary ran sporadically for two months, with several filmmakers, critics, and other interested parties registering their thoughts on the matter. As Karine Abadie has detailed in her work on French cinephobia in these years, that the people debated these new coinages suggests the prevalence of the cinephilia and cinephobia they describe.[47] Parsing terminology had strong implications in a setting where the issue of passionate attention to cinema—for good or for ill—was first being considered. For instance, Ricciotto Canudo weighed in by suggesting the term *écraniste* (*écran* = screen) to emphasize the cinema's difference from the theater ("the art of the screen as opposed to the art of the stage").[48] Both Dulac and Canudo agreed that it was necessary to separate the film "artist" from the *"metteur en scène"*—which was precisely one initiating impulse of postwar cinephilia. The true film artist, for Dulac and Canudo, transcended

the function of writing to focus on the visual elements that explicate themes (even while many of these same filmmakers spilled a good deal of ink in discussing the cinema).

Dulac concluded her contribution to the debate by putting a point on the terminology with which Tournier began: "*Cinémanie, cinéphobie*: fine. We are hoping especially that *cinéphilie* will prevail!"[49] Abadie has noted the emergence of *"cinémanie"* in France around this time: an obsessive relationship with moviegoing, it denoted something similar to cinephilia, but to the extreme, with connotations of an unhealthy relationship.[50] Cinemania is more the purview of the fan than of the elite. Although Dulac advocated a cinema for more refined tastes (*cinéphiles*), she also demonstrated a complex disposition: she depended on established and elite arts, she fostered a sense of cinema's unique ability to convey complicated ideas (elevating it to an art form in its own right), *and* she betrayed a predilection for popular forms in her own films and in her attention to other work. By Dulac's account, her films touch on both "avant-garde" and "old cinema": for her, "one and the other, without doubt," are necessary to their dynamics.[51]

The 1920s were a benchmark for the development of cinephilic dynamics: the promise of cinema coupled with anxieties about its proper parameters. Cinephilia flowered in many fields outside of France as well in this period. Several countries would develop clubs, publish journals, and begin to expatiate on the possibilities and problems associated with cinema. The cinema was adored and reviled both universally and with local peculiarities. For instance, Michael Cowan has shown how the practice of cinephilia extended to participatory contests of various kinds for the public, both in France and in the nascent cinephilic environment of Germany.[52] Indeed, Germany is an early site for a mixture of both cinephilic and cinephobic discourses similar to those outlined earlier. The 1910s and 1920s saw a similar surge of interest in cinema as an art form there, and efforts emerged to legitimize cinema's cultural value and to systematize the population's cinephilic impulses through print media, clubs, contests, and a new attention to developments in film techniques.[53]

Echoes of French debates about the simultaneously pleasurable, anesthetic, and problematic effects of cinema appeared in Germany and elsewhere. Writers from the Frankfurt School notably addressed the issue

from several angles. For instance, the complexity of early cinephilia as it developed from the beginnings of cinema through the 1920s and 1930s can be seen in ideas about how the new invention expressed or interacted with the pulse of modern life. Early on, tension erupted in the notions that cinema offered either a salutary or, conversely, a baleful influence on modern bodies.[54] Walter Benjamin made a significant contribution to this question in 1927, when he wrote an early formulation of what would become the well-known essay "The Work of Art in the Age of Its Technological Reproducibility." For Benjamin, film transforms the "ugly, incomprehensible, and hopelessly sad" surfaces of modern life—the "offices, furnished rooms, bars, big-city streets, stations and factories"—through its capacity to "explode" modern life's "prison-world with the dynamite of its fractions of a second." Having done so, it allows its audience to "set off calmly on journeys of adventure among its far-flung debris."[55] In an important sense, Benjamin discerned in the nervous, disruptive technological energy of cinema (its "fractions of a second") the capacity to reset the human sensorium. As Miriam Hansen has observed, the quality of *innervation* integral to this formulation for Benjamin includes "the possibility of reconverting, and recovering, split-off psychic energy." Innervation, or "mediating between internal and external, psychic and motoric, human and machinic registers," offers a corollary for anxious cinephilia.[56] On the level of film experience, the *calm* that Benjamin described proceeds from the *explosive* power of cinema, the navigation of subjective/individual and objective/collective positions, and psychic/somatic responses to perception. Together, these qualities negotiate several antipodal ideas about cinema and offer the possibility of renewal for modern cinematic travelers. Because modernity demonstrates, as Ben Singer has put it, "a psychological predisposition toward strong sensations" (including love and obsession),[57] cinema as modernity's most apt aesthetic invention was empowered to embrace both extremes, often simultaneously.

In the field of film criticism, Germany similarly fostered an environment ripe for cinephilia. Early on in the journal *Bild und Film*, writer Will Scheller glossed cinema's suitability for modern audiences, which he connected to their reactions of being "delighted" and "moved" at the movies as well as to their "particularly passionate" desire to get away from material things into a realm of illusion. Cinema is a panacea for modern

viewers, whose senses are constantly being assaulted: "For contemporary people of all stripes, rushed and swept away by the speed of the present epoch, harried by the general conditions of existence, film . . . satisfies the need for pacification, for the easily obtainable relaxation of their mistreated senses, and above all for the pleasure of looking."[58] Movie attendance increased throughout the 1910s and into the 1920s, and many people attended regularly, inciting remarks in the press about cinema's addictive qualities. For instance, Czech writer Milena Jesenská made a case for the emergence of addictive moviegoing, but with characteristic ambivalence about its effects:

> I know people who can go to the movies every day. It's not that they don't want to work or have nothing to do. Rather it is because it is a comfort to the soul to sit in the movies. Everything we see appears to be life. And still, such a powerful and such a comfortable difference. . . .
>
> We puzzle over the meaning of our existence. And look, at the movies the puzzle is solved, and done so with all the falseness of our fantasies about life. How pleasant!. . .
>
> Cinema is different than entertainment. We can compare cinema with a drinker's alcohol, with an addict's opium—it is something that allows forgetting, tickles pleasantly, and rocks one to sleep. Cinema is something that we cowards happily give ourselves in order to better endure life; it is something easier to bear, because in the face of our deformed lives, we are powerless.[59]

Like Epstein, who spoke of getting his "dose" of cinema, or Dziga Vertov, who censured Western cinema's "cine-nicotine," Jesenská described the addictive qualities of cinema as seductive. Depending on one's perspective, this was either a salve or a threat to the minds of the mass of moviegoers. Like writers in other countries, several German observers of the first decades of cinema focused on the movie houses and behavior therein or worried over the potential the movies held for corrupting youth. Again, some of the anxiety issued from a difficulty in bridging high and low cultural realms. Cinephobia erupted alongside the censorship debates, which were tied to uplift movements around the same time, as we have seen. The attributes of film on which the debates fixated were

wide ranging: the content might be harmful, but the apparatus of cinema might also prove dangerous:

> The most profound and serious danger of the cinema has been seen only recently by just a few observers—namely, when someone goes to the cinema one, two, or three times a week, he suffers psychic damage from the *form* of the presentations alone. . . . [T]he sheer fact that the viewer becomes habituated to the flashing, fluttering, and twitching images of the flickering screen slowly but surely destroys his psychic and, ultimately, his moral stability.[60]

From all these positions, these authors showed themselves to be in thrall to the influence of cinema; in their focus on the power of its effects, they considered it either an ultimately unstoppable force ready to wreak havoc on the senses or a cure for what ailed the modern subject—or both. Anxious responses often drew on precisely the same elements of cinema that were also cited as foundations for an addictive love.

Cinephilic and cinephobic discourses—tied to cinema's possibilities as an art form, as a medium to educate the masses, or as a balm for the onslaught of modern technologies and social ills—appeared in many countries prior to World War II. The ubiquity of these topics appearing in disparate locations suggests a consistency in the simultaneous delight and worry inspired by the cinema. Moreover, cinema as a site divided between the interests of high and low culture also corresponds to this transnational tendency. In parts of China, film culture thrived in the 1920s and 1930s. Audiences who sought more information about current films, their stars and directors, a larger sense of film history and aesthetics, and information about films from other countries found satisfaction for their curiosity particularly starting in 1921 when they were able to enjoy several film magazines and journals that began to materialize. Zhang Zhen has detailed the ways such print media appealed to a wide range of audiences.[61] These publications enlisted several of the same modes of cinephilic engagement we have just seen in Europe. For instance, several filmmakers and founders of Chinese film journals, like their French counterparts, lamented the quality of contemporary Chinese filmmaking and called to improve it by looking to better examples. Although some of the new journals where their writing appeared replicated fan

fare elsewhere and were filled mainly with glossy images, others included intellectual debates about the medium of film, the influence of Soviet ideology and film form, and the appropriate directions for developments in the local film industry.[62] Contributing to a general increase in national interest and investment in cinema, film lovers of every ilk created a demand for film culture outside of the movies, extending their experience of moving images into other parts of their daily lives.

This demand generated a site for the experience of what Hansen has dubbed vernacular modernism, which she describes as "a sensory reflexive horizon for the contradictory experience of modernity," offering "a matrix for the articulation of fantasies, uncertainties, and anxieties" associated with modernity's rapidly changing environments.[63] For instance, in Shanghai films of the 1920s and 1930s, several of the tropes of modernity in themes, settings, and cinematography express anxieties about sweeping sociological and technological changes. (Hansen especially focuses on those contradictions concentrated in the figure of the modern woman: the female figures of this period of Shanghai cinema are "the sites of greatest ambivalence and mobility, as traditional binarisms may at once be invoked and undermined."[64]) A thriving film culture allowed audiences to fixate on the contradictions they regularly faced—in the midst of visual pleasures such as the glamour of stars and the aesthetic values of well-financed productions. It is also worth drawing attention to the ways in which a film culture such as the one in Shanghai during this time relied both on the development of its own fiercely national cinema and on developments in other countries' national cinemas (the uneasy relationship between Soviet montage theorists and Chinese revolutionary cinema, for instance). Cinephilia creates a volley of influences among ideas and styles under the rubric of an attraction to the site of moving images. As Ling Zhang has pointed out, films such as Xiling Shen's *Shízí jiētóu / Crossroads* (1937) use the dynamic backdrop of the modern metropolis in ways indebted to Hollywood aesthetics and traffic in a similar ambivalence about the speed, danger, excitement, and social conflicts of modern life.[65]

These relations inflected the way cinephilia appeared in a wide range of global contexts. Similar discourses concerning the relationship of cinema to the other arts and to popular consumption popped up in diverse locations in the prewar years. These discourses were likewise tinged with

affective concerns running the gamut from *phobias* to *philias*. In Italy, early writers on the cinema noted their love of the new medium, often in terms that underlined a range of its fearsome powers.[66] Recent studies of the cinephilic environments in the postrevolutionary Soviet realm and in India of the 1940s to the 1960s consider the variances among different national cinephilias at similar times and point to further areas of consideration for these issues.[67] Taking full stock of multiple other sites of cinephilia is beyond the scope of this study, but, despite local particularities, the manifestation of similar cinephilic affects and practices across different places and times—including cinephilia's extension into print media and the establishment of film societies, its tensions between individual and collective concerns, its ubiquity in both elite and popular audiences, and its underlying sources of anxiety—suggests the need to broaden our sense of cinephilia in terms of history, geography, audience identities (e.g., class identity, nationality, and so forth), as well as the nature and practice of cinephilia. Examples from the prewar period handily expand our notion of the historical and geographical reach of cinephilia.

EPICENTER: FRENCH POSTWAR CINEPHILIA

Because the French postwar case of cinephilia exerts such powerful sway, and so that we might observe its influential and yet anxious nature, I turn to it now to reassess its unrelenting position in the history of cine-love. Many recent considerations of cinephilia take the immediate postwar period from the 1940s to the 1960s as the center point, if they do not altogether eschew other contexts. "The originary moment of cinephilia" addressed by Thomas Elsaesser denotes a status often taken for granted, whether scholars are focusing on cinephilia's critical positions or on its practice.[68] Others echo this originary status even when they are making a larger point about cinephilia and its boundaries in different periods: for instance, Malte Hagener's essay "Cinephilia in the Age of the Post-Cinematographic" provides an overview of the "socially and culturally situated practice" of cinephilia primarily in order to discuss the future of cinephilia but in so doing sets cinephilia in relation to the dynamics of its "classic" version in postwar France.[69] Although these essays and others provide a sense of how cinephilia has changed and adapted in

subsequent generations (as well as compelling explanations as to *why* it has changed), they still tend to consider this "first" cinephilia as a model for its inheritors and often treat it as the concept's core. This has the ancillary effect of downgrading both earlier and later moments of cinema-love. Moreover, this cinephilia abides in several facets of its current and past practice, as well as its long-term theorization and historicization. As such, a restrictive notion of the concept perseveres.

Annie Fee has observed as much in recent public debates in France, noting that "the idea of cinema as an enlightened art form worthy of respect and official support but threatened by pollution of popular film culture is still salient in French cinephile circles."[70] Indeed, several recent colloquia and events on the topic are indebted to this entrenched, singular form of cinephilia even when they recognize or expose its anxious defensiveness about its predilections. In March 2017, a special session entitled "Cinephilia Today" held at the Society for Cinema and Media Studies annual conference in Chicago fixated on the postwar French moment of cinephilia, despite the session's titular charge to bring the concept up to the present day. Featuring editor and the longtime film critic and writer for *Positif* magazine Michel Ciment in conversation with Professors Dudley Andrew and Kelley Conway, the panel discussion focused on (and demonstrated) the pervasive influence of the postwar French context on both historical and current notions of cinephilia. Although there were several nods to other versions of cinephilia—for instance, how it has become more democratized by cyberculture and its continuity with and connection to earlier cinephilia and cinephiles (e.g., Antonin Artaud and Robert Desnos)—the panel nevertheless returned repeatedly to aspects of cinephilia that are strongly linked to the 1950s in France, locating its cynosure in that time and place.[71] Among the features noted were cinephilia's coincidence with intellectual, political, and literary traditions; its focus on writing as a means of development and transmission; its eclectic but centralized canon of films and filmmakers; and its dependence on cultural institutions (archives, cinematheques and cine-clubs, governmental support). For the inheritors of postwar French cinephilia, these conditions are necessary for moviegoing to qualify as cinephilic activity. Other forms of love around the cinema do not count (or at least not as much). At one point, Ciment rebuffed the notion that "film fans" in current culture are cinephiles, arguing that,

for one thing, their passion for new releases rather than for all film distinguishes them from earlier *cinéphiles*. He insisted: "I don't think you can use the term *cinephilia* in such an expansive way. . . . It's not discouraging for the mass audience who loves cinema, but it's not the same kind of love."[72]

The French postwar moment has wielded perhaps more than its fair share of influence on how we have defined the nature and parameters of cinephilia, such that any current study tends to build upon, apologize for, rebuff, or be indebted to it. It is a cornerstone for how we understand what cinephilia is—then, earlier, later, and now. This context may be as influential as it has been because it was the first time and place that the issue received concerted intellectual and cultural consideration, although, as we have seen, the idea and practice of cinephilia as well as even the name preceded it. Howsoever postwar French cinephilia came to have such purchase on the cinephilic imaginary, it demonstrates features that broadly transcend its own context in other cinephilic activity outside of France both before and after this period. These features include its focus on comparison and outside relations (particularly in its sense of canon making), its affective and metacinematic qualities, and its deeply complex and contradictory foundations (e.g., it is simultaneously fiercely individual and collective).

The dynamics of postwar French cinephilia have been well rehearsed in cinema studies. As the story goes, in the pages of *Cahiers du cinéma* and through André Bazin's influence, in the cine-clubs, in the aspirations of new filmmakers such as Jacques Rivette, Jean-Luc Godard, and François Truffaut, "cinephilic clans" began to form—committed to different political ideologies as well as to different cinematic styles.[73] Because its emergence coincided with (or perhaps even compelled) the birth of the *politique des auteurs*, postwar French cinephilia was marked by insistence that the director and the cinema's specific expressive functions were crucial to the shape and importance of a film.[74] Relatedly, this moment cemented the notion that making films could function as a cinephilic practice, such that several inveterate *cinéphiles* were or became important filmmakers (e.g., Godard, Truffaut, Claude Chabrol, Eric Rohmer, and others). The Nouvelle Vague (New Wave), which materialized in this moment, though it has been characterized as rather short-lived (circa 1958–1962), helped establish directors who endured much

longer, as did the cinephilic environment from which it was born.[75] Inasmuch as *Cahiers du cinéma* played a part in spreading ideas about cinephilia and auteurs, the notion of critical writing about cinema became a hallmark for the phenomenon of cinephilia. To write with lucidity about one's experience of Humphrey Bogart's interior mode of acting, for example, befitted the reverential practice.[76] And although the site of cinephilia might well have been the environs of Paris at this time, the significance of other places and national examples to the cinephilic writers and audiences in France should not be underestimated. Dossiers on Italian cinema, Hollywood cinema, and Japanese cinema as well as judgments of directors and films important to the circuit of international film production diversified the spectrum of film styles at home and came to shape the canon of films of interest.

The period's cinephilic avowals focused on specific features of the cinema and relied on a set of value judgments particular to that time. For instance, there was a call for the improvement of French cinema. In this appeal, love and scorn were equally applied toward a politics of taste making. In a roundtable on French cinema, Jacques Rivette lamented the "selling out" to commercial interests of most of the talented French directors, causing "the disintegration of what we [have] regarded as the core of French cinema."[77] Although the relationship of cinema to politics and literature frequently preoccupied ideas about a work's genius or failure, the details of what was lacking and what was valued varied from cinephile to cinephile. Preferences may well be argued for, but they remain individual and arbitrary: they do not undergird cinephilia for all times and places but belong to this or that cinephile in his particular moment. As we see in these dynamics, a paradox underscores the postwar French cinephilic practice: the individual and the collective both commingle and clash. Although much of what characterized the cinephilia of the postwar French context relied upon an unrepentant admiration for popular culture, particularly in the form of Hollywood genre and pulp movies, its notion of connoisseurship and its membership by the intellectual and cultural elite separated it from the average person. The question of elitism plagues postwar cinephilia, as does a more recent concern about its gendered nature. At one point in the session "Cinephilia Today," Dudley Andrew, like other scholars before him, broached the important question of whether postwar cinephilia weren't something of a "boys' club,"

with an exclusivity that more contemporary cinephilia works to undo. As Geneviève Sellier has pointed out, the dynamics of the French New Wave borne out of the postwar moment's cinephilia may be convincingly distilled down into a "masculine singular" (and, surely, white) perspective.[78] What would it mean to cinephilia to expand it to include more kinds of cinema and more kinds of spectators of the cinema, even in this postwar French moment? What if cinephilia were not so dependent on a canon of taste governed by a sliver of the population and based on the structures of financial reward that disproportionately lend the tools of production to a certain type of filmmaker making certain types of films? Writing on the history of film criticism, Mattias Frey identifies another source for the anxiety that could be extended to the in-club ethos of postwar French cinephilic circles. Frey explicates how anxiety has always dogged the notion of professional criticism, reminding us of the challenges to authority that plague those claiming professional criticism's loftier position, including the fact that "rival critics and recalcitrant readers" challenge professional opinion and that the "diversification or fragmentation of their audience" threatens the respect conferred upon them by holding an authoritative position.[79] Ciment's position reminds us that the ongoing discussion about cinephilia's objects and subjects is situated in similarly anxious territory: it insists that some have earned the right to offer judgments about the cinema through pedigree and that challenges by those without that pedigree just don't belong in the same category.

Cinephilia of postwar France is also strongly linked to criticism. Those who were able to publish their perspective in places where it would be read became some of the strongest voices for shaping the concept as well as the reception of certain directors and films. The flurry of cinephilic writing in this period proceeded from the anxieties that are of concern here: foremost among them was the attempt to safeguard one's predilections for certain styles, directors, films, or ways of watching those films, against all comers, even at times against all reason. (A backlash—or a rebalancing correction—for this unreasoned love may well account for the variety of moves to recuperate reason attempted in film theory of the 1970s.[80]) Consider the opening of Jacques Rivette's examination of Howard Hawks's films as a case in point: "The evidence on the screen is the proof of Hawks's genius: you only have to watch *Monkey Business* to know

that it is a brilliant film. Some people refuse to admit this, however; they refuse to be satisfied by proof. There can't be any other reason why they don't recognize it."[81] Rivette depended on his innate sense of cinephilia to guide him: the evidence of Hawks's genius is self-evident, and the films speak for themselves, requiring nothing more than seeing them to confirm a judgment. Rivette's appeal to the evidence pivots in fact on no evidence at all: his is an unreasoned, unquantified, unqualified love. What matter, though, if the thrust of the appeal is simply to confess one's love? But Rivette's aim was slightly wider: his writing was an effort both to distinguish his love from the refute-niks and to find those who shared it. Still, we might well ask: Who gets to speak for or against a film or the way one consumes films more generally?

Likewise, the films of the New Wave issued from this cinephilic environment. With their clarion cry of war against the old guard, films of the New Wave prompted both delight and a sense of resistance and scandal. Writing about films, making films, going to the cinema, and moving in tribes of cinephiles—this set of activities flowed from and extended the influence of cinephilia. The films themselves are cinephilic acts. For instance, Jean-Luc Godard's *Vivre sa vie / My Life to Live* (1962) pays unabashed tribute to Carl Theodor Dreyer's *La passion de Jeanne d'Arc / Passion of Joan of Arc*, intercutting images of Anna Karina with Maria Falconetti. The New Wave also explores the possibilities of cinema in revolt against the so-called cinema of quality, dismissed as "daddy's cinema," to establish a new, completely individual cinema (individual but in conversation with fellow cinephiles). *Vivre sa vie* interrupts the developing plot with asides and diversions. It adopts cinematic novelties that jar and dodge and pleasantly disrupt its spectator's expectations. For instance, in the conversation that opens the film, the characters are shown from behind: Godard denies a view of the actors' expressions (as he does later by having characters read long passages with their faces hidden by books). Such a cinema depends on a knowledge of cinema's conventions (e.g., studio filming, continuity editing) such that each might be turned on its ear. The New Wave instead embraces a specific, unruly, personal, and rather caustic sense of what cinema is or should be. In short, this cinema issues from the same impulses of cinephilia that caused the postwar French cinephile to write to distinguish beloved films from unworthy pretenders: it establishes a personal vision of the proper uses

of cinema and puts them into action. New Wave filmmakers founded a movement by asserting their personal vision of and love for the capacities of cinema, and its impact was seismic and lasting. As Michel Marie has suggested, "Despite its brief duration . . . the New Wave completely altered France's cinematic landscape, provoking a number of psychological 'shocks' felt across the world, as national cinemas discovered these films and greeted them with a mixture of amazement and discomfort."[82] The New Wave's contagious cinephilic approach to filmmaking extended to the international filmmaking community and was felt far from France—for instance, in the unruly, personal, on-location film *Touki Bouki* (Djibril Diop Mambéty, Senegal, 1973) (fig. 1.2). For better and for worse, the New Wave helped to propagate globally the same cinephilia that inspired it, but in new contexts.

Besides writing and filmmaking, a vibrant film community that encouraged engagement with moving images and debate about all aspects of that engagement developed rapidly in postwar France, providing outlets for active cinephilia. In cine-clubs, neighborhood theaters, festivals, and cafés, the influence of cinephilic ideas and habits deepened. Not exclusive to the intellectual community, filmgoing in France increased dramatically after the war, with annual attendance figuring at around 400 million—around double the prewar figure—in the decade following

FIGURE. 1.2. *Touki Bouki* (Djibril Diop Mambéty, 1973).

the war.[83] In addition, the establishment of the Cannes Film Festival in 1946 and the International Federation of Film Clubs in 1947 helped postwar France's particular cinephilia influence communities of cinephiles elsewhere and facilitated the infusion in France of international ideas within and about films. The ready flow of passionate and peculiar ideas about cinema flourished in this environment. Writing, debate, and active public moviegoing served as points of connection as well as sites of contention for French cinephiles through this period and beyond it.

EXPANDING, CELEBRATING, AND MARKETING CINEPHILIA: FILM FESTIVALS

The cinephilia of the French postwar moment has exerted a lasting impact on the cinephilic imaginary. However, granting primacy to the cinephilia of that moment and place skews the ways cinephilia has been understood outside of that context. In addition to existing under the different conditions of early periods, cinephilia has transformed into other practices and ways of thinking about and engaging with the cinema in later periods. The session "Cinephilia Today" suggests that features underscoring "the originary cinephilia" persist to the present day; that it still wields such influence has led some to point out the necessity for disrupting its reach. For instance, in July 2017 the Cinémathèque française created a small scandal when it published an introductory essay to its Dorothy Arzner retrospective authored by Philippe Garnier that diminished Arzner's contributions in a context already not inclusive toward female directors. Garnier's introduction is tepid about Arzner's work, ascribing her position as director to her financial independence rather than to skill in that position, dismissing all of her late films in one sentence, and attributing the "cult status" of *Dance Girl Dance* primarily to Lucille Ball's hula dance.[84] Judith Mayne, the author of a study of Arzner's work as well as a proponent of a more inclusive notion of which films are of value to film history, called out the Cinémathèque and Garnier for upholding an "old-fashioned cinephilia" and for disparaging rather than clarifying the value of Arzner's films:

> Could the Arzner program offer a refreshing change in the Ciné-
> mathèque's offerings, perhaps even a sign that traditional French

cinephilia—which has been defined by men's love of films made by other men featuring women who exist only to be seen—is loosening its hold on French film culture? Sadly, not. Judging by the introductory essay to the Arzner retrospective written by Philippe Garnier, old-fashioned cinephilia is still out there, kicking and screaming about women (and some men) who dare to suggest that there are ways of loving the cinema that differ from their own.[85]

The upshot of the scandal was quick and scalding censure not only by Mayne but by several critics, scholars, and cinephiles, leading Mayne to muse, "The many responses to Garnier's essay that have appeared and may well continue to appear make it clear that French cinephilia is far more diverse than this most venerable institution [the Cinémathèque française] would have one believe."[86] Mayne's own response is squarely in the fold of a new manifestation of cinephilia. Like Shambu's observation that multiple and diverse cinephilias thrive, especially in online forums, Garnier's essay as well as Mayne's and others' responses to it in print, online, and in social media demonstrate the range of current cinephilic positions, expressed in rapid, catholic, and democratic fashion.

When distilled to their foundations, features of postwar French cinephilia may be detected as common activities over the full breadth of cinema's history and in many places other than France, challenging its dominance. For instance, Hugo Ríos-Cordero has demonstrated the continuity of cinephilic discourse in Cuba alongside politically charged film criticism in France and the United States.[87] More broadly speaking, as Adrian Martin argues, "there is no essential form or content to cinephilia." Instead, he suggests, "maybe there is something like an essential cinephile process or gesture."[88] Significant overlap materializes when one pays attention to historical manifestations of the "process or gesture" of cinephilia and resists limiting cinephilia to a specific demographic or isolating it in post–World War II France. Cinephilia takes root in a number of forms earlier and later.

One of the important outcomes of transnational cinephilia starting around this same time after the war was the establishment of international film festivals—some, such as the ones in Berlin and Cannes, still in operation today—which nurtured cinephilic exchange and geographical expansion. These long-standing festivals have thrived in part because

as they have aged, they appeal to nostalgia for an earlier moment of cinema and cinephilia; in other ways, they have adapted to the times in order to remain relevant to changing audiences' tastes and concerns (as we shall see in a moment, this combination of looking forward and backward at once is illustrated at key festivals). Moreover, in the time since certain historic festivals established a model bridging popular and elite interests, a diverse range of other festivals, both international and highly local, has sprung up. In short, the film festival comprises a nexus for cinephilic ideas and activities into the present, complicating and expanding the notion of cinephilia.

International festivals have been a boon to global film networks particularly since the coming of sound, when language barriers threatened the ability of national cinemas already imperiled by Hollywood's dominance to reach larger audiences.[89] After World War II, several countries adopted methods such as establishing or increasing quotas for home-grown cinema versus foreign imports to bolster their national cinemas.[90] By limiting the influx of imports, especially of Hollywood films, national cinemas aimed to shore up their local industries. In addition, the international film festival further affords a method for promoting national cinemas by granting them exposure in celebratory circuits as artworks seeking audiences that might embrace films outside of the mainstream. International festivals provide a common space, transcending national boundaries, for the circulation of films deemed worthy of an international audience's attention.

The recognition that festival contenders may receive is coupled with a sense of striving to create winning films—the competition not only shows off films but also creates or reflects transnational tastes for specific kinds of "better" cinema, thus shaping canons of global cinema. The notion of film as an art form gains traction within the international festival circuit, which helps global art films find distribution and appreciative audiences, potentially worldwide. As Ian Rae and Jessica Thom note in their study of Canadian international film festivals, many festivals have piggybacked on the success of films that premiered at more established festivals, culling together a "best of the best" list of films that are more likely to do well with their audiences and that have already generated word-of-mouth endorsements and press copy that can be used for marketing their selections.[91] The curation of films in subsequent

international festivals generates a tested selection of works for consumption by those who are drawn by the festival's promise of access. But festivals might also aim to separate themselves more definitively from quotidian fare. Festivals' unique or rare offerings (the Giornate del cinema muto's silent films, the Nitrate Picture Show's films on nitrate, the retrospectives of Bologna's Ritrovato, the independent films of Sundance, to name a fraction of the options) can be a strong motivator for cine-tourism, and there is no shortage of people who make the rounds come various festival times, traveling far and wide to gain access to the more or less hidden gems of worldwide cinema production. Festivals both initiate and culminate in strengthening domains of cinephilia, contributing to the global porosity of cinematic ideas whose exchange is facilitated by the exposure granted filmmakers from one national cinema to another.

International festivals erect a bridge to span distances between cinephile communities. They also allow a site for the expression of specific identities within national cultures, drawing on an international audience to bolster that identity: for example, Soyoung Kim demonstrates how the Seoul International Women's Film Festival is part of the trend in South Korea to organize festivals as "one of the major cultural practices for feminists, queer groups, young film-makers, college students, youth groups and citizen activists."[92] Such festivals allow the transmission of cinephilic affects across national boundaries and for like-minded locals to connect with international audiences.

The act of traveling to festivals sets a cinephile apart, and the location and event allow the free exchange of cinephilic enthusiasms. The festival site inspires finding and asserting claim to new loves, contesting one's choice against others, and establishing, as always, provisional, loose canons of new treasures. In addition to international pathways forged by large film festivals, several festivals have operated on a more local level, passionately and strategically attuning themselves to specific and sometimes marginal audiences. They include the fairly recent establishment of the Boston Asian American Film Festival, which aims to "[empower] Asian Americans through film by showcasing Asian American experiences and serving as a resource to filmmakers and the Greater Boston Community."[93] Although at its center the Boston festival's goal may be less cinephilic than simply to grant exposure both to Asian

American experience generally and to Asian American filmmakers' work specifically, it serves as an example of a festival that seeks a community of film lovers who identify in one way or another with the films shown and who are looking for others with whom they can share that experience.

Whether local or global in their reach, festivals seek to attract audiences through a range of strategies. Early festivals like those in Cannes and Berlin established themselves for the long term by mixing (in very different ways) the popular and more specialized art cinemas in their choices of programming of films, invited judges, voting procedures, and types of awards. They represent on the one hand an elitist ethos similar to that discerned in other cinephilic practices and on the other a tendency to cater to an industry marketplace mentality—bringing into play both stars and the red carpet as well as forms of democratic participation in the festival's activities. Festivals, of course, are neither simply utopian spaces for cinephilic exchange nor simply grasping business enterprises; they are complex entities negotiating any number of local and international concerns, often initiated by cinephiles and tapping into the energies underlying a great deal of cinephilic activity in order to sustain themselves—glamour, access to privileged objects (including stars and directors), a sense of insider knowledge, a sense of discovery of the latest hits or filmmakers, and so forth.

In some cases, festivals came into being out of broader cinephilic discourses, as Cindy Hing-Yuk Wong has noted in the case of the Hong Kong International Film Festival, which grew out of burgeoning interest in cinema at the level of popular periodicals, college courses, and film societies.[94] This festival galvanized these interests into an annual event, drawing both on the expertise and passions of those who organized the festival and on the interests of those who would attend it as locals and as cine-tourists. It blossomed because it was planted in fertile cinephilic territory. In many other locations, ambitious and modest festival programs alike target audiences in similar ways, building on momentum established in other areas of cinephilic activity or on audiences that have been waiting in some sense to be activated. Some festivals have done so successfully, whereas others have not, like the now defunct Stratford International Film Festival (Canada), which drew from its base in the Stratford Festival (theater) for an audience but failed to energize that

audience sufficiently to sustain itself.[95] Also, several festivals initiate or build on other cinephilic discourses for sustenance: like many festivals, the Wicked Queer festival in Boston (formerly the Boston LGBT Film Festival) uses a blog to which audiences can contribute their impressions; it also supports screenings throughout the rest of the year to remind its audiences of the festival and to capitalize on and extend its successes from the festival's previous run.

Many of the festivals that have emerged recently as well as those with longer histories have looked to the successes and struggles of established festivals as a model to follow or depart from. The cinephilic atmosphere capitalized upon by early festivals such as Venice and Cannes has been sustained as well as transformed over a fairly long history. The combination of glamour, fan activity, and high-minded seriousness about films and their place in the world arena of politics and culture became benchmarks by which other festivals would develop their own protocols. First established just before World War II but not actually convening until just after it, Cannes has always been closely associated with the example set by the old guard of French cinephilia. In its aim of separating itself from Venice's politically charged festival before the war and developing a glamorous profile against the backdrop of wartime deprivations, Cannes early on adopted the strategy of blending elite cinephilic and popular fan approaches for its annual roster of events.[96] Starting in the 1950s, it played host to a large number of celebrities, who in turn attracted press and visitors.[97] At the same time, it featured films deemed important by sponsoring countries (until the 1970s, when the selection process was shifted to the festival organizers). These films might otherwise have flown under the radar of international attention, but at Cannes and in Venice they met with decisive (and sometimes divisive) critical opinion during screenings. The seriousness of that critical opinion defined Cannes. One American reviewer in Venice noted that the "stomping and booing" during a screening in 1962 was refreshing: "Must say, this take-it-seriously spirit has a certain charm for someone accustomed to the blank responselessness of American audiences."[98]

Alongside taking films seriously, Cannes has also made political struggles visible on an international stage: in the festival scheduled for May 1968, several participants took offense at the glib glamour of the festival in light of the uprisings happening in Paris that month and called

upon the organizers to cancel the proceedings. They did indeed call it off at the near midpoint, during the screening of Carlos Saura's film *Peppermint Frappé*, where, among others, Jean-Luc Godard, François Truffaut, and the director of the film attempted to stop the screening by pulling on the theater curtains to prevent them from opening, eventually getting dragged by the moving curtain as they hung onto it, according to one onlooker, "like grapes."[99] Former president of the festival, Gilles Jacob, recollected that the events of May 1968 had a lasting impact on the way cinephilia of the *Cahiers du cinéma* variety affected the festival: "Cinema changed, the *cinéma d'auteur* became a reality. . . . [The] creation of *La Quinzaine des Realisateurs* (Directors' Fortnight) in 1969 . . . forced the festival to make less classical selections and put the onus on cinephilia. In a way you might say that I'm a child of May '68, because I was made director of Cannes on account of my cinephilia."[100]

Drawing on this model, the worry about what films count, how to present and protect them, and which films to valorize beyond the festival period has shaped both the high-profile festival and its effects on film canons. The creation, for instance, of multiple sections of the Cannes festival allows it both to operate in the mode of a more classical cinephilia through the films in the main competition, which the festival press kit describes as "representative of 'arthouse cinema with a wide audience appeal,'" and to demonstrate efforts toward greater inclusivity of films not fitting that mold.[101] The effort toward inclusion, however, has not been fully realized, prompting contemporary worries about who makes the selections among many possible kinds of films.

Recent iterations of the festival at Cannes have served as the site for controversies related to these issues, in particular the question of who controls this key site for cinephilia and how they will move the festival into the future. As had been done for years, in 2017 the organizers at Cannes chose films and judges in part to bridge popular and elite cinephilic tendencies; they also made an effort to represent at least a peppering of different national, racial, and gender backgrounds. Specifically, the main competition's jury included international auteurist directors Pedro Almodóvar, Paolo Sorrentino, Park Chan-Wook, Maren Ade (one of the few female directors to be chosen for this role over the festival's history), and actor Will Smith. As we saw in the introduction, these jurists stood up for divergent notions of contemporary filmgoing

and film loving. The key point of conflict was whether to include Netflix's entries into the festival because Netflix hesitated to screen its films theatrically (a stipulation of the French cultural exception[102]) before they could be entered into competition at the festival. Smith made some waves in offering his support for films premiered on Netflix as entries in the competition, arguing that "in my house, Netflix has been nothing but an absolute benefit. . . . [T]hey [Smith's three children] get to see films they absolutely wouldn't have seen. Netflix brings a great connectivity. There are movies that are not on a screen within 8,000 miles of them. They get to find those artists." Smith represented the populist view, whereas Almodóvar represented the elitist view by arguing that films should be screened theatrically: "You must feel small and humble in front of the image that's here."[103] Of course, both Smith and Almodóvar also represent the format they are most closely working with in their own careers: Smith had a film coming out that year through Netflix, and Almodóvar's reputation is built upon being the classic cinephilic film auteur. In 2017, two Netflix films, Bong Joon-ho's *Okja* and Noah Baumbach's *Meyerowitz Stories*, were contending for awards. However, in the following year, 2018, the question of Netflix's distribution strategy met more concerted opposition by the festival, which banned Netflix's streaming-platform-only releases from the main competition partly as an effort to sustain the classic cinephilia that encourages seeing films on the big screen.

In addition, the 2018 edition of the festival sparked a protest by an aggregate of the festival's participants—eighty-two women, including jury president and actress Cate Blanchett and director Agnès Varda—regarding the lack of female directors in the main competition. They aimed to draw attention to the fact that since 1946 only 82 films directed by women have been entered in competition at Cannes versus 1,645 films directed by men.[104] Coverage of that event illustrates the tensions inhering in the festival's format and allure: one reviewer reported on Diane Kruger's comments about "creating opportunities and awareness" for women struggling to gain purchase in the film industry in exactly the same breath as she commented on Kruger's "old-school glamour in a sweeping dress by Armani Privé."[105] In another way, the banning of selfies on the red carpet at Cannes further indicates the conflict between popular enthusiasm for more contemporary (some say upstart) versions

of cinephilia and the distinguished (some say fusty) behavior of the grande dame of festivals.

The collision between the cinephilia emblematized by Cannes's history and the realities of the contemporary moment—an acknowledgment if not yet quite an acceptance of multiple forms of cinephilic representation—generates a strange hybrid of love interests through the cinema festival. Few sites so well capture the complexity of anxious cinephilia. Although the charge of elitism in film festivals is not wholly unfounded, most festivals have always drawn their vitality from a number of populist forces (from the inclusion of celebrated actors giving Q&As to democratic voting on festival winners, to opening-night features of more familiar and popular fare, to awards for a range of film orientations from documentary to queer to animated and short films—something for everyone) to rally the broadest possible audiences. The most entrenched international film festivals play host to cinephilia in its broadest sense.

CINEPHILIA'S SPREAD

By the time the first of the global New Wave cinemas had brought their energy to several shores and the next waves were immanent, and in light of the establishment of global networks exposing film fans to a variety of national cinemas, a few circumstances developed in the history of cinema that would further shape cinephilia and cinephiles around the 1970s and 1980s.[106] Although this section focuses attention on just a handful of trends discernable in the United States, similar developments happened elsewhere as well. The discussion here suggests some of the ways cinephilia overflows the container into which it is sometimes set. First, the rise of the blockbuster or tent-pole feature film led to, second, the countering of that trend with renewed interest in independent cinemas, both of which were aided by, third, the introduction of inexpensive media platforms that made watching or rewatching films much easier to do at home. All of these circumstances provided an object and method for investment in the cinema both of the moment and of the past. They derived from a shift in strategy for marketing films as well as from specific responses to that shift from various constituencies of cinephiles.

These developments also challenge the too-tidy division of fan and cinephilic discourses into separate camps.[107]

Many accounts of the rise of the blockbuster feature point to *Jaws* (Steven Spielberg, 1975) as one of the key "firsts" that shaped aspects of distribution that would play a major part in the development of the summer-blockbuster phenomenon. Some of the film's impacts are palpable still today in terms of patterns of distribution, production circumstances, and aesthetics. In point of fact, of course, as Sheldon Hall and Steven Neale have outlined in *Epics, Spectacles, and Blockbusters: A Hollywood History*, films built on the foundation of big budgets, spectacles, and sensation began long before the summer of 1975.[108] Marketing schemes and the gigantic production programs that characterize blockbuster releases have surged and ebbed from the beginning of cinema to the present. In the case of *Jaws*, its blockbuster strategy hinged on saturating the potential ticket-buying market with publicity for the movie at every conceivable level—by aiding in the campaign to make the novel on which it was based a best seller; by focusing the advertising materials on one single recognizable and compelling image of a disproportionately large shark rising in waters toward a small, lone swimming girl; by sending its creators on the talk-show circuit; by flooding the public with print, image, radio, and television advertising for the film (mass advertising was advertised as a noteworthy aspect of the film's release even at the time); and by releasing it in a comparatively large number of theaters at once. Within the next few years, the sequel *Jaws 2* and the introduction of the *Star Wars* franchise began to lend further shape to these features by drawing on the audiences and hype of the originals and the novels that went along with them. Even with some significant differences, contemporary blockbusters still draw on many of these strategies.[109]

The courtship of potential or current audiences for such films happens on the level of the marketing campaign and in the film itself. Within the film, as Michael Pye and Lynda Myles have discussed in *The Movie Brats*, the influence of Spielberg's reverence for film history in general and for Alfred Hitchcock in particular may be felt through the style of *Jaws*, with the dolly-zoom *Vertigo* shot of Brody just one notable instance.[110] Such references work to connect the spectator to the lineage of auteurs paying homage to recognizable and significant moments in the

films they love and add a layer of cinephilic legitimacy to a corresponding love for *this* film.[111] The blockbuster phenomenon casts as wide a net as possible and encourages familiarity and an insider view of the film property in question; it makes friends of its fans in advance and throughout the experience of its release. What's more, it inspires a sense of collective belonging that is furthered by subscribing to the realm of things one can do or things one can buy to further one's experience of the film, whether by writing slash novels and zines or by demonstrating an identification with a film by thumb-tacking above one's bunk bed a poster of an iconic shark rising to taste the legs of a teenager or by ironing on a patch of this same image or by purchasing a Happy Meal with an action figure in it. These tokens infused with the ostensible spirit of the film are on offer from companies exploiting the film's popularity, but they also allow fans to dwell in the experience of the film alongside the many other folks who share their obsession—and to identify themselves to others who may feel the same way. And when these fans find each other by putting their hearts on their sleeves (so to speak), the collective reckoning of a private passion begets a living cinephilic discourse.

Coincident with the rise of the blockbuster, the percentage of independently produced films also increased.[112] In some cases, like the connoisseurship of the postwar French cinephiles, those who discover and join the tribe of special interests represented in independent features draw both on the contrast of their comparatively unique interest against the mainstream and on the familiarity embedded in their preferred directors or film genres doing something differently. In "independent features," I would include experimental fare as much as the work of directors associated with, say, the L.A. Rebellion or work made by individuals who create a single film or a set of unique films upon which a fan base fixates. Interestingly, independent features and the cinephilia they inspire—which would seem poised to provide some leavening for the bombast of the blockbuster—depend on some of the same elements as blockbuster fandom. The ways in which spectators find themselves addressed by or engage with these films marks the cinephilic encounter. Their jean pockets may not sport iron-on patches with Stan Brakhage's face to identify themselves to each other, and there may be far fewer fellow travelers in their specific cinephilic journeys, but this lack of public and group identification only makes the encounter all the more potentially

intense when it does happen: a cohort sporting a specific taste for a rarer dish. In the present, blogs and social media connect these specialty fans more readily; in the 1970s, however, there were a number of outlets for independent film fandom, including grindhouses and alternative film clubs, both for the grittier pleasures of independent fare and for the loftier aims of the avant-garde in distribution and exhibition venues such as New York City's Cinema 16 and Anthology Film Archives, the San Francisco Cinematheque and Canyon Cinema, the Walker Art Center's Film in the Cities (established in 1970) in Minneapolis, and the like.

Fueling both the blockbuster and the independent film was the emergence and then speedy ubiquity of home recording and playback devices as well as to a certain extent the rise of cable network programming focused on cinematic content. As Caetlin Benson-Allott has noted, in 1980 a scant percentage of American households had a VCR (around 1 percent); by 1988, the majority of an average spectator's experience with moving images arrived courtesy of recorded media.[113] The ability to exercise one's choice of viewing pleasure in both current and "classic" releases, to binge on that choice as in a marathon of Hollywood musicals, as well as to be able to practice the pleasure afforded in repeat viewings of any of these choices, contributed to the cinephile's ability to obsess over the cinematic object. Although die-hard or elite cinephiles might object to the inclusion of video formats in this scenario, the fact remains that by now most cinematic content is consumed outside of cinemas, and enthusiasm for cinema has nonetheless continued to grow in new directions.

The popularity of home viewing demands the rethinking of cinephilic territory. Cinephilia has always been and remains complex, individual, and not fixed to a single space, characteristics that the 1970s and 1980s helped to solidify. We cannot speak of cinephilia without recognizing the role of recording devices and home (or office or commuter train or campsite or anywhere!) spectatorship. As Barbara Klinger reminds us, essentializing cinephilia is a futile endeavor, anyway, considering all the varieties of possible spaces in which films are and have always been screened.[114] From nickelodeons to movie palaces to drive-ins, libraries, multiplexes, airplanes, subways, bars, and bedrooms—from the seedy, tilted, sticky-floored, sit-where-you-like space of many a second-run cinema to luxury-recliner, cocktail-serving, space-reserving,

many-screened cinemas—the specific spaces of cinema are not and have not been stable. Nor are the varieties of love that might be brought to bear upon any given cinematic object by any given cinematic lover. Klinger details the ways home spectatorship activated another kind of "new cinephilia": she includes as components of this phenomenon the comforts of the home space, the technophilia that accompanies the purchase of new gadgets for home theaters, the acquisitive delight of purchasing and thus possessing copies of beloved movies, the nostalgia invoked by watching older movies, and the familiar pleasures of repeated viewings.[115] In these shifts in cinephilia due to playback technologies, I would underline the peculiar pleasure of being able to study a film—to learn more about it and to be more specific about its elements—as useful for a cinephile's desire to apply close and even obsessive attention to beloved films. Moreover, these changes facilitated the curation of screenings for specialized groups, who could now more easily look at films together or separately and then discuss them. Similarly, they simplified the process of sharing and studying films in a classroom situation—a setting that underscores the rise of film studies as an academic discipline in earnest around the same time. All of these technologies were helpmates to the spread of cinephilia through increased access to and sharing of films and film enthusiasms.

The tension between large-scale productions and smaller, individually or independently produced films—along with the ability for the amorous consumer of films to extend the cinematic experience by rewatching, pausing, rewinding, studying, memorizing, and otherwise engaging with either kind of film at home on a smaller screen—revises the look of cinephilia, if not its broader nature. Cinephiles from the 1970s forward could more readily watch films on their own time and decide ultimately which films to appreciate and which to reject by owning a copy at home or by renting a copy. At the same time, the activation of this type of cinephilia has the potential to damage other kinds of cinephilia. Many varieties of cinephile, from film fans to film scholars to directors to connoisseurs and every gradation in between, have registered their anxieties about the disappearance of the right, preferred, loved kind of cinema as a result of these shifts. After 1976 in the United States, tax breaks that had led to an increase in independently produced films disappeared, making it less palatable to invest in such films and decreasing resistance

to blockbuster productions at the box office.[116] Moreover, the increase in home spectatorship coincided with a decrease in cinema attendance, affecting the usual sites of cinephilia. A lament has also been voiced about losses incurred in a number of important cinematic qualities—from shared spectatorship to image quality to format issues—through the increased reliance on video formats. In short, the dramatic changes specific to the cinema landscape in the 1970s and 1980s inspire both utopian hopes about and fears for the medium that have echoed throughout a history of cinema and cinephilia.

INTO AN UNCERTAIN FUTURE: CINEPHILIA NOW AND LATER

Since the 1980s, cinephilia has continued to transform alongside cinema's changes. Film festivals have expanded and encompassed a range of special interests; the internet has provided new options for engagement with films and platforms for cinephiles from every kind of background; conferences and societies have brought people interested in specific kinds of films or film personnel together; and shifting positions on specific films, fashions, or filmmakers have been defended. The amplification of the types of products considered to be within the purview of both "cinema" and "cinephilia" has continued to increase. The dynamics of GIFs and videographic essays as well as of related media such as television, interactive programs, and gaming formats are increasingly intersecting with cinephilia. In short, on every level cinephiles are grappling with love in a changing media environment and world.

Amid the complex cinephilic *dispositif* in the contemporary moment, we may recognize the nexus of issues emblematized by physical cinemas. Sites for cinema not only represent the history of cinematic presentation—a galvanizing source of dispute about the proper nature of the cinema—but also express aspects of cinephilia's productive technological touchpoints. For instance, they are the arena for the competition between the digital format of most current offerings and the nostalgia attributed to film. New cinema-restoration projects such as the restoration of the Louxor cinema in Paris demonstrate the way cinephilia, cultural cachet, nostalgia, and commerce intersect in response to the recent digital turn. Restored at a cost of approximately thirty million euros, the

Louxor was originally built as a luxurious Egyptian-style cinema, which then went through several transformations. Its changes point to the position of film over the period of time from when it opened in 1921 until the present. Within a decade of its opening, it was converted for sound; later, it lost its Egyptian theme to successive contemporary styles to retain its commercial viability; in the 1970s it began to cater in its film choices to the immigrant populations of its neighborhood; it closed as a cinema and did a stint as a nightclub in the 1980s; it was shuttered in the late 1980s, but because its facade had gained status as a historical preservation site, it withstood demolition. Later it was purchased by the City of Paris and painstakingly rebuilt with the original design in mind (the original seats on display in one of the lobby spaces provide a reminder) but with multiple updates in terms especially of the site as a social and technological phenomenon (with a bar on the second floor and bolstered architecture to withstand the shaking produced by the Metro). Reopened in 2013, the Louxor now includes four smaller cinema spaces and has the capacity to project moving images in both digital and film formats. Each of the details of the Louxor's transformation is indicative of steps within an unfolding history, a fight for territory for a cinema under constant threat by changes not only in the technologies that undergird it but in the social and economic construction of its audience. These details also speak of the forces that combine to resuscitate the cinema at various points as it falters, including its claims to history and the specific cultural patrimony of Paris.

Although some stalwart cinemas of the past—for example, the Ziegfeld in New York City, which closed in January 2016—have been shuttered because of a lack of business at brick-and-mortar cinema sites in general, new cinemas have opened following paths that bear a kinship with the example of the Louxor, drawing explicitly on the trappings of cinephilia to distinguish themselves in the landscape of theater options. The Metrograph cinema in New York City, which opened in March 2016, is a case in point. It has cannily packaged itself as a cinephile's paradise: most of the press covering the opening specifically used the word *cinephile* to describe the Metrograph's expected, targeted audience, and we see copious evidence of a more expansive notion of cinephilia intrinsic to its marketing strategies.[117] Modeling its operations on historic and contemporary cinematheques, the Metrograph programs

single screenings of special features as well as multiple screenings of more popular features in ongoing release. Through an eclectic mixture of titles, it highlights the work of new and historic auteur directors alongside current releases in programs that often feature people involved in making the films on offer. The space includes a restaurant, a bookstore, and a bounteous candy shop. The two screens are outfitted with "archive-quality, 35mm changeover, exclusively on Kinoton FP-30D, alongside DCP and all-format video."[118] (Even if you don't know what Kinoton FP-30D is, you undoubtedly sense it must be serious.) The Metrograph staff are earnest about the notion that their audiences will care about such technological flexibility, and yet they also do not take for granted that every cinephile is a celluloid purist. Indeed, the chief programmer of the cinema, Jake Perlin, democratically assures his potential clientele that screening experiences of value are not limited to one specific technological format or even to the experience of being in a cinema. Although he begins with a predictable plug for the Metrograph experience—"Seeing a film projected in a dark room on a gigantic screen on 35mm—or digitally—is just an experience that can't be duplicated anywhere else"—he also envisions an audience that takes pleasure in a variety of formats: "There's a great exhilaration you get from watching things at home and a great exhilaration you get from watching in the theater. So it doesn't have to be one or the other. They can complement each other."[119] In the same article, the founder of the cinema, Alexander Olch, likewise waxes inclusive while asserting a unique edge, emphasizing the whole cinephilic experience at the Metrograph, from the restaurant to the screening space to the movie proper: "Watching something on a computer doesn't stop you from going out if it's a fantastic experience. So we're invested in giving you a fantastic experience, both for the movie itself and for everything else."[120]

The Metrograph embrace of cinephilia notably exceeds the obsession about the film to include the filmgoing experience and its nostalgic (e.g., candy splendor) accoutrements. It foregrounds aspects of the cinema experience that are from earlier times or that emphasize the celluloid past and present of the cinema. For instance, from the upstairs lounge, you can look through a window into the projection booth, which Olch describes as "part of the experience that's so exciting. . . . In our opinion, there's a huge appetite for that—to see the roots of what cinema really is:

Celluloid and light projected through it."[121] Further, the activity of cinephilia elicited by the Metrograph is not limited to frequenting the restaurant, bookstore, or screening spaces: its website includes the *Metrograph Edition*, a blog space for original essays under the categories "Metro Retro" (featuring writing with a nostalgic bent on the retrospective fare the cinema has on offer), "Movie Love" (cinephilic writing billed as "personal essays on the experience of cinema"), and "In Conversation" (interviews with persons of interest in the industry). In one of the "Movie Love" essays, the artist and former curator for Anthology Film Archives Andrew Lampert recalls in detail a burning-film episode in Baltimore (apparently a running motif for cinephilia originating in the time of celluloid): "Without question I knew that I was experiencing one of the most sublime moments of my life."[122] As a whole, the aim of the "Metrograph stamp," as Perlin put it, is to expand the boundaries of the cinephilic experience, flowing out from the material cinema space into other products, places, and activities. The Metrograph's far-reaching aims, media-format promiscuity, and financial success in its first year of operations speak to the fact that cinephilia may well be expanding rather than contracting in the so-called digital age.

Such expansions are not limited by geographical region. In Shanghai, the opening of the Cinker cinema, specializing in classical and arthouse films from Hollywood, Europe, and China, parallels many of the strategies for targeting cinephiles—or at least those attracted by a cinephilic exterior. As at the Metrograph, part of the Cinker's allure spills outside of the screening spaces and into the form of a 1930s-style bar as well as a rooftop restaurant and screening space. The luxury seats and cocktail specials reflect the trends of reconfiguring cinema spaces within American chains such as AMC (with recliner seating) and Alamo Drafthouse (with full restaurant and drink service during the film, plus marketing gimmicks, retrospective clips, ads, and other ephemera associated with the cinema from an earlier era); they also harken back to Olch's comment about the influence of cinematheques on the Metrograph's style. The founders of the Cinker claim that their cinema is based on another cinema in this vein: the Electric, a movie hall originally opened in 1910 in London. Like the Louxor in Paris, the Electric, too, went through renovations and reconfiguration: the trend, if there is one, is to

invoke nostalgia at the same time as updating the going-out-to-the-movies experience, looking simultaneously forward and back. Hollywood style is part of the Cinker's décor as well: in addition to the brass and glamour of the bar area, which reflects the cofounders' appreciation for Wes Anderson's *The Grand Budapest Hotel* (2014), press photos show that the flooring echoes another grand hotel, the Overlook Hotel in Stanley Kubrick's *The Shining* (1980).[123]

These examples of investment in revivals of a cinephilic past suggest the enduring appeal of the cinema in the present day. However, for all of these instances, it is not unreasonable to ask whether this revival movie-house phenomenon is evidence of cinephilia or of something else—something possibly akin more to the venture capitalist than to the cinephile. Does the hull of each of these vessels harbor a love of cinema, or is it an empty shell merely sporting the *look* of cinephilia? Here we may have something of a vogue for looking the part of the movie lover without the hassle or anxiety of actually being one. One can revel in the ready-made cinephile environment of a nostalgic movie neverland and indulge the apparent patented cinephilic tastes of the past—often not exceptional ones at that: the Cinker's roster of recent films includes art-house fare such as "early Woody Allen" and revivals of *Casablanca*[124]—without developing and nurturing that love from one's own predispositions. This is an anxiousless cinephilia, which may be the mark of a boundary at last: something curated and nurtured for you is not quite cinephilia at all, however much it may look like it. An image of a screen in a review of the Cinker suggests as much. In a photograph of the Cinker's rooftop, people are gathered at small tables for an outdoor screening. On the screen in the backdrop of the image, there is a large medium close-up of Ingrid Bergman. Almost no one on the rooftop is looking toward the screen. It is possible that Bergman is in a still image and that the movie hasn't started yet (or that this marketing image does not depict an actual screening at all). Either way, the occupation captured by the image is going out to the movies, not being in thrall to cinema. Bergman's strained expression conveys nothing to no one at the Cinker circa 2017. The other patrons compete with her in their present-tense glamour, and she goes unnoticed.

Places like the Louxor, the Metrograph, and the Cinker have a model of exhibition that works for this moment: they have figured out a way to

reel in audiences for older formats, among them cinephiles. Whether this type of exhibition is cinephilia or a marketing ploy is not a question unique to their situations: it underscores discussions of movie love from early on. And it reminds a body to ask: Who am I to say how to love? Within all of the expansions of cinema and the tension between democratizing and elitist impulses, the nostalgic and the looking-forward ideas of cine-love continue to play out, making the new cinephilia like the old cinephilia, but with more and varied technologies and sites of production and reception at play. And who knows what will begin to worry us next about our great cinematic loves?

The cinephilia of the present moment is no less passionate and anxious than historical versions of cinephilia. Even a cursory excursion into some of the online forums for cinephilia, including the Facebook group Confessions of a Cinephile, demonstrates the sometimes protectively pugnacious quality of self-professed cinephiles (and cine-haters). There, one might debate whether an actor or director is worthy of consideration. On more than one occasion, someone has posted a query about who moderates the forum, how contentious posts have disappeared, and whether it is a democratic forum or something controlled by one specific position of cinephilic interests.[125] Another bone of contention involves the legacy of cinephilia itself, with certain cinephiles upholding an earlier version, seen as conservative, elitist, and patriarchal by a newer version, which in turn is seen as more political than aesthetic or historic by the earlier version.[126] Both reckon they have something to lose—for example, the beloved objects of their cinephilia, the proper shape of film history, their identities as cinephiles with specific and considered tastes, an ability to advocate for larger aesthetic or political issues—if they do not speak out to protect their cinephilic territory. That these issues play out in the more ephemeral media of blogs and social media posts makes them no less pertinent to the history of cinephilia: here we have evidence of an ongoing, immediate, and sometimes easily agitated cine-love in the face of rapid media and cultural changes.

In the midst of cinephilia's complicated dynamics in the contemporary moment, it behooves us to look at its long history. It is a history that weaves together the cinema's and cinephilia's mutual transformations. The earliest responses to cinema demonstrated anxieties about the cinema's power to move, titillate, and shape the spectator, and the most

recent responses follow suit by drawing attention to these aspects even while they also bemoan losses from what were never more innocent times. Specific technological changes of cinema are also a constant thorn for those who would grasp after cinema's roses, as the third chapter addresses in greater detail. But the sheer amount of space devoted to discussions or manifestations of cinephilia—even long after it was proclaimed dead—suggests its continuing value as a conceptual tool for thinking about cinema's dynamics.

Enchanting Images

Thus film is like the mirror. But it differs from the primordial mirror in one essential point: although, as in the latter, everything may come to be projected, there is one thing and one thing only that is never reflected in it: the spectator's own body. In a certain emplacement, the mirror suddenly becomes clear glass.

—CHRISTIAN METZ, *THE IMAGINARY SIGNIFIER*

Fool, why try to catch a fleeting image, in vain? What you search for is nowhere: turning away, what you love is lost! What you perceive is the shadow of reflected form: nothing of you is in it.

—OVID, *METAMORPHOSES*

As we have seen in chapter 1, the history of cinephilia may be charted across many places and moments in cinema's history. Expansive, inclusive, and threaded through with anxieties, cinephilia emerges in a range of times and locations. Moreover, its occurrence among audience members, makers of cinema, and purveyors of cinema in theaters and festivals makes plain some of the complex operations of cinema spectatorship—the ways audience members engage at and beyond the movie theater. Whereas the main concerns of the first chapter were to chart the history of cinephilia and its trajectory paralleling cinema's history, to show its relationship to the anxieties of several moments and places, and to demonstrate its ubiquity over time and across national boundaries, the present chapter turns to these intricate spectatorial operations and addresses phenomenological concerns regarding negotiations between the cinephile and the screen image. The anxious undercurrent of cinephilia comes into clearer view as well when aspects of that spectatorial relationship are scrutinized.

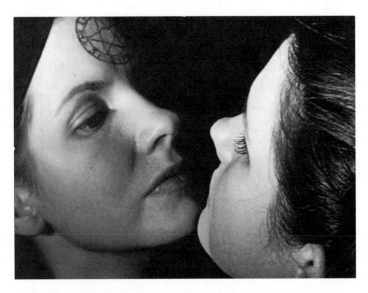

FIGURE. 2.1. Still from *Witch's Cradle* (Maya Deren, 1943, incomplete).

I do not make a general claim about this relationship here. As a vibrant nexus of practices, institutions, people, and affects, cinephilia necessitates the embrace of multiple, nontotalizing, fluid, contingent, and expansive options for thinking through such relations. Moreover, cinephilia involves a specific set of affects that do not apply to every type of spectator or situation: not only do people love cinema differently, but they also watch it differently (and these two things may well be related). Thus, rather than proposing a theory of spectatorship, I aim to demonstrate how certain dynamics between spectator and screen derive from forces that parallel an anxious love of cinema.

Connections between theories about spectators (many of which seek specifically to conceptualize cinematic pleasure) and anxious cinephilia should be readily apparent, even if neither discourse tends exactly to highlight this connection. The nature of the cinephilic relationship comes into relief by considering ideas about spectatorship more fully, and several theories lend clarity to the relationship between the cinephile and modes of watching films. These include theories that address the identification of spectators with characters, actors, or the objects on screen;[1] the resemblance of the cinema screen with a mirror;[2] the positioning of subjects' affective lives through specific object relations;[3] the

ideological stakes of these relationships;[4] debates about the apparatus's enveloping of the spectator's field of vision;[5] the suturing effects of editing patterns and other aspects of cinematic syntax;[6] feminist interventions between the gaze and the female bodies gazed upon;[7] and the social, cultural, embodied, and psychological nature of imagined or real spectators.[8] In their efforts to generate productive ways of thinking about spectatorial engagement, such theories share some common ground, especially their aim to define what allows the spectator to become immersed in the worlds of the films she watches (or demands that she does so in a particular way), what distracts her, and what the consequences of that immersion or distraction are both for the spectator and for her cultural and historical moment. In this aim, these theories also illuminate several aspects of anxious cinephilia—most brightly in the way identification prompts not only a particularly pleasurable but also an addictive and fraught sort of engagement with moving images.

These theories of spectatorship center on the investments people make as they experience moving images. Together they encompass a range of explanations based on the agency of the spectator in relation to the powers embedded within the *dispositif* of cinema. From an active position to a position characterized by extreme passivity, the nature of the spectator's relationship to what unfolds on the screen enables a suite of possibilities corresponding with degrees of agency and immersion. The range includes full awareness of the tools at work in signification, the view of an oppositional or queer gaze, the ability to fashion and imaginatively enter into larger worlds based on cinematic cues, partial or total identification with characters or images, and the option of total escape from the self and the present.[9] Relationships posited between spectator and screen may be inflected by the kind of cinema being viewed or may remain separate from content because (one might argue) the enticements and address of cinema are consistent no matter the content. Both ends of the spectrum of awareness (and everywhere between) can produce anxious pleasures.

For apparatus theory, for example, the lure of cinema has mostly to do with the invisible work wrought by a "set of instruments" used to produce the situation of viewing (from plan to image to projection) as well as with the subsequent ideological positioning of the spectator by this

apparatus through his passivity and deep susceptibility to cinema's call to identification.[10] The spectator's vulnerability as posited by apparatus theory, however, is reminiscent of the attitude of the type of cinephile who finds pleasure (even a mildly dangerous pleasure) in losing oneself at the movies. Importantly, as Elizabeth Reich and Scott Richmond have summarized of the persuasive and impassioned responses to it, apparatus theory's totalizing impulse neglects both technological and situational or individual circumstances, leading to its positing of "a monolithic bloc of viewers, undifferentiated by sex, gender, race, sexual orientation, ability, age, class, nationality, historical moment, or any of the other factors that make people different from one another in structural ways."[11] Restoring a degree of specificity to spectators also makes it easier to see how different kinds of viewers might be affected by the apparatus's operations.

One set of more specific responses to these operations, for instance, lies in feminist film theorists' troubling over the female spectator put into positions by certain dynamics typical to cinema, with active agency of the male gaze on one side of the equation and passive objectivity and "to-be-looked-at-ness" of the female position on the other.[12] Notably, Laura Mulvey's solution to the problem is to eliminate the specific type of pleasure built into the system of cinema to make way for a new way of articulating desire:

> It is said that analysing pleasure, or beauty, destroys it. That is the intention of this article. The satisfaction and reinforcement of the ego that represent the high point of film history hitherto must be attacked. Not in favour of a reconstructed new pleasure, which cannot exist in the abstract, nor of intellectualised unpleasure, but to make way for a total negation of the ease and plenitude of the narrative fiction film. The alternative is the thrill that comes from leaving the past behind without simply rejecting it, transcending outworn or oppressive forms, and daring to break with normal pleasurable expectations in order to conceive a new language of desire.[13]

Mulvey in effect seems to suggest the disruption of one type of cinephilia—a dangerous kind—by means of another, ideologically cleaner

form. Barring the "total negation of the ease and plenitude of the narrative fiction film" (modeled for instance by the experimental mode of films such as Mulvey and Peter Wollen's *Riddles of the Sphinx* [1977]), in order for female viewers to enjoy cinema's pleasurable attractions, feminist film theorists argue, they require ancillary operations to square themselves with the film's identificatory operations. As Mary Ann Doane has put it, "The a-subjectivity of the represented woman goes some way toward explaining the convolutions and complexities of the attempt to theorize female spectatorship. A sometimes confusing array of concepts— transvestism, masochism, masquerade, double identification—is mobilized in the effort to think the relation between female/non-male spectator and screen."[14] The female spectator reasserts her subject position through one or another form of psychic gymnastics. The "confusing array of concepts" by which she does so represents Doane's effort to grapple with a wider range of kinds of spectators who might occupy the position afforded by the cinematic apparatus as well as with the kinds of investments they make in the moving image.

Taken (perhaps somewhat perversely) together, the range of theoretical responses to the relationship of spectators to the image and screening situation—from apparatus theory to feminist film theory, however seemingly diametrically opposed—allows us to map the highly variable but also recognizable phenomena of being deeply involved with moving images. In particular, each specific response seeks to identify the ionizing charge of self and other/s (including abstract others as much as human figures that resemble the viewer) in a multifarious landscape of spectator involvements. The variability of responses to the same question of investment at the movies also accounts for theories that gravitate toward psychoanalytic models inasmuch as they promote exploration of underlying energies that animate passionate moviegoers: they traffic in subject/object relations that help describe how spectators relate to moving images. Taking Freud's notion of paranoia, for example, Doane discusses the way the paranoia associated with a subcategory of the woman's film, "paranoid gothic films" from the 1940s, derives from an inability to separate subject and object sufficiently. The paranoiac has difficulty navigating this "opposition" and compensates for the difficulty through the process of projection, which serves as "a desperate attempt to reassert,

reconstitute the opposition between subject and object which the patient lacks." For Doane, this necessary reconstitution is problematic because doing it makes the paranoid subject "witness to the fragility of the very distinction between subjectivity and objectivity. By constantly transforming an internal representation into an exterior perception, projection destabilizes the opposition between internal and external, subject and object, so that the boundary between the two is continually in flux."[15] Not unlike cinematic identification, this paranoia prompts the oscillation of internal and external signs, making spectatorship a site of fluctuation between the two. Because the boundaries of the subject in the cinema seat threaten to cross over into the diegesis and vice versa, the hazards of identification are high, though undoubtedly the possibilities of the thrills of narrative pleasure are, too. (Indeed, the question of cinematic love and, yes, pleasure for female viewers is of sustained interest to the feminist theorists beyond eliminating it, for example, in discussions about the perverse and masochistic pleasures of women's films such as melodramas or weepies.[16])

Moving-image identification raises the question of how certain subjectivities are represented cinematically according to conventions—or how those conventions are challenged by other points of view and other subjectivities.[17] French impressionist cinema has frequently been defined by its propensity to represent subjective states, such as in Germaine Dulac's *La souriante Madame Beudet* / *The Smiling Madame Beudet* (1923), whose titular character reads Baudelaire's poem "The Death of Lovers" only to imagine (and cinematically manifest) images of her own life with the husband who repulses her. The cinema can also represent or mimic states of mind, sensations, perceptions, mental images, memories, thoughts, so that, for example, the handheld swirling camera in *Der letzte Mann* / *The Last Laugh* (F. W. Murnau, 1924) signifies a character's drunkenness. Recognition of cinema's capacity to represent such states reflects a belief in the containment of a subject's whole consciousness and experience of the world. Other ways films explore identification include works such as Kelly Reichardt's *Meek's Cutoff* (2010), which reconfigure the conventions of a genre (here, the Western) for a different point of view (here, the women's view of the proceedings). This reconfiguration happens both within the film, as the women wear bonnets that confine their

vision and as they linger at the margins of conversations their husbands have about their plans for travel across the punishing landscapes of their westward journey, as well as outside of it, through Reichardt's use of academy ratio (compacting the vistas) and long tracking shots (suspending resolutions) of the women so marginalized. Reichardt reworks these conventions of identification and consequently provides feminist commentary upon them. Such shifts in identification alter the way viewers invest in the film's images of women. Whether they make identification readier or not must be left to the specific viewer, but they are significant for thinking of the flexibility afforded by these operations in cinema.

Just as with love, the dynamics of spectatorship depend on both what and how one beholds. From the position of beholder, the spectator negotiates the distance—actual and felt—between that position and what is beheld as well as her feelings about what she sees. From the position of the lover, the urge is frequently to bridge that distance somehow: to merge with the object of desire. Or as Jean Epstein put it in relation to his own confrontation with close-ups, "Between the spectacle and the spectator, no barrier. One doesn't look at life, one penetrates it. This penetration allows every intimacy. A face is seen under a magnifying glass, exhibiting itself; it flaunts its fervent geography. . . . This is the miracle of real presence, life made manifest, opened like a beautiful pomegranate and stripped of its covering, easily absorbed, barbaric."[18]

As Epstein's description suggests, the relationship between spectator and spectacle may be peculiarly amorous in the spectator's effort (and desire) to get closer, to lean in or lean back and absorb, to consume, to be consumed, to merge with and to penetrate the fourth wall and the space of the world apparently beyond it. Several films concern themselves with these issues—most blatantly Woody Allen's *The Purple Rose of Cairo* (1985), which narrates the sort of longing for connection with the world onscreen envisioned by Epstein and enacted in cinephilic relationship. It imagines a reciprocal relationship, inverse to the way filmic identification works, in which the character onscreen, Tom Baxter (Jeff Daniels), is lured out of his onscreen world by the attention paid to him by Cecilia (Mia Farrow), whose great virtue in his eyes is to be so enamored of him that she wants only to watch him. This scopophilia becomes an important component of Cecilia's cinephilia, and Allen parses it for narrative purposes. Allen narrativizes what Susan Sontag observed a decade later:

that a cinephile wants to be "transported by what was on the screen," so much so that she wishes "to be kidnapped by the movie."[19] In the end, Cecilia is put in the same place as before, again immersed in her longing for the world of the film but from the relative safety of her seat in the cinema. She has enacted the usually imaginary and immersive operations of identification in her "real life" (ironic of course because nothing in the film is "real life"). The film processes these projective energies for the sake of the fiction as well as to explore as a theme how spectators enter fictional film worlds. Cecilia's predicament elaborates the comedy and poignancy of that familiar spectatorial urge to join the action when it is in fact not (physically) possible to do so.

Cinephilia derives from similar negotiations taken up by the spectator in relation to what is imaged on screen. Broadly speaking, of course, amorous attention to cinema may derive from a variety of sources. Although we should recognize that there are many ways to engage with cinema and many things specifically to love about it—from its sensation of motion to the warmth or sharpness of its light, its ability to tell visual stories, its creative use of sound or other technical aspects of the medium, its reflection of the world, the aesthetics of its images, the feeling of immersion or escape into its own world, and so forth—one of the initial and key building blocks for cinephilia's complex modes of love is this engagement on the level of identification. In his investigation of the way cinema engages spectators, Christian Metz distinguishes between types of identification. Primary identification aligns spectators with the apparatus of cinema, whereas secondary identification aligns them with parts of the film, including characters.[20] Fueling identification is the play between a sense of immersion and a sense of thinking of oneself positioned relative to the screen, which involves fluctuation between a loss of self as one becomes immersed in the work and a sense of oneself as the beholder of the work. As Michael Fried has suggested in the context of eighteenth-century painting, one of the key aims of the artwork was that it "had to attract the beholder, to stop him in front of itself, and to hold him there in a perfect trance of involvement. At the same time . . . it was only by negating the beholder's presence that this could be achieved: only by establishing the fiction of his absence or nonexistence could his actual placement before and enthrallment by the painting be secured." Such aims are consistent with cinematic absorption. That "perfect trance

of involvement" arrests the viewer and allows that "enthrallment ... be secured" and "transcendence" reached.[21] Cinephilia invites and even demands such absorption by spectators in the cinema and at the same price (or benefit) of having to absent themselves in the process. (However, this absorption is also necessarily a negotiation, and the spectator is free to reject it; the experience is likely different depending on the level of giving-over of the self the spectator allows.)

Stanley Cavell reminds us that this process enables the "presentness of the world" to inhere in the nature of this photographically based medium precisely because we must accept our absence from the world there depicted, which is always already absent in its own way by being a depiction of a moment that has already passed: "The reality in a photograph is present to me while I am not present to it; and a world I know, and see, but to which I am nevertheless not present (through no fault of my subjectivity), is a world past."[22] The tension between presence and absence in the cinema seat and in the image screened before it as well as the tension between immersion and distraction raise a set of negotiations for identificatory spectatorship. Is the spectator here, or is she projected up there? To what degree is a spectator aware of her body in the cinema (both in the seat and with the image)? It may be for this reason that so many of the postwar French cinephiles emphasized their bodily position in the theater (e.g., How and where: feet up on the seat while semi-slouched, perhaps, or just "sitting closest to the screen"?[23]) as a way of entering into and sustaining a cinephilic relationship: first you show up and sit down before the screen. You situate yourself. And then?

Then, between the spectator's embodied and subjective state and the contained diegesis of the projected image world, some kind of an exchange takes place that varies from person to person and film to film. The transaction of key interest here involves oscillation between the subjective and objective positions, such that a spectator immerses herself there and loses some part of the here, becomes a bit of the you and loses the me to varying degrees and with a range of results. The types of investment and awareness of the transaction *as* an investment (rather than as immersion in or as another) varies widely, of course. Knowledge that one has not traded oneself for the position of another does not make the connection less empathic, and, howsoever aslant, forms of identification traffic in and

allow pleasure through that understanding: *I know very well, but all the same.* The apparently dichotomous positions of self and other in the cinema—the centered self of the spectator as opposed to "projections" of the other—necessarily collapse to a greater or lesser extent, revealing both parties' semipermeability. This is a point of intersection in which discourses on spectatorship and cinephilia illuminate each other's dynamics. Cinema provides a site for reckoning between subject and objects, expressed through identification and marked strongly and equally by unease and delight.

ADVENTURES THROUGH THE LOOKING GLASS: NEGOTIATING SELF AND OTHER

Of particular interest in the identificatory relationships forged by cinema is the way spectators respond to seeing an image of themselves (very broadly speaking) onscreen. I include here not only images of the self taken by oneself ("selfie" images) and images regarded by oneself though taken by another (self-images more broadly) but also images that are not of the self per se but rather ones that in some way encourage identification or that strike the viewer with a sense of likeness, an extension of self-images that involves others and prompts special attention. In each of these cases, the consumer of the image recognizes something of her individual self in the image presented (though she might relate to it differently depending on her involvement in producing the image). This relationship is a cornerstone of cinephilia. Spectators, finding in the cinema a kind of mirror, linger enraptured there. Thus, doubling figures— mirrors, doppelgängers, multiple selves, others one is asked to relate to, others one follows closely or surveils—abound in the cinema.

The phenomenon of actual self-images has long provided a special site for exposing these dynamics, and several writers have conflated them with feelings of delight or unease or both. In an essay from the mid-1920s, Jean Epstein recounts an episode in which he experienced the frisson of seeing himself reflected in mirrors that lined a staircase he was descending. He uses his account metaphorically to illustrate one of cinema's powers: allowing an objective view of oneself from the perspective of an outside observer.

I descended surrounded by images of myself, by reflections, by images of my gestures, by cinematic projections. At every turn I was caught from another angle. . . . The opposing angles of other images cut across and amputated each other; reductive and fragmentary, they humiliated me. . . . I had never been seen this way before and I regarded myself with horror. I understood those dogs that bark and the apes that fly into a rage in front of a mirror. I thought myself to be one way, and perceiving myself to be something else shattered all the vain notions I had acquired. . . . I would have run a long way to escape this spiraling movement in which I seemed thrust down toward a terrifying center of myself.[24]

Epstein observes that the cinema's essence depends on exactly this type of "analytic power" that doesn't spare egos and that "sees features in faces and human movements that we, burdened with sympathies and antipathies, habits and thoughts, no longer know how to see."[25] Cinema unsettles preconceived notions to make visible that which is already there but has become unnoticed by human eyes through habit. Embedded in an essay inclined to raptures about the experience of traveling on Mount Etna during an eruption—"Sicily! The night had a thousand eyes. . . . Glorious volcano!"[26]—Epstein's metaphorical exploration of cinema's powers through the mirrored staircase aligns with the same tensions between beauty/majesty and destruction/horror he ascribes to the volcano.[27] He highlights the powerful ambivalence of feelings in his encounter with the self within this primal, molten, explosive landscape as representative of cinema's intense operations. A self-image brings together conflicting strong sensations—wonder, narcissism, horror.

Similarly, on the other side of the world around the same time (1926), Edogawa Rampo was committing similar sentiments to paper in "The Horrors of Film," which begins with the pronouncement "I am terrified of moving pictures." The sources of his concern run the veritable gamut—from close-ups to images burning in the projector (again!), to slow motion, to negative images used out of context as leader, to experiments with three-dimensional (3D) images. In terms of self-identification with images, he echoes Epstein's remarks as he conflates the terror of the giant faces on the screen with a sense of projection of himself into that space:

I can only imagine: what if it were my own face up there! For the most part, film actors keep a firm grasp on their sanity. But have you ever seen your face reflected in a concave mirror? Even a face as smooth as a newborn baby's appears distorted and bizarre; the sort of thing you might spy through a telescope on the surface of the moon. Skin like fish scales, pores deep as caves—concave mirrors are fearsome indeed. Film actors constantly have to stare into them. It's truly a wonder they don't lose their minds.[28]

Both Rampo and Epstein mobilize the metaphor of a distorting mirror to reflect the feeling of being overwhelmed by cinema's unique presentation of the self. They draw on the same source that in 1919 Sigmund Freud used to narrow down the elusive notion of the uncanny. Discussing the phenomenon of catching a glimpse of yourself in a mirror without realizing it is your own image, he attributes to it the same "uncanny effect of a 'double'" and remarks that it may cause a person to "[start] violently." He notes that such doubles hearken from "regression to a time when the ego was not yet sharply differentiated from the external world and from other persons," which is one of the "factors . . . responsible for the impression of the uncanny."[29] Seeing oneself as an other both actualizes a slippage between persons—it makes the world and the self more continuous—and leads to the uncanny's thrill of fluctuation between misrecognition and recognition.

Mirrors are a pervasive emblem for situating spectators in cinema. Metz postulates that cinema is a "chain of many mirrors" because the spectator is enveloped in and reflective of a series of operations, which he notes also literally comprises lenses and mirrors:

When I say that "I see" the film, I mean thereby a unique mixture of two contrary currents: the film is what I receive, and it is also what I release, since it does not pre-exist my entering the auditorium and I only need close my eyes to suppress it. Releasing it, I am the projector, receiving it, I am the screen; in both these figures together, I am the camera, which points and yet which records.

Thus the constitution of the signifier in the cinema depends on a series of mirror-effects organized in a chain, and not on a single reduplication.[30]

The spectator is aligned with the apparatus of cinema: though she may be swept away in a film, she has the power to start and stop it, and she is both reflected in it and reflects it. Her reception of the film—how she takes it in and what it becomes through her—is the site of the two-way mirror. She sees herself as an other and as if she is an other looking at herself. The precarious position of the self in relation to what it sees—or the madness of mirrors and the notion of the Self viewed as an Other—underlines the eerie feeling of encounter with the self-image. However, identification in these cases does not snuff out the self—one is less kidnapped by a moving self-image than multiplied and made strange to oneself. In this process, the feeling that identification with the cinematic other might be *total*—such that one is irrevocably lost in the movies—is belied.

As much as people have been charmed by self-images, anxiety haunts such images, as these examples suggest. The delight and worry that accrue to images of the self are frequently close-knit companions. Narcissus may serve as the veriest emblem for the simultaneous fascination and trouble that characterize such encounters. Punished for his self-absorption, he sees the object of his love in his watery reflection but cannot connect with that person because it is also only himself, projected outward. He is the object of his own desire but cannot fully occupy that object position in order to reciprocate love. He is neither here nor there, but in some kind of liminal space between subject and object. Freud similarly identifies the sources of narcissism in a person's effort to navigate between self and other, specifically between ego-libido and object-libido, such that the person is constantly divided between self-love and a love directed outward toward other people and objects.[31] These facets of the libido derive from the same source, which manages self-preservation as well as the self's relationship to the world. For the individual to be healthy, these facets must be distributed in a balanced ratio with each other.

The difficulties of navigating the self with what is outside the self are exacerbated by the cinema situation: one may not literally cross over the boundary of the screen's surface, no matter how it beckons for one to do so and no matter what the *Purple Rose of Cairo* might depict.[32] Obsession and anxiety about seeing a version of the self outside of oneself—the problem of swapping self and other—constitutes a motif for cinema's operations more broadly. The reversible nature of self and other is

underscored in Maurice Merleau-Ponty's formulation of the "fundamental narcissism of all vision," by which he argues that because "the seer is caught up in what he sees, it is still himself he sees. . . . [T]he seer and the visible reciprocate one another and we no longer know which sees and which is seen."[33] By way of Merleau-Ponty, Vivian Sobchack emphasizes the positive charge of this exchange in the reversibility of expression and perception, detailing the chiasmic space, a site of exchange, between the dual perceiving subjects of the film and the spectator: "two embodied views constituting the intelligibility and significance of the film experience."[34] Drawing on Sobchack's formulation, perhaps we may say the film is like a mirror when it acts like the mirror situation in *Duck Soup* (Leo McCarey, 1933) (fig. 2.2). The mirror, which breaks without the primary viewing subject (Groucho) noticing, is a false divide between him and his apparent mirror image (actually his brother Harpo). One man anticipates and reflects the other's every move (each knows the other very well and doubles the other); at a certain point, they circle each other and cross the mirror line, suggesting the limited force of the

FIGURE. 2.2. *Duck Soup* (Leo McCarey, 1933).

division between them. The scene is both comic and representative of the complicated relationships of viewing and investing in the image of another as if it were an extension or reflection of the self. What is most seductive about the slippery subject/object relationship depicted there may be applied to the cinema more generally, as Merleau-Ponty suggests when he posits a link between one's body reflected and one's body regarding the reflection: that body is present both in the mirror and where it is felt, in the body of the beholder.[35] Cinema traffics in captivating variations on self-images, providing a foundation for these operations.

In the encounter with the image of the self, a dynamic fluctuation ensues—feelings between recognition and misrecognition, pleasure and displeasure, control and vulnerability. There are many ways in which the intersection of enjoyment and uneasiness reveals itself in self-images, all of which tend to be magnified when the images have both duration and movement. For one thing, the view of the self is characterized by its allowance for the simultaneous envisioning of self-power (a "jubilant assumption," for Jacques Lacan[36]) and its activation of the apperceptive illusion that also demonstrates one's vulnerability. Kaja Silverman has described this fluctuation as symptomatic of the system of enunciation in cinema, which emphasizes the filmic discourse to the potential detriment of the spectator's entry into the symbolic order. This situation offers cinematic solutions as a salve to anxieties prompted by situations of troubling cinematic identification. Silverman focuses on suture as one such solution. For example, she notes that when the cohesive system of identification in *Psycho* (Alfred Hitchcock, 1960) suffers a blow to its solidity after the film eliminates its main object of identification (i.e., its apparent heroine), it "obliges us to understand . . . that we want suture so badly that we'll take it at any price, even with the fullest knowledge of what it entails," including its "passive insertions into preexisting discursive positions." In this way, the spectator clings to the structure at her own expense as a subject, so that the narrative and its momentum forward trump pleasure at feeling mastery over it: "In fact, the more the operations of enunciation are revealed to the viewing subject, the more tenacious is its desire for the comfort and closure of narrative—the more anxious it will be to seek refuge within the film's fiction. In so doing, the viewing subject submits to cinematic signification, permits itself to be spoken by the film's discourse."[37] In this space of "refuge," the spectator is inserted in the film's

discursive devices, spirited away by its exigencies and narrative drive. The act of identifying thus makes the spectator lose agency within the space of the narrative.

Images that strongly relate to the self employ an ambiguity that has to do with a sense of connection and disconnection between subject and object. Similar to the contemplation of (aesthetic) objects, distance is required for observing the image of the self or likenesses/relatives of the self—Walter Benjamin's notion of the aura as well as Kant's and Schopenhauer's notions of the sublime are indebted to these geometries of position, perspective, and environment. Like anxious cinephilia, discourses on the sublime also center on an admixture of pleasure and pain; the requisite vista of distance generates simultaneous satisfaction and suffering for the beholder. In moving self-images, the reenactment of a lived slice of time as well as the uncanny articulation of a person's movements in a new relationship to space (from outside rather than from inside the self) conspire to generate this concentrated effect, merging love and anxiety in relation to oneself's view and one's view of oneself in the world.[38]

Similarly, Sobchack's phenomenological view insists on a space of sorts between subject and object within the film experience. In it, the here and the there, the I and the you, the self and the other negotiate their being and experience, and each simultaneously occupies and does not occupy the position of the other. This space between is

> a shared space of being, of seeing, hearing, and bodily and reflective movement performed and experienced by both film and viewer. However, this "decentering," this double occupancy of cinematic space, does not conflate the film and viewer. The "Here, where eye (I) am" of film retains its unique situation, even as it cannot maintain its perceptual privacy. . . . It is also perceived by the viewer as a "There, where I am not," as the space consciously and bodily inhabited by an "other" whose experience of being-in-the-world, however anonymous, is not precisely congruent with the viewer's own.[39]

This "double occupancy" and nonconflation may sound paradoxical, but it powerfully accounts for aspects of the cinema experience. It maintains

the unique force of the film—a force that is and is not constituted by the spectator. That is, however much I experience the film uniquely, it remains a film to be experienced by others that both blends with and resists their/my overtures to it. This account of identification has it both ways: the self merges with—shares—the being and experience of the film, *and* it remains its own. As Roland Barthes opines, in leaving the movie theater one is "a little dazed, wrapped up in [oneself] . . . coming out of hypnosis" for however long one blinks in the sun; that is, however much one is potentially changed by the experience, one remains, after all, oneself and is not any of the film's selves. Barthes similarly invokes a duality in himself as a film spectator, commenting that he lets himself

> be fascinated *twice over*, by the image and its surroundings—as if I had two bodies at the same time: a narcissistic body which gazes, lost, into the engulfing mirror, and a perverse body, ready to fetishize not the image but precisely what exceeds it: the texture of the sound, the hall, the darkness, the obscure mass of other bodies, the rays of light, entering the theater, leaving the hall; in short, in order to distance, in order to "take off," I complicate a "relation" by a "situation". . . . [I]t is, one might say, an amorous distance.[40]

In this duality and sense of oneself as someone immersed in the movies and someone outside them looking, the split self is reconciled through active engagement *with and at* the movies.

Part of the tension between a self-image's positive and negative effects depends on how one thinks of the prospect of seeing oneself projected on film: Is the cinematic image a friendly mirror, an uncanny experience, an intrusion on one's privacy, or perhaps even a theft of one's soul? When taken together, this collection of cinephilic and cinephobic reactions has important implications for studies of cinematic spectatorship more broadly. Taking into account the ways in which the beholding self confronts varying degrees of its representation, we get closer to understanding the foundations upon which cinematic experiences depend—including cinema's unique points of intersection between subjective and objective understanding, its reliance on systems of identification, and the simultaneous distance and collapse (intellection and immersion) it effects for contemplation of and engagement with moving images.

Several films have used doubles or doubling within their narratives to express the fascination and repulsion of self- and identification images. Roman Polanski's *Le locataire* / *The Tenant* (1976) uses doubling to explore subjectivity and these same concerns about identity and cinematic identification. *The Tenant* depicts the protagonist, Mr. Trelkovsky (Polanski), experiencing a doubled identity with the person who lived in the apartment he is now occupying, Simone Choule. At the beginning of the film, Choule is in the hospital, having recently attempted suicide by jumping from her apartment window; Trelkovsky visits to gauge her chances of recovery and his own chances of keeping the apartment. Wrapped from head to toe in bandages like a mummy, she begins to howl when she sees Trelkovsky. Soon after that, she dies, and Trelkovsky moves into the apartment, which still retains several of Choule's personal belongings.

At the not-so-subtle urging of several of the people who had been part of Choule's life, after taking the apartment Trelkovsky allows himself to be molded into her habits: he begins to smoke her brand of cigarettes, sit in her spot at the local café, and adopt her friends. She asserts an unavoidable fascination that Trelkovsky cannot resist. The film creates a number of echoes connecting his view of himself with her, and these echoes have increasingly uncanny outcomes. Davide Caputo's study of perception in Roman Polanski's films explicates this doubling as connected to the character's apparent schizophrenia and the film's interest in the reality/illusion, male/female, and observer/participant dichotomies in the film.[41] While Trelkovsky's initial descent into madness is signaled on the sonic register (the film sound becomes slightly unsynchronized), it is confirmed visually, first through shots of Trelkovsky seeing himself across the courtyard watching himself from his room while he visits the communal bathroom (fig. 2.3). After he returns to his room, he looks again to the bathroom where he just was; only now it is Choule, his female doppelgänger, wrapped in bandages, whom he sees across the courtyard.

Thereafter, the film begins to distinguish between what Trelkovsky perceives (often a delusion, such as believing a door-to-door salesman is his downstairs neighbor) and what is really happening, so that we see the same point of view twice but with different things, people, or actions. The camera distinguishes the point of view of the audience (the diegetic "reality") and the point of view of the character (his personal delusion), even

FIGURE. 2.3. Trelkovsky sees himself watching himself in *Le locataire* / *The Tenant* (Roman Polanski, 1976).

while the two points of view are conflated in the person of Trelkovsky. After the sequence that suggests he is the object of his own look, Trelkovsky begins to dress in Choule's clothes and to pursue the tragic fate she suffered. He abandons himself and shapes his experience into Choule's, externalizing what was becoming a confusing conflation of self and other within himself.[42] To end his immersion in a feminine otherness, Trelkovsky tries to kill off the other but does so according to Choule's past suicidal choice, so that her agency seems to infect him still. When the first effort is unsuccessful, he goes back upstairs to throw himself from the window again (a double effort is required to kill oneself if one is double). At the very end of the film, Trelkovsky is in the hospital bed wrapped in bandages just as Choule was at the beginning of the film, and the same scene replays in which the person on the bed howls at the sight of Trelkovsky, who is now again seen, but as his double, privy to and afflicted by the horror that has come to pass—and occupying both positions at once.

The film's traffic in Egyptian symbology at several points also highlights Trelkovsky's anxieties and subject/object issues. Choule's death does not prevent her from continuing to function through Trelkovsky: her apparent mummification (wrapped head to toe in bandages) suggests she is preserved in some sense for further living. The Egyptian bust in

his room emblematizes fears about disarticulation and, relatedly, commerce between subject and object in the film. At one point, Trelkovsky muses about identity in the following terms: "If you cut off my arm, I say me and my arm. But if you cut off my head, do I say me and my head, or me and my body? What right does my head have to claim to be me?" His increasing alienation from his subjectivity is symptomatic of this recurring loss of his head (also expressed in his hallucination of his head bouncing like a ball outside his window, not long before he throws it and the rest of himself out of it), which also has sexual overtones inasmuch as he expresses this anxiety of disarticulation after Stella (Isabelle Adjani) has brought him home to sleep with her after a party, a desire Trelkovsky leaves unmet. Dichotomies of subject/object, male/female, life/death have continuity rather than clear separation, as underscored by the Egyptian themes.

The *mise-en-abîme* layers of paranoid scopophilia in the film become increasingly complex and knowing. In addition to the shots of Trelkovsky watching himself (across the courtyard and in the hospital), at several points he looks to the mirror while dressing as Choule, reflecting his own image and, obliquely, hers, within the mise-en-scène. The doubling of Trelkovsky within the film is further multiplied by the fact of Polanski's vision behind and in front of the camera, watching himself watch himself. Trelkovsky sometimes tellingly turns away from the mirror to face the camera directly—for instance, to shyly proclaim, "I think I'm pregnant" (another moment of aiming to double the single body by creating another that issues from it and in a way resembles it). The lens of the camera focused on his simultaneously fracturing (head cut off) and multiplying (reflected, doubled) identities demonstrates the flexibility of the subject/object relationship in cinema. The panoply of engagements with subject and object and self-images employed from the inside and outside of Polanski's film demonstrates how cinema is primed to navigate and come to terms with both ends of spectrum. Through uncanny effects, doubling, and an emphasis in general on the affective undercurrent of Trelkovsky's dilemma, the film reconfigures the terms of a spectator's position as an outsider witnessing something—upon further consideration, that outsider may also be an insider. Such images of the self may help to unmask the dynamics spelled out in phenomenological approaches to spectatorship and tied to the same dynamics in anxious cinephilia.

The Tenant troubles the distinctions between subject and object in cinematic terms and begins to answer with deep equivocation the question "What right does my head have to claim to be me?"

DOCUMENTARY SELF-PRESENTATIONS AND REFLECTIONS

In a documentary mode, cinema also may fulfil the desire to see oneself from the outside. The attraction of seeing oneself in moving images may be witnessed historically in the practice of itinerant filmmakers venturing into communities to take moving pictures of the locals and later screening the films for that populace. Such screenings would typically follow after only a brief interlude so that those filmed would have immediate recollection of the manner and circumstances of being filmed, thus allowing a strong connection between the act of being filmed and the curious sensation of watching an event just witnessed from the inside but now subjectively shifted to the outside, objective view of the self. In certain cases, as Martin Johnson describes in an account of H. Lee Waters's Movies of Local People series, the cameraman would return many years later, thus making such films of historical interest, too. This practice accords with a further level of self-recognition inherent in a handbill for a screening of films taken some twenty years earlier: "If you were around he probably got your picture along with your children. We guarantee that you will enjoy seeing the years rolled back for you."[43] It is as much the self (in a younger version) as "the years" that are the attraction on offer. The promise (and threat) of revivifying people one knows (including oneself) both taps into the desire to see loved ones in action again and has the ancillary potential to activate an eerie discrepancy between memory and actuality and between youth and age. Waters claims in the handbill, "See yourselves and your friends as you looked 20 years ago. You won't believe what you see . . . but the camera doesn't lie!!!"[44] That is, "you won't believe what you see" despite the fact that you were there. The same kinds of uncanny feelings that accrue to seeing yourself from the outside are doubled by the sense of uncanny preservation of the self (and others) after many years of time—the aging process made personal and poignant. If the loved ones revivified by the camera twenty years later have died in the meantime, the images carry the

further jolt of the inevitability of mortality, too close to home. Such films are driven by simultaneous fascination and dread.

Many forms of local films existed, including a rage in the 1920s for fictional set pieces that cast locals in a set scenario as well as civic films that showcased a town's people and institutions, capitalizing on the desire to recognize and preserve one's own life and environment (as well as to provide entertainment).[45] As Johnson has richly detailed, the attraction of these films drew on the notion, used frequently in publicity for these productions, of "seeing yourself as others see you."[46] These films provoke the charm associated with recognition that goes back to the earliest cinema and that is frequently seen as a defining characteristic of it. For example, Tom Gunning notes that the "local identity" of early cinema is characterized by "the gasp of recognition and the naming of familiar faces or places."[47] The staying power of that sense of "local identity," however, endures well beyond the first years of cinema's development of attractions, past the local film craze of the 1920s and 1930s, and through the intervening years up through the present, where it has continued to find purchase in a range of different kinds of documentary films, including amateur and home movies, which often embrace a more personal perspective through these same tropes.

Indeed, local films provide just one example of a mode of documentary moving images that rely on self-recognition for their meaning. Variations on the trope of self-recognition and the desire to see oneself onscreen are common across documentaries. Part of the magnetism and tragedy of Little Edie in *Grey Gardens* (Albert Maysles, 1976) is that even in the film's cinéma vérité mode, and even while it details her isolation and entrapment with her mother at their crumbling estate on Long Island, New York, she demonstrates vivid self-awareness and performs for the camera, sometimes interacting with the people filming her. Likewise, at a screening of the Romanian documentary *Cinema mon amour* (Alexandru Belc, 2015), the director commented that the greatest difficulty of making the film was that his subject (cinema owner and cinephile Viktor Purice, who is attempting to keep his Soviet-era state-owned cinema solvent) kept wanting to participate in his own representation. Purice would suggest to the director and crew topics, locations, and better positions from which to take shots, undermining some part of the truth value of following the subject as he is but also underlining both his

delight and his anxiety about appearing as himself in a film: he wished to assert a degree of control over his own image as the filming went forward.[48] In other cases, the spontaneous representation of selves in documentary might be complicated by planning scenes more carefully, as in the fascinating portrait of a real family in Samira Makhmalbaf's *The Apple* (1998). For that film, although the director initially took raw footage of that family with a hand-held video camera, she returned to them a few days later to film their "story" using more deliberate film camera setups and planned scenes, in which the same real people played themselves.

Filmmakers have also presented their own unique self-image in their films. Playful and moving self-images are the default mode for several of Agnès Varda's personal documentaries that explore an idea without effacing her presence in that exploration. For instance, in *Les glaneurs et la glaneuse / The Gleaners and I* (2000), as Varda investigates the practice of gleaning in France, she takes a moment to consider her aging hands in an extreme, de-familiarizing close-up, brings the spectator into her home to observe her own gleanings (for instance, rejected potatoes in the shapes of hearts), and shows herself filming the subjects of her film, including herself in a mirror (fig. 2.4). She refuses the objectivity one might strive for in a different kind of documentary, instead highlighting the ways in which she is implicated in the subject of her film. As such, in her own person she collapses some of the distance between herself on both sides of the camera and herself as a consumer of her own image and of images more generally.

Other self-presentations in documentary are poignant for other reasons. Consider Chantal Akerman's *No Home Movie* (2015), her last film: though the film's primary subject is her mother (who would die just after Akerman completed filming) and the intimacy of their relationship, because Akerman committed suicide a year after finishing the film, as Manohla Dargis puts it, it is also "even more of a memento mori than perhaps it might have seemed when she finished it."[49] The knowledge of this documentary being Akerman's final self-presentation makes it difficult not to read the film in that way; accordingly, simple scenes, such as her tying her mother's shoelaces or discussing her own mental instability with her mother, take on a different charge. Further, several critics have read the film as a cause for the depression that led to Akerman's

FIGURE. 2.4. Inclusive documentary: Agnès Varda turns the camera on herself in *Les glaneurs et la glaneuse* / *The Gleaners and I* (2000).

suicide: the death of her mother and her grief are intimately connected to the film.[50]

Other films work with self-representations in other ways. Some ascribe potential powers of healing to the situation of seeing oneself in moving images, as Kate Rennebohm has detailed: films taken in order to document and show those who struggle with drugs or with psychiatric disorders have been mobilized for therapeutic purposes for many decades.[51] Other self-representations work toward political goals, as the FIERCE and Paper Tiger Television collectives' video *Fenced Out* (2001) demonstrates: a group of LGBTQ+ youth decided to make a film about the pier near Christopher Street in New York City, a haven for their "peers on the pier," in order to raise awareness about their plight as the city pushed them out of that space to create a riverside park in the midst of wholesale gentrification of the area. Because part of their interest has to do with such truth values and representation—so that the spectator is confronted with whether what she sees is being performed for her or just revealed to her—documentaries elaborate self-presentation in a range of succinct, clarifying ways. This elaboration of selves happens both for the persons within the documentary, as *Cinema mon amour* demonstrates, and for its spectators inasmuch as the film models for

them a way of being onscreen, a way within which spectators may imagine themselves. The urge to see oneself or a kindred likeness in action is a powerful motivation that has led to such documentaries' success.

The desire to see one's self-image onscreen emerges out of a culture where obsession with celebrity is a norm. Once one is onscreen, however, mixed feelings sometimes prevail. Even celebrated actors have frequently reported a range of unpleasant feelings in seeing themselves on film. Whether one should take them at their word or not, accounts (instigated both by the celebrities and by reporters) about fascination with and anxieties about seeing oneself onscreen are common. For instance, actor Jesse Eisenberg has mused on the experience of seeing himself and others in different ways when on set than onscreen: "I don't like looking at myself. I like looking at the other actors, but I had opportunities to do that on the set. I think it's strange." Reese Witherspoon demurs about the image of herself on screen, stating that she will not watch her own work "because if I did I would spiral into a state of self-hate."[52] In one of several pop-culture articles devoted to the topic of screen stars who don't like to see their own movies, Adrienne McIlvaine considers reports by actors, including Eisenberg, whose regular comments on this issue inspired her to perceive a connection between personal struggles with anxiety and actors' avoidance of their image on screen. She notes Joaquin Phoenix's distress about seeing himself onscreen: "Phoenix has commented that he avoids watching his films because he doesn't want to see himself the way the camera does. It's a sentiment that a lot of the actors and actresses on this list share since the camera reveals things we may not necessarily want to see."[53] In each of these comments about celebrities' confrontations with their image, actors and commentators take for granted that the experience of being and performing on set differs from being in the audience looking and perceiving the performance of the self as other. The feeling of commingled anxiety and pleasure that appearing onscreen instigates has the power to affect laypersons and professional actors alike.

With noncelebrities and noncommercial formats, the effects may be more pronounced because of the lack of control over one's image. This is particularly true in anthropological contexts, such as ethnographic portraits of native peoples by anthropologists, travelers, tourists, and

others. In this arena, moreover, the anxieties inhering in self-images assert themselves on both sides of the camera. For the sitter, the right to control the dissemination of one's image seems to be key, a right often denied her. For the photographer, the impulse to establish distance between the "savage" and technologically savvy Western colonialist interlopers suggests anxiety about difference. In the past, one means for establishing this distance was to propagate an idea about another anxiety: that the natives feared their souls being stolen by the photographic process. Both Z. S. Strother and Janet Hoskins have debunked this notion,[54] but it nonetheless has remarkable staying power even today and deserves further discussion.

That a photograph not only divides but possibly also robs the sitter of some part of herself is a potent, long-standing myth offered as justification for certain behaviors by "primitive" peoples as well as by superstitious folks in any society when confronted by a camera. However, as in the likely apocryphal story of early film spectators jumping out of the way when a train on the screen appeared to be moving toward them, this story's ubiquity and longevity as an explanatory mechanism for native people's reluctance to be photographed may tell us more about those who initially formulated the story and those who continue to circulate it than it does about the people it describes. Ethnographic photographers generally aimed through their photography of native peoples to capture a scientific record of those people, often to peruse their physiognomies and cultural practices at the photographers' leisure or to present as part of their field research. In these cases, the camera was used as an instrument of scientific investigation: as David MacDougall has noted, photographs of natives of India frequently depict them as scientific specimens (recording information on their positioning and lighting of the frame, for instance).[55] Promoting the idea that, against this scientific context, the subjects of the films feared the stealing of their souls underlines the distance the researchers or the culture they represented wanted to assert to maintain dominance. As Strother notes by way of Michael Taussig, an understanding (or lack thereof) of technology is frequently mobilized to solidify difference and to establish "civilized identity-formation."[56] Knowing something of the difference between the camera and magic marks a subject as modern and civilized rather than old-fashioned, naive, or savage.

Strother notes that however much anthropologists and traveling photographers wished to affirm civilization through such differentiations, they perpetuated the rumor through a number of contradictions. For instance, they would exploit natives' unfamiliarity with certain technologies, including the camera, to put on a kind of show, so that "despite the claims to science, Europeans enjoyed playing the role of 'wizards,' 'medicine men,' 'sorcerers,' and 'magicians.'"[57] In their accounts, anthropologists described the enormous power of the camera from the apparent perspective of the naive natives: the camera is capable of rending the self, leaving the subject in jeopardy in the same way as superstitions about shadows, mirror reflections, and sleep, all of which "project" the body outside of itself. Beholding the self in an image was also cause for concern lest someone harm the self in this unprotected state of being outside the body proper. The same is true of any notion of the body as object: it is both marvelous to behold and a source of deep worry for its safety, divided from the vigilant protection of the self. Thus, the story tells us something crucial about how people (including the researchers who perpetuated the myth) have perceived the powers—scientific yet also nearly occult—of the camera.

The further circulation of the myth in popular circles is indebted to James Frazer's book *The Golden Bough* (1950), which interprets the ways native people imagine the power that the photographer (or anyone else in possession of the photograph) may wield over the subject of the image: "As with shadows and reflections, so with portraits; they are often believed to contain the soul of the person portrayed. People who hold this belief are naturally loth to have their likenesses taken; for if the portrait is the soul, or at least a vital part of the person portrayed, whoever possesses the portrait will be able to exercise a fatal influence over the original of it." Frazer devotes a chapter to superstitions related to the soul and its being "projected out of the body" through shadows and reflections in water or mirrors, a separation that leaves the soul vulnerable, out in the open, and susceptible to not being reunited with the body should any evil spirit want to snatch it or any other mishap befall it.[58] Such beliefs strongly parallel the disquiet inherent in accounts from "civilized" sitters, who find in their own image something distressing, too, even if this distress is not so pronounced as to feel potentially lethal. In

diverse cultures and contexts, the effects of seeing oneself outside of one-self have the potential to unnerve a person: the persistence of the soul-stealing-camera myth underlines that notion.

Although ethnographers and touristic photographers also frequently did not ask permission to take pictures and may have been perceived as intrusive or worse, practices of photography in the same areas were at times also playful, two-way collaborations between photographer and subject, as in photographs in which subjects dress up and control the look and the fantasy of their own representation. When the sitter maintains control of his self-image (and this sitter has the ability to exercise this agency as a tourist, for example), he would gladly pay good money for the fun of dressing up and getting a picture made of himself and his family.[59] But when it is perceived that the views provided of the self come from a realm that potentially seeks to control people—such as in the even more extreme case of surveillance—then the balance between delight and anxiety about self-images dips in favor of the latter.

THE UBIQUITOUS CAMERA: SELF AND SURVEILLANCE

The potential pleasures of seeing oneself on film may be acutely under-mined when one fears being caught in a compromising position. The most paranoia-inducing version of self-images may be those produced under surveillance. Although this anxious type of image may seem far removed from the cinephilic/narcissistic delights of self-imaging, it shares some of the positive charge of images of the self. First, many self-images are unconsciously captured without them being intended as surveillance per se: they share the same potentially positive after-effects as those self-images described earlier, if not the same motivating intentions. Such self-images need not derive from a surveillance camera, a stalker, or another kind of negative agent capturing one's image. Take, for instance, Dziga Vertov's notion of "capturing life unawares" or the delight of dis-covering oneself on film after having been oblivious to the camera, as the hidden cameras throughout Disney's Magic Kingdom theme parks illus-trate (one can pay extra to have snapshots of oneself taken throughout one's visit). Moreover, even images captured through surveillance offer the promise of self-safety or the amusement of surveilling others rather

than oneself (the latter being the premise of the long-running show *Candid Camera* or, more recently, *Punk'd*).

Unsuspecting actors for the camera abound from the beginning of the history of moving images. In his work on the hand or "detective" camera, Tom Gunning traces anxieties related to unawareness of being filmed, especially in the wake of the growing craze for cameras. In an account of the perceived dangers of people running around with cameras hidden in their hats or up their sleeves, Gunning notes that this phenomenon "invok[es] scenarios of both erotic and criminal encounters" and demonstrates how early films articulated some of the fears of cinematographic technologies. For instance, in the Biograph film *Bobby's Kodak* (1908), the eponymous Bobby lurks around the house looking for (and finding) spicy content to capture.[60] Showing the audience this content is both the film's appeal and its way of highlighting people's fear of the newish technology. The cameraman controls which aspects of daily life to expose and puts the person filmed in a vulnerable position. These images do not provide the opportunity for the person imaged to present what she might deem the best version of her public self, and the images' appeal often has to do with others' pleasure *at the expense of* those who are imaged.

The public imaginary has fixated on such stories for a long time: they have flourished from around the mid–nineteenth century to the present and are tied up with the development of imaging technologies, including the camera obscura, photography, and moving images. In the late 1800s and early 1910s, the pages of trade magazines were rife with references to new devices and ways of obtaining views of oneself. Among these accounts were stories of people being filmed unawares, including one about a crowd gathered for a stereopticon lecture in a church who became unwitting participants in a wedding film[61] and another about the development of devices for taking surveillance of city centers:

> A new application of cinematography has been devised by Herr Sborowitz, a Berlin engineer . . . [his] invention provides for the installation of [an] apparatus for taking moving pictures in the works of all public clocks. Herr Sborowitz's idea is that the apparatus— which can either be arranged to work continuously, or be set in motion when desired by wireless telegraphy from a central

station—will provide the police with records of street happenings and of passersby, which will greatly facilitate the detection of crime, and the arrest of "wanted" individuals.[62]

Seeing oneself unexpectedly on film—in a wedding film, for instance—may be the positive side of the potential inherent in surveillance images, while the negative side is the paranoia about being caught (or mistaken) in an awkward, unattractive, or criminal position of some sort. The surveillance equipment in public clocks suggests a view that citizens might appreciate for keeping law and order and deterring potential criminals, but it also of course means that no one is spared being the potential focus of the camera's attention. The current ubiquity of cameras in public places—traffic cameras, security cameras, and so on—is foretold by these early-twentieth-century engagements with placing cameras where they might capture misbehavior.

Anxiety about being caught on film finds purchase in a number of accounts from the same period. The camera might well capture people on film who would prefer not to be on film, for whatever reason—because they are shy or desire privacy in general, because they are criminals, or because they simply fear being misconstrued as a criminal (the "wrong man" syndrome). In one account from 1908, a man taking a film of a parade inadvertently captured the wife of a leading businessman in the background. The film reveals her departing the bath in a state of semi-dress, chasing some chickens with a broom. The following evening, she attended the movies, where the film (which she did not know had been taken) was being screened. The resulting film "was amusing to all but the lady who figured most prominently in the little comedy the camera caught and faithfully reproduced. . . . Horror-stricken she sat and gazed as each sickening detail of her morning's adventure was minutely reproduced on the screen."[63] The account further suggests that her horror existed in inverse relation to her companions' merriment, for the fear of being captured on film perversely corresponds to the attraction of such titillating images. From the wholly unaware or unwilling object of the camera's gaze to the semi- or fully complicit ethos of apparently unrestricted views of people who are only too willing to provide intimate life details and everything in between, there is a market for such full-access images, both fictional and nonfictional. On the illicit end of the spectrum,

there is the possibility of using sordid scopophilia to attract (or repel or both) an audience through phenomena such as Facebook Live, which in the recent past has served as the site for live streaming of an alleged gang rape, suicide, and a group of bullies threatening a classmate.[64] These live streams feature the added ignominious attraction of happening in real time, but they are also recorded and downloadable: a lasting record of people who do not want these self-images to circulate and who were filmed without consent or agency.[65] This type of recording turns surveillance to capture criminal activity into a criminal activity itself.

A number of films narrativize the theme of capturing embarrassing deeds, misbehavior, or criminality on film (or a related magical or televisual screening situation) and exploit tensions between the pleasure and the pain in those imaged and for whom such footage is screened, from early films such as *The Cameraman's Revenge* (Lladislav Starevich, 1912) and *L'erreur tragique* (Louis Feuillade, 1913) to *Liliom* (Fritz Lang, 1934), *Peeping Tom* (Michael Powell, 1960), and *Jarhead* (Sam Mendes, 2005). *Peeping Tom* in particular illustrates the fluctuation between distance and the conflation of subject and object caught up in a dangerous labyrinth of scopophilic and voyeuristic looks, which draws on the issues related to cinematic identification and the spectating self as described above. Garrett Stewart proposes that the film "offers a lacerating exposure of surveillance as the very cause of voyeurism" and to illustrate this point fixes on the history of the protagonist, Mark Lewis, as the subject of his father's scientific studies—the crux of which depends on his being filmed in moments of his greatest vulnerability.[66] Mark subsequently identifies with the role of the victim, from which follow a number of identificatory contortions in the film. Elena del Rio's work on *Peeping Tom* makes a case for the way these dynamics belie the boundary between subjective and objective positions that the protagonist is meant to occupy or exploit. To do so, del Rio considers the impact of Merleau-Ponty's phenomenological reading of the mirror stage: in contrast to the Lacanian model, such a reading (related to Laura Marks's notion of haptic visuality[67]) puts tactility rather than vision alone at the center, so that the child experiencing his mirror image "does not merely experience the mirror as an invisible psyche (here) confronting a visible body (there)." Instead, del Rio argues, Mark's body relates to the image through the sense of touch or "the introceptive image."[68] For del Rio, the subject/object

positions collapse through the film's emphasis on tactility and mim-icry. Rather than being simply voyeuristic or scopophilic, with the pen-etrating male gaze commanding the position of subject and the female object serving as victim to that murderous gaze, *Peeping Tom* compli-cates the divide between the filming subject and the filmed subject. Kaja Silverman's reading of the film similarly focuses on the collapse of dis-tance between the viewer of images of these perverse home movies and their primary actor—Mark "literally crosses the imaginary dividing line separating viewer from spectacle" and draws attention to the fourth wall dividing body in real time/space from body in screen time/space by moving twice into the projector's light while screening his murders. It is a too-close identification with his victims: as Silverman notes, he "rec-ognizes himself in that image."[69] Both Silverman and del Rio credit the film's power to the collapse of distance between Mark and his potential victims through his recognition of and identification with them (via his own youthful experiences on camera). In this collapse, the film demon-strates a new way of conceiving of the partial permeability of the fourth wall and the porosity of subject/object relations in filmic identification.

Fritz Lang's films also frequently explore the dynamics of being cap-tured in mechanisms of surveillance and how surveillance may com-pound the comforts and dangers of living in a society that has a predi-lection for keeping an eye on others—for instance, in a trilogy of films made shortly after Hitler rose to power in Germany: *M* (1931), *Liliom* (1934), and *Fury* (1936). In *M*, Lang mobilizes the apparatus of surveil-lance through networks of law enforcement on the one hand and the beg-gars of the city on the other, both of whom work to discover the identity of a child murderer, Hans Beckert, who terrorizes their city. *Liliom* offers to its protagonist an option for partial redemption by screening aspects of his life for him in purgatory to help him reform his ways. And *Fury* most of all offers a complex representation of surveillance's double edge in societies that focus their attention on watching others closely. The problem of mistaken identity in *Fury* is in part remedied and in part made worse by the accidental presence of a camera, which records the mob's actions in setting fire to a jail where the protagonist, Joe Wilson (Spen-cer Tracy), is presumed to be trapped and therefore burned alive. The resulting happenstance documentary film—which retains its damning truth value in large part because its actors are completely unaware of its

existence—becomes evidence in court. Joe manages to secure the conviction of the townsfolk who apparently were responsible for killing him (but not actually because he did not die) by using footage from that surreptitious camera that documented the rampage, which provides close views of the individuals who took part in it. Stewart notes that surveillance had long been part of Lang's thematic obsessions in his works, paralleling his own mode of filming: "Long before the director introduced his own projective technology into given screen plots as an explicit instrument of moving-image capture and accusation . . . his filmmaking was always implicitly just that: a form of cornering and exposure."[70] *Fury's* central ambiguity relates to whether such footage damns these participants or does not because in fact Joe managed to escape the fire: the participants were at least momentarily murderous in their hearts if not in their deeds, and the camera knows more about their intents than they seem to know themselves. Moreover, Joe's own redemption is dependent on resisting the impulse toward revenge generated by his viewing of the graphic footage.

Interestingly, the prison footage and the act that it captures are presented in a way that conjures several of the terms that underlie self-images more generally: pleasure and pain, recognition and denial, delight and paranoia. Tom Gunning's reading of *Fury* focuses on the combination of the apparent "merriment" and "enjoyment" of the mob in a lynching mood and their near inability to recognize themselves on film in the aftermath of it: "Their horrified looks as they watch these images seem to express not only their fear of discovery, but a disbelief before these images of themselves filled with such power and destruction, a bursting forth of an energy they had always held in check and now refuse to recognize, and have difficulty even remembering."[71] It bears noting that the images of their passion are not pictured earlier in the film—that is, we do not see this violence until well after it has been committed. Instead, we see first the buildup to that violence and then (eliding the violence itself) Joe's fiancé's arrival on the scene, after the violence has already been spent. In the space between the performing of the deed (when the citizens are engaged and forgetful of themselves) and the witnessing of that performance (when the citizens are watching themselves as beings outside of themselves in that courtroom moment), pleasure has turned

into both forgetfulness and paranoia, and the law uses this visible evidence of the true nature of these individuals against them.

Witnessing and filming criminal events as they unfold have been woven into several fictional film narratives in small and large ways: for example, footage taken by a bystander of the police beating of Rodney King is repurposed in the opening credit sequence of Spike Lee's *Malcolm X* (1992), and the narrative of Ryan Coogler's *Fruitvale Station* (2013) details the events leading up to the real-life fatal shooting of Oscar Grant, which was captured by a cell phone camera. Recent true events in the United States concerning police or civilian violence also circulate in public contexts, on the internet, in court, or in various types of watchdog organizations. A populace might well agree to submit to systems of surveillance, including police body cameras and the ubiquity of cell phones, always ready to record daily happenings and generally posited as a grassroots way of potentially curbing tyranny, even though such surveillance might just as readily backfire, be misused, or fail when needed and put an innocent person at risk. Nevertheless, the positive possibilities are highly compelling. Activist groups such as Witness are able to prosecute human rights violations, including elder abuse and gender-based violence both domestically and globally, by putting cameras and footage into play as evidence for criminal activity.[72] The possibility of being captured unawares on film not only might delight a person but also carries a strong message to the would-be subjects of films (i.e., potentially everyone). Wrongdoers beware: you may be on film, anytime, anywhere.

EXPERIMENTAL SELVES

In addition to the multiplication of selves in narrative and documentary contexts, it is also found in the realms of film art, especially in experimental films. Because many experimental filmmakers use themselves as a subject in the film (a phenomenon explained in part by financial considerations as well as in part by the desire to control the images more closely), their films also demand some investigation of self-imaging operations.

Several examples of the filming-self filmed occur in avant-garde, art, and experimental cinema. In many cases, artists use self-images as a

foundation for thinking through the self as artist or other themes related to self, identity, and the world of the artist. Examples are many and varied: Maya Deren observes herself running along a beach in *At Land* (1944); Stan Brakhage asks his wife to turn the camera on himself for his reaction to her as she is giving birth in *Window Water Baby Moving* (1959); Vito Acconci boxes with his shadow in *Shadow-Play* (1970); Anne Charlotte Robertson films herself undergoing her dietary regimen in *The Five Year Diary* (1981–1997); Lorna Simpson plays chess with versions of herself in costume in her multichannel video installation *Chess* (2013); Matthew Barney appears in various guises in the *Cremaster* cycle (1994–2002). The use of the self varies, but for each of these artists as well as for others working in these circles it is one of the building blocks for generating specific meanings outside of narrative concerns. Making images and being part of the product of that making are folded together. In the 1970s and 1980s, the personal explorations of this type of film were served by employing moving self-images—especially those made in order to give voice and image to a wider range of individuals (e.g., not male, straight, and white) often excluded from a serious place in making or appearing in commercial cinema. In these types of films, documentary aspects also register, but they are harnessed for yet another set of purposes—for instance, to demonstrate a way of seeing the world that is unique to a single, female body within it. That tendency is present in films as different as Barbara Hammer's *Dyketactics* (1974), Marjorie Keller's *Daughters of Chaos* (1980), Trinh T. Minh-ha's *Reassemblage* (1982), and Ngozi Onwurah's *Coffee Coloured Children* (1988) and *The Body Beautiful* (1990). In such films, discovery of the formal and expressive capacities of cinema comes within the context of exploring not just identity but also subjective experience. Rather than demarcating collective boundaries or a group mentality (e.g., "a lesbian film"), these films may be understood as exploring ways of knowing the world through the individual self and manifested by imaging that self.

As Hammer did in *Dyketactics*, in one of her later films, *A Horse Is Not a Metaphor* (2008), she foregrounds her presence in front of the camera and behind it so that the relationship between making images and being part of the product of that making merges. In *A Horse Is Not a Metaphor*, the focus falls on Hammer's treatments for cancer, her equestrian respite in the country, her aging body, and her creative

capacity for transformation, enacted through the making of the film. The film details her experience in illness, depicting her in a weakened state taking the chemotherapy drip through a tube in the hospital and talking with her nurses about what the procedure involves; it is a brave, unflattering look at one's own body in a state of vulnerability, unflinchingly processing a vision of her disease. Hammer also offers the view of her naked body walking through the countryside, cinematically enhanced and glorious, depicted in its aging state (fig. 2.5), a view not usually provided in films—certainly not in mainstream cinematic depictions of women, which are still likely to fetishize youthful female bodies and deride older ones. Finally, in addition to the film's use of the body of the filmmaker as subject and muse, the title of the film and the energy of metaphor more generally offer another way of reading the self-images mobilized by Hammer's camera. Although the title denies metaphorical values, Hammer nevertheless invokes them at an opportune moment, inasmuch as a metaphor serves nicely as an emblem for the simultaneous split and unity of self/other relations: a metaphor puts two separate things together in parity at once. Unlike in a simile, in a metaphor something *is* something else (*life is a dream*), collapsing the terms, much like Hammer's being (subject/object) on both sides of the camera is collapsed within the film. Moreover, the way she divides the words in the title with editing belies what the title suggests (fig. 2.6): the image of the horse literally reads in the same shot as "a Metaphor," so that the image of a horse seems to be illustrative of the concept of a metaphor. The film employs a range of images of the self (harshly lit in hospital rooms, radiating cinematic light, captured in shadows, and compared to a number of natural phenomena, including horses) to explore the terms of Hammer's body in all of these contexts as imagined before, through, and on the screen.

Images need not be made by the person imaged to demonstrate that other kinds of self-images may generate experimental meanings. Agency related to the self happens on the spectator's end, too. For one of the most sustained examples of this sort, consider the hundreds of *Screen Tests* made by Andy Warhol between 1964 and 1966 documenting his Factory regulars, celebrities, and others as they sat for moving portraits of themselves. Differences among the *Screen Tests* speak to the myriad ways of understanding how a person may generate meaningful self-images

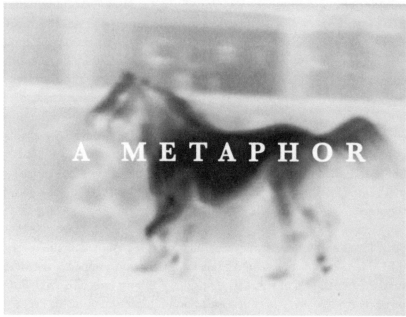

FIGURES. 2.5 AND 2.6. Stills from *A Horse Is Not a Metaphor* (Barbara Hammer, 2008).

FIGURE. 2.7. *Screen Test: Ann Buchanan* (Andy Warhol, 1964).

generally—from Paul America, acutely aware of the camera and his self-image, to Lou Reed, hiding behind sunglasses and a bottle of Coca-Cola, to Jane Holzer, appearing to use the camera as a mirror while she brushes her teeth, to Ann Buchanan, unblinking and impossible to read (fig. 2.7).[73] The resulting films are documentary in one sense and present a true likeness and historical document of their sitters, but their purpose is less to document than to explore other issues—for example, they provide a formal exercise with a set of rules (slight slow motion for four minutes in duration) and meaningful variations within the very terms they set up, wherein they explore the significance of motion and stasis, close views and long shots, lighting, silence, and other formal aspects of the film medium. Further, they demonstrate the conditions of the screen as a boundary between an audience and the subject of a film, troubling again the notion of the divide between self and other.

Illustrating each of these issues, Buchanan's *Screen Test* builds meaning based on the availability of all of these factors within the film of her. Justin Remes's account of the experiential fluctuations inspired by the film tracks through all of these issues: he becomes "unnerved by the eyes looking directly at me" in one viewing, is "deeply moved" by witnessing Buchanan's tears and impassive face in another viewing, and discovers himself getting impatient and beginning to feel like the whole exercise

was Warhol's "practical joke" in yet another.[74] How the spectator deals with the provenance of Buchanan's tears (generated at least in part by Warhol's instructions not to move, perhaps even not to blink, but also more mysterious in terms of what goes on behind the facade of any given face when presenting itself to an audience) demands the formal and phenomenological terms of engagement Warhol provokes in his spectator. He puts the self—both as a spectator and as the object of the spectator's gaze—in the forefront, and the result is a confrontation with the terms of spectatorship for moving images more generally. Especially when viewed together, the *Screen Tests* prompt a recognition of the ways to be a subject (from flirtatious to cocky, aggressive, elusive, hip, and everything in between), even while they also encourage the spectator to think about the act of spectating as they peer into the faces of these private and public other selves.

THE NATURE OF CINEMATIC SELVES

Self-images may prompt the most telling explanations of relationships between spectators and cinephilia, even if they are not the only path for tracking that relationship. As we have seen, the exploration of selves in moving images is helpful for understanding the nuances of subjectivity within the experience of cinema; in moving images' playing out of fascination and anxiety, the confrontation with images relating to the self establishes a foundation for cinephilia. The persuasive subjectivity of the cinematic view coupled with spectators' acceptance of that view in order to enter the film leaves them vulnerable to any number of ideological operations. Take the reproach directed at avant-garde film pioneer Jonas Mekas, in part motivated by his past defense of the antisemitic film *Jew Süss* (Veit Harlan, 1939), which he saw as a student in Lithuania and about which he recounted that he and friends "left the theatre all deeply moved" and confused as to why it was interpreted as antisemitic. For those who are certain that it is virulently so, his defense suggests complicity with the film's perspective.[75] If the cinema is capable of taking over or tapping into the dark recesses of fearful, negative thought, then it becomes a threat to audiences made vulnerable by its allurements.

We might bear in mind Francesco Casetti's reminder that the devices employed to suggest a specific subjectivity in a film are simply narrative

modes for telling a story rather than the nature of the camera's gaze, which is mechanical and tied to modern ways of seeing and experiencing the world. This insight inspires him to consider both the revelatory qualities of the camera and the anxieties that might result within the context of a mechanically inflected subjectivity. Casetti concludes that "the image does not always offer us an illuminating revelation. It can also be the font of a profound unease. The cinematographic gaze often lays things too bare." The peculiar nature of cinematic subjectivity occasions questions about the relationship between the human and the mechanical view as well as about the apparent autonomy of consciousness: cinema demands that we ask what the difference is between self and others, even (or especially) when the other imaged is a version of that self.[76]

To confront one's own image inevitably inspires a number of other questions as well. Does identification at the movies derive from the potent impulse to view the self in others? Does one look differently at oneself than one does at others? Does a self-image allow closer access to the self, or does it offer an escape from the self (the view from outside: at last one is free of oneself)? Somewhere between the distance required to observe an image and the proximity experienced living in one's own body lies the problem of self and image getting on familiar terms with each other. Moving images of oneself capture a version of the self divorced from the flow of time. This can be wonderful and terrible at once: it effectively erases the terms of difference that define individual perception.

One example from 1910 illustrates some of the negotiations that are implicit in the joys and anxieties of seeing views of oneself, which extend long past this moment in film history. In his article "In the Cinematographic Theater," Berthold Viertel remarks on the German kaiser's visit to Vienna, an occasion that Viertel calls "worthy of eternal memory" and that was accordingly filmed for posterity and then screened to an audience that included, not coincidentally, the kaiser himself (a self-confessed cinephile). As Viertel reports on the audience's experience, he casts their apparent pleasure (and his own) as an encounter with the self: "They saw a true likeness of themselves. And the audience in the picture applauded. And the audience in the theater also applauded."[77] It is a scene of delight, composed of all the elements of narcissistic observation, doubled and quadrupled by the *mise-en-abîme* of the audiences within the film and outside of it, loving watching themselves loving the also watching kaiser.

The positive slant of that "true likeness," however, shifts into a different register, first as the author considers what it means to be situated somewhere between a representation of oneself and being oneself observing that representation: "Where does representation begin? Where does it end?" he wonders. "And the people, twice present here, and therefore doubly delighted, cheering at their own cheers, hailing their naïve existence in the mirror: Is that not dangerous? Could they not become frightened, as if they had seen their own ghost? Could they not instinctively react and go mad?" Viertel reassures his reader that madness is not likely. However, the episode further invites contemplation between states of being and feeling oneself being. The screened image and the monarch's witnessing body incite a moment of literal rupture when the film rips, sending "shivers" up Viertel's spine; he wonders, "Did this tear go through the real people? Horrified, I asked myself, who here is the real one?"[78] This example shows how the medium of film is implicated with the image on it—the film can rip, burn, or fade, which reminds the spectators of their own corresponding fragility and vulnerability to time and use. Their representation and their reality are too close, and the spectators are thus prone to feel it when they are torn asunder.

Anxieties about how the cinema represents and replicates the self have been present from its beginning; the kaiser incident underscores the way the "real" and the "image" of filmgoing bodies invoke both marvel and paranoia. The view of oneself on film for these audiences inspires an intensified sense of unity with *and* distance from the real body. Further, cameras betray equivocation when it actually comes to the truth they hold and the evidence they provide, even when the subjects are documentary, factual, and straightforward. The camera's mechanical and revelatory powers of vision, greater even than those of the human eye, have been touted in a variety of contexts over cinema's history. The scientific field is particularly ripe for revelatory analyses about the nature of selves, as Kirsten Ostherr's work has shown.[79] Her presentation "Live-Tweeting the Awake Craniotomy" succinctly demonstrates how the craniotomy performed on an opera singer while he was awake represents the double-edged power of imaging technology to reveal and withhold vital (so to speak) information about images of the self.[80] Images of a man's brain do not show us who he is exactly, even though there seems to be a direct correlation between the way the surgeons manipulate the brain and the

capacity for glorious song that constitutes this particular person's self-dom. The camera's representations of selves, of course, may also fail those who would depend on them in other ways—for instance, through a failure of interpretation of what is imaged, through conscious misrepresentation of visual information designed to mislead the viewer, or through the technology's shortcomings. But the questions inspired by self-images beg the further question of what a self is and what it does or might look like.

Aiming to control the way one presents oneself—or projects oneself—into the world, the mixture of desire and uneasiness of self images points to how spectators may contend with what the screen reveals to them about themselves. This relationship to moving images can be profoundly moving, wonderful, unnerving, horrifying, and formative. As a result, the encounter with the self on screen elaborates the experience of anxious cinephilia.

NATURE, COLOR, TEXTURE, AND THE CINEPHILIC ENCOUNTER

In a letter to poet Thomas MacGreevy, Samuel Beckett described his impressions of Paul Cézanne's Mont Sainte-Victoire paintings, noting "what a relief" they were "after all the anthropomorphized landscape" and attributing to Cézanne the ability "to see landscape & state it as material of a strictly peculiar order, incommensurable with all human expressions whatsoever."[81] Similarly, some spectators of moving images gravitate toward views that do not relate to human perspectives or to the self more particularly in the ways just described. Although human images, faces in particular, powerfully demonstrate the dynamics of anxious cinephilia, they are not the only kinds of images through which viewers derive or channel their love of cinema. (Anthropomorphizing the world around us has been for ages both an asset and a drawback to ways of relating to our environment, but it is not the only option for building a relationship to that environment.) As Metz's notion of secondary identification suggests, spectators identify with any number of faces, places, and things that do not resemble them one whit.[82] Reich and Richmond have observed that for Metz "secondary identification" is "a catchall phrase that includes any identifications in which the spectator participates

beyond the technical operation of the cinema—and not only with characters."[83] Secondary identification crucially offers a way of thinking about relationships to cinema that transcends the echo chamber of self that identification with self images might suggest is identification's only target.

Landscape and nature belie the role of identificatory dynamics as singular and related only to the self. Both have long been sources for cinematic splendor and cinephilia. David Desser observes that in addition to serving the role of "lyrical paeans to the power of the close-up" for our understanding of cinema's power, long shots and especially the landscape "excite the artistic imagination as much as the intimate portrait." Turning to the early film *Baby's Lunch* (Lumière Brothers, 1895), he wonders whether it is the intimate portrait of the family or the "rustling of the leaves behind them that truly engages our sensibilities," and he attributes "both the birth of cinema and the birth of cinephilia" to this twin focus on the human and the landscape at an early moment in film history.[84] The development of widescreen technology was prompted in part to capitalize on grand, panoramic vistas that were seen as an attraction to get people into movie theaters. When displayed on a very large scale, landscape and nature can induce sublime encounters involving the powerful feeling of being overwhelmed that is characterized simultaneously by both wonder and fear.[85] Films that include landscapes that function to overwhelm the human form, whether they are real or cinematically manufactured, amplify affect and make an appeal to a cinephilic disposition. From the climax of Alfred Hitchcock's *North by Northwest* (1959), as the protagonists cling to the iconic faces of Mount Rushmore, to the vast golden farm fields in Terrence Malick's *Days of Heaven* (1978), which both give life and threaten their inhabitants, to the stunningly beautiful beaches, marshes, and tall grasses threatening to subsume settlements and hiding fierce aggressors in Lucrecia Martel's *Zama* (2017), to the glistening frozen expanses of lake and forest that sequester the main character in Darlene Naponse's *Falls Around Her* (2018), landscape complements and yet distracts from narrative exigencies. It provides alternate foci for a spectator's attention and affection.

Films are in fact open to many modes of engagement and love. Spectators might at any time occupy a range of oppositional positions in which they refuse the *dispositif* of cinema and its identificatory

operations, its neglect of representations of marginalized groups, or its parlous powers that lead citizen brigades to warn teachers and parents against the "damage which films can cause in the moral health of their children" (as one Italian writer put it circa 1919).[86] Whether a spectator prone to focus on elements of cinema that do not squarely conform to narrative's demands (including its appeal to identification and ideological positioning) is an oppositional spectator probably depends on the spectator and the kind of attention she pays to moving images. But failing to comply with the conventional arrangements of attention and investment that a narrative film might ask of her does strain the parameters of how that type of cinema has been seen to work.

In the place of more conventional positions, such a spectator may develop an amorous relationship with the screen on any number of other levels. What one spectator is drawn to or paying attention to—the lure of a fantastical world, documentary truth values, the contributions of the foley artist or production designer, a striking color—might differ wildly from what the spectator sitting right beside her in the movie theater or on the sofa or a seat on the bus notices. Matters of taste and individual ways of looking matter for how cinephilic relationships are forged. Just as two or ten people lying in the grass will look up in the sky at actual clouds and see human faces, animals, confetti, nature, marshmallows, heaven, nothing, and/or clouds, two or ten spectators might approach a moving image of clouds equally variously—as humanlike, symbolic, literal, and so forth. Further, some will love these impressions, and others will be indifferent. People fall in love with cinema because it is witty, talkative, or charming; others love the texture of textiles on film; still others love nothing more than fog lifting slowly in a single shot over a landscape. Cinephilia is as individual as the ways of looking are to audience members.

Cinephilia's motivating forces are multiple and exceed the idea of the self being reflected in moving images. Acknowledgment of the many pathways to love in all the kinds of worlds and sensations encountered by spectators is fitting when one recognizes the volatility and plurality of what cinema has been, is, and will yet become. Its constant transformations coupled with its enduring appeal signal a plentiful source of energy to draw upon affectively. Pinpointing the worlds and sensations in which spectators have invested and about which they have gushed

begins to map cinephilia's constellations of engagement. In addition to the dynamics of films that present landscapes and nature as outside of strictly personal interest, some films address viewers within the boundaries of personal interest but quite differently from the identificatory dynamics described in the first part of this chapter.

If, for instance, instead of identifying with the cinematic apparatus's operations or with characters' emotional or psychological journeys, a viewer dwells on the worlds of lush, wet, and green forest in Debra Granik's *Leave No Trace* (2018) or the pop of a sudden bright color in Jia Zhanke's *A Touch of Sin* (2013) or the marvelous damp dirt of Shirin Neshat's *Women Without Men* (2009) or the technique of cutout silhouettes in Lotte Reiniger's *Thumbelina* (1955) or a splash of yellow handpainting for a woman's dress as it judders around a circle with its wearer in a short dance sequence in *The Great Train Robbery* (Edwin S. Porter, 1903), she ruminates on the aesthetic or sensuous content available to film worlds. As Joshua Yumibe has described, color has often functioned in a way that is in excess of narrative and even realism. He notes that the history of color in cinema points us toward how in "experimental and contemporary digital cinemas . . . so many of our colors have become once again vividly unhinged from photographic reality."[87] Filmic aspects such as color have the power to lead away from narrative immersion and into a different kind of rabbit hole for the viewer's attention, one based on abstraction and without specific anchors for psychological ways of interacting with images. As Yumibe notes, the history of color "raises fundamental questions about cinema itself: color calls attention to those material aspects of film that attract and repulse us."[88] Indeed, elements of film such as color and texture have the power to draw the spectator toward abstract effects or the material of the medium, which can serve as a different type of site for affective expression. Giuliana Bruno descries in contemporary screens' plurality, mobility, and tendency toward tactility a medium for haptic materiality that fosters "reciprocal *contact* between us and objects or environments." Such contact becomes "the communicative interface of a public intimacy"—or a kind of collective amorous connection to the medium's expressivity.[89]

Bruno echoes Laura Marks's notion of haptic visuality, in which surface texture and embodied perception merge, producing ways of looking that put cinema's appeals to the body as a whole front and center.

Marks contrasts haptic visuality with optic visuality: the former "tends to move over the surface of its object rather than to plunge into illusionistic depth"; the latter includes sufficient distance "that allows the viewer to organize him/herself as an all-perceiving subject." Haptic visuality (an inclination toward an embodied way of looking) relates to the way a film addresses itself to memories or sensations of touch. For Marks, "the haptic image forces the viewer to contemplate the image itself instead of being pulled into narrative."[90] Neither haptic visuality nor optic visuality is an absolute in terms of defining a relationship to watching film images, but if a viewer is drawn to how the image inhabits textures in soft close-ups of dress pleating in *The Phantom Thread* (Paul Thomas Anderson, 2017) or to the rich graininess revealed in a 16mm film's transfer to high-resolution digital, as in the DVD release of Charles Burnett's *Killer of Sheep* (1978), she may be encouraged to partake in haptic rather than optic visuality, emphasizing touch, sensuousness, and contact over the eye's control of the visible domain. A sense of the plenitude of the image compels consideration of the shift from the institutions of cinephilia to the bodies of the cinephiles. A significant motivator for cinephilia is a drive toward possession; however, the moving image is the elusive object par excellence, a fleeting, changeable, ungraspable nonobject that nevertheless derives from real things and generates real experiences. Without a precise thing to hold onto, the cinephile or theorist of cinephilia might turn to her own experience and to her "illusion of perceptual mastery"[91] or to the visible, outward signs of that experience (such as the acts of writing or the finding of communities discussed in chapter 1). Amid the threat of disappearance and absence, having loved and pursued the image in whatever way constitutes a trace of the anxious cinephilic act.

Thus, in a variety of ways, the cinema—in its depictions of nature and landscape or of color and texture and in its cultivation of special experiences for watching movies and its activation of a sense of momentary plenitude—draws in new kinds of lovers and holds them with a variety of appeals. Of course, some also love a particular kind of cinema— there are fans of Westerns and aficionados of expanded cinema—whereas others love a particular kind of cinema space, such as a crummy old drive-in movie theater, a luxurious historic cinema restored to its former glory, a sleek modern multiplex, or a particularly raggle-taggle armchair

in the family room. Recall Barthes's idea of being seduced "not [by] the image but precisely [by] what exceeds it: the texture of the sound, the hall, the darkness, the obscure mass of other bodies, the rays of light, entering the theater, leaving the hall."[92] Some love simply the illusion of motion, the foundations of cinema in whatever form it happens to take. Still others love most of all being *at* the cinema, the experience of a particular cinema situation more than the specific images before them. If a spectator is susceptible to the thrill of IMAX or to a specific kind of movie experience, she may find that going to the movies is for her something of a habit or addiction. The introduction of new technologies—widescreen, 3D, special effects, and so forth—has been a source for accessing delight and wonder in viewers.[93] All of these technologies are equally productive of anxieties associated with change as well as a feeling of being overwhelmed, as addressed further in the next chapters. The apparent magic of going to the cinema is a sensation capitalized upon by the film industry in the form of the condensed emotional gambit of movie trailers as well as the glamour of the Academy Awards or films that romanticize the moviegoing experience. Indeed, a vast variety of kinds of attention shapes amorous relations to moving images.

Cinephilia and Technology

Anxieties and Obsolescence

ANXIETY AND OPTIMISM AMID
TECHNOLOGICAL CHANGES

In Michelangelo Antonioni's *Blow-Up* (1966), swinging London photographer Thomas (David Hemmings), a character with aspirations to both artistic and commercial success, takes photographs in a park. Enveloped in a green, leafy hiding place, he captures snapshots of a scene as it plays out before him: a woman leads a man across a field; both are unaware of the photographer's presence. When they discover they have been photographed, the woman confronts Thomas, demanding the film. He refuses and departs without giving the incident much thought beyond the sense of having taken some really smashing pictures. As the plot unfolds, however, he becomes suspicious about what might be on the film. When he develops it, he becomes privy to several shots that, taken together, seem to add up to a murder. One image in particular when blown up repeatedly seems to reveal something amiss: it appears to show a blurry mass that Thomas takes to be a dead body; however, its quality deteriorates with each magnification so that it confirms and increases his doubts in near equal measure.

Blow-Up investigates issues related to cinema as an aesthetic medium and, importantly, as a technology. It scrutinizes both the power and

FIG. 3.1. *Blow-Up* (Michelangelo Antonioni, 1966).

fallibility of cinema to render images of the world, to provide evidence of what is before it, and to lay bare the process required to construct and interpret that evidence—a process often less accurate than we might want to believe. Cinema's technological qualities have also been a foundation for cinephilia for as long as cinema has existed. There has been room to grow with the beloved object as it has undergone a number of transformations, though the process of keeping up with the sometimes whiplash speed of those changes has not been simple or unemotional.

The technology of cinema has been a source of astonishment and enthusiasm throughout its history. From the notion that the camera itself as well as its views are attractions to the medium-centric delight over what the camera can uniquely do (close-up, tracking, superimpositions, etc.) and the sense of sensory fulfillment registered with the coming of sound, the introduction of color, the immersive address of wide-screen and 3D technologies, and recent spectacular digital special effects, technology has frequently been a source of nourishment for cinephilia. However, perhaps no other source of cinephilia has been so bedeviled by anxiety at the same time: indeed, technology is an uneasy fulcrum balancing hope and fear for the nature of cinema as one has come to know it and as it has not yet fully revealed itself for the future.

Antonioni's film encompasses cinephilia from several angles even while it traffics in anxiety about the different kinds of images it presents (moving and still, silent and sound, abstract and representational, documentary and evidential). The anxiety threaded through *Blow-Up* serves as a counterbalance to some of the rapture expressed in cinema's history over cinematic techniques, such as the close-up. Thomas believes in the power of the image to betray evidence he did not discern when in its presence. Malcolm Turvey has dubbed a version of this kind of thinking about cinema "revelationist," a trend he descries in early observers of cinema such as Jean Epstein, Dziga Vertov, and Béla Balázs, who have commented on cinema's capacity to reveal things previously concealed or beyond the endowments given the human sensorium.[1] As Béla Balázs has suggested, the close camera has a facility for revealing the world from new angles and distances: "The first new world discovered by the film camera in the days of the silent film was the world of very small things visible only from very short distances, the hidden life of little things. By this the camera showed us not only hitherto unknown objects and events ... By means of the close-up the camera in the days of the silent film revealed also the hidden mainsprings of a life which we thought we already knew so well."[2] However triumphant close-up views may be, they also have potential to trouble the spectator, much as they do for Thomas in Antonioni's film. The possibility and threat of the teeming life around a person (e.g., cinematic extreme close-up images of germs in action, murderers lingering on the margins of a park) may reveal themselves like the visitation of an otherwise unseen and (possibly) unwelcome specter. Moreover, more broadly, although the close view can be a source of wonder, it also might disturb or overwhelm, as a much-magnified view of a Brobdingnagian breast disturbs poor tiny Gulliver in his travels or as a fragmented view of the body suggests going to pieces. Cinema's powers inspire reverence but do not go untouched by doubts and ambiguity.

The circulation of anxieties attached to image making and image reading is complex in *Blow-Up*. Antonioni uses Thomas's predicament as a vehicle to contemplate the naïveté, doubt, and wonder that haunt the technological foundations of cinema. Thomas was initially oblivious to the apparent murder, but then he depends on the camera's better-than-human capacity for visual testimony. However, the information contained in the image is fuzzy, subjective, and problematic: its clarity

deteriorates as he tries to focus it. Antonioni widens the gap between the surety of images as material evidence and the doubts that inherently underlie them through his cinematic treatment of still photographic images as Thomas develops them. The first time he examines the photographs he has printed, the full resources of a specifically cinematic exploration are put into action. In a series of still shots, Antonioni shows Thomas putting the evidence together into a "story."[3] To do so, he puts the spectator in Thomas's position as he looks at the photographs, which are a conduit for his memory of the moment that he took them. Earlier in the film, when Thomas's surreptitious shoot takes place, the park is alive with the susurrations of grass and trees. Now, when Thomas stands back to regard the photographs he has printed and pinned on the wall, the soundtrack replays the sound of leaves blowing in the wind (although he is now in his studio and not in the park). Because nothing other than the black-and-white photographs he took are shown, taking up the whole screen, he and the spectator have nowhere to go but into the mind space proffered by the developed images. The photographs' edges are subsumed by the edges of the screen's frame, preserving the illusion common to the movies of being unframed, of *being* unfolding like a dream within instead of in front of the viewer, a total immersion.

In this sequence, Antonioni alludes to the fact that photography's capture of life as it unfolds is only as reliable as the observer's powers of perception are acute and brought to bear upon successfully reading it. Believing what he sees in the photographic images, Thomas declares to a friend over the phone that he has saved someone's life. But . . . later he finds a body in the park. But . . . even then the filmic narration overall undermines this stage of Thomas's discovery as "evidence." The resonance of the dead body with mannequins featured in other parts of the film (Are any of these bodies "real" or animate?) and the underscoring of sound that is suggested as being just in Thomas's mind (as it is later when he watches mimes play tennis and the film includes the sound of an invisible ball hitting invisible rackets) hint that the dead body may be in Thomas's imagination—images without a material referent—despite the powerful visible (photographic) evidence of what Antonioni and the cinema show us. Why believe that the images we see have a referent in the first place when we know cinema has equal facility in fabricating realities? *Blow-Up* lays bare the interplay between perception and the truth

value of cinematic images. Meanwhile, the gap between what the basis of cinema's photographic technology promises and what it actually delivers occasions anxiety for Thomas and leads him to seek out other means of verifying his experience.

Blow-Up confirms the problem of cinema's trade in ambiguous signs precisely because of the nature of its technology. That is, cinema holds the potential to show everything, even things the person behind the camera missed; this same quality, of course, means that the image indiscriminately registers whatever happens before it, leaving its meaning to be shaped by its beholders. The image's advantages may also be liabilities and a source of almost existential anxiety: Is what one sees what is there? Is what one misses lurking at the periphery of one's visual acuity? The trick of Antonioni's film lies in sustaining the ambiguities and anxieties pertinent to the technology of cinema even as it capitalizes on the things that give pleasure in images—indeed, Thomas takes intense pleasure of varying kinds, including aesthetic and sexual, in the processes of image making.

In short, even as the technological aspects of cinema explored by Antonioni's film occasion cinephilic discourses—rapturous encomiums to what the cinema can do—they are also a powerful source of anxiety. This chapter outlines some of the ways cinema's technology inspires and sustains anxious cinephilia. Writing of the role of emergent sound technologies in cinema, James Lastra points out that cinema, as the ultimate expressive tool of modernity, seems "to emblematize in the most compelling and visceral way, the frequently violent shifts in social and cultural life, especially the newly possible (if not inevitable) forms of spatial, temporal, and sensual restructuring."[4] Cinematic technologies undergird these shifts, offering new ways of experiencing space and time (so that the introduction of the close view, for instance, requires a different way of thinking about the world). Subsequent shifts in cinema's technology thus also inspire anxiety in other ways: just as a body gets used to (or begins to love) one form, another emerges. Technologies do not develop in a smooth line but rather take root unevenly across related media and forms of expression such that some film audiences feel that the whole vast media landscape beneath their feet is trembling or that everything is moving too quickly. Most problematically, shifts in cinema's technologies threaten to eliminate already beloved forms of the

medium (e.g., silent cinema). Overall, the specific reasons for wonder mixed with anxiety related to cinema's technological foundations or innovations are various. Newer technologies may be marvelously innovative and exciting; however, their future is uncertain. Nostalgia for older technologies can be a point of pride shared by cinephiles and filmmakers, and love for older technologies may serve as a rallying point for specialized knowledge and clique qualification. Older, endangered, or all but wholly replaced technologies are also imbued with the affective charge of loss. Love may deepen with the threat of that loss.

Moving-image technologies work in tandem with the look and feel of a film as well, and past technology is available as an expressive tool for nostalgic effects in contemporary films. The opposite is also true: some films use contemporary technology to enhance, comment upon, or otherwise alter the look of a film for a variety of reasons. Technology and time are closely connected for cinema. Even if something made in 1911 aimed to be as up-to-date as possible at the time, in 2020 it is a vision out of the past, and its value and affective orientation have accordingly changed. Films intentionally reproduce the past with more or less accuracy—often a mixture of more and less, as both Sofia Coppola's *Marie Antoinette* (2006) and Yorgos Lanthimos's *The Favourite* (2018) playfully illustrate. Each was filmed in a historic location and offers elaborate costumes that suggest if not absolutely adhere to the period depicted, but they call attention to their historicity as a creative fabrication: the former is accompanied by an anachronistic pop soundtrack, while the latter mobilizes aspects of cinematic technology such as extreme-wide-angle lenses to press to the foreground (literally) its views of Queen Anne and her country house's corridors. They collapse the old and the new to shed new light on both. Many films more baldly conjure nostalgia as an emotional spark for their narratives, immersing their audiences in the candlelit recesses of the past. Such a move can be regressive, drawing on a longing for a past that may never have existed or eliding elements of actual history in favor of something more sanitized. Frederic Jameson describes such a vision as resembling nothing more than a "collective wish fulfillment" that inhibits our ability to live with a sense of our own time.[5] However, as Christine Spengler has shown, depictions of the past can also be progressive by opening a film to historical critique

precisely because such films often are a complex engagement with the past and encourage further engagement with that past through their unique production practices, as in the methods utilized for *Marie Antoinette* and *The Favourite*.[6] But is there a specific connection between the idea of nostalgia more generally and the technological shift(s) of any given moment?

Andrew Gilbert has argued that a slate of films from the awards season of 2011—in particular *Hugo* (Martin Scorsese), *Midnight in Paris* (Woody Allen), and *The Artist* (Michel Hazanavicius)—put nostalgia on offer as part of Hollywood's response in the present to the industry's shift to digital technology. Zeroing in on themes, settings, and situations that relate to the digital turn, he posits: "Each of these movies deals with the conflict of reconciling past and present, and offers its own solution and resolutions that while not always practical, satisfy us emotionally. In each we find the pain of nostalgia, the problem of transition, and the power of, and need for, the past."[7] Gilbert accounts for the recurring theme of reconciling past and present in these films by citing the pain that filmmakers must feel in the midst of the sure elimination of celluloid film at a turning point in the industry's technological trajectory (an apparent expression of anxious cinephilia if there ever was one). In this account, he illustrates Jason Sperb's point that the sense of the inevitability of technological changes generated by such films actually works to hide the "destructive capitalist tendencies" encapsulated in the industry's shift to digital in the present. Sperb elaborates this point and its political and economic ramifications, charging the industry responsible for these films with seeking to "naturalize the shock of a sudden change" in the industry and make technological change appear unavoidable but manageable (if one is hardy and resilient enough).[8] Although technological shifts are disruptive, these films seem to say, they are fully surmountable by stick-to-it-ive-ness and individual agency and are not merely symptoms of a capitalistic money grab in which technologies are periodically replaced mainly to ensure a cycle of obsolescence, replacement, and profit.

Several of the films Gilbert addresses, however, noticeably complicate his point about nostalgia and technology. Of Terrence Malick's *The Tree of Life* (2011), a film he groups with the trend to work through technological change by means of nostalgia, he writes that it

consists almost entirely of nostalgic memory and [is] shot with a style that lingers on the feel of the past. The main character—and at times narrator—remembers with pain and fondness a childhood that delights in the little moments of life, moments captured visually in his mind. This visual playback of the past is analogous of film. Will celluloid be missed with this type of nostalgia? Will it forever feel like home to many filmmakers?[9]

Although Gilbert's point admittedly is that there is a metaphorical (not actual) link between the nostalgia of the film and that of celluloid, the conflation of the two gives one pause when one considers the process of filming as well as, later, the reworking of the film for a Criterion collection re-release seven years later. *The Tree of Life* was shot on 35mm, 65mm, and IMAX formats, using mostly natural light and eschewing CGI. Instead of CGI, the filmmakers used any and all means of experimental tactics to achieve new effects, blending new with older methods. According to the special-effects supervisor Douglas Trumbull,

> we worked with chemicals, paint, fluorescent dyes, smoke, liquids, CO_2, flares, spin dishes, fluid dynamics, lighting and high speed photography to see how effective they might be. . . . We did things like pour milk through a funnel into a narrow trough and shoot it with a high-speed camera and folded lens, lighting it carefully and using a frame rate that would give the right kind of flow characteristics to look cosmic, galactic, huge and epic.[10]

Lest these artistic choices suggest a Luddite filmmaker chafing against the rise of the digital, a few years later, when Malick prepared the film for a new release on DVD—what he described as a new film—he hoped to employ interactive digital technology so that the film could be released in a rhizomatic format that would yield multiple versions for its viewers.[11] Similarly, *The Artist* was shot on color stock at twenty-two frames per second before being transferred to black-and-white to create its own nostalgic effects. Both films bear a more complicated relationship to their nostalgic aesthetics and technology than Gilbert accounts for. Technological innovation and nostalgic looks generate a strange tension between the old and the new, and it seems that the early 2010s

were ripe for exploration across the celluloid/digital divide at the moment when the transition from one to the other became urgent. Disappearing histories drive a sense of having missed out on the plenitude apparently available to those earlier moments. As we have seen, the notion of belatedness—of living too late for the heyday of a glorious cinephilic past—is constitutive of contemporary cinephilia. Nostalgia for celluloid film or for other outmoded technologies related to cinema, film narratives, and the moviegoing experience evokes a cinephilia anxious about losses.

Several ontological anxieties and wonderments simultaneously derive from and dog the technology of cinema. These anxieties include many of the conceivable uses of technology in the cinema, from fakery possible through special effects to the prestidigitations allowed by editing, manipulations of framing, as well as the ways cinema is a mausoleum to the dead and a means of raising up the dead to the semblance of living again. Indeed, aspects of cinema's technology on their own aim to engage makers and receivers of cinema with near-magical potency. But it is in the moment of transition that cinephilia seems most readily activated. Sperb offers a possible explanation:

> Nostalgia is always most intense during periods of dramatic cultural and technological upheaval, whereby the perceived reassurances of a simpler past anchor our perception of an uncertain present (and future). . . . Nostalgia, then, is less about reclaiming a vanishing past than about paradoxically resisting a potentially threatening future: how to pull back against the endless rush to change or against the inevitable end of mortality itself.[12]

During the many ages of cinema's technological changes, its history has been marked by a sense of nostalgia, loss, and anxiety. In addition to reservations about or adulation of the technologies, lovers of the cinema have pitted changes in technology against their sense of the proper and most expressive qualities of whatever technology is being replaced or installed (e.g., silent cinema versus sound cinema). Technological transitions prompt the expression of need for a stability in the cinematic medium amid its fundamental volatility. Does not the fear of dispossession, after all, evolve out of the feeling that there is some well-defined

thing to be lost? Anxious cinephilia by necessity leads to the (fluid) definition(s) of what cinema is.

The practice of making and showing films has undergone a steady series of changes that have challenged stable ideas about what we understand to be cinema. Radical technological change has always had the potential to render a specific approach to cinema obsolete. The more momentous shifts in cinema's technological aspects—including the shift from precinema technologies such as still photography to moving images, the addition of sound to the image, changes in the dimensions and scale of screen, the widespread use of color, and digitizing elements of production and exhibition—have prompted anxiety for a variety of reasons. However, interestingly, these responses are also cinephilic. The archivist and preservationist of cinema are frequently driven by a cinephile's urge to save the specifically material objects of cinema, each format of which (everything from film to VHS to digital to the next format yet to come) is threatened by decay and obsolescence as changes to the medium take place.[13] This cinephilia fosters nostalgia for an about-to-be-forgotten past, recalling Thomas Elsaesser's notion of the cinephile's anxiety "in the teeth of cinema's technological change," a love that is in constant danger of being destabilized by such changes.[14]

By closely following shifts in technology, we identify the crises that have been perceived as threats to cinema's "true" nature. At these moments, discourses arise that are characterized by anxiety and optimism about the technological transfigurations that have played a role at every turn of cinema history. Although any number of the transformations would serve as a microcosm of these tensions, the three cases I take up for the remainder of the chapter represent suggestive variations. First, tracing the broader strokes of the change that came with the introduction of sound to the cinema allows an entry point into these debates that is likely to be familiar as a moment of major upheaval. I begin with a brief account of this well-known debate about the conversion to sound to outline the tensions between fear of loss and hope of gain (both artistic and financial), a debate now made more legible at some remove from its historical moment. Second, I consider the issues that arose surrounding a contentious trend to colorize older films for re-release on television in the 1980s, a trend that mobilized people nostalgic for a film history that they feared was being irrevocably damaged. A more modest entry in the

history of changes to the medium, colorization was for the most part a technology thwarted by parties interested in preserving the status quo and thus represents a moment when the push and pull of nostalgia and forward thinking came to uneasy resolution rather than to an enduring industry change. And third, I address one corner of the digital turn by focusing on the recent shift from the projection of film to exhibition in digital formats. This debate brings us to the point of the (constantly evolving) present and attempts to observe the ways that such debates play out in the heat of the moment. Together these examples serve to delineate some of the key factors that figure in the welter of influences that changing technologies have had on cinephilia and vice versa.

ANTICIPATION AND ANXIETY IN THE AGE OF CINEMA'S TRANSITION TO SOUND

An image, even with few events, kindles a much richer and quicker mental life than a cluster of words might fuel in the same amount of time. Hence this impression of slowness, which surprised us in the first sound films around 1928.

—JEAN EPSTEIN, "PURE CINEMA AND SOUND FILM"

Although experiments with sound in cinema began early, it was not until the end of the 1920s that the shift to a sound cinema began to happen in earnest. As Douglas Gomery has shown, sound went through full and successful phases of invention, innovation, and diffusion,[15] with the result that the medium of cinema was fundamentally and irreversibly changed. In the United States, within a very short period of time after the release of, most famously, *The Jazz Singer* (Alan Crosland, 1927) as well as of other part and full talkies circa 1927–1929, the major production companies began to make the majority of their films in sound versions. Most countries followed suit within a few years, depending on local concerns. Several film historians have examined these years in detail,[16] but what matters here is how the shift was greeted in terms both euphoric and suspicious. On the one hand, it was met with excitement about the new technology's potential to deliver a fuller, more sensuous experience of the cinema—one that would appeal to and satisfy a larger audience—and, on the other hand, it was met with doubts about throwing out the gains

made by the art of silent cinema in favor of a hampering realism wrought by "obvious" and "awkward" sound—in particular speech.[17] As Rudolf Arnheim put the latter issue in the late 1950s, "It was precisely the absence of speech that made the silent film develop a style of its own, capable of condensing the dramatic situation."[18] The "quicker mental life" Epstein hailed as a trademark of the silent cinema was feared lost amid the conversion to sound. This trademark of silent cinema helps accounts for the feeling that early sound films were *slow*, an impression compounded by several factors, as Lea Jacobs has noted, including the need for actors to recite their lines "very slowly and carefully" to register dialogue properly as well as restrictions in camera movements and editing in order to record the sound in one take.[19]

Looking back on this moment and crafting a story around the ways producers, actors, and audiences grappled with the coming of sound, the film *Singin' in the Rain* (Stanley Donen and Gene Kelly, 1952) illustrates in shorthand both the wonder and the anxiety accompanying the shift. It uses the screening of a "talking pictures" demonstration at a party to tout the surprise and wonder of sound film, even while it narratively dwells on the anxieties felt by those within the industry about how well they will weather the transition. It draws on the cliché of the fear that dialogue makes banal the raptures of a silent, rhythmic, gestural language when its translation of the subtle passion of a silent love scene becomes ridiculous as the lovers audibly say "I love you! I love you! I love you!" over and over to each other.[20] But akin to how it happened in the real film industry of the time, in *Singin' in the Rain* sound film's technology triumphed in the end, like it or not, with those who were positive and optimistic about it forging on into cinema's bright future and those who were negative and pessimistic wallowing in the losses accruing to the rich visual realm of silent cinema and thus left behind.

Singin' in the Rain is not alone as a film that resuscitates the expressive art of silent cinema for narrative, thematic, or simply nostalgic reasons. As we have seen of more recent films, *The Artist* relishes and recapitulates (at least in part) a silent-film aesthetic as its total modus operandi, and *Hugo* uses Georges Méliès's films as visual set pieces; Olivier Assayas has imported silent film as theme and homage in *Irma Vep* (1996) and *The Clouds of Sils Maria* (2014); and Todd Haynes's *Wonderstruck* (2017) offers an extended thematically poignant entry in the

nostalgia for silent cinema. As in *Singin' in the Rain*, one of the narrative threads in *Wonderstruck* transports the viewer back to the age of silent cinema on the cusp of its conversion to sound. It contemplates the demise of silent cinema as a particular kind of loss to one of its most sympathetic characters, a deaf child whose mostly absent mother, a silent-film actress, is made more legible to her in silent films than in life (inasmuch as within that context the mother conveys her thoughts and feelings using the same silent language as her daughter). The film's nostalgia centers throughout on the qualities of cinema that allow direct, intimate communication that comes without needing to emphasize spoken language.

Thus, although the loss of silent film's language—drowned out by sound's distraction—was most keenly felt in the moment of its passing into disuse, it is felt and commented upon even to the present day. The ways it is felt, importantly, are not confined to a focus on the aesthetics of silent expression versus that of sound cinema. Films such as *Wonderstruck* demonstrate in miniature how losses associated with a technological changeover may be felt on a number of registers and long after the transition. Sound technology's insinuation in the industry leaves a certain direction never (well, seldom) trammeled again in the mainstream cinema. The sense of loss feeds nostalgia for a supplanted, supposedly simpler aspect of the medium. However, this perspective of comingled anxiety and love for the disappearing or disappeared technological aspects of cinema gets complicated beyond its relationship to nostalgia. An emphasis on the close-up or on the many elements of a visual language employed by the silent cinema of course did not vanish with the coming of sound. Nor did silence—or something keenly resembling it—disappear from sound films.

Both anxiety and optimism arise from both a sense of the artistic potential of the cinema (past and future) *and* the commercial aspects of leaving one technology behind in favor of (a major financial investment in) another. In fact, they inflect each other: worry emerges amid the enthusiasm and vice versa, suggesting their coexistence as a response to the change and in anticipation of the future of the medium. A piece in the *New York Times* on February 10, 1929, typifies this conflicted response in its attempt to assuage the fears of exhibitors who might be left behind by not converting their cinemas immediately to sound: it insisted that

silent films would always have a devoted audience (they are "too firm of foundation, too stanchly embedded in the esteem of patrons, to be even remotely disturbed by the first tremors and upheaval swept up by the popularity of the new medium") and, furthermore, that the quality of the silent films would improve by the higher quality of actors recruited from the stage for sound films. Both of these arguments reacted to the "sensation" of talkies and addressed the "false alarms" rung by theater owners that they faced a loss of business due to the challenge against the "old reliable" silent film.[21] Of course, this particular response was off by more than a bit: the silent film may continue to have a devoted audience even to this day, but that audience is only a fragment of those in general who watch films. In fact, there may well be reason to worry in the face of swift and seemingly irrevocable technological change at the cinema.

Hopeful but wary responses to the coming of sound arrived in the form of writings by an array of people invested in films, from filmmakers to sound technicians to audience members. Few cinephiles today continue to mourn the losses brought about by sound or to champion the capacity of cinema for sound instead of silence. The technological shift is a done deal. But the moment in which the change happened signals singular points of attention for cinephiles: specifically, it inspires stocktaking of the purview of cinema that proves instructive for the way it has developed over changing times and places.

The cinema of the late 1920s was frequently hailed as the peak of the *visual* art of moving images. Commentators saw a refining through visual means of the artistic ambitions of the so-called seventh art in these years, coincident with larger claims to art by the cinema that, as we have seen, were tied to cinephilic sentiment at that time. As an art form, cinema came more properly into its own in the late 1910s and through the 1920s on a number of fronts both aesthetic and geographic. Filmmakers such as Norimasa Kaeriyama and Germaine Dulac contributed ideas in both writings and films to the notion of cinema as a unique art form. And they argued repeatedly at this time for a language of cinema centered in the image—for instance, in Dulac's observation that cinema's true purview is in its use of pure movement, its suggestive qualities centered in a visual, medium-specific language: "Should not cinema, which is an art of vision . . . lead us toward the visual idea composed of movement and life,

toward the conception of an art of the eye . . .?"[22] For these filmmakers, the cinema can and should manipulate visual representations of time and angles of presentation and draw on the power of the real world photographed. Further, cinema of the 1920s connected to the realm of art from other angles: it was inflected by art movements in the larger art world (surrealism, art deco, and so on, which lent it cachet by proximity); it gave birth to innovations according to the specific language of the cinema (montage, technological experimentation, etc.); and it exercised claims to art within local national milieus (e.g., German expressionist cinema).

Within these contexts, the cinema around the 1920s found its share of cinephiles, and they valorized its claims to the realm of art on these levels. Of the features they extolled, those that were specific to the cinema (as it existed) stood out. These features ran the gamut of the cinema's modes of production, from its cinematography (e.g., the close-up) to its mise-en-scène (the décor in general and props/sets in particular occupied a key position in the cinephilic imaginary[23]) to its editing and its rhythmic possibilities. It is not surprising that the concepts of *photogénie* and varying claims regarding montage emerged at this moment. These unique aspects of cinema's art occupied a privileged position among cinephilic fixations. They inspired written commentary and film practices that were founded on a near euphoric sense of what cinema can do—and they were partial to the visual realm.[24] Indeed, lovers of the cinema at this time understandably tended to put stock in visual elements as fundamental to its allure.

Just at the peak moment for cinema's visual realm, sound arrived. Those invested in the visual sense of cinema responded to the new arrival with both optimism and skepticism—and in many ways visual aspects grew in importance from the perspective of its loss. Béla Balázs issued a "farewell to silent film" in 1930, a lament about the sound cinema throwing the medium "back to the most primitive stage." Even while he detailed the atrocious fixity of sound design at that point, he concluded that "great sound film is definitely coming" and held out hope for its development.[25] Sound galvanized debates about cinema's proper qualities: some allowed for the change, whereas others excoriated it. Many felt that sound coming to cinema was part of its natural evolution. In addition to commentators on the ground, several early sound-film theorists remarked on the

role of sound coming into the cinema in the decades following its intro-
duction into the mainstream. Looking back on the moment of transition,
in "The Myth of Total Cinema" André Bazin argued that the development
of silent into sound cinema was merely a fulfillment of the original imag-
ination of a cinema that includes the possibility through technology
(before it is even invented) to render life as one experiences it, in full
"sound, color, and relief." He dismissed the notion that silent cinema was
the apotheosis of film art; technological changes are, instead, the grad-
ual invention of the total cinema conceived *avant la lettre*:

> It is understandable from this point of view that it would be absurd
> to take the silent film as a state of primal perfection which has grad-
> ually been forsaken by the realism of sound and color. The primacy
> of the image is both historically and technically accidental. The nos-
> talgia that some still feel for the silent screen does not go far
> enough back into the childhood of the seventh art. The primitives
> of the cinema, existing only in the imaginations of a few men of the
> nineteenth century, are in complete imitation of nature.[26]

Bazin focused on the cinema's relationship to a fuller experiential real-
ity, created step by step, and taking the sense of loss out of the equation.[27]
Interestingly, it is precisely this movement toward greater realism that
was often the crux of the counterargument against sound, such as that
expressed by filmmaker René Clair when he wrote in 1929 that through
sound the cinema "has conquered the world of voices, but it has lost
the world of dreams." He observed that people leaving the cinema
after a talkie "showed no sign of the delightful numbness which used to
overcome us after a passage through the silent land of pure images. . . .
They had not lost their sense of reality." Although Clair conceded the
power of sound in cinema in creating the potential for expressive
effects—for example, by alternating the use of sound and image—he
also lamented this loss of cinema's potency when it comprised "pure
images."[28]

Those invested in a relationship with cinema at this time reacted
strongly to the change. At stake on both sides were not just resolute
notions of film art and form but livelihoods as well. The perception and

realities of the financial aspects of the change should not be underval-
ued: the coming of sound was praised for expanding the industry at large
but blamed for ruining careers (and, in retrospect, for solidifying the
dominance of major studios over smaller ones). Representative of the
notion that sound was disruptive to many in the industry is a piece by
Guy Flatley in the *New York Times* in 1977 commemorating the fifty-year
mark after the coming of sound: "Everyone was affected: actors, direc-
tors, studio chiefs, cameramen. For many the sound of the talkies was
the sound of doom." Doom came in the form of actors losing contracts
because their voices did not match the expectations prompted by their
visual image, directors being "shushed by the newly all-powerful sound
technicians," studio heads "crumbl[ing] behind doors in solitary panic,
frightened by the vast sums gambling on 'talkies' required," and so on.[29]
Many people in the film industry worried over the new technology.
Actress Clara Bow, for instance, famously disliked the conversion to
sound, remarking once in an interview in 1930, "I hate talkies. They're
stiff and limiting. You lose a lot of your cuteness, because there's no
chance for action. . . . And people are so quick to pounce on you if your
voice isn't perfect."[30] All the same, several actors or their studios took
out insurance policies on their voices in the first blush of the talkie era,
marking a quantifiable financial value for their personal sound stamp on
the movies.[31] In fact, although the coming of sound may have left some
individuals behind, it had a favorable effect overall on the financial pros-
pects of the film industry more broadly.[32] Whether the uptick in ticket
sales was coincidental or not, it was monumental: Steven Mintz and
Randy Roberts report an upsurge in movie attendance from around 50
million per week in the mid-1920s to 110 million in 1929.[33] Several national
cinemas found their industries boosted as well by the demand for films
in the language of the country of origin.

Meanwhile, in addition to financial incentives, the cinephiles and
cineastes of world cinema considered whether sound cinema could play
a role in furthering the direction of cinema as an art. In a well-known
statement released by Sergei Eisenstein, Vsevolod Pudovkin, and Grig-
ori Alexandrov in 1928, there was an effort to direct the contributions of
the "double-edged" invention of sound in ways that would not detract
from cinema's best qualities. The authors began by staking a claim to the

better development of the uses of sound for film, drawing attention to the threat sound posed to cinema as an art form:

> We consider it opportune to make a statement on a number of prerequisite theoretical principles, particularly as, according to reports reaching us, attempts are being made to use this new improvement in cinema [sound] for the wrong purposes. In addition, an incorrect understanding of the potential of the new technical invention might not only hinder the development and improvement of cinema as an art form but might also threaten to destroy all its formal achievements to date.[34]

Among other areas of contention, Eisenstein, Pudovkin, and Alexandrov took up the question of visual versus textual language in cinema, conceding that a film's intertitles and "explanatory sequences" (e.g., information expressed in long shots) "complicate the composition of the montage and slow down the rhythm" (as Epstein's statement would later echo).[35] Several films prior to this point had minimized intertitles to combat the interruption of the visual rhythm, and a few—such Henry Edwards's *Lily of the Alley* (1923), F. W. Murnau's *The Last Laugh* (1924), and Dziga Vertov's *Man with the Movie Camera* (1929)—attempted to do without them altogether.[36] The intrusion of verbal language threatened to change the rhythm of visual images as well. Nevertheless, as filmmakers and theorists from Viktor Shklovsky to Alfred Hitchcock noted, intertitles—and, extrapolating from there, perhaps sound—could be used effectively by not "correspond[ing] to the shot"; they instead might "change the shot," providing an additional layer of expression within a sequence.[37] Several parties expressed something hopeful for sound along these lines.

The worry, however, was that sound would be used in a way that would flatten the image and make it redundant to words. In fact, anxiety about the inability of images to "speak" existed even before the coming of sound, and Eisenstein and others recognized that the changeover to sound cinema, too, might be met with good or bad techniques that could enhance or detract from the image. Several writers debated the possibilities of sustaining film art by harnessing sound for creative purposes. Several suggested good techniques or decried bad ones. Walter

Ruttman, a few weeks after the statement by Eisenstein, Pudovkin and Alexandrov was issued, concurred that *counterpoint* was the key to using sound in a way that would work against the regression of film as an art in the sound era. But, he concluded, there was cause for hope: "The fact is that . . . for artistic purposes, great possibilities abound."[38] In the following year (1929), Esfir Shub advocated for "organic raw material" in sound footage, to be used on a par with the "authentic, unstaged, real nature" of the film footage that artists of the cinema had been working with up to that point.[39] A statement by Pudovkin in the same year concurred with the principle of "raw material,"[40] and he later identified asynchronous sound as one direction for sound that could add texture to the image's expressive capacity.[41] Eisenstein and his comrades concluded in their statement that sound might in fact hold potential to solve some of the problems of visual montage: "Sound, treated as a new element of montage . . . cannot fail to provide new and enormously powerful means of expressing and resolving the most complex problems, which have been depressing us with their insurmountability using the imperfect methods of a cinema operating only in visual images."[42] Not everyone was hopeful, however. For example, Viennese critic Egon Friedell, reflecting in 1931 on the coming of sound cinema, remarked in less-happy terms that cinema had become "a brutish dead machine," incapable of the spiritual dimension made possible in silent-film productions.[43] The mixture of anxiety, despair, hope, and enthusiasm expressed in each of these responses derived from a passionate investment in a particular kind of cinema (one expressed visually) coupled with a worry about losing it by a trite use of a new technology that would cater to the "simple curiosity" of the spectator rather than contribute to a revolutionary, spiritual, or artistic aim.

Debates about sound did not stop after the transition was accomplished, of course. Moreover, aesthetic possibilities for sound are still being developed, and banal uses of sound are still being foisted on the filmgoing and media-watching public. Such a moment of technological transition crystallizes debates about cinema's raisons d'être—among them its relationship to reality, its financial potential, and the texture of its expressive features. And it points to the fact that cinephilia before, during, and after the postwar period has inspired the anxious spilling of

ink on behalf of how cinema might satisfy those who passionately protect or expand its boundaries in the midst of changes.

FILM COLORIZATION

> The medium is threatened today by a mixture of technology and greed, by corruption and reduction to infantilism—in the year 2000 producers will be 10-year-olds making movies for an audience of 6-month old babies, unless the creative people can stop it. To do that, they must be respected. To be respected they must be fairly treated, financially and otherwise.
>
> —FRED ZINNEMANN, HONORARY PRESIDENT OF THE DIRECTORS GUILD OF GREAT BRITAIN, 1986

> I would like to tell you how it feels as an actor to see yourself painted up like a birthday cake on the television screen. . . . It looked as if we had all been spray-painted or doused with dye. . . . It feels terrible. It hurts. It's embarrassing and insulting.
>
> —GINGER ROGERS, STATEMENT TO THE U.S. CONGRESS, MAY 1987

One might wonder whether Bazin, in conceiving of a total cinema fully fleshed out in depth and color as well as in sound, would have warmed to the brief vogue for colorizing black-and-white films. The process came to national attention in the mid-1980s. In August 1985, media mogul Ted Turner made a $1.5 billion takeover bid to purchase MGM/UA. That deal would not go through quite as he planned (it took nearly a year and involved selling parts of the property to other investors along the way), but the jewel of the acquisition, for Turner, was the MGM film library, which he planned to use as programming for his existing media holdings.[44] By 1986, capitalizing on the idea that people wanted and would pay more for color, he had entrusted several black-and-white titles to a colorization company so that they could be reissued on television in color versions. In 1987, Turner also acquired the RKO library and made similar plans. For starters, the plan was to color one hundred titles, including classics such as *It's a Wonderful Life, Casablanca,* and *Citizen Kane.*[45] Many of the titles had fallen into the public domain or had passed into Turner's business holdings through such purchase agreements, and he was fond of making blistering remarks about his claim to the films: "The last time I checked, I owned the films that we're in the process of

coloring," he commented to the press in October 1986. "I can do whatever I want with them."[46] Although a furious debate about the matter erupted thereafter—with the Directors Guild of America (DGA), the Directors Guild of Great Britain, the American Film Institute, and several celebrity actors, directors, and critics making impassioned pleas to Congress and in the press about the damage such a process would wreak upon career legacies and film history more generally—it fizzled out almost as quickly as it arose. As a technological transformation, the trend for colorization ultimately did not bring about a lasting change in the industry. In fact, the push to colorize films was fairly short-lived, despite Turner's eventual legal victory concerning copyrights in the matter. That is, although he was assured that in fact he did possess the legal right to colorize (a loss for those who fought to block the process), colorization ultimately did not stick as a trend (a win for the interests against it). Whatever the reason for this outcome, the stymying of this technological "advancement" makes for a unique case in the history of cinema's technological changes.

The debates about colorization in the mid-1980s reflect broader anxious and cinephilic attitudes regarding technology. On the one hand, the proponents of colorization—Turner and those in his camp, dubbed "Coloroids"—advanced the renewal of older film images in color as a miracle made possible by technology, although economic interests were also always at the heart of their position. On the other hand, those who opposed colorization rallied around the preservation of beloved classic films that they argued were materially damaged by the technology. For both sides, aesthetic preferences and a notion of how the national historical artistic patrimony should be preserved (in a manner of speaking because preservation proper was not on the table) were key issues.

Three issues seem most important to these debates, which the rest of this section addresses in greater detail. First of all, the colorization debates represent an instance when the financial interests of applying a new technology are blatantly at the fore. Coloroids argued they were following the dictates of the marketplace, strongly tied to the financial incentive driving their own immediate interests rather than an aesthetic one. Second, interestingly, the technology in question did not transform the process of production of the films because it happened after (sometimes long after) the films were made. It was an additive

technology and promised or threatened to change the nature of the original creation. Anticolorization advocates recognized a precious quality in that originality; the urge to keep it and the specific films they focused on intact also speaks to the pervasive nature of canons of great films in formulations of cinephilia (the stature of which they wielded as weapons against the Coloroids). And finally, as a result, these debates set off anxieties about authorship and national artistic patrimony, which somewhat circuitously led to the establishment of the National Film Registry, one of the first pieces of legislature that aims however minimally to protect specific American films deemed important and to encourage (though not to legislate) that they be kept intact. That is, the anxious cinephilia illustrated by the colorization debates is very much tied to notions of film authorship and masterpieces of cinema history: I can find no evidence of anyone worried about the colorization of *Popeye* cartoons, although that also happened. The debates mobilized anxieties about the beloved, privileged objects of cinema history and made the first inroads toward preserving that history (or certain parts of it) for future audiences, thus perpetuating canons of "great works" of cinema.

As the press liked to note, the colors on which Turner and the Coloroids primarily based their argument for colorization were green and gold. One writer for the *Washington Post* summarized the financial motivations of the colorizers versus the apparently purer motives of those who ranged themselves against colorization:

> If the battle lines had been fuzzily drawn before Turner's retort, they have now become bitterly clear, and there don't appear to be shades of gray. On the one side are Turner and his fellow businessmen and the two companies that do most of the coloring work: Colorization, Inc. in Toronto, and Color Systems Technology (CST) in Marina Del Rey, Calif.
>
> On the other side are film directors, film scholars, film fans, film critics—and all the decent, God-fearing, law-abiding, hard-working human beings who on the planet earth do dwell. Colorizing appears to be another of those abominations wrought by a technology gone berserk, or at least amok. Advocating it seems Philistinism pure and simple—or not so simple. Nor, come to think of it, so pure. More like Philistinism dyed the color of money.[47]

For the Coloroids, there was nothing wrong with promoting their business interests and making the best financial investment in their holdings possible, and in any case, they argued, they were catering to what consumers wanted: to watch color films. They did not mince words about the financial aspects of their position. Wilson Markle, president of Colorization, Inc., told the *New York Times* in August 1986: "The reason we are doing it is monetary. . . . People don't like black-and-white. They do like color, and when we color it, they buy it."[48] Earl Glick, chairman of Colorization, Inc., further noted that television stations and other outlets did not consider black-and-white as valuable as color, meaning that it could not command the same fees for the license to show the film or for the advertising that would accompany its broadcast: "Every time we went to sell something to them, they'd say, 'Well, this is only worth so much, because it's black and white.' So we thought, well, if these pictures were in color, they'd command a much bigger price."[49] The higher asking prices of color versions for distribution to smaller regional television networks constituted a robust profit margin for the Coloroids. National and local networks could also balance out their own costs by charging more for advertising during the broadcast of color versions of the films.

Those who sold VHS copies of a film likewise cashed in on the vogue for color: in 1985, a tape of *It's a Wonderful Life* in black-and-white sold for $9.95; about 10,000 copies were sold that year. The following year, at least five times that number were sold of the colorized version for between two and four times that amount (the list price of $39.95 was cut to $19.95 as a promotion around the holidays).[50] For several films, both the black-and-white and colorized versions remained available, leading proponents of colorization to argue that the marketplace provided a choice for consumers. Thus, Turner and others leveled the charge of elitism against the Anti-Coloroids: Who were they to deny the people what they wanted or to say that the color version was less valid for those who liked it and were willing to pay for it? In fact, the cost of making the colorized version (estimated at between $180,000 and $300,000) was more than recouped by its popularity—at least as a novelty, if not as a work of art in its own right.

The question of art in its own right in fact drove much of the debate surrounding colorization. The Anti-Coloroids focused their campaign on just a few key issues. First, they argued, the film is a work of art and as an artwork should not be manipulated ("vulgarized," "destroyed,"

"desecrated") by those who are not artists. They compared colorization to the marring of an original work of art, like adding pastels to a drawing by da Vinci or painting an Ansel Adams photograph, and thus materially damaging and cheapening it.[51] The Coloroids had an answer for this point. They argued that the films never were works of art so much as commercial ventures for which the creators agreed to and received payment. On June 21, 1987, Roger Mayer, president and CEO of the Turner Entertainment Company, testified along these lines for the subcommittee hearing the case for the Film Integrity Act of 1987, which treated the colorization issue:

> These movies were made as entertainments in commercial ventures by production companies who assumed all the risk. Those who helped make them took no financial risk and were paid, often handsomely. They did not return their salaries with an apology if the movie flopped. It is crucial to point out that the broadest possible ownership rights were obtained from directors and others through collective bargaining and personal negotiation in exchange for those large salaries and sometimes profit participations and residuals. The owners, in return, received control of the methods and manner of distribution, advertising, and the use of the various media, such as TV, videocassettes, and now color conversions.[52]

The Film Integrity Act, introduced the previous year by Representative Richard Gephardt (D–MO), aimed to safeguard the legal rights of authorship for directors. In fact, no laws were in place protecting the "moral rights" of authors to protect their own works once those works entered into the marketplace, and it was a fraught issue to introduce legislation that would do so, as those in the United States who worked toward implementing the Berne law, which had afforded this right in Europe for more than a hundred years, were to discover.[53] The new bill focused on making "principal directors and writers of theatrical motion pictures" the "artistic authors" of their own work. As such, "material alterations, including computer coloring of motion pictures, once released for commercial distribution, would not be permitted without the express consent of the artistic author."[54] The authors of the bill wanted to make as sweeping a claim for authorial rights for the director and writer as

possible. They recognized their effort as "clearly a very broad prescription for preserving and defending the artistic integrity of motion pictures."[55] In the end, a narrower prescription would prevail, involving only minimal protection for keeping motion pictures from being tampered with for commercial-broadcast considerations. Along the way, legislators, the film industry, and the public would engage in discussion about the "nation's cultural treasury" of "classic" films and what colorizing them would mean for the interests of all parties involved. The details of these discussions show the contours of what each party felt they had to lose—the sources of their anxieties—about a certain set of films that were considered part of the national patrimony.

Part of what was at stake in the question of the new, colorized version of the film as an artwork in its own right was the question of how it was made. Colorization was accomplished by cleaning up and making a video transfer of a film, enlisting a color specialist to choose color palettes for each scene of the film, making an initial set of frames that employed those palettes to check for accuracy and image quality, and then running the transfer through a computer program to color each frame. (It was possible to turn this version back to film, but the image ended up being fuzzy, and the point of colorization was mainly to provide television programming, so that part of the process was seldom undertaken.[56])

The question centered on whether this process was sufficiently creative or whether it represented a nonartistic, mechanical, or technical intervention in the original work. The day after testimony regarding the Film Integrity Act was heard, the Library of Congress submitted its decision regarding copyright registrations submitted for colorized versions of motion pictures, with much of that decision based on precisely this question. Its Copyright Office had been deliberating on the matter since 1985, at which time it had begun to receive applications for copyright registration of motion pictures that had been colorized. Recognizing "the unusual nature of the claimed authorship," the Library of Congress first made a Notice of Inquiry in the Federal Register (51 FR 32665) to gather more information about what it took to create colorized versions. On the table were four questions, which the office aimed to review before issuing copyrights to such versions: First, does the process of colorizing films "involve individual creative human authorship"? Second, who would be

named as authors of the copyrightable elements in the resulting colorized films? Third, what is the computer's role in the generation of the colorized film (how are colors selected, how many color choices are presented, etc.), and are any further cinematographic choices necessary for colorization? And finally, would the resulting colorized products be designed solely for television or also be re-released theatrically?[57]

In all of these queries, the Copyright Office focused on issues pertaining to the act of creation and to the maker of an artwork, with creative choice central to its conception of art. Despite the fact that most of the responses it received objected to the aesthetics of colorized images, the Copyright Office made it clear that such preferences would not be part of its deliberations. In the end, it determined on all counts that there was indeed sufficient creative choice in the making of colorized versions in that "all of the steps involved in colorization involve human authorship since the process is directed by human operators who follow the dictates of a human art director. . . . [T]he selection, coordination and application of color, and the review of the final product amount to 'individual human authorship.'" It was not willing to say that all changes in a film's color scheme would qualify: for example, cases would be considered newly copyrightable only if "the overall appearance of the motion picture [were] modified," and no film for which the color had been removed would be considered. Nonetheless, the Copyright Office condoned the present practice described by "the typical colorized film"—those ten films submitted for copyright protection to that point. Such a film "is the result of the selection of as many as 4000 colors, drawn from a palette of 16 million colors," it argued, making the film a candidate for copyright protection on the basis of containing "sufficient original authorship."[58]

Those who opposed colorization argued that although some parts of this process entailed human interaction with the print, the vast majority of the labor was accomplished by the computer program (only a handful of frames were monitored by the colorizing art designer, who in any case would not be the copyrighted author of the new version of the film). Furthermore, they argued, the parts of the colorization process that required human labor were motivated by interests and persons divorced from the initial choices made by the director of the film in consultation with the cinematographer, lighting designer, and other personnel

working on the film in the past as part of a unified effort to create specific images. They opposed the idea that a new color version was a work of art in its own right and argued it should therefore be denied copyright protections.

The second issue at the center of the campaign against colorization was intimately related to this point about the validity of the colorized print as an art form in its own right. The Anti-Coloroids argued for the "moral right" of the author of the film to control his or her artistic product and legacy. If the director wanted it colored, fine. If not, then it was no one else's right to do so. Changing a work of art for commercial profit and without the endorsement of the work's author was a "desecration" or a "criminal mutilation" of the art. Well-known directors such as John Huston, Milos Forman, Fred Zinnemann, and Woody Allen made statements condemning the act of colorizing films. Two weeks before his death, Orson Welles, having heard that Ted Turner planned to color *Citizen Kane*, was reported to say, "Keep Ted Turner and his goddamned Crayolas away from my movie!"[59] The notion of the director as the conduit for "individual creative human authorship," as the Copyright Office put it, had purchase on the cultural imagination at this point for many reasons, not the least of which was the influence of Andrew Sarris's importation of the *politique des auteurs* from France in the preceding decade.[60] However influential that idea was, however, very little in the legal realm supported it.

This part of the anticolorization argument illustrates a gap between notions about the authorship of films and the legal rights of such "authors." Several directors vehemently argued during the ongoing public debates in the press and in congressional hearings that the directors of films were overseers of the final artistic product and as such had legal and artistic rights. The directors who led the charge against colorization occasionally further argued that the collaborative nature of film production necessitated a wider view of authorship, but they did not harp on this point because it might well have led to the rise of other claimants (outside of directors) to rights about the fate of the films, perhaps especially cinematographers and art directors, who made choices for a film based on its being filmed in black-and-white.[61] In fact, the notion of the director as the visionary artist and author of a film that has been so pervasive in the history of cinephilia played an important role in the fraught

political battle over colorization. Recognizing that directorial author-ship is mostly unsupported when it comes down to future legal rights—unless a director has an extraordinary contract, as Welles did for *Citizen Kane*—the DGA and the Directors Guild of Great Britain saw an oppor-tunity to bridge the chasm between a perception about film author-ship (that directors are films' "authors") and a legal reality (that they have no rights after a film is completed). Some contracts allowed that directors should be consulted about certain issues after a film's release (e.g., when films were released on television, some contracts stipulated that director should be consulted about where commercial breaks should be inserted),[62] but there were no widespread rights for directors about their works once those works were purchased by a separate agent for distribution on television networks. The DGA hoped the colorization debate would introduce the legal possibility for much longer-term direc-torial control. The Coloroids answered this charge with the exact oppo-site claim, as Mayer continued in his testimony before the subcommit-tee hearing: "These owners [Turner and others] not only have the clear legal right to color their old movies, but we think they also have a moral right. Despite propaganda to the contrary, these old movies were not the immaculately conceived children of the director. They were made in the heyday of the old studio system and are basically the children of the studio moguls and their staff producers who oversaw every aspect of the production."[63] In this legal and cultural paternity battle over films, the question of the films' artistic provenance colored the way the debates played out in favor of the owners.

The debates were made highly visible by national press attention for the celebrity actors and directors who argued against colorization as well as for some vocal advocates of colorization within the government. The issues they pressed betray more than a little anxiety about the ways a technology can alter the original meanings of film art: several parties in initial discussions about strategies for fighting colorization asked to extend the battle to include pan-and-scanning techniques, cutting down the runtime of movies to fit in a commercial television time slot, and the broader possible effects of allowing nondirectorial interventions to alter works of film art. The idea that directors lose control of the film once it is released led to fears of what would happen to it once it leaves their care and legal purview. Along these lines, in 1990 Steven Spielberg

summarized some of the broader fears of technology that were evoked in the wake of the colorization debates: "We are terrified of technology. It wakes me up at night. . . . The technology is such today, and will be even more quantum in 10 years, that they will truly be able to replace actors in existing movies, continue the backgrounds, and all the action and all the shots, and put other actors in their places."[64]

Technology continues to be both a wonder and a risk to the vision of a film artist or collaboration of artists. The types of fears plaguing Spielberg's dreams have been more than realized in the present day, such that interests outside of the filmmaker's vision may well influence how the film appears in the end. The film *All the Money in the World* (Ridley Scott, 2017) illustrates as much: the producers decided to erase actor Kevin Spacey (on the basis of accusations leveled against him for inappropriate sexual behavior) and replace him with another actor. The reshoots use much of the same footage, with the former actor digitally replaced within the shot by the new actor.[65] Although technology also offers the expansion of possibilities, for Spielberg and others the age of seemingly unlimited technological capacities renders precarious a director's agency over the film's look and conception. During the colorization debates, DGA members perceived their struggle as pitted against media monopolies armed with money, power, and control over all the networks that made it possible to see the films.

Meanwhile, the consumers of the films waged their own debates about the merits of colorizing black-and-white films or keeping them intact. As the Coloroids suggested, there was no shortage of people who were delighted by the colorized versions of films, and ample testimony reveals that they found the images fresher and more alive in color. Polls taken at the height of the skirmish took the temperature of the situation. The Coloroids supported their claims with a rough in-house (probably biased) survey, which Earl Glick (chairman of Colorization, Inc.) cited in an interview with the *New York Times*. The survey claimed that "85 percent of people would only watch something if it was in color," with the distaste for black-and-white seeming disproportionately to reflect a coveted television demographic, according to Glick's rather loose report: "In the age group under 20, nobody wants to watch anything in black-and-white."[66] Other polls would seem to support the charm of color on those who gave it a chance: in a poll in the *New York Post* in 1985, Anthony

Slide reports, two-thirds of those polled opposed colorization. After the colorized version of *It's a Wonderful Life* aired during Thanksgiving Day week of 1986, though, only slightly more than half of those polled opposed colorization.[67] Of course, many may have foregone the airing altogether if they had a strong preference for black-and-white, and as Leonard Maltin suggested on his program for *Entertainment Tonight* in October 1986, the mere novelty of colorization may also have accounted for the apparent favor given to colorization in the ratings: "For the first time, everyone's watching to see what the films will look like. I predict the third or fourth time those films are shown, the ratings will be exactly the same as they were for black and white."[68] Even so, the ratings suggested interest in the colorized version, which the Coloroids literally capitalized upon.

The popular discourse surrounding colorization in the 1980s and up to the present often insists on the validity of colorized versions of films, perhaps in part because that is the first or only way some viewers experienced certain films. In comments on YouTube postings of colorized versions of older movies, viewers still debate about the atrocity or the merits of colorization: "When I was a kid, I went out of my way to find colorized versions at the video store. I don't know what these people are talking about."[69] Others demonstrate a cinephilia specifically tied to colorization's short-lived heyday: one commentator, for example, waxes nostalgic on his childhood experience with colorization:

> I don't get this. I personally love the colorization of some of the old classics. . . . The first time I ever saw an old black & white classic that received modern colorization was when I was a child—somewhere between the ages of 6–8 years old—who viewed King Kong for the first time on TNT in the early 1990s. I fell in love with it and recorded it on VHS where I watched it relentlessly over and over again. The jungles of Skull Island in the colorized version were so rich and luscious, and the final battle atop the Empire State Building with the Manhattan skyline in the background looked majestic. Later when I finally wore out and broke my old VHS tape as a result of endless watching, the colorized King Kong was no longer being sold in stores nor was it still being aired on TV. After watching the B&W version of Kong, I did feel as though something was missing from

it compared to the colorized version. The jungles just didn't contain the same richness in B&W as they did in color, and I ultimately found it to be a more muted version of the film altogether.[70]

In the average home viewer's comments, there is repeated bafflement based not so much on whether color is better or worse than black-and-white but on the fact that they should be denied the choice. If the Coloroids are frequently accused of greed, this denial of choice leads colorization sympathizers to think of the Anti-Coloroids as elitist, out of touch with popular trends, and dictatorial about what people should like.

In addition to the average home viewer, some people involved in the film industry also expressed their delight with colorization. Although the anticolorization crusaders enlisted President Reagan's help with securing rights for film authors, not only did he not provide any material assistance, but First Lady Nancy Reagan also wrote a note to Raymond Caldiero, one of the directors of Hal Roach Studios (a shareholder in Colorization, Inc.), congratulating him on the success of the colorization of *Topper*: "I didn't think *Topper* could ever be improved, but we were most impressed with the colorization of that fun movie. The soft colors were not intrusive but added just the right touch. A clever idea. Thank you for sharing the concept with us. The president joins me in sending best wishes for your continued success."[71]

The question of what film is for—popularity and profit or art and the cultural patrimony—comes to the fore in the colorization debate. It underlines anxieties about technology on many levels—the objects of cinephilia were threatened with the violence of an unwanted change. Though so brief and so ineffectual in making a significant change that it may seem to be a glitch in the history of cinematic technology, the colorization debate demonstrates the stakes of cinephilia and why one might have to worry about such issues in safeguarding the history of cinema (and safeguarding one's personal cinematic passions).

Although colorization has mostly disappeared—or at least the scandal inspired by the attempt to broadly apply it has disappeared—the practice is not extinct. As a technology, it does a healthy business for companies such as Composite Films, which since 2013 has provided these services for media, including coloring archival black-and-white footage for the film *I Am Not Your Negro* (Raoul Peck, 2016). It also recently

provided the colorization for *America in Color*, a series on the Smithsonian Channel. A writer for Smithsonian.com emphasizes the wondrous aspects of colorizing without acknowledging any of the fraught aspects that charged the debates about its use in the 1980s:

> Researchers spent more than 5,800 hours digging through obscure archives and home movies, and more than 27 miles of film were transferred. The team also created a methodology for ensuring historically accurate colorization. For the 1920s and '30s episodes, researchers relied on sources including postcards, modern-day color images of recent images, and the few chromatic photographs taken during the era.[72]

The Smithsonian team emphasized their act of labor and historical research as part of their claim to historical (rather than an aesthetic) accuracy. They highlighted that research. For instance, they based their color tints on photographer Charles Zoller's work and celebrated small victories, such as definitively concluding that New York City buses used to be green. Their researchers identified the color of a pin owned by Franklin Roosevelt after chancing upon a painted portrait of him wearing that same pin, and they used a Google Maps tour of Sumner, Mississippi, to find houses captured in footage of the Emmett Till trial.[73] The focus on delight (aside from the publicity aspects of Smithsonian's shilling of its own product) has more to do with the documentary content of the film: the highlighting of the documentary qualities of the work assuages some of the "creative labor" aspects of a fiction film that the DGA was fighting for, even though of course documentaries are no less subject to artistic choices than fiction films. The aim was to revitalize the past through the more familiar visual idioms of the present.

Regarding his film *They Shall Not Grow Old* (2018), Peter Jackson similarly proffers the rigorous historical research that went into his project as testimony to its authenticity, wonder, and interest. He winnowed down six hundred hours of audio and one hundred hours of historical documentary silent-film footage to about an hour for the final product, added sound effects from historical artillery, employed lip readers to figure out what people were saying, identified the regiments and the specific regions of the United Kingdom they came from, added authentic

accents and dialogue, researched uniform colors, and took photographs of the landscapes as they exist in the present so colors could be matched, and in general aimed to make the footage as realistic as possible.[74] The result is a partly colorized, 3D, sound documentary on World War I detailing the experience of British soldiers at the western front. Jackson draws attention to the process of colorization he used for the film both in the manner of its theatrical presentation, which in some locations included a brief introduction by Jackson, encouraging people to stick around at the end for a separate short documentary that would explain the making of the film, as well as within the film itself. The film highlights its technology along the way. Beginning with a small, blurry, juddering, and worn image of soldiers marching on the front, Jackson slowly expands the frame toward the edges of the screen. The image eventually comes to fit the frame; the frames per second and the contrast are adjusted, and the image grows clearer and plays more smoothly. Soon thereafter, the images also start to include color. These effects echo accounts of the earliest cinema projections, in which a still image on the screen would suddenly spring to motion-picture life or Dorothy would open the door of her little black-and-white house to discover a Technicolor dreamland, such that they all foreground the technology that generates a technological or magical-seeming transformation. Moreover, more than one producer working for Stereo D, the company Jackson employed for the colorization and 3D effects, commented on building the effects in *They Shall Not Grow Old* to create a more "immersive" environment for contemporary viewers: something that would enthrall and consume them.[75]

Together, these effects—adhering to a vision of the past that is as accurate and authentic as possible while highlighting the wondrous modern technology that renders the vision thus—marks Jackson's documentary cinephilia and technophilia in equal measure. As Adam Gopnick points out, however, the film's "eerie and enthralling" overall effect gives one pause—for him, the source of concern centers precisely on the status of the technology in generating an "authentic" representation of history:

> We congratulate ourselves on the effective updating—on how we now can see the war as it was seen by those who fought it. But no

truth is truer than how the look or sound of what seems eerily convincing changes radically as technologies change. . . . We adjust to the technology of our time as much as it adjusts to us. . . . The medium shapes our response to it. . . . When it comes to film, at least, black-and-white and silent are the way the period saw itself, understood itself, made sense of itself. By altering that mirror, we fail to see the subjects staring into it quite accurately.[76]

Is the colorization of documentary footage actually less problematic than the colorization of narrative films? Jackson asserts at one point in his making-of featurette that if the cameramen of the 1910s had been presented with the choice of color or black-and-white film, they would have assuredly chosen color. Sure, maybe . . . but they were not. The urge to see the past through a contemporary lens is one of the driving forces of the nostalgia into which the film taps. The simultaneous wonder at the technology and the problematic status of changing part of film history for contemporary purposes that inheres in Jackson's film neatly captures some of the dynamics of the original colorization debates and spells out the tension between wonder and anxiety that is a characteristic of cinephilia for all times. Whatever the status of these more recent documentary colorization efforts, the vogue for colorizing classic narrative films has definitively waned. Although the Coloroids claimed a legal victory for colorization, the human and financial market for it failed to demand it strongly enough to make it worth their while. Those who were adamantly against it have a reprieve if not a mandate for thwarting the technological changes that Spielberg and others lie awake at night wondering and worrying about.

FROM FILMS ON FILM TO DIGITAL EXHIBITION

The current version of the ongoing transformative process for cinema is intense in its breadth if not its depth. Digital technology's foothold seems to have inspired a great deal of writing about losses. Multiple platforms are affected by digital changes—it is a highly inclusive transformation of aspects of production and exhibition of films. The digital turn has also prompted many small- or large-scale reevaluations by film and media scholars of the ontological, phenomenological, and epistemological

aspects associated with cinema.[77] Audiences and the makers of moving images equally have weighed in on the conditions of the shift. Although in many ways the digital revolution is much quieter than the coming of sound or other transformations, it has far-reaching implications that have inspired nostalgia, purism, an embrace of the future, and anxiety in various configurations. As Francesco Casetti has characterized the matter in *The Lumière Galaxy: Seven Keywords for the Cinema to Come*, in the present moment "media have ceased to be identified with a particular device or with a single support and now utilize new technologies, change their size, and redefine their functions."[78] If we cannot even categorize media according to the things with which they have been traditionally associated, then what purchase do we have on those media? Perhaps everything is up for grabs. Or as one *New York Times* reader put it mournfully in relation to the complaint that digital effects are ruining movies, "When virtually ANYTHING is possible, nothing is really very interesting."[79]

A key source of cinephilic anxiety concerns changes in exhibition formats, wherein the pleasures of certain filmgoing practices are at risk. For close to a hundred years, film was the mainstay of theatrical projection at the cinema; after the turn of the millennium, digital exhibition became increasingly the norm. The shift from 35mm projection to the use of digital cinema packages (DCPs) or other digital formats happened with relative speed, with the Digital Cinema Initiative, a collective representing studios and engineers, releasing a best-practices report specifying the system requirements for digital exhibition in 2005 and the majority of cinema chains and even a great number of independent and art-house cinemas installing or wholly converting to digital cinema by the end of 2012.[80] As John Belton has shown, the pace of the transition to a fully digital film industry was in fact slower than some of the other major shifts in the film industry: the transition lagged and developed unevenly across the production, distribution, and exhibition sectors due to multiple factors. He attributes this slow pace largely to the demands of the home-entertainment market and to the relative invisibility of digital technology on the level of exhibition. That is, for Belton, unlike the revolutions promoted by other technological changes in the cinema, the difference between celluloid and digital projections reads as rather negligible to audiences:

Digital projection as it exists today does not, in any way, transform the nature of the motion-picture experience. Audiences viewing digital projection will not experience the cinema differently, as those who heard sound, saw color, or experienced widescreen and stereo sound for the first time did. . . . Digital projection is not a new experience for the audience. What is being offered to us is simply something that is potentially equivalent to the projection of traditional 35mm film.[81]

Because most people would be hard pressed to tell the difference between celluloid and digital projection, there was a consequent lack of a driving force (the audience) compelling a rapid, wholesale transformation to digital. But, as we shall see, that "potentially equivalent" experience for the audience comes to be one key source for the anxiety that nonetheless accrues in the midst of the transition.

Other aspects of the shift may be rather small as well. In his scrutiny of claims about digital media's radical novelty, Phil Rosen has suggested that its "practically infinite manipulability" is no novelty at all but rather is consistent with earlier aspects of moving images.[82] Rosen delineates the numerous ways digital cinema's apparent promises are actually continuations of what has preceded them. Echoing these observations, David Bordwell has noted that the difference between the digital and sound cinema revolutions makes them unworthy of comparison. "Talkies were markedly, triumphantly different from the silent cinema that they replaced," whereas digital projection proper often goes unremarked: "Today most moviegoers wouldn't be aware that they were no longer seeing film prints in their local multiplex. Few would care." All the same—and this is key—Bordwell underlines the massive changes that have happened "behind the scenes" and urges us to be aware of how the shift to digital projection has changed the social processes that bring films into being: "Technology affects relations of power, along with the choices that moviemakers and filmgoers are offered. As films become files, cinema changes in subtle, far-reaching ways."[83] Indeed, although the average moviegoer may not perceive the difference in the image produced by digital or film projection, and although the digital turn is a continuation of many features of earlier cinema, the changes wrought by digital exhibition are nonetheless felt as deeply significant—even revolutionary

in their impact on the industry overall—and they have registered in multiple ways.

Moreover, before dismissing out of hand that any significant changes to image quality have happened in the shift to digital, we must recognize that however negligible the difference may be for the average cinemagoer, a number of cinephiles have made passionate claims for the celluloid/digital differential—on behalf of the superiority of either one or the other form of projection. For the celluloid lover, the "warmth" of the film medium, predicated on its transparency and collaboration with real light, makes it more beautiful, realistic, and "soft," whereas digital is "cold" and "crisp."[84] For admirers of digital, a DCP provides a bright, sharp image—which they also often describe as more realistic and cleaner than a celluloid print's accrual of flaws over time and use. Whether the difference is actually discernible or not, what matters here is the perception of difference as well as a sense of loss once the medium transforms to digital and leaves behind whatever capacities have been attributed to celluloid (or the difficulty of reinstalling older forms such as 70mm for films released in those formats after most theaters have converted to digital). Cheerleaders for celluloid include layperson cinephiles as well as people in the industry, such as directors, exhibitors, and archivists who have touted the importance of making, showing, and preserving films on film. Celebrity directors such as Christopher Nolan and Quentin Tarantino endorse the medium by continuing to make films on film beyond the apparent demise of celluloid; exhibitors who have held on to 35mm and 70mm projectors have done so both for economic reasons and for the quality of the image. As David Schwartz, former curator of the Museum of the Moving Image, has put it, "You get a much bigger image, you get more detail, you get more light going through the film from the projector. . . . You basically get a much brighter more vivid image."[85] Archivists such as Paolo Cherchi Usai have further noted the stability of film as a medium of preservation over the unknown but unpromising stability of digital formats. As he provocatively and pragmatically suggests, digital formats are just as likely as celluloid to be replaced eventually: "I don't see a good reason not to take advantage of the hard lesson we are learning with the decline of traditional movie projection and prepare for the day when we will be struggling to find the right venue for a digital screening."[86]

The change from standard 35mm to digital projection has prompted responses from several corners that fixate on a cluster of concerns for each side, from the material quality of the image to the loss of a way of life to the promise of something new and better. Writers observing the digital turn tend to worry over the loss of aspects of the cinema experience—the sound of the projector, the quality of the image, the places where a film is screened, and so forth—things seen as essential and personal. A love of the cinema as it used to be in better days predominates these accounts. Against this view, there is a counterbalance of enthusiasm that sometimes appears in writings about digital quality. Reasons for such enthusiasm tend to focus on several utopian claims, such as those represented in a *New York Times* article by Rob Sabin that emerged in connection with George Lucas's new digital focus for *The Phantom Menace* and AMC's conversion of its twenty-five-screen theater in Times Square to digital projection in late 2000. Sabin first cites issues that are echoed in other dispatches from this period, such as the economics of digital cinema, and prognosticates that digital cameras will "allow dramatic reductions in costs," which in turn will "open avenues for the exhibition of less commercial films, creating more choices for consumers." Image quality is equally touted: "it [digital] will allow movie lovers to see, for the first time in history, exactly what the director sees in his final cut, without the degradation of image that is inevitable with film prints." And in a way peculiar to an executive frame of mind, these reasons are collapsed in the move to digital: "we see this as an opportunity to keep the film experience competitive. The goal of our member companies is for digital cinema to be better than what's up on the screen today."[87]

A key utopian aspect as suggested here that is often attributed to digital exhibition is that it will offer new access to a wider range of perspectives. The promise of digital projection is often situated in its potential as a democratizing force for the film industry: it is hailed as a change that could put on offer and inspire the making of a wider range of movies.[88] Will underrepresented groups find their way to the director's seat by taking a digital turn?[89] It remains an open question, with mixed answers. Meanwhile, in terms of image quality, even reports at the time of Sabin's article were also decidedly mixed. As one reader responded to Sabin's article, "Alas, there are many aspects of quality." He proceeded

to deconstruct the experience of seeing *The Phantom Menace* on digital and on film:

> We saw the digital version first. When we moved to the film version, we were shocked at how much less bright and less clear the film was. By almost every possible technical measure, the digital screening had higher quality than the film. On the other hand, all three of us enjoyed the film version more.
>
> In one scene, a fighter crashes. My wife said it looked like a video game in the digital version. Our friend thought it looked cartoonish. To me, too, it looked fake. We all agreed that that scene and others looked more believable in the film version. We left the digital auditorium delighted with the projection but thinking poorly of the movie; we left the film auditorium thinking the opposite.
>
> Now, which offered improved quality?[90]

Related to the issue of conversion to digital platforms is the question of medium specificity. Certain directors and cinephiles insist that the medium by which a film is projected should be the same as the one in which it was made.[91] When dealing with avant-garde cinema, for which medium specificity is sometimes the point, the stakes can be particularly high for maintaining celluloid projection. Experimental filmmaker Nathaniel Dorsky, for example, will not issue copies of his films on digital, arguing that they make no sense without the medium for which they were conceived; the same can be said for Su Friedrich's *Gently Down the Stream* (1981) (fig. 3.2) or any number of other films whose very sense depends on the legibility of their medium. And this issue need not be limited to the experimental realm. Cinema purists argue the necessity of seeing a film made on film also projected on film in a theater. As in the colorization debates, purists aim to preserve a historical status quo that is disappearing. Meanwhile, in the wreckage of this cinema experience of the past, cinephiles and scholars wonder: Can you watch Antonioni on your iPhone and still call it cinema? Or do such conditions change the nature of the cinema altogether? Moreover, if much of film history has not been converted to digital formats, one might worry over the inability of cinemas (or even home viewers) to project films that were not converted because so many cinemas did not keep 35mm as an option.

FIG. 3.2. Etching on film: *Gently Down the Stream* (Su Friedrich, 1981).

This could lead to the losses embedded in Cherchi Usai's warning: for want of a film projector, film history was lost.

Howsoever different the degree and kind of technological change it may be, a resemblance between the debates about the conversion to sound from silent cinema and the debates about the conversion from film to digital projection is apparent in the sense of losses for cinematic experience, quality, and culture. What is paramount in this simultaneous sense of optimism and anxiety inspired by such transitions? First, that there is something exciting to be gained by a technological transformation. Second, conversely, that something may be lost when what we have come to know will perhaps be rendered wholly obsolete. And third, that we do not really know what the consequences will be in the wake of a transformation or how far the transformation will go. Amid the ascension of the DCP, digital exhibition was marketed as an improvement over many of the vicissitudes of theatrical screenings (poor illumination from the projector lamp, distracted projectionists, battered prints). But,

certainly, there are others whose passionate relationship with film spectatorship is equally fueled by these vicissitudes: Adrian Martin has recently noted that a happy memory of seeing Eduardo de Gregorio's *Sérail* (1976) derived from what he thought was a surreal effect within the film itself but that turned out in retrospect most likely to be the projectionist ending the screening hastily by removing the anamorphic lens required to see the film in the proper dimensions.[92] The confluence of uncertainties that mark the celluloid projection process adds to the potential for cinephilia, which is often activated by the surprise and delight attending certain facets of the film experience.

At this time, the nearly wholesale shift to digital projection formats, like the shift from silent cinema to sound, is incontrovertible. From 15 screens offering early digital screenings in 2000, the number rose to about 400 theaters in 2006; by 2009, AMC Theaters made a deal with Sony to replace its chain's movie projectors with 4K digital projectors; the year after that about 15,000 screens were equipped for digital projection; and by the mid-2010s the exhibition industry had nearly totally converted to digital at a cost of around $75,000 per projector.[93] In the process of conversion, many of the 35mm projectors were simply thrown away.

Despite susceptibility to the shift in the exhibition market to digital, holdout cinemas do still continue to show film on 35mm (or 16mm or 70mm). Many reasons for their perseverance exist. Several represent specific special interests such as academic aims (e.g., the Harvard Film Archive), an emphasis on experimental or a wider range of independent programming (e.g., New York's Anthology Film Archives, the Gene Siskel Film Center in Chicago), or a focus on older, niche, or cult films (e.g., the New Beverly Cinema in Los Angeles). Even after the conversion to digital projection was all but complete, a lifeline for celluloid films persisted in the recognition that a market of cinephiles existed who distinguish between digital and celluloid and would be bolstered to seek out screenings based on the format if the choice were presented to them.

In other cases, however, especially for smaller cinemas, the choice to convert was simply not available. Independent cinemas that were unable to raise the financing on their own for converting to digital looked to their communities to help them either sustain a retrospective 35mm practice or to raise money to convert to digital, but many of them

faltered. As the moment when film would all but disappear drew nigh, many smaller, independently owned cinemas shuttered their doors rather than continue to struggle against industry behemoths. Whereas larger chains benefitted from industry incentives for converting to digital projection, independent cinemas often had to pony up the cost to purchase new digital projectors.[94] This aspect of the digital turn became a key point of fixation for anxious cinephilic discourses of the early 2010s. That is, several accounts focus on the rise of digital cinema as the cause of the loss of a vital swath of cinema history through the loss of these independent cinemas—the sites for specific and significant cinema experiences. Writers investigating this aspect of digital cinema discern the loss of the local, cultural, and personal histories embodied by these theaters in the aftermath of the transition. Nostalgia for the cinemas threatened by these costs and for the history of moviegoing they represent predominates in these accounts.[95] Let us consider the ways this loss of certain sites of cinephilia has been addressed in some specific cases.

Significant media coverage of the difficulties experienced by small cinemas points to an interest in flailing former cinematic technologies in relation to cinema's physical locations. (The theaters imperiled by the digital conversion are models for what the Metrograph and others of its ilk evoke in a sleeker and more modern format [see chapter 1].) A typical article highlighting the nostalgia for these disappearing spaces is "Resort Towns Face a Last Picture Show," published in the *New York Times* in August 2012. Accompanied by an online slide show of theaters confronting difficulty in securing loans for conversion to digital, the article's nostalgic tone indicates an awareness of an audience for whom these losses might matter, not because the format of projection is being lost, but because that change in format has had the effect of causing another aspect of the experience of going to the movies to change irrevocably. The long-term residency of these theaters in vacation locations also adds to the sense of a historical loss (one cinema has been operating continuously since 1938; these routines of the past are becoming lost). The images in the slide show, steeped in summer sunshine or the dim light of the movie-house interior or captured in a movielike twilight, are accompanied by sympathetic captions. Typical examples are "John Deleonardis and his wife, Judith, reopened the drive-in eight years ago and are pressing on—even though digital conversion loans are proving

hard to secure" and "A Harbor 5 projectionist, Joe Griesbach, laments that his profession may become redundant. 'With digital you pretty much don't need anyone in the booth at all,' he said." The article and slide show describe those affected by the situation on a highly personal level, using names and positions and highlighting inheritances through generations. The loss to cinema history and culture is a loss to individuals, too, and among them are the many people who have come to these theaters on their vacations for many years. The ticket taker at the Strand cinema in Ocean City, New Jersey, tells the *Times* reporter, "Time and again I've had people come up to me and say, 'I remember coming here when I was little, and it was only 15 cents to see a movie.'"[96] The impression of a simpler means of leisure and a nostalgia for one's own past is also at stake in this particular loss of cinema's past/passing places.

In 2013, among major cultural news outlets, at least one story ran per month about the loss of cinemas in the wake of having to buy digital projectors. Typical headlines include Gary Susman's entry in *Rolling Stone* in September: "How Digital Conversion Is Killing Independent Movie Theaters." The article begins: "America's movie theaters have been dragged, kicking and screaming, into the digital age, not without a lot of collateral damage."[97] Harkening back to Bordwell's assertion that the shift to digital might change cinema in "subtle, far-reaching ways," the broad implications of the shift have frequently focused on the loss of a cultural and personal heritage related to cinema-going. Part of the problem is exactly the issue that both Bordwell and Belton describe: the theater patron does not discern a difference in what is being delivered, so the costs associated with conversion do not offer anything worth paying more for.[98] The love of local, independent theaters is tinged with the fear they will be closed because of the high costs of conversion to digital. This love/fear dyad bespeaks the fear of losing independent cinemas coupled with a deep suspicion about the economic incentive for the conversion to digital that favors distributors at the expense of both filmmakers and audiences. Take the media scholar Heather Hendershot's letter to the editor in response to Sabin's article on the digital future: "It is insulting for Jack Valenti, chief executive officer of the Motion Picture Association of America, to argue that shooting and projecting films digitally will make them 'more enticing' for viewers. There is only one reason Hollywood is interested in going digital: money. By not buying 35-millimeter film stock

or striking 35-millimeter prints, it stands to save millions."[99] Like many others reporting on the digital cinema conversion, Hendershot draws attention to the economic incentives for distributors: a strong motive for the conversion to digital lay in the cost to ship a 35mm film (around $1,500) versus the cost to ship digital technology (around $150). These incentives are anathema to cinephiles with their purer motives; they also affect the personal stories of those who have dedicated their lives to cinema (without making a fortune doing so, it seems).

Such stories are cinephilic, humanistic, and pessimistic: they ruminate on the loss of cinema spaces as if it were the death of a dear friend. For example, in the article "Digital Projection Threatens Some Community Theaters" published in late January 2013, the film critic Ty Burr begins with the following description:

> The family of Gerry Herringer, owner of the Cottage View Drive-In in Cottage Grove, Minn., once owned 21 theaters in the Twin Cities. Converting his only remaining theater would cost Herringer about $75,000. Instead, he's selling the land to Wal-Mart.
>
> "It's really kind of a stab in the heart to lose it," said Herringer, pausing to clear his throat. "It's a part of our family."[100]

Few emblems of corporate self-interest resonate more universally than Walmart, which can afford to drain the life force of the cinema (and its community) from those who had been nurturing it. Note, too, that the cinema dies violently: it takes a "stab in the heart" to put an end to this thing that is "part of our family." Such accounts echo those by filmmakers such as Steve McQueen, who discern something more human in celluloid more generally (notably, the love of *film* and the love of *film spaces* are frequently conflated in these accounts because the loss of celluloid is the cause of the loss of these spaces). Asked what he thinks about the digital conversion in 2014, McQueen replied: "There's something romantic about film. . . . Some sort of magic—it's almost like it breathes. Film feels much more . . . I don't know. Maybe 'human'?"[101] Such conceptions of film and of the cinemas where it is (less and less often) screened predominate in this brief period of conversion and precipitous decline for small theaters.

Likewise, in an article about cinemas closing in York, Pennsylvania, the writer makes human and personal the experience of going to a local cinema, valorizing the history of the building and its place in the local community and focusing on a single moviegoer: "Melissa DeTota fell in love with the Glen Theatre. Last summer, her sister introduced her to Glen Rock's single-screen movie house. Built in 1913, when film projectors started to put vaudeville acts out of business, the theater is one of the oldest in the area that still shows films. 'I don't know what it is,' DeTota said as she stood outside on a Friday in March. 'It's adorable. It's nostalgic.' "[102] The author also marks the nostalgia for the loss of these theaters in the deeply human terms of a singular experience with cinephilia:

> Lance Wolf started working in theaters when he was 9. His paycheck was free movie admission, which, at the time, would have set him back about a dime. . . . Wolf fell in love with the business— from the equipment to the stars. But the film and projectors he's worked with for decades—vital for decades of movie screenings— are disappearing. As the industry switches to digital projectors, Wolf, now in his 70s, remembered the days of 35-millimeter film. . . ."I love the old theater," Wolf said. "My dad took me there. It's just in my blood."[103]

The coverage of digital conversion for small movie theaters appears in dozens of articles in local and national newspapers around this time. The love of these old theaters—the idea that "the movie theater is really the heart of this town" or somehow a part of the human family—is marked by a sense that these cinemas embody the history of a culture, specific locale, and experience. These qualities drive the fear of their loss as an essential component of the cinema as one has come to love it.

These kinds of comments are infused with cinephilia—a nostalgic love for the places where films are seen, for the qualities of the earlier form of projection, and for the sense of film history. The discourses surrounding the digital conversion of most cinemas are prompted by a range of fearful, even occasionally paranoid responses, but in all but a few cases we can see that these reactions are predicated on love of perceived qualities in cinema and their locations. Presently, in light of the digital turn,

requiems for the cinema as a medium, an institution, a place, and a way of life have been registered from cinephiles of many descriptions. In fact, feeling nostalgic and clinging to an idealized and highly personal sense of cinema provide necessary ingredients for cinephilia: the very anxiety about losing the object of one's love affords shape to a phenomenon that is otherwise rapidly changing, transforming into other methods of delivery, production, and consumption—right at this very moment.

The Exquisite Apocalypse

APOCALYPTIC CONCERNS

It is time to turn to a certain type of films that makes the notion of an anxious cinephilia intelligible in another way. Perhaps no type is more suited to this task than apocalyptic films of the recent past, which offer a number of entry points into comprehending the dynamics of cinematic love and anxiety. This chapter takes up these films as a case study for how a notion of cinephilia informed by anxieties might enrich our understanding of the films, the motifs that run across several prime examples, and the modes of production and consumption that drive (and are driven by) their meanings. Several of these meanings seem to derive from modes of attraction as well as certain anxieties in society and culture. As Susan Sontag has put it in relation to a set of science-fiction films from the 1950s that bear some of the same traits, "Alongside the hopeful fantasy of moral simplification and international unity embodied in the science fiction films, lurk the deepest anxieties about contemporary existence."[1] Similarly, postmillennial apocalyptic films express in cinematic terms ideas about their moment and the world in which they were made, through the worlds they depict and how they depict those worlds. They represent a set of complex allegorical operations having to do with their medium, expectations of their viewers, and an atmosphere of rapt or rapturous anxieties.

A veritable glut of films from the postmillennial period adopts the apocalypse as topic and theme.[2] Riddled with anxieties about the end of all things, such films channel filmgoers' apocalyptic fears into stories depicting the destruction of cities and showing the struggle to survive, perhaps allowing viewers catharsis for their fears. However, not all is anxious: that these films unfold always with vivid and dramatic action as well as with visceral, emotional, and cinematic spectacle and soundscapes demonstrates the tension between anxiety and cinephilia at an intense and extensive site of merger.[3] The requisite images for this type of film include stunning scenes of vast destruction yet also—particularly in recent iterations of the disaster film—quiet landscapes void of people and returning to a state of nature, deep space, surfaces frozen with blue ice crystals, and forests, fields, and oceans that speak to time (and in many cases the natural world) enduring beyond human existence. Many of these landscapes are presented in gorgeous detail, using filters, lighting, and camera angles and distances to narrate their ruined (or renewing) beauty. In these contradictions between eschatology and beauty, anxiety is made cogent, even poignant, through cinematic magnificence.

Recent apocalyptic films—for my purposes here, those produced during an approximately ten-year span from 2005 to 2015—imagine the end of the world from a variety of perspectives and in wildly different ways. These films range across nearly every cinematic genre—comedy (e.g., *The World's End* [Edgar Wright, 2013], *This Is the End* [Evan Goldberg and Seth Rogen, 2013]), romantic comedy (e.g., *Seeking a Friend for the End of the World* [Lorene Scafaria, 2012]), art-house fare (e.g., *Children of Men* [Alfonso Cuarón, 2006], *Melancholia* [Lars von Trier, 2011]), and, predictably, variations on the genre set containing the disaster, sci-fi, fantasy, action, and adventure film (e.g., *Transformers: Age of Extinction* [Michael Bay, 2014], and many, many more).[4] Even films aimed at children appear in the apocalyptic mode, including *Wall-E* (Andrew Stanton, 2008), *The Lorax* (Chris Renaud and Kyle Balda, 2012), and *Tomorrowland* (Brad Bird, 2015). The end of all things is clearly on a lot of minds. The eschatological narrative has become something of a genre of its own, carrying the freight of utopian and dystopian ideas, visualizing the world's end and frequently proffering hope for new beginnings, though those beginnings may be wrought out of violent change.

The spate of recent postmillennial apocalyptic films draws on contradictory energies: they exhibit a push-me pull-you struggle between technology's ability to cause problems and its ability to provide answers as well as between wanting to witness what total annihilation looks like and the desire to shield one's eyes from its awesome destruction—or, conversely, to beautify and thus tame it to some degree. Further, the technology charged with such ambivalence in the film's narrative often bears a strong relationship to cinema itself, begging the question of what anxieties the film is channeling about its own position in a doomed society, one that has seen the decline of certain cinephilic moviegoing practices associated with movie houses and the loss of celluloid's guiding light, as we have seen. The desire to see the world destroyed bespeaks an urge to start anew, to throw out the old ways and bad feelings, and to be redeemed. "The lure of such generalized disaster," Sontag posits, "is that it releases one from normal obligations": it plays on the "fantasy of occupying the deserted city and starting all over again."[5] None of the usual rules or routines applies—once the world as one has come to know it has been unburdened by so many people, so much noise, so much traffic, so much everything heading to hell in a handbasket. Sometimes the content of these films involves simply showing survivors in a postapocalyptic world struggling to make do with only the essential components of life, whatever the film might deem them to be—food, shelter, love, art, or just a bit of greenery and a faithful dog. In short, the postmillennial apocalyptic film sets into motion an explosive mixture of impulses that threaten to destroy the world at the same moment they might also save or renew it. As such, it functions as an allegory for its time and, curiously, as we shall see, the cinema of that time.

Films addressing the apocalypse go about their business in both predictable and wholly unpredictable ways. Although their variance speaks to their different anxieties as well as to their different creative visions, interesting parallels run through many of them. Most of them address issues with technology and nature. Many of these films posit that technology is destructive and that humankind has harnessed that destructive force for selfish desires (money, power, convenience, etc.), but some of them equally depict it as a way to positively recalibrate the imbalance wrought by humans who use it wrongly. Further, in many cases nature

is presented as a foil to technology and in these films is creative: it comes up with ways to protect itself and is ready to take back the landscapes human civilization has ruined. As Georg Simmel suggested in the case of the architectural ruin, which is precisely what many of these films depict, when "the brute, downward-dragging, corroding, crumbling power of nature" has gone to work on the edifices humans have erected, "there rises a new form which, from the standpoint of nature, is entirely meaningful, comprehensible, differentiated. Nature has transformed the work of art into material for her own expression, as she had previously served as material for art."[6] Natural beauty is a hallmark of many of the films in question: amid shots of devastation, there is seldom a film that does not also include shots whose aesthetics aim rather to please. Humanity operates at odd angles to these issues: vulnerable, fleshly, and organic, the body needs protection from the cold edges of technology and the ravages of warfare, zombies, human hubris, and time. However, humanity is also generally deeply resilient and resourceful and lends warmth and feeling where inhuman technology cannot. It can harness technology or develop it outright for its designs, including regenerative ones. Thus, the fraught relationship of the human body to technology and nature figures strongly in many of the narratives, with the contest among them often at the crux of the film's tension. In several films, the question *"What is organic?"* versus *"What is machinery?"* comes into play, collapsing aspects of the human with machinery or technology with both healthy and baleful effects on the human bodies with which the films are preoccupied (e.g., *Elysium* [Neill Blomkamp, 2013], *Pacific Rim* [Guillermo del Toro, 2013], *Godzilla* [Gareth Edwards, 2014]).

Many of the films draw apocalyptic situations together with specific ideologies from the present context to lend those ideologies more urgency. *The Book of Eli* (Albert Hughes and Allen Hughes, 2010), for instance, corresponds with a subgenre of the apocalyptic narrative film that takes religion as a central conceit.[7] It conflates a religious message with the redemption of the Wild West, mixing genres liberally and putting its postapocalyptic world into the context of the book of Revelations as a sign to be read—literally and figuratively—toward faith in regeneration of a desolate world. The hero, Eli (Denzel Washington), travels with his Bible—the only remaining copy in the world—through the decimated landscape, going west because of a voice he has heard instructing him to

do so. After trials of many kinds in savage and desolate desert landscapes, he finds his way at last to San Francisco, where things are renewing; the backdrop of his adventures becomes subtly green at this point: nature is reclaiming the right to her own artistry. An enclave of survivors has taken residence at Alcatraz, where they collect art and books—the beautiful, worthwhile, nostalgic artifacts of a lost culture. There Eli recites the Bible—one of the most treasured artifacts to be salvaged (it inspires, as ever, both good and bad men to use it for their purposes)—to someone who writes it all down, so it may be printed, and renewal may begin. The destruction/re-creation motif—a new genesis, a motif with a decidedly religious bent—informs the exquisite apocalyptic production design, featuring scarred and spare but beautiful landscapes infused with intense tints and lighting. The film works out its anxieties about the end of days through that design.[8] Along the way, the message that one must "save beautiful things" implicates the disappearing, beautiful, worthwhile, nostalgic cinema that is the vehicle for the message.

Many of the apocalyptic films dwell on the idea that it is "too late," but others equally posit a "just in time" relief (which goes for the destruction—and its ability to be restorative—as much as for the rebuilding). They are lamentations for loss at the same time that they are expressions of hope for a new future. Their laments are also a way of valorizing a specific aspect of the cinema. These apocalyptic films provide a case study for similarly strong but ambivalent feelings about big transitions in a medium that depicts and utilizes technology with that same ambivalence. Just as we have seen in Jason Sperb's observation that several films (such as *Hugo* from 2011) take up nostalgia for a cinematic past as a way of redirecting complicated feelings about the digital turn, several of the films of the postmillennial apocalyptic film similarly signal in their spectacular effects, their "all-out 3D spectacle," a tension between their technological foundations and their themes. Is it a coincidence that this nostalgic period is also a time in which many apocalyptic films have appeared in rapid succession?

Probably not. In virtually all cases, these films depict the apocalypse with decidedly exquisite, sometimes startlingly beautiful imagery. Whether the landscape is a technologically mediated battle scene on ruined plains or a forest full of eerily quiet trees to which filters lend an unearthly air, these dazzling images are primed for a cinephile's

attention. Some of the films were released in 3D or IMAX and enjoyed extended stays on large screens at a moment when parts of the industry and its audiences feared the immanent diminishment of that format. The stunning visual elements of these films, often generated through making pointed use of digital technology, belie the thematic distrust of technology and point to symbiotic relationships among technology, nature, and, ultimately, cinephilia and anxiety. By attending to the imagery and the way technology is both depicted and mobilized in them, we see that these recent apocalyptic films marshal the postmillennial technologies of cinema to generate narratives with an equivocal relationship to those technologies. They incline to love in the midst of fears both expressed and intensified through their images.

The next sections more closely consider some of the recent films that visualize apocalyptic circumstances, which represent a wide range of imagery and issues related to eschatological thinking. These films adhere at least loosely to a sense of historical and genre cohesion and yet fixate on different relationships among their common interests and strategies. It bears noting that the films of the postmillennial period inherit several of the tropes of earlier apocalyptic or disaster films from both the postwar period (circa 1950s–1970s) and the premillennial period (roughly the 1990s), including their fixations on specific fears, their frequent use of a structure that demonstrates *how* main characters survive during or after a disaster, and their catalyzation of disaster events to bring people together. The films considered here employ many of the same strategies and obsess about many of the same issues; however, they also differ in important ways. First, the specific fears engaged by the films have changed. As Kirsten Moana Thompson demonstrates in her book on the premillennial period, *Apocalyptic Dread: American Film at the Turn of the Millennium*, the films of the 1990s address a set of specifically premillennial concerns, including, for instance, technology fears associated with the possible Y2K bug.[9] The films of the 1970s focused on disaster that was often associated with the Cold War. Postmillennial films are no exception to the rule that they aim to speak to their specific times; thus, they focus on different issues. Second, earlier forms of the apocalyptic film tended to focus on disaster and surviving it (e.g., *The Poseidon Adventure* [Ronald Neame, 1972], *Deep Impact* [Mimi Leder, 1998]); this is not quite the case with the postmillennial films. Although some

considered here do inherit this mode (e.g., *The Day After Tomorrow* [Roland Emmerich, 2004], *World War Z* [Marc Forster, 2013]), few of them make it their primary focus or follow the formulae of their fore-runners. Like the earlier films, which use the disaster to unify family units, several of these films comment on a family in crisis; however, unlike those films, they often do so with much more ambiguous results—-e.g., the narrative does not necessarily move toward the solidification of a family structure. The primary differences, then, point to different kinds of work being done by the postmillennial apocalyptic film.

The films under consideration in this chapter also engage spectacle differently than many disaster-oriented films that also depend on big images. Things are not just blown up to engage the viewer in pageants of destruction (as in, say, *Independence Day* [Roland Emmerich, 1996]); they are often quieter for longer periods of time. Their emphasis on large-scale, dazzling imagery takes a wider array of forms, and their exquisite images serve as emblems for the anxieties they explore or express. The postmillennial apocalyptic film tends to engage the specifically digital technology that enables their existence and cinephilic effects, but as marked by a range of anxieties—about cinematic technology as well as about the actual end of the world. These films are perfect metaphors for cinema's own apocalyptic (at least for the cinephile) end. Their use of digital technologies—providing sites of exquisite spaces marked by deep paranoia—affirms this type of film's unique position in recent cinema history.

REFLECTIONIST CINEMA: PROCESSING OUR BEAUTIFUL APOCALYPSE

Critical writing about postmillennial apocalyptic films has often focused on their embodiment of certain fears: of terrorism (e.g., *War of the Worlds* [Steven Spielberg, 2005]), of global warming (e.g., *Snowpiercer* [Bong Joon ho, 2013]), of natural disasters and the government's inability to sufficiently respond to them (e.g., *World War Z*), among other contemporary anxieties. Wheeler Winston Dixon's study of films that mete out destruction upon cities, monuments, and cherished ideals focuses on the malaise and cynicism of contemporary media and society as a basis for these stories. He censures the Hollywood approach to such material: "I feel that we are experiencing a global cultural meltdown, in which all the values

of the past have been replaced by rapacious greed, the hunger for sensation, and the desire for useless novelty without risk. Indeed, in all our contemporary cultural manifestations as a worldwide community, we seem 'eager for the end.' "[10] He argues that the films and media phenomena he considers—many in the immediate wake of the attacks on the World Trade Center in New York City on September 11, 2001 (9/11)—are both implicated in and generative of the current social climate and the public's mindset. Similarly, E. Ann Kaplan asserts that the many entries in the genre of what she calls "future dystopia" or "future disaster" films—in depicting not just possible but also probable futures (considering a preponderance of evidence in the present)—are "pretraumatic" in nature and symptomatic of the widespread upsurge in anxieties at the present moment. Their circulation "induces a kind of pretraumatic stress, both in the individuals watching the films and in U.S. culture more broadly."[11]

The idea that films channel, reflect, and even generate the fears of the society that creates them regularly prevails in accounts of apocalyptic films. David Bordwell has been one of the more vocal critics of this "reflectionist" strain of film criticism. One of his more vitriolic critiques in fact pertains to writing by Frank Bruni and Ross Douthat in an op-ed conversation for the *New York Times* blog precisely about the postmillennial apocalyptic film *Dawn of the Planet of the Apes* (Matt Reeves, 2014), about which they posit various correlations between the film and its present moment.[12] In the same piece, they use a similar approach to two other films in this genre: *Snowpiercer* and *Elysium*. There may well be cause to be skeptical about such claims, and Bordwell hies to pie charts, statistics about television viewership as a barometer of current ideas, and film historiography to chide the perpetrators of this mistaken connection and illustrate his case against them.[13] His complaints center mainly on the notion that it is impossible to establish causality between the film and its moment, that television offers a closer but still imperfect glimpse into the cultural and political zeitgeist than films, and that the timing of developing and producing a film makes it well-nigh impossible to say that the film reflects its time because it is released long after its conception and production. Bruni and Douthat, for their part, replicate a tendency that, however right or wrong, speaks to the way these films are frequently read by their audiences—as part of a larger cultural conversation. Perhaps it is less important that the correlation is exact than that such films

seem to tap into certain anxieties or issues on the minds of people who see them. Is it sheer coincidence that so many of these films were released around the same time or that genres develop in uneven yet discernible patterns? We may not be able to track exact correspondences, but there is a great deal of room between exact relation and no relation. So, what is it that critics, scholars, and moviegoers are getting at when they consider similarities between the anxious backdrop of a film and the anxious backdrop of the present moment?

For one thing, maybe these anxieties are not specifically confined to whatever moment the films seem to reflect. Films can tap into deep currents of feeling—a source, too, as we have seen, for both cinephilia and cinephobia. Sontag reminds her readers that the image typical of disaster films "derives most of its power from a supplementary and historical anxiety, also not experienced *consciously* by most people, about the depersonalizing conditions of modern urban society."[14] Sontag's reminder points to the idea that modern living's shocks are reflected in and channeled through modern movies. If we consider, for instance, Walter Benjamin's observation that "successive changes of scene and focus . . . have a percussive effect on the spectator"[15] or Siegfried Kracauer's claims about the speed of change between film shots that discourages contemplation,[16] we might note that it is often through cinema's specific expressive tools that cinema is seen to parallel modern experience. If human perception changes in the wake of modernity circa the late nineteenth century (coincident with the emergence of cinema),[17] what might we say the cinema facilitates lately through its specific tools? For one thing, strong reactions to current life persist but on an even larger scale in these recent apocalyptic films. Indeed, renewing an old story for a new time, the postmillennial apocalyptic film delves into catastrophic, irrevocable loss and how one might come to terms with such loss when it arrives. A strong continuity is discernible between the modern world's exasperation with life's useful but disconcerting transformations of time and space—where vast distances are accessible and one's horizons are constantly shifting—and the present moment, in which the digital age has pushed the limits of such transformations toward new boundaries. Both represent coming to terms with nostalgia for the past as well as with anxiety and excitement about a rapidly changing present that replaces the past. Or, as Robert Hass's poem "Meditation at Lagunitas" puts it, "All the new thinking is

about loss. / In this it resembles all the old thinking."[18] Whether conscious or unconscious, contemporary fears that are reflected in these films find expression in a number of ways. The popular success of many of the action blockbusters made in the postmillennial apocalyptic mode suggests the draw of that mode itself. They address fears suited to that type of film. Besides general, unnamable dread about the certainty that society is too technologized, too crowded, and environmentally doomed, related issues find purchase in the apocalyptic-anxiety mode, including the fate of women, minorities, and immigrants in terms of their social roles in a changing economy and the difficulty of discerning fantasy from reality in a world so heavily mediated in images (Is this real?). Thus, several films take up a postapocalyptic society to explore these issues. For instance, *Snowpiercer* makes a fear of climate change explicit in that humankind causes the freezing of the globe by disastrously using science to cool down the planet from its global-warming acme. In the aftermath of the earth's freezing, a train circles the globe, carrying representatives of all levels of society, with the Have-nots at the back plotting revolution against the Haves at the front. The film multiplies its apocalyptic fears by focusing also on these social divisions. Complications ensue as the train dwellers emblematize anxieties about class, sacrifice, and whether nature might renew itself in the Anthropocene (as is typical with many of these films, there is a promise of nature's rebirth in the end). Who messed up this planet, anyway? The obsessions and excesses of the people at the front of the train seem to suggest an answer related to these ancillary anxieties.

Snowpiercer mobilizes these resoundingly contemporary issues to move the plot forward, making it a candidate for reflectionist readings. Bruni and Douthat provide just that. Bruni, agreeing with Douthat's positive assessment of the film, responds to the idea that it is flawed but consistent with expressing certain long-term and possibly even universal fears:

I am so glad you brought up "Snowpiercer." . . . I am fascinated by the way it and "Elysium," the 2013 Neill Bloomkamp film, are creating a whole new genre, not just of future dystopias but of future dystopias in which the salient dynamic is the income

inequality—no, the *cosmic* inequality—between the self-indulgent rich and the wretched poor.

In this sense I do think moviemakers are tapping into the American psyche, but I also think they're replicating a flaw of the American political debate. I'm not sure we'll get very far by painting the rich as morally hopeless people who must be subverted, vanquished, overtaken.[19]

The rich exploiting the poor is a theme not exclusive (or even necessary) to the apocalyptic film, but it intensifies the anxieties driving *Snowpiercer.* Bordwell's critique seems most relevant in light of Bruni's suggestion that these films should better fulfill their responsibility for helping the American people to advance their political debates. But the positive reception of *Snowpiercer* as well as of *Dawn of the Planet of the Apes* and other films like it suggests that they successfully tell us something about ourselves that speaks to our anxieties.

For a further example of the ubiquity of the reflectionist framework, take the critical promotion and reception of *Mad Max: Fury Road* (George Miller, 2015). Kate Aronoff, writing in *Yes! Magazine,* begins her assessment of the film and its predecessors in the series with observations about its reflection of constantly changing fears:

> When the first *Mad Max* was released back in 1979, the era's reigning existential threats were nuclear winter and, to a lesser extent, peak oil. Set in a not-too-distant dystopian future and against the harsh backdrop of rural Australia, viewers' ability to map their own fears onto the screen was crucial to that film's success.
>
> Although the fears have changed, you could say the same thing about *Mad Max: Fury Road,* the series' long-awaited fourth installment. Released this month in the midst of California's historic drought and increasingly bleak studies about the likelihood of catastrophic climate change, the film plays more on viewers' anxieties about a carbon bomb than a nuclear one.[20]

The notion that audiences find space in such films to "map their own fears onto the screen" features in reflectionist views about the work

that cinema accomplishes. That these fears loosely relate to the films' historical moment matters to the way the films are talked about and received: the films serve as a safe place for coping with those fears, for seeing them play out in a closed system of narration.[21] Following in this vein, A. O. Scott, in the opening of his *New York Times* review selecting *Mad Max: Fury Road* as a critic's pick, likewise frames the film through its address of different anxieties over the franchise's history and its audience's histories: "Desolate, post-apocalyptic landscapes, zombie-ridden or not, are perennial popular tourist destinations for 21st-century moviegoers and couch potatoes. *Mad Max: Fury Road* is like a visit to a World Heritage site. Some of us—old enough to remember when nuclear Armageddon had not yet given way to climate change as the main source of existential anxiety—harbor a special fondness for the young Mel Gibson as Max Rockatansky."[22] Shifting cultural anxieties find stability in the expurgation this genre effects. Jeffery Fleishman's *Los Angeles Times* review provides insight into how audiences need and ultimately respond to the excesses of such films:

> We are at once frightened by and drawn to the precipice. Movies about cataclysm articulate our anxieties and—despite insipid dialogue littering the fiery road to oblivion—allow our vulnerabilities to be laid bare, our catharsis shared.
>
> During the Cold War, films such as *Invasion of the Body Snatchers* and *Dr. Strangelove* embodied our paranoia about the Soviet menace and nuclear annihilation. Over the last 20 years, movies about the end of days have been steady. *Contagion* deals with a global pandemic, *Independence Day* has us tangling with laser-slinging aliens, *The Day After Tomorrow* sticks us in the deep-freeze of climate change, and *Deep Impact* sends comets rocketing our way.[23]

The events of each of these films serve as a conduit to access "our vulnerabilities" and "articulate our anxieties." This cathartic function is the modus operandi of apocalyptic films. From a certain slanted angle, therefore, they belong in the category of "body genres" proposed by Linda Williams, where the film's effects on the bodies of spectators are a central part of its mode of expression and being (though in a

decidedly different register than Williams's original claims).[24] Recurring strong and unfixed feelings, especially anxiety and release, are worked out through spectacular, bigger-than-life imagery and in the midst of life-and-death stakes. The ubiquity of these films, which circulate, recirculate, and reboot similar eschatological narrative ends, suggests a need for such catharsis and release of tension. As Julia Kristeva has put it, "Films remain the supreme art of the apocalypse . . . because the image has such an ability to 'have us walk into fear.' "[25] They allow us to try on a possible though unpleasant situation to expunge our anxieties about it.

Many millennial and postmillennial fears are candidates for guiding the creation of these narratives. The films are meant to be timely, even if many of the anxieties they draw upon are timeless. The coincidence of 9/11 with the early years of the new millennium extended the paranoia of deep-seated premillennial anxieties, which Thompson has outlined in her book. She identifies a rise in disaster films related to millennial fears in the years leading up to 2000: by her count, productions of apocalyptic narratives in the United States doubled (to around sixty) in the premillennial period of the 1990s. Thompson's account argues that the ways dread is generated in the films depend heavily on cinematic devices—such as abrupt jump cuts and shifts in shot distance (being suddenly too close to something, for instance, or swiftly and startlingly producing an object feared but out of sight). I would extend her assertions by recognizing that there is something about the technology of cinema more broadly that underscores the dread generated in these films. Much as did the turn of the twenty-first century, the turn of the twentieth century played host to the delight and anxiety fixated on technology and the human expressed in cinematic terms (fig. 4.1). Some hundred years later, in the midst of cinema's recent technological changes moving into the postcinematic/digital age, films such as *Mad Max: Fury Road* tend also to highlight the manipulation of the image and the cinematic intersection between the human and the technological. It uses 3D technology, digital enhancement of landscapes, and slow or fast motion to generate spectacular effects as well as technologically induced anxiety (e.g., things penetrating the space between screen and audience and nearly poking one's face in 3D).[26] Cinema serves as a vehicle for apocalyptic fear *and* as a remedy for it. It remedies fear both by

FIG. 4.1. Cinema technology and the human: *Man with the Movie Camera* (Dziga Vertov, 1929).

"working it out"—that is, working through the anxieties prompted by mortality's inevitability—and by normalizing the malaise of the age, rendering it large, legible, and manageable. This is the heart of the reflectionist idea: that the movies reflect or refract fears that already exist and by visualizing them contribute an outlet to reckon with these fears.

However, these films also specifically harness, mitigate, and shift the meanings of millennial anxieties by ministering *exquisite* cinematic images of the near end or its aftermath or both—assuaging the ravages of technology *through* technology and transforming its deleterious effects with the radiance of its visually arresting images, most enhanced with digital technologies that are part of their appeal. As is the case in many of these films, exquisite imagery is sometimes applied to decimated, gloomy, hopeless, aphotic zones of action and is sometimes contrasted with them, the more to bring out the brilliance and beauty depicted (or emerging) elsewhere. In *Snowpiercer*, the train on which the travelers hurtle through time and around the belt of the world contains both dark, dingy cars and luminous, exotic cars filled with life's varied riches for the wealthy: trees and flowering things, an aquarium, a hair salon, a nightclub. The darkest images are sheer blackness as the security forces on the train don night-vision goggles and shut the lights off, the better to butcher those who would rise up against the wealthy. In

stark contrast are the images of the bright, white, snow-encrusted, formerly civilized landscapes taken back by nature outside of the train, of which the film allows glimpses at several points throughout the train's journey (often with the dark figures on the train in the foreground to show the contrast). The final shots move the beleaguered survivors—a child and a woman who can see the future—into this brilliant, blinding whiteness, a space of renewal for the species. Animal life has already resurfaced there as well (polar bear alert), and it is assumed that life will be able to blossom again. The focus on this imagery offers an easy visual allegory, a remedy for the humiliations the victims have suffered and a hope for a clean, bright future stripped of all the nonsense that led to a global climate collapse and social agitations in the first place.

Tension between suffering and release are emblematized in these films through their painfully beautiful landscapes—their exquisite aesthetics. *Exquisite* is an appropriate label for these operations; its applications bring these tensions together neatly into a single etymology: *exquisite* is the apt modifier for describing the provinces of pain, of intensity, and of beauty experienced simultaneously. This is likewise the thematic terrain trammeled by these films: they stage the natural world taking over the corrupt, too technological, too populous human species in these visual terms. As such, their imagery becomes a parallel argument for the need to productively deal with the provocative mixture of technology and nature taken up in so many of these films.

These postmillennial apocalyptic films iterate aspects of the current debate about the digital turn in visual, technological, and thematic terms. In their use of digital and 3D imagery for stunning effects, several of the films make oblique reference to their digital inheritance in both positive and negative ways—they are made possible through that inheritance but in some cases reflect on the cinema they have left behind. The popularity of these films—which is both an asset and a drawback to critical consideration—also depends on recent digital platforms for intensified distribution strategies. Indeed, they tend to do well at the box office (broadly speaking) even if they tend not (with a few exceptions) to be rated highly in critical terms—by either audiences or critics.[27] Their position within the digital revolution is a necessary component of the way

they function in terms of their purchase on the collective moviegoers' imagination, which is certain, repetitive, and persistent.

APOCALYPTIC SPACES, PLACES, AND THE SUBLIME

The way places are imagined in postmillennial apocalyptic films highlights their examination of these tensions. Typical are depictions of familiar urban spaces transformed by their encounter with near-total destruction and subsequent takeover by nature (like Simmel's ruins). *Dawn of the Planet of the Apes*, for instance, is set in and just outside of San Francisco and the natural area just across the Golden Gate bridge.[28] It plays with the boundary of the city and what lies outside of it, as the survivors of the simian flu build a "colony" for themselves with difficulty in familiar spaces at the center of the city, and the apes endeavor to build utopia in the lush (and getting lusher) natural outskirts of the city.

Peaceful spaces in both environments are imbued with hints of the return of nature, a creative force extraneous to (most of) humanity. Yet there is a sense of collective loss due to the apocalyptic contagion of the flu, which as the opening graphics demonstrate has caused the whole world to go dark and the fate of humankind to become uncertain. Many of the people who remain are nostalgic for the past, a nostalgia that mostly takes the form of an almost desperate desire to turn the electricity back on and return to a technological state of being. However, it may not be the humans (or at least not most of them) whose side we are meant to take: the film emphasizes the noble leadership of the apes as well as the beautiful, green forests and soft, watery forest light, which brings about a different nostalgia for the leafy, unpopulated world of a distant past.

Several plot details crystallize the poignancy of the dilemma between the natural/organic and the manmade/technological separated by and (eventually) merged within these spaces. For instance, the simian flu—transmitted through a manufactured virus—has killed all but one out of every five hundred people prior to the start of the film. However, it has also bolstered the capacities of the apes, who now build a new world for themselves in the forest. That is, nature (in simian form) wins but through the help of a scientifically engineered (technological

or manmade) product, which harms those who have made it, to the benefit of nature. Similarly, technology and the organic collide directly at several moments in the film, including a brief sequence in which Dreyfus (Gary Oldman), a leader at the humans' outpost, gets electrical power for the first time in a long while and looks at his iPad, which shows snapshots of his dead family. How foolish, the film seems to remark, to make everything digital! What if the power goes out on the whole world? Where will these emblems of the past be when one's iPad is cracked and useless? (Where would we be if Kracauer had been unable to peruse the image of his grandmother?[29]) This moment is one of several instances when some of the tensions *outside* of the film's world enter into symbiosis with tensions played out *within* the film. For example, the film's cinematographer, Michael Seresin, remarked that the production team wanted to shoot the picture on film, but the studio insisted it be digital (and 3D). In this scene, the reflection on the precarity of digital images seems to place film photography versus digital photography into play among the dichotomies of the natural versus the technological that are the source and solution for anxieties in the film. Moreover, in this scene of discovery of nostalgic images of his past, the camera observing Oldman's performance has an organic feel that the creators contrasted with much of the rest of the film's content, which was meticulously storyboarded and subjected to previsualization techniques and painstaking planning. Here, they let Oldman's spontaneous performance guide the scene.[30]

Indeed, several of the film's production circumstances echo themes of the organic/natural versus the technological/manmade. On the one hand, for many films of this genre, the technological aspects are simply indispensable for creating the worlds depicted. In this case, the filmmakers sought to make the apes (played by humans) as realistic as possible by grounding them in human-performance-capture technology on set. Although a vast amount of the resulting imagery results from VFX manufactured by Weta Studios, the actual bodies, lighting, 3D images, and so on were onsite or created onsite (in other cases they might instead be generated in postproduction) to lend heft and natural shadows to their representations of both human and simian characters in specific spaces. For the natural, green, rainy sites in the Muir woods and a slowly

naturalizing city of San Francisco, the filmmakers did not use either real location at all, as is typical of many movies. Rather, the film was shot on Vancouver Island and at the now defunct amusement park Six Flags New Orleans, which closed in the aftermath of the very real disaster of hurricane Katrina. The past and the future disasters, the real and the substitute or the necessarily manufactured because the real is not natural enough, and the general vivid imaginary effected through spectacular effects make the technology and nature in and out of the film stand in evocative relationship with each other.

Nature fills in the formerly inhabited places with grasses and ivy, while the protagonists grasp for the reassertion of technology in the attempt to bring human order over everything that remains. The balance between the peaceful/creative and explosive/destructive forces animated within these spaces underlines a more general tension between delight and fear expressed through cinema, particularly in terms of cinema's volatile qualities associated with technological possibility, change, and obsolescence. In many cases, the tension between technology and nature—with humans bridging the gap in fascinating, tenuous ways—is borne out as the drive behind apocalyptic visions. Whether this mitigation of anxiety takes the form of a return to a pastoral, sublime, surreal, or grotesque vision, these movies posit a strong connection between the cinema and the dreaded apocalyptic ends it depicts.

In multiple cases within these films, the mise-en-scène of apocalypse intensifies the cinematographic novelty of perception, presenting familiar spaces and landmarks transfigured by disaster. Cities in particular are addressed in shorthand through their most recognizable icons, many of which become focal points for the disaster that is about to take place or, more often, has already taken place (e.g., San Francisco's Golden Gate Bridge and New York City's Times Square [figs. 4.2 and 4.3]). Similar to the kind of awe David Nye has traced as inspiring those who witness architectural wonders such as the Statue of Liberty,[31] these films use such spaces to activate the viewer's sense of the sublime through reworking these wonders in an apocalyptic mode. It is no mistake that the kinds of places highlighted in several of these films are often wholly familiar: their familiarity allows them to be treated in a de-familiarizing way that echoes the operations of the uncanny. Startling juxtapositions of the familiar

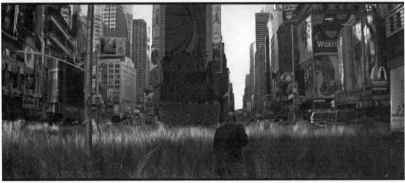

FIGS. 4.2 AND 4.3. The Golden Gate Bridge in *Dawn of the Planet of the Apes* (Matt Reeves, 2014) and Times Square in *I Am Legend* (Francis Lawrence, 2007).

and the unfamiliar offer unsettling configurations. The camera in *The Day After Tomorrow* rounds the bend past the Statue of Liberty, giving us at first a view that makes the statue familiar, but oddly so (figs. 4.4 and 4.5). A longer view confirms the identity of the thing we are looking at, but it is still made strange by its being surrounded not by the waters off the southern end of Manhattan but by frozen white floodwaters, with the freezing hulls of ships jutting out of the ice. The uneasy tranquility and beauty of these spaces belie the catastrophe or violence that brought them into being as well as the potential or continued threat to the remaining humans that populate them.

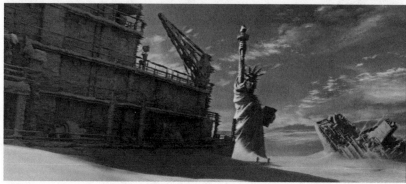

FIGS. 4.4 AND 4.5. Defamiliarizing familiar landmarks in *The Day After Tomorrow* (Roland Emmerich, 2004).

TECHNOLOGY, CINEMA, AND THE ORGANIC BODY

> Still, a few of these upholders of the present order know that their tremor of fear and indignation does not only owe to a richly sensual [cinematic] image. Their fear comes from farther away and encompasses more: it can sense the monster of novelty, of creation, pregnant with all the fast-transforming heresy of a continuous evolution.
>
> —JEAN EPSTEIN, "INDICTMENT"

The issue of technology taken up by postmillennial apocalyptic films is fraught with ambivalence. On one hand, technology coupled with human hubris brings about certain destruction. On the other hand, technology promises to make good what has gone wrong. These films do not

abandon the idea that technology could, by fulfilling its better impulses, save the day: science or technology often plays a part in the revitalization or re-creation of apocalyptic end points. But at the same time these films tackle technology's purchase on the present as one of the apocalypse's initiating factors. Although these films therefore seem to reflect the present population's (or at least the present scenario writers') inability to imagine something outside of a technology-laden society, the opposite is also true. That is, these films again and again activate an image of the world rid—at least temporarily but very compellingly—of technology. They seem to entertain a fantasy of a world simplified by the forcible loss of technology capabilities: cars stop running and the highways become grassy for want of wear; cell phones, tablets, and computers die, and no electricity exists to reboot them; the grid goes down, and everything is dark and quiet. No one laments a cell phone going off loudly nearby. The Milky Way is visible again.

Interestingly, technology as it is represented maintains a close connection to human bodies, with organic material pitted against the manufactured, machine world but also sometimes absorbed by it. In fact, in many cases this absorption is literal in that the human and mechanical regularly conflate: Furiosa (Charlize Theron) sports a mechanical arm in *Mad Max*; both Ray Ferrier (Tom Cruise) and the aliens in *War of the Worlds* operate their mechanical pods as if they are the brain of that machinery's body; Max (Matt Damon) in *Elysium* merges his despoiled human body with the greater power of a mechanical spine; two human bodies are needed to occupy and mind-meld with the machines of *Pacific Rim*; and so forth. Moreover, the compelling imagery of these films draws on the convergence of the mechanical and the organic, sometimes in narrative terms and sometimes in more abstract, cinematic terms, so that slow motion, for instance, allows a new look—a new world—to open up among de-familiarized landscapes. As Trond Lundemo has put it in relation to Jean Epstein's prescient book *The Intelligence of a Machine* (the machine in question being the cinema), these views constitute a confrontation of the machine with human perception and experience of that world: "Close-ups and slow motion do not help the spectator to see closer or better but open up a different world. Superimpositions or decomposed motion are not representations of mental processes like attention, contemplation, or fantasy. It is a different world that can only exist within

the technology of cinema, and which always confronts the human psychological world."[32] The films express anxieties about the merger of humans and machines even while they focus on technologically mediated visionary scenes, balancing thematic apprehensions with the restorative, optimistic power—the cinephilic potential—of stunning visual aesthetics.

Let us take a closer look at a film that adopts the theme of man and the mechanical within an anxious and exquisite filmscape: Steven Spielberg's version of *War of the Worlds*, widely released in the United States on June 29, 2005, not enough years after 9/11 not to be shadowed by that event.[33] Thompson has detected several allusions to the imagery associated with 9/11 in the first attacks by aliens in Ray Ferrier's neighborhood of Bayonne, New Jersey, just across the water from the southern tip of Manhattan and therefore a point of witness to the falling of the World Trade Center towers.[34] Ray goes out to the street with all of his neighbors to see what is going on with some peculiar weather (e.g., lightning strikes twenty-six times in one place). An attack erupts out of the pavement suddenly, unexpectedly by alien spaceships or pods placed in the earth long ago now manned by alien invaders (transported into the pods through the lightning bolts). The aliens quickly begin to pursue the curious bystanders, who run for their lives, only to be vaporized by the pods: just clothing remains where people once were, and shirts and ash float gently over the places they once occupied (an image Thompson associates with the people caught in the fall of the twin towers). Ray, lucky enough to avoid the death beams, manages to collect his children and make a getaway in the only running car for miles. His daughter, Rachel, becoming hysterical when things begin blowing up behind them, asks, "Is it the terrorists?" *War of the Worlds* is haunted by 9/11; traumatized by what he has seen, Ray finds himself unable to speak about it. He goes into survival mode, and the rest of the film is a series of set pieces of attacks by the aliens and of Ray's and his children's responses to those attacks.

What is most interesting about *War of the Worlds* is, first, this channeling of specific and timely anxieties for its audience into a fairly gripping, very bleak narrative overall—at some point it feels as if there can be no escape from destruction, so that the survivors' tactics can only delay the inevitable takeover of the planet by hostile alien life. The film puts faith in virtually no human endeavor to put an end to the alien

invasion. Instead, the denouement depends on a glitch in the aliens' plans. That glitch represents an entry point into the other most interesting aspect of this film: its use and representation of technology and nature.

The aliens are presented as technologically superior beings—with a supremely organized plan. The first thing they do is shut down human technology: all cars and lights stop working, save a jerry-rigged car and a battery-operated camcorder (which further underlines the connection between the film's technology and the technology being displayed in the film [fig. 4.6]). But the film's technology is also impressive and organized; its own apparatus of effects is a triumph over the end days, too. Spielberg shot *War of the Worlds* in just seventy-two days—during an unexpected opening in his and Cruise's filming schedules—approximately half of a typical blockbuster schedule in 2005.[35] Reports indicate that he mobilized a great deal more previsualization techniques and postproduction technology than in any other film he had made to that point: he depended on specifically digital technology to get the effects that he once got with a mechanical shark.[36] Echoing the aliens' facility with their tripods, the first image of Ray Ferrier is of him operating machinery to load tankers; the technical finesse of this crane shot mirrors the crane he runs, in which he is able, by manipulating a small shifter (almost a joystick) at his fingertips, to virtually and actually move gigantic, heavy equipment.

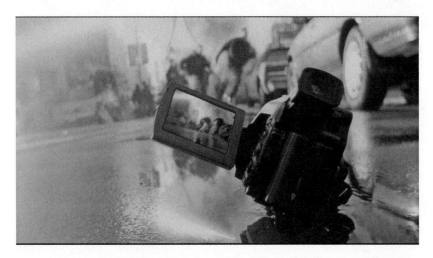

FIG. 4.6. *War of the Worlds* (Steven Spielberg, 2005). Push the button, and the camera does the rest (then run!).

War of the Worlds indeed offers a strange concatenation of human and alien qualities, mixing organic/living and mechanical/technological being. At one point, as his son, Robbie, attempts to follow the urge to help the fight against the aliens by joining soldiers with their tanks and guns traveling toward the aliens in their pods, Ray rebukes him: "You want to go in that direction? There's nothing living in that direction!" At first that seems to be true: it's all machinery and firepower there. But Ray is not correct: along with the aliens (who are, by the way, vulnerable and fleshy outside of their pods), a red-veined living plant has taken over everywhere the aliens have been, like a red weed. It flourishes until the unseen life of the earth—bacteria and microscopic organisms—kills it. The film constructs what turns out to be an inverse hierarchy from technology to human to plant to microbial—with the last triumphant in the end. As this scene suggests, distinctions among organic material, inorganic matter, and technology are often blurry. The aliens mainly stay inside their tripodlike vehicles, protected from attack by a shield and also distantly observing their victims from a height of a hundred feet (as specified in the H. G. Wells novel). But Spielberg wanted these pods to resemble jellyfish—aquatic organisms—even while their tripod structure also calls to mind camera equipment. Interestingly, too, the pods need organic human material to make them run. They keep humans fresh in cages underneath the main body of the vehicle, then draw them through an orifice, where they spike them on a spit and draw their blood for sustenance. When one pod is at last taken down, it gushes icky, organic slop. Although the pods' cool, steel frame and technological superiority seem to suggest otherwise, these aliens depend on a curious mixture of the organic and the inorganic, reflecting ambivalent feelings about both. *War of the Worlds* provides an example of one of the early films in the new millennium to be affected by postmillennial worldly and technological concerns. Its dependence on spectacular digital technologies for its own take on cinematic spectacle is revealing: in the films that follow it for the next decade, this aspect gets only more and more emphatic as a production ethos and aesthetic choice.

A fear expressed through apocalyptic films of the early millennium and related to the fears explored in Spielberg's film has to do with the frailty of the organic human body. Concerns about medical technology provide a natural extension of these fears. Apocalyptic zombie films, a

subgenre of the postmillennial apocalyptic film, emphatically address such fears. Two representative films treat this issue—Francis Lawrence's *I Am Legend* (2007) and Marc Forster's *World War Z* (2013), both of which depict a medical epidemic run to its most devastating ends, killing or damaging almost everyone and leaving only a slew of zombielike survivors and just a fraction of the original healthy population intact. Each film puts image construction and aesthetics at the forefront to express the anxieties and longings that are at the center of its concerns.

In *I Am Legend*, the action begins before the devastation, when in a news report a doctor (Emma Thompson) is interviewed about the results of her virology research. Homing in on anxieties similar to those appearing in *Dawn of the Planet of the Apes*, the good doctor reports that she has discovered the cure for cancer in a mutated measles virus. Her success rate with her research subjects has been extraordinary, and the whole populace is duly vaccinated with the doctor's manufactured inoculation. Although her research subjects do not become kindly, intelligent apes living in the forest, her technological/scientific solution similarly decimates humanity. Some 90 percent of the population dies, and most of the rest are transformed into "Nightseekers," aggressive, zombielike mutants who cannot bear sunlight. They convene in communal pods in the city's dark places during the day and roam freely at night.

This devastation of the population is elided in the film; the narrative takes up again some years later, when all of New York City has become virtually devoid of people (literally: many were erased from the image in postproduction).[37] Robert Neville (Will Smith) drives around New York City as its sole remaining human inhabitant. Human bustle is replaced by a return to pastoral tranquility. De-familiarizing cinematographic transactions occur similar to those articulated in *The Day After Tomorrow*: when Neville moves into grasslands to hunt a deer, the audience cannot be sure what natural place he has come to. The camera follows him, tilting up and revealing Times Square, the ultimate nonnatural space having been transformed by time and disuse (fig. 4.3).

The film's appeal hinges on the opposing tropes of the city quietly depopulated and its landmarks spectacularly devastated—in a flashback, a helicopter accident at the Brooklyn Bridge provides backstory for Neville's feeling of personal tragedy (the largest percentage of the budget went to this sequence). The film's tranquil postapocalyptic landscapes offer a

fantasy remedy for gridlock, a cinematically generated image of elbow room not otherwise found near Washington Square, where Neville has barricaded himself against the Nightseekers. This tranquility offers the besieged New Yorker in the audience—or anyone overrun by traffic, technology, noise, and modern city life—a spell of quiet. Moreover, that quiet is associated with specific ideologies—for example, the desirability of small-town America over the gaping maw, urban sprawl, and violence of the metropolis. *I Am Legend* explicitly deals with these opposing lifestyle ideals when its conclusion shows the woman and child who have connected with Neville leaving the city with the antidote and finding a colony of immune survivors building a new life behind built walls in a color-saturated, photogenic autumnal idyll: small-town Vermont. The beautiful depiction of this space of respite—a pleasant bird's-eye view, with warm light and autumnal reds and yellows—is just slightly diminished by the fact of the high wall they have built to bar illegal entrants, which separates the colony from the threat that has taken over the more vulnerable cities.

In *I Am Legend*, the sense that life is and will forever be technologically mediated is challenged, even as technology—medical and otherwise—eventually saves the day. Though systems have shut down, the handy Neville manages to MacGyver his way through various problems by setting clever traps for Nightseekers and powering things with horded batteries and makeshift generators. Most important is the fact that the film cannot fully blame the hubris of the doctor who thought she could cure cancer with medical technology—not when the solution to the apocalypse is the very similar act of manufacturing an antidote, though one based on the more humble blood of Dr. Neville.

A similar set of moves related to medical technology arrives in *World War Z*, in which a former United Nations investigator, Gerry Lane (Brad Pitt), must identify the source of a pandemic that turns people into fast-moving zombies. *World War Z*'s opening shots intercut news footage with other images to generate an uneasy, accelerating montage that juxtaposes conflicting information and interests, accompanied by a repetitive set of piano notes that set a mood of anticipation and dread. The first shot is of the ocean and beach with warm yellow light, accompanied by the calming sound of waves on the shore. Next comes a shot of the sky

and the clouds scuttling across the rising sun; then the sun rises in a cityscape, connecting the natural with the urban environment. Setting the scene—the dawning day and its natural beauty—here functions in much the same way as beautiful images of deep space are used in other apocalyptic films to suggest an inhuman, interstellar distance and the vastness of time that threatens to dwarf all human existence on this planet, which is just what the film will address. *War of the Worlds*, for instance, also begins in just such a way, with a series of related but contradictory images—strands of DNA within microbes, a green leaf seen through a circular droplet of water, the roundness of which transitions to an image of Earth from space, which transitions to a red dot, which becomes a red traffic light, which becomes a droplet of water again. Almost a rebus puzzle, these opening images (microbes, water, earth, stoplight, water) forecast the trajectory of the film's narrative arc, accompanied by Morgan Freeman's narration: "Yet across the gulf of space, intellects vast and cool and unsympathetic regarded this earth with envious eyes, and slowly and surely drew their plans against us." Reinforcing the fact of forces that exist beyond strictly human concerns—the purview of science, space, and nature—renders the peoples of these films vulnerable and myopic. They do not see the apocalypse coming, though the signs are everywhere and ready to be deciphered.

In *World War Z*, staying alert to such signs is a large part of how Lane keeps his family alive and leads to him finding a way to slow the spread of the infection. As in *I Am Legend*, the drama of *World War Z* hinges on the action of surviving attacks by zombies while simultaneously trying to discover the medical means for ending the glitch that allowed them to come into being in the first place. Technology of the moment becomes obsolete in most places, in part because the zombies are attracted to noise and commotion. (Indeed, technology is a liability: when a phone rings unexpectedly, it puts Lane in danger.) Lights go out as cities burn, the grid essentially shuts down, and medical science is unable to deal with the growing threat of infection we hear being reported in the film's opening minutes. Even so, hope lies in the possibility of medical technology solving the problem, just as it does in *I Am Legend*. Although there is skepticism about science in general and medical science in particular, the latter ultimately provides relief from the otherwise relentless onslaught

of zombie infection and devastation. Also as in *I Am Legend*, in *World War Z* the remote places of the world—ultimately Nova Scotia in this case—are havens from the problem, which flourishes in urban, densely populated areas that cannot be kept separate or safe because of the sprawl of noise and contaminants of every kind. At one point, Lane travels to Jerusalem, which has walled itself off: like *I Am Legend*'s Vermont walls, the walls represent the uninfected residents' hope that they will therefore be protected from harm, but that is not what happens. The film does not follow a simple trajectory from problem to solution, and the anxiety inspired by the film never fully dissipates.

Although *World War Z* does not feature the same kinds of defamiliarizing and exquisite images of abandoned city sites such as Times Square in *I Am Legend*, the opening credit sequence similarly introduces its complex operations relating to narration, technology, and the age of ubiquitous digital transmission and manipulation of information and images. After the first three shots mentioned earlier—ocean, clouds, city sunrise—the sequence continues with quick cuts, accruing over seventy shots in less than two minutes. Digitally fragmented into mirror-like shards and in constant motion, these shots eventually merge to generate the words of the film's title. Natural images of increasing violence (wolves attacking) are juxtaposed with inane daytime television shows ("Your socks are so cute!") and news that has a direct or thematically connected relation to the impending zombie pandemic: an interviewer asks, "Are there any real threats we know of?" Later, we hear another voice say, "Unsettling." With increasing speed in the cuts, the images become a jumble of information one has to sort through, but the message is clear: World War Z is coming, and people are by and large in denial about it. The sequence mobilizes the kinds of images (both vapid and doomsaying) to which people have become accustomed on the news and on talk shows alongside tranquil images of nature to underline the complacency of contemporary society in the midst of potential threat.

Together, *I Am Legend* and *World War Z* proffer the notions that medical apocalypse is a real possibility in the current age *and* that medical technology can nonetheless solve the problems it wreaks. The two films' equivocations about technology extend to their dependence on digital imagery to creatively underline their thematic interests (in terms of technology of the contemporary moment) and their artistic

interests (in terms of how they use technology to connect those images and concerns).

DOUBT AND DREAD: APOCALYPTIC FEELINGS

A much quieter film, Jeff Nichols's *Take Shelter* (2011), draws on other cinematic anxieties for its thematic and narrative complexity. Composed of remarkable, vivid images and slipping subtly between the hard-scrabble reality of living on the margins of middle-class respectability and the protagonist's imagination (posited as a question: Are the images shown hallucinations or visions of the future?), *Take Shelter* marshals both euphoric beauty and immobilizing anxiety related to images to tell its story.

Set in Elyria, Ohio, the film follows Curtis (Michael Shannon), who has been having apocalyptic dreams as well as nightmares about being attacked. He feels unsure about whether the dreams are prophetic or signs of schizophrenia, from which his mother suffers. The dreams are so real to him that they persist beyond waking, so that he feels a dog's bite from his dream long after he wakes up. He keeps these dreams hidden from his family and coworkers. But he cannot hide them from the spectator, who also witnesses the dreams in cinematic terms. They happen without segue so that they blend seamlessly with the rest of the action and are thus presented as realistically as other parts of the film. At a certain point, Curtis no longer witnesses these visions only when he sleeps. He starts to experience strange apocalyptic signs (blasting sounds in the sky, for example), while the world goes on otherwise normally around him. The line between what he perceives and the "normal" life that everyone else perceives becomes indistinguishable for Curtis—and for the spectator. Because the audience sees what Curtis sees, the film prompts a revaluation of diegetic boundaries: Are the lightning bolts something from the world of the film itself, from Curtis's imagination only, or merely part of the film's added effects? These possibilities blur.

Curtis attempts to cope with his visions in a number of ways. He visits his mother, who long ago was institutionalized, to ascertain any similarities in his condition and hers. He begins to see a social worker. Finally, he reluctantly enlists his wife's help. When one evening Curtis cannot come out of a dream, his concerned wife, Samantha (Jessica Chastain),

calls an ambulance, prompting Curtis to have to explain. He describes his dreams to his wife (which we have seen unfold cinematically already): "They always start with a kind of storm . . . dark thick rain like fresh motor oil. And things, people, it just makes them crazy. They attack me sometimes. . . . It's hard to explain, because it's not just a dream. It's feeling. I'm afraid something might be coming, something that's not right. I cannot describe it; I just need you to believe me." The anxiety provoked by the dreams unravels Curtis's life piece by piece, but in fact this moment of contact with his wife is the beginning of the story's arc toward resolution. She just needs to believe him, and so does the audience. Curtis's only request—and the question on which the narrative hangs—is that we give him the benefit of the doubt, of his doubt, so as to understand his feelings as manifested in the debilitating fear of these night-time visions. We need not decide what they mean: we just have to believe that they are there. It is precisely Curtis's visionary doubt that the film's stunning imagery negotiates.

The film includes spectacular digital effects of the storm Curtis sees (figs. 4.7, 4.8) as well as his visions of gravity-defying furniture, strange formations of birds in the sky, oily rain, and characters (including Samantha) who act in ways that pose a threat to Curtis and sometimes to his deaf daughter, Hannah, whom he tries to protect. *Take Shelter* treats the question of an image's beauty and authenticity both in terms of the narrative and in terms of the way the film constructs that narrative through digital effects.[38] E. Ann Kaplan frames the film as part of her notion of

FIG. 4.7. *Take Shelter* (Jeff Nichols, 2011): picturing exquisite visions.

"pretrauma" media that envision (here, literally) probable future traumas based on climate change.[39] Curtis represents the pretrauma subject, able to see impending crisis vividly. Indeed, the film plays with audience expectations about the visionary imagery Curtis experiences, toeing the line between authenticity and reality effects as well as between falsity and imagination. That is, Curtis sees what we also undeniably see in filmic images, but we cannot be sure about the status of those images, at least in terms of the narrative's ends. Are we meant to see Curtis's dream images as visions of a true, coming apocalypse or as the dawning of psychosis in a man whose family possesses a history of mental illness or or as just some particularly intense dreams? Are they friendly images (e.g., a real warning so he can prepare himself) or unfriendly images (e.g., figments of a troubled imagination that cause him to lose his job)? Is their beauty deadly?

Even though the digital storm in particular is stunningly beautiful, these images operate in a deeply anxious realm in terms of the dread they produce in Curtis *and* because they inspire uncertainty in the audience. It is impossible to tell whether these images are meant to be taken as realistic depictions or as something of cinematic genesis (oriented toward the outside of the film) or psychotic genesis (oriented toward the inside of Curtis). The lines between Curtis's internal diegetic world of dreams, the diegetic world of the film in which he can wonder about their status, the nondiegetic world of effects production, and the reception of all these levels by the spectator become increasingly less distinct as the film progresses. Curtis's apparent perspicacious perception as a character is the fulcrum between the visions and the realities generated by the film both through and outside of him.

The film playfully smudges the line between its depiction of reality and the cinematic reality that is responsible for these apocalyptic images. Twice Curtis asks whether someone else is witnessing what he witnesses. The first time, he sees birds forming patterns in the sky and asks his partner at work, "You ever see birds fly like that?" The audience does, even if his coworker may not. The drill they are working is too loud for his partner to hear Curtis, so the question goes unanswered for the time being, the reality of the birds within the diegesis remaining inconclusive. The second time, Curtis seems almost to ask the audience. He stands looking in the camera's direction as he witnesses a strong storm on the

horizon and asks, "Is anyone seeing this?" Samantha is sleeping in the back seat, so he could choose to seek confirmation from her within the narrative, but he asks the audience instead. Again, no matter what the storm's status is to the "real" world of the film, the film's audience is summoned as a witness to it.

The status of the film's world is sometimes starkly different for Curtis and for all the other characters. When Curtis hears violent cracks of thunder and ducks for cover, Curtis's partner clearly does not hear the same thing (though we do) and wonders what might be wrong with him. However, when the film transitions without signaling the shift between quotidian activities (drying his child off after a bath) and the dream world in which bad things begin to happen (his wife, whose eyes are "not right," stands contemplating a knife on the counter), paranoid images and the realistic narrative become inextricable. The film's visions of the end of the world depend on the obscurity of that line between real and not-real, with the two blending into each other at moments, as when Curtis slowly destroys everything important in his life based on his inability to shake the reality of the dream visions. The status of the images cannot be verified.

Experimental filmmaker and theorist Maya Deren writes about the power of "reality" in engendering new, specifically cinematic realities, harnessing "show-it-to-me" power—for example, using the heft of a real tree in a film shot to creatively manipulate the terms (temporal or spatial) of reality.[40] Something like this happens in *Take Shelter*, when it shows Curtis's visions in spectacular detail. Being introduced to these images as if they are part of the same reality as the rest of the film is not unlike the remarkable sequence in *Possessed* (Curtis Bernhardt, 1947) when Louise Howell (Joan Crawford) pushes her daughter-in-law down the stairs in a pique of jealousy, only to realize that she imagined that act when some short time later the girl comes bounding home after an evening out. Seeing is believing, and films draw on that maxim to make the spectator invest in that world (and to startle the spectator when she realizes that she made that investment wrongly).

These dynamics are complemented by the disturbing beauty of the world created by the film's digital sequences. At the end of the film, Curtis and his family go to the beach for a last vacation before Curtis is to commit to serious treatment for his apparent illness. He and Hannah sit

on the beach making sand castles, when Hannah looks up and begins to make the sign for "storm." Indeed, a CGI storm is brewing on the horizon. When Samantha emerges from the house to see what is going on, we see the storm reflected in the windows flanking her (fig. 4.8). This mediated view of the storm mirrored in the windows signals the possible registers of authenticity being mobilized by the film's image circuits. The audience both sees her seeing and sees what she is probably seeing through the reflection in the windows behind her (a collapsed shot/reverse shot); as such, it gains a less-limited access to the visions that first only Curtis but now also Samantha experiences. Although one might well take this scene as confirmation that Curtis's visions are "real" (i.e., for the whole diegetic world, not just for Curtis's inner experience), the only thing certain is that now the vision is real for at least both Curtis and his family, effecting the thematic resolution typical of disaster films by bringing the family together more closely. To confirm their mutual vision, Curtis and Samantha look at each other. She nods; he nods. The now familiar oil-like rain falls on Samantha's hand, which up to this point has always signalled a shift from the film's world to Curtis's inner visions, thus making her privy to the same apocalyptic vision and weakening the power of the line between reality and uncertainty that the film had drawn up to this point. Curtis says, "Sam?" She says, "Okay." They are now sure of the alignment of their vision, as is Hannah, who signed *storm*. Again, the audience is implicated in this vision, too, so the status of Curtis's visions is a shared, cinematic psychosis. That is

FIG. 4.8. Reflected storms: implicating new witnesses to visions in *Take Shelter.*

the nature of these apocalyptic films more generally: they offer more direct access to the delight and dread of people with whom we identify and to the landscapes we recognize, even if they are about to be—or have just been—obliterated.

The mitigated views of the storm, the oily rain's harking back to the moment of shift to a semidiegetic register, the clearly CGI spectacular effects of the storm in the distance—all point to an ambiguous way of reading the film that leaves cinematically unanswered the question of whether one can trust what one sees. That these views inspire awe only further complicates the matter: becoming absorbed in the splendour of these visions—wanting them, so to speak, really to be there, if only so Curtis's actions are justified—happens at great expense. That is, if Curtis is right about the apocalypse, and the storm is as real as his awe and terror of it, then we are rooting for doomsday. The ending is ambiguous, so that both possibilities may be sustained through the final images. Curtis, Samantha, and Hannah see and they believe, and the consequences of their visions may be great indeed. *Take Shelter* depends on ambiguity like this specifically to explore the nature of anxiety in cinematic terms. Through its CGI effects of beautiful, vivid, dangerous landscapes, the film evokes anxiety in order to work out the narrative and extranarrative meanings engendered by its exquisite images.

ART AND OBLITERATION AT THE END OF THE WORLD

Nowhere are exquisite, apocalyptic moving images more foregrounded than in the prologue to Lars von Trier's film *Melancholia* (2011). Comprising stunning, richly saturated, carefully composed frames, the opening slows motion to the point of near stasis, highlighting the arresting intensity of the images. Each image unfolds in extreme slow motion, drawing attention to the use of cinematic devices for the prologue's peculiar power. The rest of the film equally but differently depends on arrested motion: in the first of two narrative sections, Justine (Kirsten Dunst) falls slowly into a catatonic stupor in the aftermath of her failed wedding ceremony, an occasion marked by delays (at one point Justine takes a long bath while her guests wait for her downstairs) and ending with the groom leaving the premises entirely, never to reappear. In the second narrative section, the stakes are a little higher as the apocalypse

stealthily creeps up on the characters, and at the conclusion of this section (and of the film)—unlike in all of the other films under consideration here—Earth is completely, irrevocably obliterated. Thus, the film charts its way toward total destruction. Along the way, it treats the relationship between Justine and her sister, Claire (Charlotte Gainsbourg), Justine's wedding and illness, and the way each of the main characters deals with the possibility of an apocalyptic collision of Earth with another planet, Melancholia.[41] Although the plot meanders (making it quite different from the chugging along of plot in the action version of the apocalyptic film, such as *World War Z*), it moves toward an ultimate form of closure (the end of everything).

The narrative presents sensational subject matter with visually stunning and meticulously composed shots, but it is the opening prologue that serves as the film's most unique visual feature. Nearly completely still tableaux set the film's themes and narrative elements into (extremely slow) motion. Characterized by digital manipulations, the prologue paradoxically both condenses and enlarges several of the ideas or images that will appear later in the film. As Kristen Whissel argues, major themes are introduced in a series of "emblems effects" embodied in these images. That is, the images are not divorced from narrative concerns but serve as a kind of shorthand for the details in the plot that they represent. For instance, Whissel posits that "several of the shots in the prologue externalize the internal emotional and psychological states described or experienced by the protagonists in later scenes and are, therefore, inseparable from the development of character."[42] I would further argue that these shots include wholly nonnarrative, non-character-driven, extradiegetic concerns. The effects in this apocalyptic movie lend image to the film's often abstract obsessions, anxieties and passions both. The images dwell in deep contrasts of color and light, with strange and stirring uses of details. In short, they are exquisite and (almost literally) stunning.

Broken into sixteen shots, the subjects of the prologue fall into a few main categories: footage of the estate grounds and characters responding to apocalyptic events (e.g., birds falling from the sky); allusive shots suggestive of specific paintings or shots from other films (e.g., Pieter Bruegel the Elder's painting *The Hunters in the Snow* [1565], Sir John Everett Millais's painting *Ophelia* [1851–1852], and Andrei Tarkovsky's film *The Sacrifice* [1986]); and Hubble-style space footage of Earth and

Melancholia (creating the beautiful but cold distance to human concerns discussed earlier). Some shots fall into multiple categories (figs. 4.9 and 4.10). In all of these images, especially of space, the relationship between the sublime and *Melancholia*'s themes and tone is elaborated. As Edmund Burke characterizes the sublime, it differs from the beautiful mainly in its power to make its beholder fearful and to lead her to the verge of annihilation. Contrary to the beautiful, the sublime overwhelms the senses; it derives from and is tied to pain, terror, and the most powerful feelings: "Whatever is fitted in any sort to excite the ideas of pain and danger, that is to say, whatever is in any sort terrible, or is conversant about terrible objects, or operates in a manner analogous to terror, is a source of the *sublime*; that is, it is productive of the strongest emotion which the mind is capable of feeling."[43]

FIGS. 4.9 AND 4.10. Space photography and cinematic *Ophelia* à la Millais: the prologue of *Melancholia* (Lars von Trier, 2011).

All the same, the sublime can provoke delight through its production of these strong feelings. Explicating the differences between the beautiful and the sublime, Immanuel Kant notes that the sublime is "*a pleasure* that arises only indirectly: it is produced by the feeling of a momentary inhibition of the vital forces followed immediately by an outpouring of them that is all the stronger." The resulting, intense feeling is marked by a contradictory relationship: "seriousness, rather than play, in the imagination's activity . . . the mind is not just attracted by the object but is alternately always repelled as well."[44] Tension between the painful and the pleasurable is a trait both of the sublime in general as well as of the postmillennial apocalyptic film and the themes and images of *Melancholia* in particular. In its use of exquisite images of immense, planetary movements, for instance, the film seeks a bridge between feelings of absolute dread and pleasure in splendor. Arthur Schopenhauer notes that by reflecting on the "immensity of the universe, we feel ourselves reduced to nothing."[45] Of course, the end of *Melancholia* does exactly that: it reduces *everything* to nothing. It provides an entry point for contemplating the end of oneself and the obliteration of everything else amid glorious, luminous space cinematography.

For a film that ends in the ultimate closure—the planets colliding in exhilarating, climactic finality, followed by several seconds of nothingness on the screen to allow the spectator to take it in—it has some very ambivalent ways of addressing narrative closure. The film doesn't just move forward—it leaves time to contemplate each image and its multiple palimpsestic allusions, momentarily (and repeatedly) arresting the narrative as a result, but it also clearly foretells the end from the very beginning, like a chorus at the start of a Greek tragedy.[46] *Melancholia* offers a number of mixed messages about the apocalypse. Unlike the other films considered in this chapter, it ends with a true apocalypse. There is no recovery from the explosion of Earth: no one gets out alive. Yet the film decorates the apocalypse with some of the most self-consciously beautiful, composed, artful images among the films discussed in this chapter. Unlike the other films, which end with a degree of hope for a future, *Melancholia* cancels humanity's future altogether, though it meanders a great deal on the way there, eliminating the kinds of suspense that are key to most postmillennial apocalyptic films and replacing them with a space for reflection on the creative and mortal energies of

this world. In this way, it offers yet another way the postmillennial apocalyptic film tends to be a vehicle for working through certain issues related to technology (cinematic and otherwise)—harbingers of doom in contemporary society.

THE LAST WORD IS TOMORROW (AND TOMORROW AND TOMORROW): THE FUTURE FORETOLD

Tomorrow, and tomorrow, and tomorrow
Creeps in this petty pace from day to day
To the last syllable of recorded time,
And all our yesterdays have lighted fools
The way to dusty death.

—WILLIAM SHAKESPEARE, *MACBETH*

Sitting at the fulcrum between love and anxiety, postmillennial apocalyptic films mediate familiar contradictions. They tend to depict terrible futures with beautiful and painstakingly crafted images, and they engage with the complicated and contradictory qualities of technology and nature. They may reflect anxieties, but they do so in a way that depends on stunning, sublime special effects that might either assuage or exacerbate those anxieties by imagining them vividly and allowing them to play out in the (relatively) safe space of often larger-than-life cinematic projections.[47] Another common trope of these films understandably is a focus on the future and its possibilities and inevitabilities. As Kaplan suggests, they are overtly concerned with temporal matters, which for her suggests their deployment of fears about impending, certain doom in the real world: "The obsession with dates, numbers, time, and futurist elements in many titles emphasizes the probability of the trauma—it already has a date!"[48] These films nostalgically look back to earlier, seemingly simpler times, but they also feature a strangely forward-looking nostalgia when they suggest that the simpler world left behind even before the disaster can be renewed in its aftermath. They both fantasize and brood about tomorrow.

The imaging of future worlds is a foundation of many postmillennial apocalyptic films. A trilogy of such tomorrows—*The Day After Tomorrow, Edge of Tomorrow* (Doug Liman, 2014), and *Tomorrowland*

(Brad Bird, 2015)—made over the course of a decade illustrates not so much an evolution as the flexibility of this type of film. The first, *The Day After Tomorrow*, focuses on cataclysmic climate change and efforts at survival for several folks on the edges of the resulting natural catastrophes. Near the start of the film, paleoclimatologist Jack Hall (Dennis Quaid) delivers a lecture at a United Nations conference to warn the world's leaders of the possibility of another ice age prompted by global warming's disruption of the North Atlantic Ocean current. Just exactly what he predicts comes to pass much sooner than he predicted, and the film images the resulting superstorm disasters (tornadoes, deadly hail storms, hurricanes, flash freezing) in beautiful, terrible—that is, sublime—terms. Many of the locations (as we have seen) take us to familiar, even stereotypical global locations, including landmarks such as the Statue of Liberty and the Hollywood sign, which is smashed to pieces. Elemental nature trumps these creations of the technological sublime. The locations depicted are shot through with anxieties that are connected to the relationship of humanity to technology—and to the cinema. With its large budget and small city of special-effects designers, *The Day After Tomorrow* highlights uses of digital technology to create visions of apocalypse. Indeed, in reviews the film was touted for its effects while being panned for its scientifically problematic and overall silly scenario. Putting further emphasis on the inhospitable but sublime trajectory of nature, the film provides stunning views of the planet from space, where astronauts observe the gathering storm (begging the question of what will happen to them if they cannot return to the planet from their relatively safe perch in space); the slow, elegant floating of the astronauts in their observation pod and of the pod through space underlines the cool, distant point of view, putting humankind and the fate of a single planet into the perspective of long-term time and space. The larger patterns of the universe dwarf human strife. All the same, human survival is key to the kinds of images that are shown: the juxtaposition of humans' ardor and exertion against the planet's indifference generates these complementary images of glaciers, ice shelves, superstorms, and space. The film offers imagery that is familiar from many apocalyptic films both before and after it was made.

But *The Day After Tomorrow* emphasizes different things than many of the others in this category. It belongs to a disaster/survival genre and

fits into the pretrauma films discerned by Kaplan: inasmuch as its diegetic time unfolds alongside the director's own time, it features a "traumatic scenario . . . already seemingly possible given scientific predictions. . . . These films then are not allegories. They insist on the probability of the worlds shown."[49] The title phrase "day after tomorrow" is both so close and so flexible a date (it suits whenever the viewer addresses herself to it) that it brings the future frighteningly close to right now. Tomorrow is just about here, and the film provides the eerie chill of the recognition of impending emergency. *The Day After Tomorrow* thus envisions tomorrow as something that should be dealt with now. Best not to wait until tomorrow, for disaster is already upon the world.

Tomorrow as depicted in *Edge of Tomorrow* is less familiar. Malicious hordes of space aliens, "Mimics," on the beaches of France do not recollect us to the present moment in quite the same way as do storms, however super, over Los Angeles—if anything, they recall in the guise of fantasy the beaches of Normandy in World War II and filmic versions of that time and place, to which the film pays homage. Moreover, its nods to multiple genres corroborate its more lighthearted approach, even though it, too, involves life-and-death stakes. A hybrid, it mixes the intensity of an apocalyptic film with tropes from comedy and romance films. Its hijinks are combined with action sequences, but with dire potential consequences. Major William Cage (Tom Cruise) is sent to the battle's front lines against his will and is killed within minutes of entering the fray. His death is the result of blowing up an Alpha Mimic, whose blood, spilled over Cage in the explosion, contains some element that allows Cage to reset time when he dies, so that he relives that same day of combat multiple times and in each life gains tools the better to fight the invasion. From the first reset, he encounters Sergeant Rita Vrataski (Emily Blunt), "the Angel of Verdun," who for a time had the same condition and whom he comes to love through the several cycles of his death and rebirth. The mismatch of their personalities is a romantic element of the film; Cage's failure to progress, resulting in his multiple deaths, is the darkly comic element of the film. Much like Phil the weatherman in the romantic comedy *Groundhog Day* (Harold Ramis, 1993), Cage relives the same day again and again, experiencing exasperation, determination, or a sense of bewilderment about his predicament.

Unlike many of its counterparts, *Edge of Tomorrow* puts the emphasis on technology without lingering much on nature or landscapes of any kind. A few landmark spaces are glimpsed—from London's Waterloo bridge, one catches a flash of Big Ben, the London Eye, and the dome of St. Paul's cathedral as Cage watches the Mimics emerge from the Thames to take over the city; later, the Louvre is the site where the final battle takes place—but these landmarks are shown only very briefly and never dwelt upon or lavished with cinematographic attention. Glimmers of peaceful, natural, abandoned, and even exquisite landscapes appear but are short-lived to the extreme. Battle gear, machinery, and the temporal gimmick of the plot are instead put on display—action takes the place of contemplation of potential or real losses accrued by the apocalypse at the film's heart. Moreover, as we see, the film focuses on time and imagines an apocalypse that is immanent: it will arrive *tomorrow* if Cage is not successful at pulling himself together and becoming a man capable of fighting the battle and working with others by the end. The film uses a convention of romantic comedy (he must become worthy of the woman he loves) and laces it with the threat of apocalypse to ratchet up the stakes. Anyway, the world it envisions is already in such deep danger that the landscapes it imagines are on the verge of obliteration and so appear as a near afterthought.

The film's compulsion to repeat reflects its genre's experiments with innovation in the midst of familiarity. *Edge of Tomorrow* seems less interested in enlisting cinephilic engagement in that it neglects the exquisite imagery and space of reflection provided in many films of its ilk. However, it shows that consideration of time—its pressures and passage, its opening of new possibilities and its allowances for reworking past mistakes—functions as one of the key elements of the genre, even if mobilized for repetitive, comedic purposes. The third film inflected by the notion of tomorrow, *Tomorrowland*, also draws explicitly upon temporal motifs.

Tomorrowland's utopian eponym is a fantastical place where the world's most creative inventors and explorers gather together to invent and explore. The dreamy, space-age Tomorrowland characterized by its inventors' innovation soon gives way, however, to a future dark and full of dangers. One of the chosen residents (to be chosen, one is granted a

special pin that gives access to the place), a plucky kid named Frank Walker (Thomas Robinson), eventually invents a predictive device—a catastrophe-probability meter—that casts the future into doubt, a terrible bummer of an invention for which he is expelled from Tomorrowland. At the start of the film, the expelled Frank as an adult tells us that the meter predicts (with 100 percent certainty) the end of the world within fifty-eight days.

The catastrophe meter comprises a wall of monitors that show the destruction of the earth and humankind—news-type footage of glaciers melting, wars raging all over the planet, crops dying, and angry people stoking the planet's demise. These images recall the opening sequences of several films in this genre: both *World War Z* and *Edge of Tomorrow* begin with news coverage of destruction and violence rising. David Nix (Hugh Laurie), the ambiguous authority figure who presides over *Tomorrowland*, muses on these apocalyptic images, remarking to the now older Frank (George Clooney) that he would have thought the people of earth, inundated with such images, might *do* something about the impending apocalypse. But instead they eat these images up "like chocolate éclairs." It's not just apathy and humankind's inability to change that drives the end of the world: it's an active desire to see the destruction, a cinephilic predilection for the pleasures of extreme, destructive spectacle. Similarly, James Berger notes in his book *After the End: Representations of the Post-apocalypse* that one would think so many films featuring so much destruction shown in similar ways would get tedious. But for Berger, the sheer repetition of such effects suggests that we *need* to see our destruction—the thrilling relief of the idea of nonbeing—over and over in order to relieve certain individual and historical traumas.[50] Once is never enough, and the more complete (apocalyptic) the end, the better. The delicious ("chocolate éclair") images of destruction in *Tomorrowland* are numerous, drawing on the genre of the disaster film and the way it shows audiences the vivid, cathartic images they crave. Its most salient use of such images is the bank of monitors that show a highly mediated future—cities and homes demolished, floods, fire, and nature taking back the land damaged by human technology, greed, and folly.

Moreover, like most films in its genre, *Tomorrowland* counterpoises these awful images with splendid, technologically appealing, beautiful ones. The fantastic place Tomorrowland claims to be "of the future" but

looks more like a glowing, nostalgic past. It aims to become a soft, homey, and New Agey future rather than a technologically sleek, futuristic future. Technology in the worlds the film depicts is clean, lovely, and retro. And the parallel world that allows access to it is homey and nostalgic: all farmhouses and golden fields of wheat and corn. Moreover, these positive images of technology and a beautiful, balanced natural world touched by human ingenuity and need (the rural ideal of human habitation) depict a salve for the world's apocalyptic death drive. The heroine, Casey Newton (Britt Robertson), debunks the doom-saying device simply by refusing to accept its visions; her refusal causes a glitch in the device's absolute vision of the future, which results in its probability meter lowering the certainty of total destruction of the world by a single hundredth of a percent. But that's all it takes. In the end, Casey offers hope for the future by denying that its destruction is certain: she sends out other children of the world to bring change—through action and ideas and especially through inventive thinking (need I say: not dissimilar to that which wrought the probability meter)—to tomorrow.

As such, the film offers a slippery concatenation of positive and negative charges related to technology and nature, the city and the heartland, beauty and ugliness, and the past and the future. The film's use of spectacular effects and cinematic technology underpins Tomorrowland's provenance: cinema and Tomorrowland share Thomas Edison as one of their founding fathers.[51] Technology is depicted in contradictory ways: both as a beautiful thing, cast in the glow of nostalgia for a time when kids dreamed big and earnestly about the future, and as the cause of the problems plaguing tomorrow. Typical of the postmillennial apocalyptic narrative, technology spurs both anxiety and optimism; it both brings about doomsday and serves as its possible remedy. The film's treatment of video-surveillance systems, virtual-reality platforms, and televisual images underscores its paean and dirge to moving-image technologies. As such, Tomorrowland adumbrates a highly ambiguous stance relative to technology at large and to the cinema in particular as a machine of mediation.

Whatever tomorrow the postmillennial apocalyptic film might envision or destroy, its motivations, themes, and imagery tap into both the anxious and cinephilic impulses of the audience it addresses. These films both want and do not want destruction. It's a bit like when Stacker

Pentacost (Idris Elba) in *Pacific Rim* rallies those who will go out to fight the primordial creatures that threaten the world with extinction, exclaiming: "Today we face the monsters that are at our door. . . . Today we are cancelling the apocalypse!" These films call for and show states of apocalypse, but they also fight it through narrative acts of bravery and cinematic acts of exquisite imagery. They are creative: generating images and effects to visualize something that is very much on many minds in these once again, as ever, troubled times. They strive to make something out of the aftermath of something coming to an end, even if that thing is the cinema itself in what some have described as a "postcinematic age." These are big films, often meant to be seen on the biggest screens possible: several of them were initially released in IMAX or 3D formats. Their brokering of productive relationships between beautiful and desolate images and between the natural and the technological demonstrates the complexity with which such films address key dynamics of anxious cinephilia.

Anxious Times, Anxious Cinema

Through archival resources and a poetic, associative structure, Bill Morrison's film *Dawson City: Frozen Time* (2017) recounts the circumstances leading to the literal digging up of a repository of lost silent-film reels during an excavation of a construction site in Dawson City (in the northern Yukon Territory, just south of the Arctic Circle) in the late 1970s. It is a silent-film enthusiast's giddy dream of stumbling onto hidden treasure. Although it fixates on a much wider range of losses and potential losses that likewise attend cinema as it ages to the present, *Dawson City* begins with the shift from a predominantly silent cinema to one characterized by sound and then extends the matter to attendant historical issues relating to that change. For instance, the film focuses on the volatile nature of the town's rise and fall, the fires that threatened its structures and its nitrate film stock, and the vicissitudes of commercial investment from prospectors and vested, moneyed interests. The film documents the gold rush that led to Dawson City's development and recounts the improbable set of intersecting happenstances that led to recuperating a subset of the films once shown there. It intercuts this history with footage from the films found there, cleverly inserting their images to stand in for happenings in the town. For example, when someone in the narrative of the city's development writes a letter, the film cuts to multiple scenes taken from the films in which people are writing and receiving letters. Such a sequence prompts the question of what other

observable similarities among films might have been lost due to the dearth of surviving silent films from the first decades of film history.

The film reminds us on many levels just how precarious cinema's past is. Because the films were valued at less than the cost it would have taken to ship them back to the distributor, they were deemed disposable. Indeed, the citizens of Dawson City repurposed the films as part of the fill dirt that would level out the surface of a skating rink under which a defunct swimming pool lay. Further, as the film recalls, many more of the titles left behind in Dawson City were dumped into the Yukon River or burned in a nitrate pyre; all were considered refuse. Many other titles of course never made it to Dawson City at all and did not survive in other places. The staggering sense of loss this single site of destruction entails for film history (*Dawson City* puts the loss of all silent films at more than 75 percent)—as well as for history more generally—becomes the material of the film.

The film's material matters in two senses: its nostalgic content evokes a sense of loss, and its emphasis on the materiality of the film—flammable, disposable, and dirtied—is also its matter. The film displays stray bits of content from life in the Yukon to build a context for the existence of the buried film stash, and it focuses on the material of (dangerous, decaying) nitrate film as part of that content. That any films survived at all is presented as something of a miracle. For his own film, Morrison works not on nitrate, of course, but on digital scans of the Dawson City cache, which reiterates on another level a sense of the necessity of material change as part and parcel of cinema's testimony to the past. The change from nitrate to acetate celluloid occurs in near tandem with the change from silent to sound cinema and could readily serve as another example of how technological changes harken to a range of needs, whether aesthetic expansion, expediency, safety, or money. Loss, change, and the instability wrought by the passage of time are embedded in the entire mechanism of cinema, *Dawson City* suggests, and the film's own digital (im)materiality is one way of pointing to this fact.

As in much of Morrison's work, *Dawson City* mobilizes dynamics that bring the media past and present together, putting them in proximity to reveal things about both moments. That convergence points to key elements in my own larger project, which has sought to think about the media past and present together in order to underline the continuity of

anxiety as a foundation for relationships with the cinema. At some point as I was working on this project, I came to realize how frequently I turned to Jean Epstein to help me think through relationships with cinema in the past and, importantly, in the present. That makes sense because Epstein's writing and films have been a focus of my past research—we look for familiar terrain as we forge into the future—but it also derives from the fact that media history, like all history, has a tendency to certain cycles. Epstein speaks not only for his own time but also for ours. As we look to the future, it behooves us to reflect on the past and present (without discounting or throwing them out altogether) before turning to the many ways forward. Recognizing how much an anxious cinephilia has shaped every moment of cinema's history, pushing and pulling it in various directions and indelibly shaping the way people have come to understand cinema and to talk about it, forms an important touchstone for that media past and future. It suggests the necessity of taking into account diverse spectators' investments in moving images as a way of thinking through the nature of those images, the freighted relationships they compel, and the way multiple interests slow or speed their constant transformations. A relationship between desire and wariness, anxious cinephilia fuels cinema experiences and undergirds cinema's fluidity and multiplicity. What will the media of the future look like (smell like, feel like, be like)? As we have seen, the dynamics of cinephilia carry some hints.

A couple of afterthoughts linger as this project comes to a close. One of the ideas that shadowed this work all along is cinephobia, which I initially thought would be the counterpoint to cinephilia in this book. However, early on someone rightly pointed out that rather than being the ubiquitous, often subtle feeling that accompanies a wider range of relationships with the cinema that sits at the center of my sense of the intersection between anxiety and cinema, cinephobia seems to refer to a fear more specifically *of* the cinema. Although that may be true, the uncut potency of paranoia about cinema's powers would be a productive direction to follow that is related to but distinct from the direction this book has taken.[1]

Other issues have become more urgent recently and reflect the importance of tracking technological change as a sign of the nature of cinephilic relationships and of the cinema at large. Among them, the

continuation of shifts in the media landscape, especially streaming plat-
forms versus theatrical releases and the broader development of virtual-
reality technologies and uses, may cast new light on some of the issues
explored here. As Morrison's film proposes, film's nitrate past suggests
its ongoing instability (echoed by Paolo Cherchi Usai's circumspection
about the faith put in digital formats for preserving or even just storing
moving-image materials[2]), an instability undergirding anxious cinephilia
that may have found the most apt emblem yet in streaming formats. A
recent profile of filmmaker Ava DuVernay's upcoming projects, in which
she proposes that the future lies in streaming, as well as controversies
around the production of films for streaming platforms such as YouTube,
Netflix, and Amazon (and whether these platforms are more democratic
as delivery services) exemplify this issue and stoke similar responses to
those traced here.[3] Similarly, a recent preoccupation with collecting spe-
cifically *material* media (including DVDs) would seem to offer another
way of thinking of anxious cinephilia as growing out of a fear of loss that
is specifically tinged with a worry both about ownership and about a tac-
tile relationship with media in an age when streaming has become the
default for most consumers of home media. The issues with streaming—
from the fickle availability of films offered by those who administer
content (Netflix, Amazon, etc.) to buffering and image issues to licens-
ing limitations in different countries—portend a further loss of control
over possession of the elusive object of cinema for the cinephile. A new
level of ephemerality and impending disappearance is at stake in stream-
ing: the beloved nonobject of moving images becomes even more non-
object-like when their available content hovers in a cloud, unseeable and
potentially changing at this very minute without foreknowledge on the
part of the potential spectator. Regarding virtual reality, the unknowabil-
ity of how it will find purchase in quotidian media consumption might
also spark curiosity and some anxiety. As always, the constant is change,
but the specific changes illuminate different aspects of the issues raised
here. For instance, what will it mean to think of identification with oth-
ers in a virtual-reality landscape that more fully mimics individual sub-
jectivity, and what ramifications will that have for thinking about
amorous investments in moving images? All of these issues simply
suggest that there may well be more to do with the provenance, bound-
aries, and implications of cinephilia as time moves forward.

Finally, I want to end with a few thoughts on a remarkable short-form animation that premiered at the Oberhausen Festival in 2019, *Udahnut život / Imbued Life* (Ivana Bošnjak and Thomas Johnson, 2019). Somewhat eerily, the film resonates with several of the issues and even images raised here while also forging into new terrain. Quiet, beautiful, and disturbing, *Imbued Life* toes a line between the tools of animation and photorealism. It presents a taxidermist who cuts open animal skulls to reveal a film strip inside: she takes these film strips to a young photographer, who develops the images in his darkroom. When he returns the developed images to the taxidermist, she peruses them and tries to get closer to what they depict, touching the prints as if trying to access a vision of the world that is out of her reach. Each animal's film, pulled from its skull, includes a vision of the world represented by vivid blotches of color. In the images of the photos being developed, one recalls Thomas in *Blow-Up* trying to decipher a blurry blob in a park; the images of the woman touching the prints on a wall strongly resemble the same image of Matteo in *Broken Embraces* (figs. 0.2–0.5, fig. 5.1). In these resonances as well as in the film's attention to beautiful details of fingers rustling through fur, moving water, and melting film (also familiar to this study), *Imbued Life* seems at least obliquely to pay cinephilic homage and to mobilize some of the same concerns raised earlier about occupying others' point of view, but in a new register. That is, even as these familiar motifs and

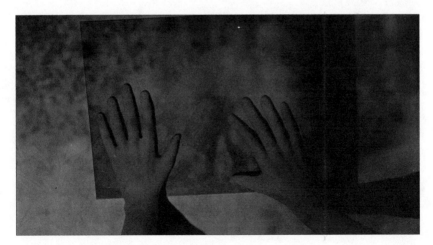

FIG. 5.1. *Udahnut život / Imbued Life* (Ivana Bošnjak and Thomas Johnson, 2019).

images uncannily reminded me of certain parameters of this project, it also struck me that animation may have a wholly different kind of role in mediating or mitigating or exacerbating cinephilia than the majority of the types of images considered to this point. For instance, Hannah Frank's frame-by-frame work on cel animation, seeking explanations in the imperceptible stillness of drawn and assembled still images, is both a cinephilic and an obsessive approach to such images.[4] What other elements of cinema unexplored as yet may help to illuminate engagements with cinema? What do the media and moving images of the future threaten and promise? It is my final wish here that this book may be of service to those who are the intrepid pursuers of ongoing obsessions and who follow their anxious hearts into the cinema, wherever it may be and howsoever it allows them to engage with moving images.

Notes

INTRODUCTION

1. The four columns produced were Mark Hughes, "If Digital Effects Ruin Movies, so Did Color and Sound," *New York Times*, March 8, 2013; Woody Schultz, "C.G.I. Has Inspired a New Era of Filmmaking," *New York Times*, March 12, 2013; Armond White, "Cinema Is About Humanity, Not Fireballs," *New York Times*, March 13, 2013; and Natalie Wolchover, "Beware of the Uncanny Valley," *New York Times*, March 8, 2013.

2. Trent Klaus, quoted in Wolchover, "Beware of the Uncanny Valley."

3. See Béla Balázs, *Theory of the Film* (1952; reprint, Oxford: Berghahn Books, 2017); Jacques Aumont, *Du visage au cinéma* (Paris: Éditions de l'étoile, 1992); and Noa Steimatsky, *The Face on Film* (Oxford: Oxford University Press, 2017).

4. David Bordwell, *Pandora's Digital Box: Films, Files, and the Future of Movies* (self-pub., 2014), 8, http://www.davidbordwell.net/books/pandora.php.

5. Bordwell, *Pandora's Digital Box*, 10–11.

6. See Christian Keathley, Jason Mittell, and Catherine Grant, *The Videographic Essay: Practice and Pedagogy* (http://videographicessay.org/works/videographic -essay/index) and Catherine Grant's webpage (https://catherinegrant.org /category/video-essays/), which includes listings of several sites for audiovisual/ video essays, including her own.

7. Susan Sontag, "The Decay of Cinema," *New York Times*, February 25, 1996.

8. Antoine de Baecque and Thierry Frémaux, "La cinéphilie, ou l'invention d'une culture," *Vingtième siècle: Revue d'histoire* 46, no. 1 (1995): 133–42. De Baecque

and Frémaux's article was published in the aftermath of a symposium they organized on the topic. Since then, Frémaux has been artistic director of the Cannes Film Festival, and both authors have been involved in the preservation of cinema. Like many writers on cinephilia, they focus first on postwar French cinephilia to sketch a comparison between that earlier cinephilia and the one they are in the process of living and advancing as advocates for contemporary cinephilia.

9. De Baecque and Frémaux, "La cinéphilie," 133.

10. De Baecque and Frémaux, "La cinéphilie," 134.

11. Christian Keathley, *Cinephilia and History, or The Wind in the Trees* (Bloomington: Indiana University Press, 2006). Keathley draws the term *counterfactual histories* from Thomas Elsaesser, "Louis Lumiére—the Cinema's First Virtualist?," in *Cinema Futures: Cain, Abel, or Cable,* ed. Thomas Elsaesser and Kay Hoffmann (Amsterdam: Amsterdam University Press, 1997), 47. Elsaesser subsequently developed the idea in his later book *Film History as Media Archeology* (Amsterdam: Amsterdam University Press, 2016).

12. In *Cinematic Flashes: Cinephilia and Classical Hollywood* (Bloomington: Indiana University Press, 2012), Rashna Wadia Richards notes that at moments of technological change in particular, films have openings that allow reading images more subjectively than according to the exigencies of the narrative system. See also Laura Mulvey, *Death 24x per Second: Stillness and the Moving Image* (London: Reaktion Books, 2006).

13. Keathley, *Cinephilia and History,* 134.

14. Marijke de Valck and Malte Hagener, "Introduction: Down with Cinephilia? Long Live Cinephilia? And Other Videosyncratic Pleasures," in *Cinephilia: Movies, Love, and Memory,* ed. Marijke de Valck and Malte Hagener (Amsterdam: Amsterdam University Press, 2005), 15.

15. Jacques Rancière's reading of *Histoire(s) du cinéma* demonstrates the power of building something new through the catalog of images that speak to a director as it allows Godard, in Rancière's mind, to "fashion a different 'history'" issuing forth from the detached metaphorical significance of each image cast together into new configurations: in so doing, "he constructs a cinema that never existed" (*The Emancipated Spectator* [London: Verso, 2009], 129–31).

16. Alifeleti Brown, "*Histoire(s) du cinéma,*" *Senses of Cinema* 46 (March 2008), http://sensesofcinema.com/2008/cteq/histoires-cinema/.

17. Nick Newman, "Christian Petzold Talks *Phoenix,* Flipping the *Vertigo* Perspective, and Letting Go of Auteurism." *Film Stage,* July 30, 2015, https://thefilmstage.com/features/christian-petzold-talks-phoenix-flipping-the-vertigo-perspective-and-letting-go-of-auteurism/.

18. Elena Gorfinkel, "The Future of Anachronism: Todd Haynes and the Magnificent Andersons," in *Cinephilia,* ed. de Valck and Hagener, 153.

19. Thomas Elsaesser, "Cinephilia, or the Uses of Disenchantment," in *Cinephilia*, ed. de Valck and Hagener, 40, 36. Similarly, Laurent Jullier and Jean-Marc Leveratto sketch three categories of cinephilia and discuss the historical, technological, and social trends that mark each. They characterize cinephilia in terms of shifts from a classical version (pre-1950), predicated on "expertise"; a modern version (1950–1980), predicated on the privatization of the film experience; and a postmodern version (1980–2010), in which the viewer controls the experience more completely ("Cinephilia in the Digital Age," in *Audiences: Defining and Researching Screen Entertainment Reception*, ed. Ian Christie [Amsterdam: Amsterdam University Press, 2012], 143–54).

20. Nico Baumbach, "All That Heaven Allows: What Is, or What Was Cinephilia?" *Film Comment* 48, no. 2 (March–April 2012): 48. Baumbach is responding to David Bordwell's article also in *Film Comment* a year earlier: David Bordwell, "Never the Twain Shall Meet: Why Can't Cinephiles and Academics Just Get Along?" *Film Comment* 47, no. 3 (May–June 2011): 38–41.

21. Elsaesser, "Cinephilia, or the Uses of Disenchantment," 38.

22. Elsaesser, "Cinephilia, or the Uses of Disenchantment," 27–28.

23. Elsaesser, "Cinephilia, or the Uses of Disenchantment," 39.

24. Belén Vidal, "Cinephilia Goes Global: Loving Cinema in the Post-cinematic Age," in *The Routledge Companion to World Cinema*, ed. Rob Stone, Paul Cooke, Stephanie Dennison, and Alex Marlow-Mann (New York: Routledge, 2017), 406–7.

25. Nicole Brenez, "For an Insubordinate (or Rebellious) History of Cinema," *Framework: The Journal of Cinema and Media* 50, nos. 1–2 (Spring–Fall 2009): 198.

26. Girish Shambu, *The New Cinephilia* (Montreal: Caboose Books, 2014). See also Shambu's blog, *girish*, http://girishshambu.blogspot.com/. Finally, for a sample of one of the several ongoing online cinephile activities taken up by this indefatigable cinephile, see the online journal Shambu edited with Adrian Martin, *Lola*, http://www.lolajournal.com/.

27. Project: New Cinephilia was an initiative by organizers of the Edinburgh International Film Festival 2011. It included a symposium onsite, essays written in advance (including Shambu's contribution), online discussions, library resources, and links via the forums on the MUBI website.

28. Girish Shambu, "Taken Up by Waves: The Experience of New Cinephilia," Project: New Cinephilia, May 23, 2011, https://projectcinephilia.mubi.com/2011/05/23/taken-up-by-waves-the-experience-of-new-cinephilia/.

29. De Valck and Hagener, "Introduction," 12.

30. Lucas Hilderbrand, "Cinematic Promiscuity: Cinephilia After Videophilia," *Framework: The Journal of Cinema and Media* 50, nos. 1–2 (Spring–Fall 2009): 217.

31. Lauren Berlant, *Desire/Love* (Brooklyn, NY: Punctum Books, 2012), 18.

32. Eugenie Brinkema, *The Forms of the Affects* (Durham, NC: Duke University Press, 2014), 34, 36.

33. Brinkema, *The Forms of the Affects*, 33, xv.

34. Brinkema, *The Forms of the Affects*, 37–38, emphasis in the original.

35. Mulvey, *Death 24x per Second*, 194–96.

36. Rancière, *The Emancipated Spectator*, 130.

37. Roland Barthes, *A Lover's Discourse: Fragments*, trans. Richard Howard (1977; reprint, New York: Hill & Wang, 2010).

38. Keen-eyed readers know homage when they see it. This echo of Jean Epstein's "Cinema Seen from Etna" (1926) (in *Jean Epstein: Critical Essays and New Translations*, ed. Sarah Keller and Jason N. Paul [Amsterdam: Amsterdam University Press, 2012], 287–92) raises the question of whether rhapsodic voices have a place in critical writing. Can the personal inform the theoretical? Or, actually, mustn't it? In any case, this allusion to Epstein's writing about cinema also confirms that the next point about the nature of cinephilia as tied to writing and other activities related to an experience of cinema are also crucial to this conception of cinephilia.

39. Laura U. Marks, "Loving a Disappearing Image," *Cinémas*, Fall 1997, 169. Interestingly, Marks builds on the notion of the disappearing image for reasons very different than trying to argue for the proper purview and dynamics of cinema in general, instead discussing surface, immersion, and identification in the context of images that are not implicated in human figuration.

40. Germaine Dulac, "The Expressive Techniques of the Cinema" (1924), in *French Film Theory & Criticism*, vol. 1: *1907–1929*, ed. Richard Abel (Princeton, NJ: Princeton University Press, 1988), 305–14.

41. Michael Cowan, "Learning to Love the Movies: Puzzles, Participation, and Cinephilia in Interwar European Film Magazines," *Film History* 27, no. 4 (2015): 1.

42. Shambu, "Taken Up by Waves."

43. Featuring varying lengths of short clips from moving images across history, *The Clock* assembles them according to their picturing of time pieces at the exact moments they are being screened. If you watch *The Clock* and see a watch that shows 3:35 p.m., the time you are watching it will also be 3:35 p.m. It runs twenty-four hours.

44. Cristina Álvarez López and Adrian Martin, "The One and the Many: Making Sense of Montage in the Audiovisual Essay," *The Audiovisual Essay: Practice and Theory of Videographic Film and Moving Image Studies*, September 2014, https://reframe.sussex.ac.uk/audiovisualessay/frankfurt-papers/cristina-alvarez-lopez-adrian-martin/, emphasis in the original.

45. Catherine Grant, "The Audiovisual Essay: My Favorite Things," *[in]Transition* 1, no. 3 (2014), http://mediacommons.futureofthebook.org/intransition/2014/09 /14/audiovisual-essay-my-favorite-things, emphasis in original.

46. Codruța Morari, " 'Equality Must Be Defended!': Cinephilia and Democracy," in *Distributions of the Sensible: Rancière, Between Aesthetics and Politics*, ed. Scott Durham and Dilip Gaonkar (Evanston, IL: Northwestern University Press, 2019), 100.

47. Henry Jenkins, Sam Ford, and Joshua Green, *Spreadable Media: Creating Value and Meaning in a Networked Culture* (New York: New York University Press, 2012), 1.

48. The difference between fans and cinephiles is not a focus of this study, nor does this difference seem to occupy much of the literature about either group. For one discussion of how they merge, see Wikanda Promkhuntong, "Cinephiles, Music Fans, and Film Auteur(s): Transcultural Taste Cultures Surrounding Mashups of Wong Kar Wai's Movies on YouTube," *Participations: Journal of Audience and Reception Studies* 12, no. 2 (November 2015): 255–74. Also Soyoung Kim's study of film festivals and cinemania offers discussion of similar intersections between what might be more properly considered fans (part of South Korea's new— since the 1990s—"cinemania") or cinephiles ("'Cinemania' or Cinephilia: Film Festivals and the Identity Question," in *New Korean Cinema*, ed. Chi-Yun Shin and Julian Stringer [Edinburgh: Edinburgh University Press, 2005], 79–92).

49. In their introduction to a dossier of essays on cinephilia in the journal *Framework* (2009), Elena Gorfinkel and Jonathan Buchsbaum note the shift in the tension between the "solitary, private act of communion" and the "public formation of collective energies" from classical formations of cinephilia (polemical) to the present (interested in but struggling to build community) (Jonathan Buchsbaum and Elena Gorfinkel, "Introduction," Cinephilia Dossier *Framework: The Journal of Cinema and Media* 50, no. 1 [2009]: 178).

50. Laura Mulvey, "Some Reflections on the Cinephilia Question," *Framework: The Journal of Cinema and Media* 50, nos. 1–2 (Spring–Fall 2009): 190.

51. Mary Ann Doane has described how cinema has contributed to shaping a modern sense of time; in that shape she identifies the "fears, desires, anxieties, and pleasures attached to the idea of the mechanical representability of time" that parallel the entire history of cinema from the moment of its invention. Further, she takes the notion of cinephilia to be a reflex against such mechanicality because it includes more of the "contingent" and the "desire, pleasure, anxiety, and lure" missing in other representations (*The Emergence of Cinematic Time: Modernity, Contingency, the Archive* [Cambridge, MA: Harvard University Press, 2002], 1, 239).

52. Jenna Ng, "The Myth of Total Cinephilia," *Cinema Journal* 49, no. 2 (Winter 2010): 149.

53. André Bazin, "The Ontology of the Photographic Image" (1945), in *What Is Cinema?*, vol. 1, trans. Hugh Gray (Berkeley: University of California Press, 2004), 9, 10.

54. Bazin, "The Ontology of the Photographic Image," 14, 15.

55. Phil Rosen, *Change Mummified: Cinema, Historicity, Theory* (Minneapolis: University of Minnesota Press, 2001), 28–29. Rosen argues that both subject and object in this situation are threatened because of this paradox. "It is in order to deal with the continual onset of the future, which holds material death, that an investment in freezing the past is incorporated into the desires and imaginative projections involved in Bazin's cherished realism" (28–29).

56. Rosen, *Change Mummified*, 41.

57. Mulvey, *Death 24x per Second*, 11.

58. Mulvey, *Death 24x per Second*, 173.

59. Mulvey, *Death 24x per Second*, 67.

60. Cinema studies scholars have comprehensively addressed some of these variations on anxiety in other contexts; for instance, see Kristen Moana Thompson, *Apocalyptic Dread: American Film at the Turn of the Millennium* (Albany: State University of New York Press, 2007).

61. For Neta Alexander, one insight into the state of anxiety is that it derives from "a specific logic or structure of meaning in our relation to our world." That is, drawing on a manifesto published online by the Institute for Precarious Consciousness, she notes the ways that neoliberalism creates perpetual anxiety in order to generate complacent users of technologies ("Rage Against the Machine: Buffering, Noise, and Perpetual Anxiety in the Age of Connected Viewing," *Cinema Journal* 56, no. 2 [Winter 2017]: 1–24). Also see Plan C's website, to which Alexander responds: WEAREPLANC, "We Are All Very Anxious: Six Theses on Anxiety and Why It Is Effectively Preventing Militancy, and One Possible Strategy for Overcoming It," Plan C, April 4, 2014, https://www.weareplanc.org/blog/we-are-all-very-anxious/.

62. I have in the past loosely termed anxiety's relationship with cinema "cinephobia." See Sarah Keller, "Cinephobia: To Wonder, to Worry," *Lola* 5 (2014), http://www.lolajournal.com/5/cinephobia.html.

63. See, for example, Dudley Andrew, *What Cinema Is!* (Oxford: Wiley-Blackwell, 2010).

64. Sigmund Freud, *Beyond the Pleasure Principle* (1920), trans. James Strachey (New York: Liveright, 1961).

65. Jean Epstein, "Magnification," *October* 3 (Spring 1977): 14.

66. Berlant, *Desire/Love*, 20. Berlant's consideration of fear in relation to desire and love is centered in political considerations related to sexual and social normativities—for example, "To the phobic—those who fear instabilities of privilege and embrace the social as a site of sameness, non-normative sexualities threaten fantasies of the good life that are anchored to images of racial, religious, class, and national mono-culture" (21–22).

67. A large subfield of media research connected to psychology has emerged in particular related to video games and virtual reality. It focuses on issues associated with a sense of being in a media environment (spatial presence) or connecting to a character's thoughts, emotions, demeanor, and so on (experience taking). These positions have obvious connections to studies of immersion and film experience such as in Ariel Rogers, *Cinematic Appeals: The Experience of New Movie Technologies* (New York: Columbia University Press, 2013). For thoughts on the psychological perspective, see Rosa Maria Baños, Cristina Botella, and Mariano Luis Alcañiz Raya, "Immersion and Emotion: Their Impact on the Sense of Presence." *Cyberpsychology & Behavior* 7, no. 6 (2004): 734–41, and Tilo Hartman, Werner Werth, Peter Vorderer, Christoph Klimmt, Holger Schramm, and Saskia Böcking, "Spatial Presence Theory: State of the Art and Challenges Ahead," in *Immersed in Media: Telepresence Theory, Measurement, and Technology*, ed. Matthew Lombard, Frank Biocca, Jonathan Freeman, Wijnand IJsselsteijn, and Rachel J. Schaevitz (New York: Springer, 2015), 115–35.

68. I refer to George Lucas's alterations of the first set of *Star Wars* films, episodes 4–6, after their initial release. For instance, he added scenes and changed special effects.

69. Almodóvar's presence is further signaled in the opening shots of the film, which show Cruz and Homar taking the place of their stand-ins.

70. Barthes, *A Lover's Discourse*, 132.

71. Jean Epstein, "Cinema and Modern Literature" (1921), in *Jean Epstein*, ed. Keller and Paul, 272–73, under the heading "The Aesthetics of Proximity."

72. Pedro Almodóvar, quoted in Lauren Turner, "Cannes Film Festival: Will Smith and Pedro Almodóvar Clash Over Netflix," BBC News, http://www.bbc.com/news/entertainment-arts-39954563.

73. Javier Herrera, "Almodóvar's Stolen Images," in *A Companion to Pedro Almodóvar*, ed. Martin D'Lugo and Kathleen M. Vernon (New York: Wiley, 2013), 358.

1. ARDOR AND ANXIETY: THE HISTORY OF CINEPHILIA

1. Girish Shambu, *The New Cinephilia* (Montreal: Caboose Books, 2014), 42.

2. Christian Metz, *The Imaginary Signifier: Psychoanalysis and the Cinema* (Bloomington: Indiana University Press, 1977), 13.

3. Metz, *The Imaginary Signifier*, 11, emphasis in original.

4. See "The Nickelodeon as a Business Proposition," *Moving Picture World* 3, no. 4 (July 25, 1908): 62.

5. Thomas Elsaesser reminds us that protocinematic devices do not develop in a straight line but that "cinema's past as well as its future [are] . . . embedded in other media practices, other technologies, other social uses," a useful reminder that places the temporal aspects of media development in line with cinephilia's similarly jagged development (*Film History as Media Archaeology* [Amsterdam: Amsterdam University Press, 2016], 19).

6. See X. Theodore Barber, "Phantasmagorical Wonders: The Magic Lantern Ghost Show in Nineteenth-Century America," *Film History* 3, no. 2 (1989): 73–86.

7. Barber describes the appeal of the phantasmagorical shows in "Phantasmagorical Wonders." In *The Great Art of Light and Shadow: Archaeology of the Cinema* (Exeter, UK: University of Exeter Press, 2000), Laurent Mannoni and Richard Crangle detail several precinematic attractions and their address to audiences.

8. Tom Gunning, "An Aesthetic of Astonishment: Early Film and the (In)Credulous Spectator," in *Viewing Positions: Ways of Seeing Film*, ed. Linda Williams (New Brunswick, NJ: Rutgers University Press, 1995), 114–33.

9. Tom Gunning, "The Cinema of Attractions: Early Film, Its Spectator, and the Avant-Garde," in *Early Cinema: Space, Frame, Narrative*, ed. Thomas Elsaesser (London: British Film Institute, 1990): 58–59.

10. These qualities later inspired feminist film theorist Lucy Fischer to argue that Méliès's disappearing of women speaks to male domination over female bodies ("The Lady Vanishes: Women, Magic, and the Movies," *Film Quarterly* 33, no. 1 [Fall 1979]: 30–40).

11. Karen Beckman, *Vanishing Women* (Durham, NC: Duke University Press, 2007), 6, 3–15.

12. Gunning, "An Aesthetics of Astonishment," 116, 118.

13. Devices such as the zoetrope provided the illusion of moving images, but the mobilizing of a larger projected image seems to have made a stronger impression.

14. Maxim Gorky, "Lumière Cinematograph (Extracts)," in *The Film Factory: Russian and Soviet Cinema in Documents 1896–1939*, ed. Richard Taylor and Ian Christie (New York: Routledge, 1988), 25–26. Interestingly, this response hints at a frame of mind *avant la lettre* kindred to André Bazin, "Myth of Total Cinema" (1946), in *What Is Cinema?*, vol. 1, trans. Hugh Gray (Berkeley: University of California Press, 2004), 17–22.

15. These "repeaters" should not be confused with "repeaters" in the sense of packages of films sent out by distributors who guaranteed that there would be no repeats of films they had already shipped in the past to the same exhibitor.

16. "The Nickelodeon as a Business Proposition," 62.

17. It is not coincidental that the propensity for narrative cinema to conduct various kinds of ideological work on spectators was both praised and blamed as narrative took root as a dominant form for cinema.

18. *Falsely Accused* (Biograph, 1908). Interestingly the murderer is caught because, unbeknownst to him, a cinematograph captures the murder, connecting this film to the recurring theme in film history of cameras and surveillance within films, a theme taken up in chapter 2.

19. *Rescued from an Eagle's Nest* (Edison, 1908), codirected by Edwin Porter and J. Searle Dawley, has made a mark in film history as it is credited with being the first film in which director D. W. Griffith appears as an actor. Griffith's first directorial effort would come later the same year.

20. C. Scott Combs, *Deathwatch: American Film, Technology, and the End of Life* (New York: Columbia University Press, 2014), 17, 16.

21. Michael Brooke, "1909 Cinematograph Act," *BFI Screen* online, n.d., http://www.screenonline.org.uk/film/id/593589/.

22. Lee Grieveson, *Policing Cinema: Movies and Censorship in Early Twentieth-Century America* (Berkeley: University of California Press, 2004), 5.

23. See, for example, John M. Bradlet, "A Tour Amongst Country Exhibitors," *Moving Picture World* 4, no. 6 (February 6, 1909): 143, and "Censors See 18,000 Feet of Films," *Moving Picture World* 4, no. 13 (March 27, 1909): 365.

24. See Miriam Bratu Hansen, *Babel & Babylon* (Cambridge, MA: Harvard University Press, 1994); Allyson Nadia Field, *Uplift Cinema: The Emergence of African American Film and the Possibility of Black Modernity* (Durham, NC: Duke University Press, 2015); and Scott Curtis, *The Shape of Spectatorship: Art, Science, and Early Cinema in Germany* (New York: Columbia University Press, 2015) for accounts of reform movements and concerns regarding the bodily, social, and ideological effects of moving pictures on female, black, and German audiences, respectively, and cinema's capacity for social uplift in each context.

25. Hansen, *Babel & Babylon*, 118–19.

26. For example, see Rosanna Maule and Catherine Russell, "Another Cinephilia: Women's Cinema in the 1920s," *Framework* 46, no. 1 (Spring 2005): 51–129; Amelie Hastie, *Cupboards of Curiosity: Women, Recollection, and Film History* (Durham, NC: Duke University Press, 2007); Paula Amad, *Counter-Archive: Film, the Everyday, and Albert Kahn's Archives de la planète* (New York: Columbia University Press, 2010); and Annie Fee, "Gender, Class, and Cinephilia: Parisian Cinema Cultures, 1918–1925," PhD diss., University of Washington, 2015.

27. Paula Amad, "Objects Became Witnesses: Ève Francis and the Emergence of French Cinephilia and Film Criticism," *Framework* 46, no. 1 (Spring 2005): 56–73.

28. Hansen, *Babel & Babylon*, 114–23.

29. F. H. Richardson, "A Few Pertinent Comments," *Moving Picture World* 4, no. 8 (February 20, 1909): 196. Richardson advocated for the production of more "cheerful" films by the industry.

30. One of the few scholars to connect the 1920s and later cinephilia, Keathley has remarked on the importance of this period for notions of cinephilia more broadly (see *Cinephilia and History*, e.g., 5, 116). Paula Amad has also identified a "first wave" of cinephilia in writings about *photogénie* in the 1910s and 1920s—a cinephilia inflected by female participation ("Objects Became Witnesses," 57).

31. Filmmakers and writers' raptures about film in this period have been well documented. See Sarah Keller and Jason N. Paul, eds., *Jean Epstein: Critical Essays and New Translations* (Amsterdam: Amsterdam University Press, 2012), which includes both essays by Epstein and essays on Epstein; Tami Williams, *Germaine Dulac: A Cinema of Sensations* (Urbana: University of Illinois Press, 2014); and Richard Abel, ed., *French Film Theory and Criticism*, vol. 1: *1907–1929* (Princeton, NJ: Princeton University Press, 1988).

32. Fee, "Gender, Class, and Cinephilia," 6. Fee shows that the often exclusionary nature of the cinephilia that developed in the 1920s was not arbitrary. It was tied up with self-interested aims, "a symptom of a struggling industry seeking tax breaks and financial security by exploiting the widespread desire in elite circles for a restoration of national pride in the difficult post-war years."

33. Regarding the development of this early cinema culture, see Richard Abel, *The Ciné Goes to Town: French Cinema, 1896–1914* (Berkeley: University of California Press, 1994), 9–58, and *French Cinema: The First Wave, 1915–1929* (Princeton, NJ: Princeton University Press, 1984), 251–60, as well as Christophe Gautier, *La passion du cinéma: Cinéphiles, ciné-clubs et salles spécialisées à Paris de 1920 à 1929* (Paris: Association française de recherche sur l'histoire du cinéma, 1999).

34. See Germaine Dulac, "Aesthetics, Obstacles, Integral Cinégraphie" (1928), in *French Film Theory & Criticism*, ed. Abel, 1:389–97.

35. Leila Wimmer, "Parisian Cinephiles and the Mac-Mahon," in *Paris in the Cinema: Beyond the Flaneur* (London: Bloomsbury, 2018), 114.

36. In my essay "Jean Epstein's Documentary Cinephilia," *Studies in French Cinema* 12, no. 2 (July): 91–105, it was the sense of a need for a corrective force regarding Epstein's cinephilia that began the project of thinking about cinematic anxieties. It may be that the same issue inheres in Malcolm Turvey's suspicion of Epstein's "revelatory" thesis: that such ecstasies about the cinematic object prompt the need for a counterweight to balance them. See Malcolm Turvey, *Doubting Vision: Film and the Revelationist Tradition* (Oxford: Oxford University Press, 2008).

37. Jean Epstein, "Cinema and Modern Literature" (1921), in *Jean Epstein*, ed. Keller and Paul, 272, under the heading "Aesthetic of Mental Quickness." See pages 271–79 in *Jean Epstein* for an introduction to these early written works by Epstein about the cinema.

38. Jean Epstein, "Magnification" (1921), in *French Film Theory & Criticism*, ed. Abel, 1:235.

39. Epstein discusses these aspects of cinema especially in later writings. For instance, in an essay published in *Ésprit de cinéma* in 1955, he remarks: "We are used to mentally re-working the data obtained through our normal vision range, to correcting what we call our innumerable optical illusions so as to build a notion of a sound, straight, homogeneous space where we can orient ourselves following Euclidean rules. Transposing this habit, as different fields materialize on the screen, we automatically and unconsciously try to regroup them into a coherent whole within our classing space" ("*Ésprit de cinéma*," in *Jean Epstein*, ed. Keller and Paul, 346–47).

40. Stuart Liebman, "Novelty and Poiesis in the Early Writings of Jean Epstein," in *Jean Epstein*, ed. Keller and Paul, 81.

41. Jean Epstein, "The Slow Motion of Sound" (1948), in *Jean Epstein*, ed. Keller and Paul, 382.

42. Tom Gunning, preface to *Jean Epstein*, ed. Keller and Paul, 20.

43. The Club des amis du septième art was founded by Ricciotto Canudo in 1921. Dulac initially served as vice president, along with Abel Gance.

44. Williams, *Germaine Dulac*, 72.

45. Journals such as *Cinéa* broadly appealed to *cinéastes* and *cinéphiles* for their readership and subscribers; see, for example, *Cinéa* 49 (April 14, 1922): inner cover.

46. Germaine Dulac, "La création d'un vocabulaire cinématographique," letter to *L'echo de Paris*, April 12, 1922, 5.

47. Karine Abadie, "Penser le cinéma contre le cinéma: L'importance de la cinéphobie dans les discours sur le cinéma en France, dans les années 1910 et 1920,' " Film Studies Association of Canada Congress, panel "Élaborer les rejets médiatiques des années 1910 à aujourd'hui," May 29, 2017, Toronto.

48. Ricciotto Canudo, quoted in "Pour et contre un vocabulaire cinématographique," *L'echo de Paris*, May 26, 1922, 5.

49. Dulac, "La création d'un vocabulaire," 5. See also Germaine Dulac, "Avez-vous peur de cinéma," a short reflection Dulac published in the inaugural issue of *Du cinéma*, December 1, 1928, in which she declares: "I have never had fear of the future [life] . . . of unknown worlds" (quoted in Jennifer Wild, " 'Are You Afraid of the Cinema': *Du Cinema* and the Changing Question of Cinephilia and the Avant-Garde [1928–1930]," *AmeriQuests* 12, no. 1 [2015]: 14).

50. Abadie, "Penser le cinéma."

51. Germaine Dulac, "Tout film ressort d'une esthétique" (1926), in *Écrits sur le cinéma (1919–1937)* (Paris: Éditions Paris expérimental, 1994), 68.

52. In his work on early German film societies, which featured significant memberships, Cowan explores the ways in which cinephilic activity was tied to other cultural discourses, including a rage for popular science and puzzles, both of which may have helped audiences to be savvier viewers of films. See Michael Cowan, "Learning to Love Movies: Puzzles, Participation, and Cinephilia in Interwar European Film Magazines," *Film History* 27, no. 4 (2015): 1–45.

53. Katharina Loew has traced how the development of film techniques in German silent cinema were tied to debates about romanticism and a strain of German thought associated with literature, philosophy, and aesthetic debates. See Katharina Loew, "Techno-romanticism: Special Effects in German Fantastic Films of the Silent Era," PhD diss., University of Chicago, 2011.

54. These tensions led to early expressions of cinephilia versus cinephobia: the latter in the idea that impressionable audiences should be kept out of cinemas for fear of the harm done within them (potential physical and mental harm, both of which are associated with the darkness of movie theaters).

55. Walter Benjamin, "Reply to Oscar A. H. Schmitz," *Die literarische Welt*, March 11, 1927, quoted in Miriam Bratu Hansen, "'Of Lightning Rods, Prisms, and Forgotten Scissors': *Potemkin* and German Film Theory," *New German Critique* 95 (Spring–Summer 1995): 162. The same phrasing appears later in Walter Benjamin, "The Work of Art in the Age of Its Technological Reproducibility: Second Version" (1935–1936), in Walter Benjamin, *The Work of Art in the Age of Its Technological Reproducibility and Other Writings on Media*, ed. Michael W. Jennings, Brigid Doherty, and Thomas Y. Levin (Cambridge, MA: Belknap Press of Harvard University Press, 2008), 37.

56. Miriam Bratu Hansen, "Benjamin and Cinema: Not a One-Way Street," *Critical Inquiry* 25, no. 2 (Winter 1999): 317. Importantly, Benjamin's innervation does not promise to return a subject to a pretechnological, natural state but to transform her, at least in part through the powers of imagination and play. For a discussion of Benjamin's sense of innervation, see Miriam Bratu Hansen, *Cinema and Experience* (Berkeley: University of California Press, 2012), esp. chap. 5 ("Mistaking the Moon for a Ball"). See also Miriam Bratu Hansen, "Room for Play: Benjamin's Gamble with Cinema," *October* 109 (Summer 2004): 3–45.

57. Ben Singer, *Melodrama and Modernity: Early Sensational Cinema and Its Contexts* (New York: Columbia University Press, 2001), 103.

58. Will Scheller, "The New Illusion" (1913), in *The Promise of Cinema: German Film Theory 1907–1933*, ed. Anton Kaes, Nicholas Baer, and Michael Cowan (Berkeley: University of California Press, 2016), 197.

59. Milena Jesenská, "Cinema" (1920), in *The Promise of Cinema*, ed. Kaes, Baer, and Cowan, 164–66.

60. Wilhelm Stapel, "Homo cinematicus" (1919), in *The Promise of Cinema*, ed. Kaes, Baer, and Cowan, 242–43.

61. Zhang Zhen, *An Amorous History of the Silver Screen: Shanghai Cinema 1896– 1937* (Chicago: University of Chicago Press, 2005), 73.

62. Weihong Bao's research has detailed the emergence and significance of several of these debates. For instance, Bao analyzes the New Film Culture movement's dynamics as well as the backgrounds of the authors who contributed ink to its key debates. See *Fiery Cinema: The Emergence of an Affective Medium in China, 1915–1945* (Minneapolis: University of Minnesota Press, 2015), 173–82. For further analysis of the influence of Soviet montage in China from the 1940s and 1950s, see Jessica Ka Yee Chan, "Translating 'Montage': The Discreet Attractions of Soviet Montage for Chinese Revolutionary Cinema," *Journal of Chinese Cinemas* 5, no. 3 (2011): 197–218.

63. Miriam Bratu Hansen, "Fallen Women, Rising Stars, New Horizons: Shanghai Silent Film as Vernacular Modernism." *Film Quarterly* 54, no. 1 (Autumn 2000): 14.

64. Hansen, "Fallen Women," 16.

65. Ling Zhang, "Shen and Cinema in 1930s Shanghai," *CLCWeb: Comparative Literature and Culture* 15, no. 2 (2013), https://doi.org/10.7771/1481-4374.2226.

66. Francesco Casetti's edited collection *Early Film Theories in Italy, 1896–1922* (Amsterdam: Amsterdam University Press, 2017) reflects his interest in cinephobia by bringing many such articles together in one place.

67. See, for instance, Fernando Ramos Arenas, "From Stalinism to Cinephilia: The Emergence of East German Film Culture in the 1950s," *Historical Journal of Film, Radio, and Television* 39, no. 2 (February 2019): 271–89; Abhija Ghosh, "Memories of Action: Tracing Film Society Cinephilia in India," *BioScope: South Asian Screen Studies* 9, no. 2 (January 2019): 137–64.

68. Thomas Elsaesser, "Cinephilia, or the Uses of Disenchantment," in *Cinephilia: Movies, Love, and Memory*, ed. Marijke de Valck and Malte Hagener (Amsterdam: Amsterdam University Press, 2005), 31.

69. Malte Hagener, "Cinephilia in the Age of the Post-cinematographic," *Photogénie*, February 10, 2015, https://cinea.be/cinephilia-the-age-the-post-cinematographic/.

70. Fee, "Gender, Class, and Cinephilia," 1. Fee describes a pair of similar roundtables in France in the 2010s that focused on the dangers of new cinephilias that are too inclusive. Reporting on the roundtable "Cinémathèques et cinéphilies de demain" organized by the Centre national du cinéma and the Cinémathèque française, she remarks: "A tangible anxiety could be felt as major academic and

institutional figures of cinephilia lamented the 'pollution of cinephile institutions,' the 'tribalization' of cinema publics and the impending extinction of the cinephile canon because the new generation failed to recognize the established chefs d'oeuvre" (2–3).

71. The repetition is understandable, considering the context (the panel was organized in cooperation with French Cultural Services in the United States, the Centre national du cinéma, and the French/Francophone Scholarly Interest Group) as well as the invited speakers' focus on France.

72. Michel Ciment, comment in "Cinephilia Today," special session held at the Society for Cinema and Media Studies annual conference, March 2017, Chicago.

73. See Antoine de Baecque, "Bazin in Combat," in *Opening Bazin: Postwar Film Theory & Its Afterlife*, ed. Dudley Andrew (Oxford: Oxford University Press, 2011), 228–30.

74. The model of medium-specific investment is spelled out for cinephilia more generally, drawn obliquely from this period, in Martin Barker, "Crossing Out the Audience," in *Audiences: Defining and Researching Screen Entertainment Reception*, ed. Ian Christie (Amsterdam: Amsterdam University Press, 2012), 203–5.

75. Michel Marie, *The French New Wave: An Artistic School*, trans. Richard Neupert (Oxford: Wiley Blackwell, 2003), 16. As Alan Williams has put it, although films after around 1962 are not New Wave, strictly speaking, using the terminology "post–New Wave" to describe them "has the advantage of following up, and extending, the label's founding metaphor. Waves, after all, crest and break, retreating back into the sea from whence they came" (*Republic of Images: A History of French Filmmaking* [Cambridge, MA: Harvard University Press, 1992], 328).

76. André Bazin, "The Death of Humphrey Bogart" (1957), in *Cahiers du cinéma: The 1950s: Neo-realism, Hollywood, New Wave*, rev. ed., ed. Jim Hillier (Cambridge, MA: Harvard University Press, 1985), 98–101.

77. André Bazin, Jacques Doniol-Valcroze, Pierre Kast, Roger Leenhardt, Jacques Rivette, and Eric Rohmer, "Six Characters in Search of *Auteurs*: A Discussion of French Cinema" (1957), in *Cahiers du Cinéma: The 1950s*, ed. Hillier, 40.

78. Geneviève Sellier, *Masculine Singular: French New Wave Cinema* (Durham, NC: Duke University Press, 2008).

79. Mattias Frey, *The Permanent Crisis of Film Criticism: The Anxiety of Authority* (Amsterdam: Amsterdam University Press, 2015), 17. See, too, Frey's earlier work on cinephilia, *Postwall German Cinema: History, Film History, and Cinephilia* (London: Berghahn, 2013).

80. Thomas Elsaesser has suggested as much in "Cinephilia, or the Uses of Disenchantment," and Nico Baumbach has discussed the matter in detail in "All That

Heaven Allows: What Is, or What Was, Cinephilia?," *Film Comment* 48, no. 2 (March–April 2012): 47–53.

81. Jacques Rivette, "The Genius of Howard Hawks" (1953), in *Cahiers du Cinéma: The 1950s*, ed. Hillier, 126.

82. Marie, *The French New Wave*, 16.

83. James Chapman, *Cinemas of the World: Film and Society from 1895 to the Present* (London: Reaktion, 2003), 236.

84. See Phillippe Garnier, "Dorothy Arzner: Une femme dans un monde d'hommes," n.d., http://www.cinematheque.fr/cycle/dorothy-arzner-378.html. Judith Mayne's response to Garnier's essay, "Scandale! Dorothy Arzner in Paris," *Film Quarterly*, Quorum, July 12, 2017, https://filmquarterly.org/2017/07/12/scandale -dorothy-arzner-in-paris/, cites an article in *Buzzfeed* that reports that only six retrospectives dedicated to female directors have been sponsored at the Cinémathèque in the past twelve years versus close to three hundred dedicated to male directors (see "En 11 ans, il n'y a eu que 6 rétrospectives de réalisatrices à la Cinémathèque," *Buzzfeed*, February 20, 2017, https://www.buzzfeed.com /mariekirschen/en-11-ans-il-ny-a-eu-que-6-retrospectives-de-realisatrices-a ?utm_term=.kvG91GRpX#.mcOMo1VX7).

85. Mayne, "Scandale!"

86. Mayne, "Scandale!" The respective illustrations for each online account of Arzner—scantily clad chorus girls in a still frame from *Wild Party* (Arzner, 1929) for Garnier's article versus Arzner gripping a camera on set for Mayne's article—also seem to underline each writer's diverse aims.

87. Hugo J. Ríos-Cordero, "Permutations of Cinephilia: Aesthetics, Technology, and Social Consciousness," PhD diss., Rutgers University, 2016.

88. Adrian Martin, "Cinephilia as War Machine," *Framework: The Journal of Cinema and Media* 50, nos. 1–2 (Spring–Fall 2009): 222.

89. For discussion of the interplay of national and international concerns as addressed in the major film festivals, see Marijke De Valck, *Film Festivals: From European Geopolitics to Global Cinephilia* (Amsterdam: Amsterdam University Press, 2007), 24.

90. For some discussion of these issues, see Kristin Thompson, "National or International Films? The European Debate During the 1920s," *Film History* 8, no. 3 (1996): 281–96.

91. Ian Rae and Jessica Thom, "The Rise and Fall of the Stratford International Film Festival," *Canadian Journal of Film Studies* 25, no. 1 (Spring 2016): 67–87.

92. Soyoung Kim, "'Cine-mania' or Cinephilia: Film Festivals and the Identity Question," in *New Korean Cinema*, ed. Chi-Yun Shin and Julian Stringer (Edinburgh: Edinburgh University Press, 2005), 86–87.

93. Boston Asian American Film Festival website, http://www.baaff.org/.

94. Cindy Hing-Yuk Wong, *Film Festivals: Culture, People, and Power on the Global Screen* (New Brunswick, NJ: Rutgers University Press, 2011), 199–202.

95. For a detailed analysis of the strategy and struggles of the Stratford International Film Festival, see Rae and Thom, "Rise and Fall."

96. The Festival de Cannes website keeps a history of the festival detailing its establishment in 1939 as prompted by Philippe Erlanger to "[vie] with the Mostra to counter the Fascist threat" and "offer the world a festival that was free of pressure and constraints" (https://www.festival-cannes.com/en/69-editions /history#).

97. Festival de Cannes website.

98. Edith Laurie, "Notes from the Venice Film Festival," *Film Comment* 1, no. 3 (1962): 12.

99. Tobias Grey, "Flashback: Cannes 1968," *Variety*, May 8, 2008, https://variety.com /2008/film/markets-festivals/flashback-cannes-1968–1117985372/.

100. Quoted in Grey, "Flashback."

101. The Cannes categories include "Un certain regard," which highlights "works that have an original aim and aesthetic, and are guaranteed to make a discreet but strong impact on screens around the world"; a shorts category; and the "Village International," which provides space for sixty nations to showcase their film industries. Meanwhile, noncompetitive selections in the Cannes Classics section include older films and hagiographic documentaries on film history.

102. Netflix was effectively running counter to the French cultural exception, which mandates in France the collection of a percentage of a film's box office, DVD release, television, and streaming revenue to help finance French films.

103. Will Smith and Pedro Almodóvar, quoted in Ramin Setoodeh, "Will Smith Defends Netflix at Heated Cannes Jury Press Conference," *Variety*, May 17, 2017.

104. Valeriya Safronova, "Protest, Glamour, and Drama: 11 Snapshots from the Cannes Red Carpet," *New York Times*, May 18, 2018.

105. Safronova, "Protest, Glamour, and Drama."

106. Annette Michelson has outlined the role of the cinephilia's "oppositional . . . transgressive impulse" that was demonstrated in the development of independent cinema networks in the United States in the 1960s as a result of the New Wave's influence across an ocean ("Gnosis and Iconoclasm: A Case Study of Cinephilia," *October* 83 [Winter 1998]: 3–18).

107. There are precedents for blurring the line between these camps, which include the cinephiles of the postwar French milieu, who, energized by the flood of genre films into Paris after the war, focused their deep admiration in these films, which inspired praise in print. The very mission of their encomiums was to remedy the error of others' taste that had caused them wrongly to dismiss the films of Howard Hawks as studio schlock.

108. Sheldon Hall and Steven Neale, *Epics, Spectacles, and Blockbusters: A Holly-wood History* (Detroit: Wayne State University Press, 2010).

109. Several writers have noted that *Jaws* as a "blockbuster" differs in many fundamental ways from the films typically considered blockbusters in the present day. See, for example, Stephen Marche, "Four Ways *Jaws* Is Unlike Any Other Summer Blockbuster," *Esquire*, June 17, 2015.

110. Michael Pye and Lynda Myles, *The Movie Brats: How the Film Generation Took Over Hollywood* (New York: Holt, Rinehart and Winston, 1979), 223–28.

111. It is well known that Spielberg has confessed his admiration for Hitchcock, especially when Spielberg was beginning his career. Hitchcock refused to meet him because, according to a report made by actor Bruce Dern, having voiced the script for the *Jaws* ride at Universal Studios amusement park, he felt he had "whored" himself to the popularity of the "fish movie" (Enjoli Liston, "Hollyweird—Alfred Hitchcock and Steven Spielberg," *Independent*, October 2, 2009, https://www.independent.co.uk/arts-entertainment/films/features/holly weird-alfred-hitchcock-and-steven-spielberg-1796069.html).

112. Frederick Wasser has shown that independently produced films peaked in terms of their distribution around the mid-1970s—at around two-thirds of the films produced—before balancing out again by the end of the decade to equal numbers of films from major studios and independent producers. Wasser further demonstrates a link between the rise of blockbusters and independent distribution in the fact that tax codes were favorable to independent investors until around 1976 and the fact that wide releases such as *Jaws* left a glut of copies of blockbuster films in circulation, making exhibitors less likely to screen independent films. The increased popularity of negative pickups (that is, when an independent studio sells part of its rights to a film it produced to a large studio in exchange for exposure and advertising) has also contributed to the push–pull between blockbuster and independent films (*Veni, Vidi, Video: The Hollywood Empire and the VCR* [Austin: University of Texas Press, 2001], 104–5, 152–56).

113. Caetlin Benson-Allott, *Killer Tapes and Shattered Screens: Video Spectatorship from VHS to File Sharing* (Berkeley: University of California Press, 2013), 1.

114. Barbara Klinger, *Beyond the Multiplex: Cinema, New Technologies, and the Home* (Berkeley: University of California Press, 2006), 3–4.

115. Klinger, *Beyond the Multiplex*, chaps. 1–4.

116. Klinger, *Beyond the Multiplex*, 115.

117. At least eight articles released that week mention "cinephiles" or "cinephilia" in connection with the opening of the Metrograph. For example, see Michael Tedder, "John Waters, Greta Gerwig, Jim Jarmusch Turn Out for Metrograph Theater Opening," *Variety*, March 3, 2016, http://variety.com/2016/film/news

/metrograph-theater-new-york-john-waters-1201722106/, and Mark Asch, "Surrender to the Screen: Introducing the Metrograph, NYC's New Temple of Cinephilia," *Brooklyn Magazine*, March 2, 2016, http://www.bkmag.com/2016 /03/02/surrender-to-the-screen-introducing-the-metrograph-nycs-new -temple-of-cinephilia/.

118. Metrograph publicity material in "About" at the Metrograph website, https:// metrograph.com/about/theaters.

119. Jake Perlin, quoted in Eric Kohn, "How New York's New Indie Movie Theater, the Metrograph, Plans to Be a Hit," *IndieWire*, March 2016, http://www .indiewire.com/2016/03/how-new-yorks-new-indie-movie-theater-the -metrograph-plans-to-be-a-hit-63789/.

120. Alexander Olch, quoted in Kohn, "How New York's New Indie Movie Theater."

121. Olch, quoted in Kohn, "How New York's New Indie Movie Theater."

122. Andrew Lampert, "The Damnedest Thing," *Metrograph Edition: Movie Love*, May 22, 2017, http://metrograph.com/edition/article/49/the-damnedest -thing.

123. Jane Perlez, "In China's Capital: A Portal to Hollywood's Golden Age," *New York Times*, July 25, 2017, https://www.nytimes.com/2017/07/25/world/asia/beijing -theater-hollywood-movies.html.

124. The review notes that the Cinker's offerings are limited by the Shanghai Media Group, which controls movie distribution, and that foreign offerings are limited because of a strict annual quota constricting the release of foreign movies.

125. Take as an example a thread about *IndieWire*'s top-one-hundred movies of the past decade, posted to Confessions of a Cinephile on July 22, 2019. Three representative responses: (1) "Moonlight? Number 1?? You've got to be f*ing kidding!"; (2) "This is not a cinephile list. This is a list made by a snowflake. Haha"; and (3) "How the hell is Tree of Life not in the top 10 AT LEAST?" Each response stakes a claim to what films (and, here, approaches to narratives) matter and what films do not.

126. An illustration of both sides might be discerned in *Cineaste*'s editorial board's statement "Cancellation Culture" in *Cineaste* (Summer 2019): 1, and Girish Shambu's response on his blog post "Conservative Pushback in Film Culture" (girishshambu.net, posted June 24, 2019). The response on Facebook to Shambu's post about his blog piece in the days following his publishing of the blog further generated a heated exchange on the topics of the erasure of parts of film history, historical guilt, and the upholding of a racist cinema history. The focus of both the *Cineaste* and blog editorials was the controversy surrounding a theater on Bowling Green State University's campus named after actress Lilian Gish, who acted in D. W. Griffith's *Birth of a Nation* (1915).

2. ENCHANTING IMAGES

1. For an excellent overview, see Gilberto Perez, "Toward a Rhetoric of Film: Identification and the Spectator," *Senses of Cinema* 5 (April 2000), http://sensesofcinema.com/2000/society-for-cinema-studies-conference-2000/rhetoric2/.

2. See Thomas Elsaesser and Malte Hagener, *Film Theory: An Introduction Through the Senses* (New York: Routledge, 2010), 55–81.

3. See Melanie Klein, "Some Theoretical Conclusions Regarding the Emotional Life of the Infant," in *Envy, Gratitude, and Other Works 1946–1963* (London: Hogarth Press, 1975), 236–46.

4. See, for example, Daniel Dayan, "The Tutor-Code of Classical Cinema," *Film Quarterly* 28, no. 1 (Autumn 1974): 22–31. Dayan scrutinizes the ideological implications of systems of filmic enunciation.

5. See Jean-Louis Baudry, "Ideological Effects of the Basic Cinematic Apparatus," *Film Quarterly* 28, no. 2 (Winter 1974–1975): 39–47, reprinted in *Narrative, Apparatus, Ideology*, ed. Phil Rosen (New York: Columbia University Press, 1986), 286–98.

6. See Kaja Silverman, *The Subject of Semiotics* (New York: Oxford University Press, 1984). See also George Butte, "Suture and the Narration of Subjectivity in Film," *Poetics Today* 29, no. 2 (Summer 2008): 277–308, and Jean-Pierre Oudart, "Cinema and Suture," trans. Kari Hanet, *Screen* 18, no. 4 (Winter 1977): 35–47.

7. See Laura Mulvey, "Visual Pleasure and Narrative Cinema," in *Feminism and Film*, ed. E. Ann Kaplan (Oxford: Oxford University Press, 2000), 34–47, and Mary Ann Doane, *The Desire to Desire: The Woman's Film of the 1940s* (Bloomington: Indiana University Press, 1987).

8. See, for example, Miriam Bratu Hansen, *Babel & Babylon* (Cambridge, MA: Harvard University Press, 1994), and Ben Singer, *Melodrama and Modernity: Early Sensational Cinema and Its Contexts* (New York: Columbia University Press, 2001).

9. This list represents a broad spectrum of theoretical positions that offer interventions in issues of cinematic identification. These positions include bell hooks, "The Oppositional Gaze: Black Female Spectators," in *Black Looks: Race and Representation* (New York: Routledge, 2015), 115–32; Manthia Diawara, "Black Spectatorship: Problems of Identification and Resistance," *Screen* 29, no. 4 (Autumn 1988): 66–79; and Brett Farmer, *Spectacular Passions: Cinema, Fantasy, Gay Male Spectatorships* (Durham, NC: Duke University Press, 2000).

10. Baudry, "Ideological Effects of the Basic Apparatus," 287.

11. Elizabeth Reich and Scott Richmond, "Introduction: Cinematic Identifications," *Film Criticism* 39, no. 2 (Winter 2014–2105): 4.

12. Mulvey, "Visual Pleasure," 40.

13. Mulvey, "Visual Pleasure," 36.

14. Doane, *The Desire to Desire*, 6.

15. Doane, *The Desire to Desire*, 134, 130.

16. See Christine Gledhill, *Home Is Where the Heart Is: Studies in Melodrama and the Woman's Film* (London: British Film Institute, 1987).

17. In *To Desire Differently: Feminism and the French Cinema* (New York: Columbia University Press, 1996), Sandy Flitterman-Lewis usefully demonstrates how filmic discourse may articulate a specific, female identificatory point of view in Dulac's, Marie Epstein's, and Agnès Varda's films.

18. Jean Epstein, "Cinema and Modern Literature" (1921), in *Jean Epstein: Critical Essays and New Translations*, ed. Sarah Keller and Jason N. Paul (Amsterdam: Amsterdam University Press, 2012), 272.

19. Susan Sontag, "The Decay of Cinema," *New York Times*, February 25, 1996.

20. Christian Metz, *The Imaginary Signifier: Psychoanalysis and the Cinema* (Bloomington: Indiana University Press, 1977), 42–57.

21. Michael Fried, *Absorption and Theatricality: Painting and Beholder in the Age of Diderot* (Chicago: University of Chicago Press, 1980), 103, 104.

22. Stanley Cavell, *The World Viewed: Reflections on the Ontology of Film*, enlarged ed. (Cambridge, MA: Harvard University Press, 1979), 23.

23. Thomas Elsaesser recounts his own and others' cinema sitting habits as part of cinephilia in "Cinephilia, or the Uses of Disenchantment," in *Cinephilia: Movies, Love, and Memory*, ed. Marijke de Valck and Malte Hagener (Amsterdam: Amsterdam University Press, 2005), 29–30. Jenna Ng has further observed "how lovingly films were watched" in accounts of cinephiles from the mid–twentieth century and cites, among others, Bernardo Bertolucci's film *The Dreamers* (2003), which is set in the 1960s and from which the phrase about proximity to the screen is quoted ("The Myth of Total Cinephilia," *Cinema Journal* 49, no. 2 [Winter 2010]: 147–48).

24. Jean Epstein, "The Cinema Seen from Etna" (1926), in *Jean Epstein*, ed. Keller and Paul, 291–92. Within the next few years, several of Epstein's films will also use mirrors and camera lenses as a metaphor for the fraught powers of vision, including *Six et demi, onze / 6½ × 11* (1927) and *La glace à trois faces / The Three-Way Mirror* (1927). The episode Epstein recounts might remind us of Marcel Duchamp's painting *Nude Descending a Staircase, No. 2* (1912), which shows multiple versions of a single figure descending stairs: Epstein's description similarly breaks the figure down into multiple single views, which gives him the eerie feeling he refers to in the essay.

25. Epstein, "Cinema Seen from Etna," 292.

26. Epstein, "Cinema Seen from Etna," 288.

27. Notably, that same tension inheres in notions of the sublime, but as Jennifer Wild has demonstrated, Epstein worked to reconstruct existing notions of the sublime the better to apply the concept to his own interest in cinema. As Wild puts it, he "begins to transform the classic Romantic paradigm of a solitary, sublime encounter with nature into a treatise on modern aesthetic experience"—a "technological sublime" that mediates the distance usually constitutive of the experience of the sublime through the technology of cinema in general and close-ups in particular ("Distance Is [Im]material: Epstein Versus Etna," in *Jean Epstein*, ed. Keller and Paul, 116).

28. Edogawa Rampo, "The Horrors of Film," in *The Edogawa Rampo Reader*, ed. and trans. Seth Jacobowitz (Kumamoto, Japan: Kurodahan Press, 2008), 137. I am grateful to Aaron Gerow for drawing my attention to this remarkable text.

29. Sigmund Freud, "The Uncanny" (1919), 16, 10, https://web.mit.edu/allanmc/www/freud1.pdf.

30. Metz, *The Imaginary Signifier*, 51.

31. Sigmund Freud, "On Narcissism" (1914), https://www.sigmundfreud.net/on-narcissism-pdf-ebook.jsp.

32. However, as Giuliana Bruno has posited, the screen may be less of a divide than a thickly layered medium through which transformations happen, where "distinctions between inside and outside temporally dissolve into the depth of surface" (*Surface: Matters of Aesthetics, Materiality, and Media* [Chicago: University of Chicago Press, 2014], 5).

33. Maurice Merleau-Ponty, *The Visible and the Invisible*, trans. Alfonso Lingus (Evanston, IL: Northwestern University Press, 2012), 139. Regarding the division of self and self-image, Merleau-Ponty asserts the permeability of these constructs, arguing that the thing perceived happens only in relation to the perceiving of it.

34. Vivian Sobchack, "Phenomenology and the Film Experience," in *Viewing Positions: Ways of Seeing Film*, ed. Linda Williams (New Brunswick, NJ: Rutgers University Press, 1997), 53.

35. Maurice Merleau-Ponty, "The Film and the New Psychology," in *Sense and Nonsense*, ed. Hubert Dreyfus and Patricia Dreyfus (Evanston, IL: Northwestern University Press, 1968), 55–57.

36. Jacques Lacan, "The Mirror Stage as Formative of the Function of the I as Revealed in Psychoanalytic Experience" (1949), in *Écrits, a Selection*, trans. Alan Sheridan (Abingdon, UK: Routledge Classics, 2001), 2.

37. Kaja Silverman, "Suture," in *Narrative, Apparatus, Ideology*, ed. Rosen, 227–28.

38. Kant's notion of awareness of the self as limited to how one perceives the rest of the world is almost, though not quite, the same as the idea that in viewing oneself in the same objectlike way, one must see a moving image of oneself. For a reading of Kant's notion of the self, see Derk Pereboom, "Kant on Intentionality," *Synthese* 77, no. 33 (December 1988): 321–52.

39. Sobchack, "Phenomenology," 41–42. Sobchack articulates elsewhere the difference between the onscreen self and the offscreen self as differently disconcerting: following Jean-Pierre Meunier's work on film experience and home movies, she argues that the offscreen self, seeing itself onscreen, feels the urge to reconcile the look and terms of that onscreen self to bring it closer in line with self-perception. See Vivian Sobchack, "'Me, Myself, and I': On the Uncanny in Home Movies," in *The Structures of the Film Experience by Jean-Pierre Meunier: Historical Assessments and Phenomenological Expansions*, ed. Julian Hanich and Daniel Fairfax (Amsterdam: Amsterdam University Press, 2019), 208.

40. Roland Barthes, "Upon Leaving the Movie Theater," in *The Rustle of Language*, trans. Richard Howard (New York: Hill & Wang, 1986), 349, emphasis in original.

41. Davide Caputo, *Polanski and Perception: The Psychology of Seeing and the Cinema of Roman Polanski* (Chicago: Intellect and University of Chicago Press, 2012).

42. As Kelly Oliver puts it, Trelkovsky "has become the tenant of his own body, at its mercy" (*Subjectivity Without Subjects: From Abject Fathers to Desiring Mothers* [Lanham, MD: Rowman and Littlefield, 1998], 48–49).

43. H. Lee Waters, handbill for *Movies of Local People in 1940*, c. 1960, reprinted in Martin Johnson, "The Places You'll Know: From Self-Recognition to Place Recognition in the Local Film," *The Moving Image* 10, no. 1 (Spring 2010): 39.

44. Waters, handbill for *Movies of Local People in 1940*, c. 1960, reprinted in Johnson, "The Places You'll Know," 39.

45. Martin Johnson details this history and variety of local films in *Main Street Movies: The History of Local Film in the United States* (Bloomington: Indiana University Press, 2018). He underlines issues of recognition, identity, and (to a lesser extent) identification in such films, including, for example, the way segregation played a role in local filmmaking's entertainment, civic, and racial dimensions. See pages 187–93 for a discussion of this aspect of local filmmaking.

46. Johnson, *Main Street Movies*, 165.

47. Tom Gunning, "Pictures of Crowd Splendour: The Mitchell and Kenyon Factory Gate Film," in *The Lost World of Mitchell and Kenyon*, ed. Vanessa Toulmin, Simon Popple, and Patrick Russell (London: British Film Institute, 2004), 52.

48. Q&A with Alexandru Belc, Edinburgh International Film Festival, July 2017.

49. Manohla Dargis, "Review: *No Home Movie*: Of Love and Melancholy," *New York Times*, March 31, 2016.

50. See Peter Bradshaw's claim to this effect in his review of the film, "Review: *No Home Movie*—Infinitely Careful, Painfully Poignant Documentary," *Guardian*, June 23, 2016.

51. Kate Rennebohm, "Re-vision: Moving Image Media, the Self, and Ethical Thought in the 20th Century," PhD diss., Harvard University, 2018, 144–51.

52. Jesse Eisenberg and Reese Witherspoon, quoted in Nicole Weaver, "10 Actors Who Refuse to Watch Their Own Movies," *Movies: Cheat Sheet*, January 9, 2017, http://www.cheatsheet.com/entertainment/10-actors-who-refuse-to-watch-their-own-movies.html/?a=viewall.

53. Adrienne McIlvaine, "15 Actors Who Hate Seeing Their Own Movies," *Screen Rant*, July 5, 2016, http://screenrant.com/actors-who-hate-seeing-themselves-on-screen/. Interestingly, in a few cases, reviewers have suggested that Joaquin Phoenix's performance is his way of dealing with anxiety and that watching it later would undo the good work of relief for that anxiety that the performance allowed.

54. Z. S. Strother traces the myth and cites its ubiquity in a variety of forums in the late nineteenth century as part of a colonialist strain of thinking (" 'A Photograph Steals the Soul': The History of an Idea," in *Portraiture and Photography in Africa*, ed. John Peffer and Elisabeth L. Cameron [Bloomington: Indiana University Press, 2013], 177–212). Janet Hoskins looks to other explanations, noting that fears about soul stealing are misread because of the power of that myth on Western thinking ("The Camera as Global Vampire: The Distorted Mirror of Photography in Remote Indonesia and Elsewhere," in *The Framed World: Tourism, Tourists, and Photography*, ed. Mike Robinson and David Picard [Burlington, VT: Ashgate, 2009], 151–67).

55. David MacDougall, *The Corporeal Image: Film, Ethnography, and the Senses* (Princeton, NJ: Princeton University Press, 2006), 115.

56. Strother, " 'A Photograph Steals the Soul,' " 185.

57. Strother, " 'A Photograph Steals the Soul,' " 186.

58. James G. Frazer, *The Golden Bough* (New York: MacMillan, 1950), 220–24, 223.

59. David MacDougall details the practice of making tourist photographs for the lower- to middle-class tourists in India, on Gun Hill in Mussoorie, which includes elaborate staging and costumes. The sitters, he reports, may have to be cajoled into having their images taken, but, "although some resist, many others do not seem to mind, for this is one of the things they came for" (*The Corporeal Image*, 164). Vivian Sobchack echoes the importance of control over the self-image as an indicator of the positive or negative charge of a confrontation with that image (" 'Me, Myself, and I,' " 208–9).

60. Tom Gunning, "Embarrassing Evidence: The Detective Camera, the Revelation of Daily Life, and the Documentary Impulse," in *Collecting Visible Evidence*, ed. Jane Gaines and Michael Renov (Minneapolis: University of Minnesota Press, 1999), 46–64.

61. "The Latest Idea in Weddings," *Moving Picture World* 2, no. 13 (March 28, 1908): 265.

62. "Continuous Motographic Records Schemes," *Motography* 7, no. 5 (May 1912): 198.

63. "She Posed for the Picture, but Did Not Appreciate the Show," *Moving Picture World* 3, no. 2 (July 11, 1908): 27.

64. Caitlin Dewey, "Suicide, Rape, and the Dark Side of Live Streaming," *Los Angeles Times*, May 31, 2016.

65. In "Habits of Leaking: Of Sluts and Network Cards," *Discourse* 26, no. 2 (2015): 1–28, Wendy Hui Kyong Chun and Sarah Friedland offer a fascinating argument about the circulation of images of young women in sexual contexts—what they term "'slut-shaming': the public shaming of women perceived to be promiscuous on or through social media" (1)—as a particularly insidious set of symptoms of an internet that is dangerous because it "undermines the separation of the personal and networked" (3). They identify a key problem in the notion that such women are subject to the internet's transparency—posed to users as a safety feature, so no one can hide behind anonymity—to their detriment.

66. Garrett Stewart, *Closed Circuits: Screening Narrative Surveillance* (Chicago: University of Chicago Press, 2015), 138.

67. Laura U. Marks, *The Skin of the Film* (Durham, NC: Duke University Press, 2000), 163.

68. Elena del Rio, "The Body of Voyeurism: Mapping a Discourse of the Senses in Michael Powell's *Peeping Tom*," *Camera Obscura* 15, no. 3 (45) (2001): 118.

69. Kaja Silverman, *The Acoustic Mirror: The Female Voice in Psychoanalysis and Cinema* (Bloomington: Indiana University Press, 1988), 35.

70. Stewart, *Closed Circuits*, 22.

71. Tom Gunning, *The Films of Fritz Lang: Allegories of Vision* (London: British Film Institute, 2000), 224.

72. Witness is a nonprofit organization founded in 1992 (https://witness.org/our -work/).

73. Paul America sued Warhol for using America's "self" images commercially, further demonstrating Warhol's use of images of "actors" as "selves."

74. Justin Remes, *Motion(less) Pictures: The Cinema of Stasis* (New York: Columbia University Press, 2015), 27–28.

75. See, for example, J. Hoberman's response to Mekas's defense of *Jew Süss* on his blog: "Why I Cannot Review Jonas Mekas's *Conversations with Film-Makers*,"

jhoberman, June 30, 2018, http://j-hoberman.com/2018/06/why-i-cannot-review -jonas-mekass-conversations-with-film-makers/. See also Michael Casper, "I Was There," *New York Review of Books*, June 7, 2018.

76. Francesco Casetti, *Eye of the Century: Film, Experience, Modernity* (New York: Columbia University Press, 2008), 77, 87.

77. Berthold Viertel, "In the Cinematographic Theater" (1910), in *The Promise of Cinema: German Film Theory 1907–1933*, ed. Anton Kaes, Nicholas Baer, and Michael Cowan (Berkeley: University of California Press, 2016), 77–78.

78. Viertel, "In the Cinematographic Theater," 78.

79. Kirsten Ostherr, *Medical Visions: Producing the Patient Through Film, Television, and Imaging Technologies* (Oxford: Oxford University Press, 2013).

80. Kirsten Ostherr, "Live-Tweeting the Awake Craniotomy," paper presented at the Society for Cinema and Media Studies Annual Conference, Atlanta, GA, April 3, 2016.

81. Samuel Beckett to Thomas MacGreevy, September 1934, in *The Letters of Samuel Beckett*, vol. 1: *1929–1940*, ed. Martha Dow Fehsenfeld and Lois More Overbeck (Cambridge: Cambridge University Press, 2009), 222.

82. Metz, *The Imaginary Signifier*, 51–56.

83. Reich and Richmond, "Introduction," 6.

84. David Desser, foreword to *Cinema and Landscape*, ed. Graeme Harper and Jonathan Rayner (Bristol, UK: Intellect, 2010), 9.

85. Danny Roy Jennings has recently completed a dissertation tracing the emergence of a cinematic sublime and arguing that films on films by Werner Herzog and Andrei Tarkovsky in particular demonstrate "the tendency of natural phenomena to reveal frontiers of matter, space, time, and human perception" ("The Aesthetics of Nature and the Cinematic Sublime: A Creative Investigation Into an Organic Transcendental Film Style," PhD diss., Curtin University, 2017).

86. Mario Ponzo, "Cinema and Juvenile Delinquency" (c. 1919), in *Early Film Theories in Italy 1896–1922*, ed. Francesco Casetti (Amsterdam: Amsterdam University Press), 303.

87. Joshua Yumibe, *Moving Color: Early Film, Mass Culture, Modernism* (New Brunswick, NJ: Rutgers University Press, 2012), 2.

88. Yumibe, *Moving Color*, 2.

89. Bruno, *Surface*, 2, emphasis in original.

90. Marks, *The Skin of the Film*, 162, 163. Here Marks relates the haptic image (an image that may invite haptic looking) to Gilles Deleuze's time-image cinema.

91. Metz, *The Imaginary Signifier*, 53.

92. Barthes, "Upon Leaving the Movie Theater," 349.

93. For a description of such films' appeal to the spectator, see John Belton, *Widescreen Cinema* (Cambridge, MA: Harvard University Press, 1992); Kristen Whissel, *Spectacular Digital Effects: CGI and Contemporary Cinema* (Durham, NC: Duke University Press, 2014); and Allison Whitney, "Cinephilia Writ Large: IMAX in Christopher Nolan's *The Dark Knight* and *The Dark Knight Rises*," in *The Cinema of Christopher Nolan: Imagining the Impossible*, ed. Jacqueline Furby and Stuart Joy (New York: Wallflower Press, 2015), 31–43.

3. CINEPHILIA AND TECHNOLOGY: ANXIETIES AND OBSOLESCENCE

1. Malcolm Turvey, *Doubting Vision: Film and the Revelationist Tradition* (Oxford: Oxford University Press, 2008).

2. Béla Balász, *Theory of the Film* (1952; reprint, Oxford: Berghahn Books, 2017), 30.

3. The still images put together to illustrate a narrative recall Chris Marker's *La jetée* (1962) and with a similar sense of dread that may derive from the tension between stillness and motion that plays out in the space of the sequence when reflected upon from an ontological point of view in relation to the cinema.

4. James Lastra, *Sound Technology and the American Cinema: Perception, Representation, Modernity* (New York: Columbia University Press, 2000), 4.

5. Frederic Jameson, *Postmodernism, or The Cultural Logic of Late Capitalism* (Durham, NC: Duke University Press, 1991), 282–84.

6. Christine Spengler, *Screening Nostalgia: Populuxe Props and Technicolor in Contemporary American Film* (New York: Berghan Books, 2009), 4–6.

7. Andrew Gilbert, "The Death of Film and the Hollywood Response," *Senses of Cinema*, April 2012, http://sensesofcinema.com/2012/feature-articles/the-death -of-film-and-the-hollywood-response. Steve Wurtzler usefully complicates his characterization, pointing to the social, scientific, and historical landscape in which acoustic technologies "fulfilled new social functions and embodied new and exacerbated preexisting social anxieties" in an uneven manner (*Electric Sounds: Technological Change and the Rise of Corporate Mass Media* [New York: Columbia University Press, 2008], 1).

8. Jason Sperb, "Specters of Film: New Nostalgia Movies and Hollywood's Digital Transition," *Jump Cut*, no. 56 (Winter 2014–2015), https://www.ejumpcut.org /archive/jc56.2014-2015/SperbDigital-nostalgia/index.html.

9. Gilbert, "The Death of Film."

10. Douglas Trumbull, quoted in Hugh Hart, "*Tree of Life* Visualizes the Cosmos Without CGI," *Wired*, June 17, 2011, https://www.wired.com/2011/06/tree-of-life -douglas-trumbull/. Trumbull reported that using these techniques allowed

those working on the film to get around "preconceived ideas of what something should look like."

11. Chris O'Falt, "Criterion's *The Tree of Life* Is Not a Director's Cut, but a New Movie from Terrence Malick," *IndieWire*, August 31, 2018, https://www.indiewire.com/2018/08/criterion-tree-of-life-terrence-malick-new-movie-1201999468/.

12. Jason Sperb, *Flickers of Film: Nostalgia in the Time of Digital Cinema* (New Brunswick, NJ: Rutgers University Press, 2015), 2.

13. See Paolo Cherchi Usai, *The Death of Cinema: History, Cultural Memory, and the Digital Dark Age* (London: British Film Institute, 2002), and Giovanna Fosatti, *From Grain to Pixel: The Archival Life of Film in Transition* (Amsterdam: Amsterdam University Press, 2018).

14. Thomas Elsaesser, "Cinephilia, or the Uses of Disenchantment," in *Cinephilia: Movies, Love, and Memory*, ed. Marijke de Valck and Malte Hagener (Amsterdam: Amsterdam University Press, 2005), 39.

15. Douglas Gomery, "The Coming of Sound: Technological Change in the American Film Industry," in *Film Sound: Theory and Practice*, ed. Elisabeth Weis and John Belton (New York: Columbia University Press, 1985), 5.

16. For an introduction to this history concerning the introduction of sound to cinema, see Rick Altman, ed., *Sound Theory, Sound Practice* (New York: Routledge, 1992).

17. For some discussion of dialogue and the subsequent changes in technologies undergirding early sound cinema, see Don Crafton, *The Talkies: American Cinema's Transition to Sound, 1926–1931* (Berkeley: University of California Press, 1997), 165–79, 235–49.

18. Rudolf Arnheim, "A New Laocöon: Artistic Composites and the Talking Film," in *Film as Art* (1957; reprint, Berkeley: University of California Press, 2007), 229.

19. Lea Jacobs, *Film Rhythm After Sound: Technology, Music, and Performance* (Berkeley: University of California Press, 2015), 2–9.

20. John Belton outlines the technological hurdles of recording dialogue and other sounds in early sound films as well as the idea that synchronized dialogue "anchored the image in the 'real,' sacrificing much of the stylistic autonomy of silent film in favor of a powerful referential illusion" ("Awkward Transitions: Hitchcock's *Blackmail* and the Dynamics of Early Film Sound," *Musical Quarterly* 83, no. 2 [Summer 1999]: 238).

21. Major Albert Warner, "Sound vs. Silence," *New York Times*, February 10, 1929.

22. Germaine Dulac, "The Essence of the Cinema: The Visual Idea" (1925), in *The Avant-garde Film: A Reader of Theory and Criticism*, ed. P. Adams Sitney (New York: New York University Press, 1978), 41. For a description of Norimasa Kaeriyama's contributions to the "pure film" movement in Japan in the 1910s and

1920s as well as of his sense of the best uses of sound in the coming of sound cinema, see Joanne Bernardi, *Writing in Light: The Silent Scenario and the Japanese Pure Film Movement* (Detroit: Wayne State University Press, 2001), and Hiroshi Komatsu, "The Foundation of Modernism: Japanese Cinema in the Year 1927," *Film History* 17, nos. 2–3 (2005): 363–75.

23. For example, see Louis Aragon, "On Decor" (1918), in *The Shadow and Its Shadow: Surrealist Writings on Cinema*, ed. and trans. Paul Hammond (London: British Film Institute, 1978), 28–31.

24. Even when Eisenstein and the others made their statement on sound and included the notion of using sound as a montage element, they were folding sound into an already fully conceived visual configuration of the idea in cinema. See Sergei Eisenstein, V. I. Pudovkin, and Grigori Alexandrov, "Statement on Sound (1928): Eisenstein, Pudovkin, and Alexandrov," in Sergei Eisenstein, *The Eisenstein Reader*, ed. Richard Taylor (London: British Film Institute, 1998), 80–81.

25. Béla Balázs, "Farewell to Silent Film" (1930), in *The Promise of Cinema: German Film Theory 1907–1933*, ed. Anton Kaes, Nicholas Baer, and Michael Cowan (Berkeley: University of California Press, 2016), 517–19.

26. André Bazin, "The Myth of Total Cinema" (1946), in *What Is Cinema?* vol. 1, trans. Hugh Gray (Berkeley: University of California Press, 2004), 236.

27. It is interesting to note that the "relief" that would seem to complete the cinema's triad of realistic effects per Bazin has not yet taken over as a technology—with a wholly 3D execution and reception—for the cinema.

28. René Clair, "The Art of Sound" (1929), in *Film Sound*, ed. Weis and Belton, 95. Clair's own early sound films, including *Le million* (1931), experiment playfully with sound design—for instance, in a sequence when a much sought after jacket is stolen and the actors run off with it tucked under their arms and try to steal it back from each other, an action accompanied by the sound of a football match.

29. Guy Flatley, "The Sound That Shook Hollywood, " *New York Times*, September 25, 1977.

30. Clara Bow, quoted in Elisabeth Goldbeck, "The Real Clara Bow," *Motion Picture Classic Magazine*, September 1930, 48–49, 108.

31. *Modern Screen* magazine ran an article on the vogue for insurance policies on several aspects of the production process, including location insurance, "love insurance" (in case a player leaves a show for love), and voice insurance. See Mary Sharon, "Matters of Policy," *Modern Screen*, November 1930, 100–103, 113.

32. Jason Sperb has observed that the loss of labor on the level of the individual has often been (unfairly) beneficial to the larger film industry at times of technological transition: "In short, the persistent utopic notion that digital's short-term cost-cutting benefits are somehow a *solution* to harsh economic situations,

rather than one key cause of it, may be precisely the root of the larger problem" ("Specters of Film").

33. Steven Mintz and Randy W. Roberts, "Introduction: The Social and Cultural History of American Film," in *Hollywood's America: Twentieth Century America Through Film*, 4th ed., ed. Steven Mintz and Randy W. Roberts (Oxford: Wiley Blackwell, 2010), 16.

34. Eisenstein, Pudovkin, and Alexandrov, "Statement on Sound," 80.

35. Eisenstein, Pudovkin, and Alexandrov, "Statement on Sound," 80.

36. In fact, Vertov's and Murnau's films are not wholly without intertitles, if you count the opening titles of Vertov's films announcing its rejection of actors, sets, titles, and so on and Murnau's title announcing the alternate ending.

37. See Viktor Shklovsky, "The Film Factory (Extracts)" (1927), in *The Film Factory: Russian and Soviet Cinema in Documents 1896–1939*, ed. Richard Taylor and Ian Christie (London: Routledge, 1988), 167.

38. Walter Ruttman, "Principles of the Sound Film" (1928), in *The Promise of Cinema*, ed. Kaes, Baer, and Cowan, 556.

39. Esfir Shub, "The Advent of Sound in Cinema" (1929), in *Film Factory*, ed. Taylor and Christie, 271.

40. Vsevolod Pudovkin, "On the Principle of Sound in Film" (1929), in *Film Factory*, ed. Taylor and Christie, 264–67.

41. V. I. Pudovkin, "Asynchronism as a Principle of Sound Film" (1934), in *Film Sound*, ed. Weis and Belton, 83–86.

42. Eisenstein, Pudovkin, and Alexandrov, "Statement on Sound," 81.

43. Egon Friedell, quoted by editors Kaes, Baer, and Cowen in *The Promise of Cinema*, 182 n. 6.

44. Turner owned many media properties at the time, the most important of which in this debate was the "superstation" WTBS in Atlanta. The designation *superstation* was relatively new at the time and indicated a station that operated via satellite, reaching markets all over the country rather than a local market only. Turner would also eventually buy the worldwide rights to other studios' libraries, including RKO's.

45. Orson Welles's contract prevented any alterations, so *Citizen Kane* was ultimately not colorized (Harlan Lebo, *"Citizen Kane:" A Filmmaker's Journey* [New York: Thomas Dunne, 2016], 251). A sample of the film in a colorized version was prepared by Color Systems Technology, Inc., in 1988 but never released due to Welles's contract (Ray Kelly, "Inside the Colorization of 'Citizen Kane,'" Wellesnet, November 17, 2017, http://www.wellesnet.com/inside-colorization-citizen-kane/).

46. Ted Turner, quoted in John Voland, "Turner Defends Move to Colorize Films," *Los Angeles Times*, October 23, 1986.

47. Tom Shales, "The Color Green," *Washington Post*, November 2, 1986.

48. Wilson Markle, quoted in Leslie Bennetts, "'Colorizing' Film Classics: A Boon or a Bane?" *New York Times*, August 5, 1986.

49. Earl Glick, quoted in Bennetts, "'Colorizing' Film Classics."

50. Figures cited in Janet Wasko, *Hollywood in the Information Age: Beyond the Silver Screen* (Cambridge: Polity Press, 1994), 34–36.

51. Martie Zad, "Colors Shower Black and White Films," *Washington Post*, November 2, 1986.

52. Roger Mayer, testimony, *Hearing Before the Subcommittee on Courts, Civil Liberties, and the Administration of Justice of the Committee on the Judiciary, House of Representatives*, transcript, on H.R. 2400, Film Integrity Act of 1987, 100th Cong., 2nd sess., June 21, 1987, serial no. 107.

53. The United States would pass the Berne Convention Implementation Act in 1988, though many have seen it as a toothless way of protecting copyright. See Samuel Jacobs, "The Effect of the 1886 Berne Convention on the U.S. Copyright System's Treatment of Moral Rights and Copyright Term, and Where That Leaves Us Today," *Michigan Telecommunications and Technology Law Review* 23, no. 1 (2016): 169–90.

54. The quotations come from a draft of the bill circulated to those on the directors' side who were planning to testify for the subcommittee hearing on the act.

55. Larry Chernikoff to Elliot Silverstein, memo, April 7, 1987, Fred Zinnemann File, DGA 1587, Margaret Herrick Library, Beverly Hills, CA.

56. Zad, "Colors Shower Black and White Films."

57. "Notice of Registration Decision: Copyright Registration for Colorized Versions of Black and White Films," United States Copyright Office, Library of Congress, *Federal Register* 52, no. 119 (June 22, 1987): 23443–446.

58. "Notice of Registration Decision," 23444, 23445, 23446.

59. Orson Welles, quoted in Roger Ebert, "*Citizen Kane* a Masterpiece at 50," April 28, 1991, https://www.rogerebert.com/rogers-journal/citizen-kane-a -masterpiece-at-50.

60. Sarris's influence began when he published "Notes on the Auteur Theory" in 1962 and continued through the appearance of his book *The American Cinema: Directors and Directions* (New York: Dutton) in 1968 and long after. The "auteur theory" had an impact on how people thought of the provenance of motion pictures at this time and up to the present.

61. The cinematographer's union coincidentally supported the DGA's efforts to thwart Coloroids.

62. "Directors Guild Correspondence," unsigned letter dated April 13, 1987, concerning directors' rights after the release of their films, with an attached note

to send it to Woody Allen, Milos Forman, John Huston, and Sydney Pollack, Fred Zinnemann file, DGA 1587, Margaret Herrick Library.

63. Mayer, testimony, *Hearing Before the Subcommittee.*

64. Steven Spielberg, quoted in David Robb, "Spielberg Fears Looming Technology," *Daily Variety*, May 21, 1990.

65. Other films, such as *Rogue One: A Star Wars Story* (2016), mobilize similar schemas in a generative way by reintroducing the youthful figure of Carrie Fisher's character, Princess Leia, digitally updating footage of her face.

66. Colorization, Inc., survey and Glick, quoted in Bennetts, "'Colorizing' Film Classics."

67. Slide, *Nitrate Won't Wait*, 126.

68. Leonard Maltin, "The Future of Colorization," *Entertainment Tonight*, October 4, 1986.

69. "LngVly22," comment posted at https://www.youtube.com/watch?v=ZKtRv BZx28c&t=33s.

70. "Britton Thompson," comment posted at https://www.youtube.com/watch ?v=ZKtRvBZx28c&t=33s.

71. Nancy Reagan to Raymond Caldiero, August 6, 1985, quoted in Slide, *Nitrate Won't Wait*, 123.

72. Meilan Solly, "Colorized Footage Is a Vivid Reminder That History Didn't Happen in Black and White," *Smithsonian Magazine*, June 29, 2017, https://www .smithsonianmag.com/history/what-did-1920s-look-color-180963882/.

73. Solly, "Colorized Footage."

74. Peter Jackson, *The Making of* They Shall Not Grow Old, DVD supplement (Warner Archive, 2019).

75. Chris O'Falt, "Peter Jackson Turned World War I Footage into a 3D Color Film, One Frame at a Time," *IndieWire*, December 13, 2018, https://www.indiewire .com/2018/12/peter-jackson-wwi-footage-modern-3d-color-they-shall-not -grow-old-1202027263/.

76. Adam Gopnick, "A Few Thoughts on the Authenticity of Peter Jackson's *They Shall Not Grow Old*," *New Yorker*, January 14, 2019, https://www.newyorker.com /news/daily-comment/a-few-thoughts-on-the-authenticity-of-peter-jacksons -they-shall-not-grow-old.

77. See, for example, Tom Gunning, "What's the Point of an Index? or, Faking Photographs," in *Still Moving: Between Cinema and Photography*, ed. Karen Beckman and Jean Ma (Durham, NC: Duke University Press, 2008), 23–40. Gunning engages with several such reevaluations in his essay.

78. Francesco Casetti, *The Lumière Galaxy: Seven Keywords for the Cinema to Come* (New York: Columbia University Press, 2015), 2.

79. Comment by "composerudin," from Allentown, NJ, posted March 8, 2013, capitalization in the original, in response to Mark Hughes, "If Digital Effects Ruin Movies, so Did Color and Sound," *New York Times*, March 8, 2013, https://www.nytimes.com/roomfordebate/2013/03/07/are-digital-effects-cgi-ruining-the-movies/if-digital-effects-ruin-movies-so-did-color-and-sound; comments no longer available.

80. Lisa Dombrowski, "Not If, but When and How: Digital Comes to the American Art House," *Film History* 24, no. 2 (2012): 236–37.

81. John Belton, "Digital Cinema: A False Revolution," *October* 100 (Spring 2002): 104.

82. Phil Rosen, *Change Mummified: Cinema, Historicity, Theory* (Minneapolis: University of Minnesota Press, 2001), 325.

83. David Bordwell, *Pandora's Digital Box: Films, Files, and the Future of Movies* (self-pub., 2014), http://www.davidbordwell.net/books/pandora.php, 11–12.

84. Such impressions are widely circulated. See Daniel Curtis, "It's Not Just Nostalgia That's Forcing Some Cinemas to Revive Celluloid Movies," *Australian Financial Record*, August 29, 2017, https://www.afr.com/lifestyle/arts-and-entertainment/film-and-tv/its-not-just-nostalgia-thats-forcing-some-cinemas-to-revive-celluloid-movies-20170827-gy56eu, and Deborah Tudor, "The Eye of the Frog: Questions of Space in Films Using Digital Processes," *Cinema Journal* 48, no. 1 (Fall 2008): 90–110.

85. David Schwartz, quoted in Frank Pallotta and Moss Cohen, "Why You Should See *Dunkirk* in 70mm," CNN Media, July 21, 2017, http://money.cnn.com/2017/07/21/media/dunkirk-christopher-nolan-70mm/index.html.

86. Paolo Cherchi Usai, "The Demise of Digital #1," *Film Quarterly* 59, no. 3 (Spring 2006): 3.

87. Rob Sabin, "The Movies' Digital Future Is in Sight and It Works," *New York Times*, November 26, 2000.

88. Samira Makhmalbaf's address at the Cannes Film Festival Forum in 2000 adopted this perspective as a positive outlook for cinema's development. See Samira Makhmalbaf, "The Digital Revolution and the Future of Cinema," in *Film Manifestoes and Global Cinema Cultures: A Critical Anthology*, ed. Scott MacKenzie (Berkeley: University of California Press, 2014), 580–85.

89. Some trends are promising: Aymar Jean Christian has produced, promoted, and theorized internet short-form subjects made by new voices in the media scene. See Aymar Jean Christian, *Open TV: Innovation Beyond Hollywood and the Rise of Web Television* (New York: New York University Press, 2018). However, John Caldwell's recent work on maker culture suggests otherwise for certain makers; it proposes that the notion that digital production has freed up the market for any and all comers is faulty. Although more people are making short

works for YouTube, for example, the difficulties in monetizing production are fraught with the same struggles found in the film industry's labor structures. See John Caldwell, "Televisioning Maker World: A Poetics of Administrative Production," presentation for the Boston Cinema/Media Seminar, Tufts University, February 5, 2018.

90. Mark Schubin, "Digital Cinema: Still a Matter of Taste" (letter to the editor), *New York Times*, December 3, 2000, https://www.nytimes.com/2000/12/03 /movies/l-digital-cinema-still-a-matter-of-taste-438910.html.

91. Digital/celluloid hybrids have long been the compromise of progress in digital intermediates and other processes that blend the processes within the production of a movie.

92. Adrian Martin, "Three Scenes of the 1970s," *Metrograph* blog post, January 3, 2018, http://metrograph.com/edition/article/55/three-scenes-of-the-1970s. I also include myself among those charmed by projection oddities: in addition to my experience of the print of *Bob le flambeur* (Jean-Pierre Melville, 1956) burning in a screening at the Music Box in Chicago, mentioned in the introduction, I was present at two other felicitous viewings: Wong Kar-Wai's *Happy Together* (1997) being shown with the reels out of order and during a screening of *Kill Bill, Vol. 1* (2003) the screen going black just as Gogo Yubari's flail pops open to reveal its razor-sharp spikes, amid gasps, due to a power outage. For me, these are cinephilic moments in the Christian Keathley sense.

93. Dombrowski, "Not If, but When and How," 235–36.

94. In "Not If, but When and How," Dombrowski details the economic issues that made it difficult for independent and art cinemas to survive the conversion to digital.

95. See, for example, Duane Marsteller's article about conversion costs for drive-in cinemas in Tennessee: "Theater Owners Weigh Film Perfection, Conversion Costs," *Tennessean*, February 22, 2013, reprinted in *USA Today*, February 23, 2013, https://www.usatoday.com/story/life/movies/2013/02/22/digital-theater -movies/1940067/.

96. Eric Hynes, "Resort Towns Face a Last Picture Show," *New York Times*, August 24, 2012, https://www.nytimes.com/2012/08/25/movies/resort-towns -face-a-last-picture-show.html.

97. Gary Susman, "How Digital Conversion Is Killing Independent Movie Theaters," *Rolling Stone*, September 4, 2013, https://www.rollingstone.com/movies/movie -news/how-digital-conversion-is-killing-independent-movie-theaters-89265/.

98. It is worth noting that the conversion has been tied to the reemergence of 3D's popularity, for which the difference for audiences would be noticeable. However, many of the smaller theaters were also not offering films in that format for similar financial reasons.

99. Heather Hendershot, letter to the editor under the heading "Digital Cinema: The Economic Factor," *New York Times*, December 3, 2000, in response to Sabin, "The Movies' Digital Future Is in Sight."

100. Ty Burr, "Digital Projection Threatens Some Community Theaters," *Boston Globe*, January 27, 2013.

101. Steve McQueen, quoted in Helen Alexander and Rhys Blakely, "The Triumph of Digital Will Be the Death of Many Movies," *New Republic*, September 12, 2014.

102. Erin McCracken, "Last Reel: A Movie Projectionist's View from the Booth in the Waning Days of Film," *York Daily Record*, May 4, 2013.

103. McCracken, "Last Reel."

4. THE EXQUISITE APOCALYPSE

1. Susan Sontag, "The Imagination of Disaster," in *Against Interpretation and Other Essays* (New York: Farrar, Straus and Giroux, 1966), 220.

2. I differentiate this postmillennial period from the period analyzed by Kristen Moana Thompson in *Apocalyptic Dread: American Film at the Turn of the Millennium* (Albany: State University of New York Press, 2007), which focuses on premillennial films that anticipate (with dread) the coming of and potential aftermath of the changeover of millennia.

3. Sontag argues that the "aesthetics of disaster" are writ large and in expansive terms: "disaster is rarely viewed intensively; it is always extensive. It is a matter of quantity and ingenuity. If you will, it is a question of scale" ("The Imagination of Disaster," 213).

4. This subgenre of the apocalyptic film is one of the few that regularly introduces fantasy elements to the genre, which is otherwise interestingly set mainly in realistic locations and with realistic situations that underline the *likeliness* and *realness* of apocalypse.

5. Sontag, "The Imagination of Disaster," 215.

6. Georg Simmel, "Two Essays," *Hudson Review* 11, no. 3 (Autumn 1958): 381.

7. Rapture narratives, for instance, are also part of this subgenre: they deal with reading the apocalypse as a religious event.

8. In *Apocalyptic Transformation: Apocalypse and the Postmodern Imagination* (New York: Lexington Books, 2008), Elizabeth Rosen argues that such uses of religion in the context of apocalyptic "myths" serve as a critique of apocalyptic thinking.

9. Thompson, *Apocalyptic Dread*, 155 n. 1.

10. Wheeler Winston Dixon, *Visions of the Apocalypse: Spectacles of Destruction in American Cinema* (London: Wallflower Press, 2003), 3.

11. E. Ann Kaplan, *Climate Trauma: Foreseeing the Future in Dystopian Film and Fiction* (New Brunswick, NJ: Rutgers University Press, 2016), 3.

12. Bordwell is engaging with "Introducing Frank Bruni and Ross Douthat as the Moviegoers," *New York Times* op-ed blog, August 7, 2014, https://op-talk.blogs .nytimes.com/2014/08/07/introducing-frank-bruni-and-ross-douthat-as-the -moviegoers/. See David Bordwell, "Zip, Zero, Zeitgeist," *Observations on Film Art* (blog written by Kristin Thompson and David Bordwell), August 24, 2014, http://www.davidbordwell.net/blog/2014/08/24/zip-zero-zeitgeist/.

13. Bordwell notes the circumstances of the production of *Dawn of the Planet of the Apes*, which predates the conflict in Gaza (2006–present), a conflict that Douhat claims to be a "poignant" "backdrop" for the film (Bordwell, "Zip, Zero, Zeitgeist").

14. Sontag, "The Imagination of Disaster," 224, emphasis in the original.

15. Walter Benjamin, "The Work of Art in the Age of Its Technological Reproducibility: Second Version" (1935–1936), in *The Work of Art in the Age of Its Technological Reproducibility and Other Writings on Media*, ed. Michael W. Jennings, Brigid Doherty, and Thomas Y. Levin (Cambridge, MA: Belknap Press of Harvard University Press, 2008), 39.

16. Siegfried Kracauer, *Theory of Film: The Redemption of Physical Reality* (New York: Oxford University Press, 1960), 165.

17. Jonathan Crary, *Techniques of the Observer: On Vision and Modernity in the Nineteenth Century* (Cambridge, MA: MIT Press, 1990), 20. See also Miriam Bratu Hansen, "The Mass Production of the Senses: Classical Cinema as Vernacular Modernism," in *Reinventing Cinema Studies*, ed. Christine Gledhill and Linda Williams (London: Arnold, 2000), 332–50.

18. Robert Hass, "Meditation at Lagunitas," in *Praise* (New York: Echo Press, 1979), 4.

19. "Introducing Frank Bruni and Ross Douthat as the Moviegoers."

20. Kate Aronoff, "*Mad Max: Fury Road* Is a Resource-Conscious Blockbuster for Our Time," *Yes! Magazine*, May 22, 2015, https://www.yesmagazine.org/people -power/mad-max-fury-road-review.

21. The closed system of reflectionist art is exactly what it is often criticized for: the argument goes that in working out anxieties for the spectator, the reflectionist artwork allows the spectator to feel that she no longer needs to do anything about them in life.

22. A. O. Scott, "Review: *Mad Max: Fury Road*, Still Angry After All These Years," *New York Times*, May 14, 2015.

23. Jeffrey Fleishman, "*Mad Max: Fury Road* an Apocalyptic Tale as Old as Man's Existence," *Los Angeles Times*, May 28, 2015.

24. Linda Williams, "Film Bodies: Gender, Genre, and Excess." *Film Quarterly* 44, no. 4 (Summer 1991): 2–13.

25. Julia Kristeva, *Black Sun: Depression and Melancholia*, trans. Leon S. Roudiez (New York: Columbia University Press, 1989), 223.

26. In *Cinematic Appeals: The Experience of New Movie Technologies* (New York: Columbia University Press, 2013), Ariel Rogers demonstrates how 3D effects work on audiences, simultaneously immersing them and pushing them out of that immersive experience.

27. To get a cursory idea of "user" assessments (admittedly with a large margin for error) for the films discussed in this chapter, the Rotten Tomatoes rating combined with the IMDb rating yields an average score of 65 percent for critics and 69 percent for audiences: a D/D+ average. Outliers include *Mad Max: Fury Road*, which scores high in both categories, and *Transformers: Age of Extinction*, which scores low in both.

28. Locations with the highest demand for housing and the most expensive rents in the country—for example, the San Francisco, New York, and Los Angeles areas—have a special place in these narratives that imagine depopulation as a key narrative element.

29. Siegfried Kracauer, "Photography" (1927), in *The Mass Ornament: Weimar Essays*, trans. Thomas Y. Levin (Cambridge, MA: Harvard University Press, 1995), 48–49.

30. "The Meaning of Life," *British Cinematographer*, n.d., https://britishcinema tographer.co.uk/emmanuel-lubezki-amc-asc-the-tree-of-life/.

31. David Nye, *American Technological Sublime* (Cambridge, MA: MIT Press, 1996).

32. Trond Lundemo, "A Temporal Perspective: Jean Epstein's Writings on Technology and Subjectivity," in *Jean Epstein: Critical Essays and New Translations*, ed. Sarah Keller and Jason N. Paul (Amsterdam: Amsterdam University Press, 2012), 217.

33. The *War of the Worlds* screenwriter David Koepp remarked in an interview that references to 9/11 worried him at first, but "once we decided to neither deliberately remove or [sic] deliberately add anything relating to 9/11 or Iraq, or the world we live in today, then it just was itself because we all live in the same world, same year, so it should look like that" (Ian Freer, "David Koepp on *War of the Worlds*," *Empire* online, October 17, 2012, https://web.archive.org/web /20121017165808/http://www.empireonline.com/interviews/interview.asp ?IID=378).

34. Thompson, *Apocalyptic Dread*, 146–48.

35. Frank Rose, "Close Encounters of the Worst Kind," *Wired* 13, no. 6 (June 2005), http://archive.wired.com/wired/archive/13.06/war.html.

36. Rose, "Close Encounters."

37. Jeff Jensen, "Will Smith Takes on *I Am Legend*," *Entertainment Weekly*, September 6, 2007, http://www.ew.com/article/2007/09/06/will-smith-takes-i-am-legend/2.

38. For an incisive reading of the way such digital effects work for recent films, see Kristen Whissel, *Spectacular Digital Effects: CGI and Contemporary Cinema* (Durham, NC: Duke University Press, 2014).

39. Kaplan, *Climate Trauma*, 1–22.

40. Maya Deren, "Cinematography: The Creative Use of Reality," in *Essential Deren*, ed. Bruce McPherson (Kingston, NY: Documentext, 2005), 110–28.

41. Whissel, *Spectacular Digital Effects*, 171–84.

42. Whissel, *Spectacular Digital Effects*, 179.

43. Edmund Burke, *A Philosophical Enquiry Into the Origin of Our Ideas of the Sublime and Beautiful* (1759), part 1, sec. 7, http://www.english.upenn.edu/~mgamer/Etexts/burkesublime.html.

44. Immanuel Kant, *Critique of Judgment* (1790), trans. Werner S. Pluhar (Indianapolis, IN: Hackett, 1987), 98, emphasis in original.

45. Arthur Schopenhauer, *The World as Will and Representation*, trans. E. F. J. Payne (New York: Dover, 1969), 206.

46. "Poetry and the Film: A Symposium with Maya Deren, Arthur Miller, Dylan Thomas, Parker Tyler," in *Film Culture Reader*, ed. P. Adams Sitney (New York: Cooper Square Press, 2000), 171–86.

47. Most of the films mentioned here belong to the genre of films that aims to draw as much of its audience as possible to large screens, including IMAX.

48. Kaplan, *Climate Trauma*, 32.

49. Kaplan, *Climate Trauma*, 32.

50. James Berger, *After the End: Representations of the Post-apocalypse* (Minneapolis: University of Minnesota Press, 1999).

51. Tomorrowland's other founding fathers also loosely make up the loci of cinema's building blocks—Nikola Tesla (whose competing drive to harness electricity spurred Edison), Gustav Eiffel (whose tower serves as an emblem of modernity, of which cinema is another artistic outlet), and Jules Verne (whose stories would eventually be adapted many times for the screen).

CONCLUSION: ANXIOUS TIMES, ANXIOUS CINEMA

1. Francesco Casetti has begun to pursue this important work in his research on early cinephobia: "Why Fears Matter: Cinephobia in Early Film Culture," *Screen* 59, no. 2 (Summer 2018): 145–57.

2. Paolo Cherchi Usai, "The Demise of Digital (Print #1)," *Film Quarterly* 59, no. 3 (Spring 2006): 3.

3. Kyle Buchanan, "Ava DuVernay: Real People Aren't Seeing Most Movies," *New York Times*, June 20, 2019.

4. Hannah Frank, *Frame by Frame: A Materialist Aesthetics of Animated Cartoons* (Berkeley: University of California Press, 2019).

Selected Bibliography

Abel, Richard. *The Ciné Goes to Town: French Cinema, 1896–1914*. Berkeley: University of California Press, 1994.

——, ed. *French Film Theory and Criticism*. Vol. 1: *1907–1929*. Princeton, NJ: Princeton University Press, 1988.

Alexander, Neta. "Rage Against the Machine: Buffering, Noise, and Perpetual Anxiety in the Age of Connected Viewing." *Cinema Journal* 56, no. 2 (Winter 2017): 1–24.

Amad, Paula. "Objects Became Witnesses: Ève Francis and the Emergence of French Cinephilia and Film Criticism." *Framework* 46, no. 1 (Spring 2005): 56–73.

Andrew, Dudley. *What Cinema Is!* Oxford: Wiley-Blackwell, 2010.

Arenas, Fernando Ramos. "From Stalinism to Cinephilia: The Emergence of East German Film Culture in the 1950s." *Historical Journal of Film, Radio, and Television* 39, no. 2 (February 2019): 271–89.

Arnheim, Rudolf. *Film as Art*. 1957. Reprint. Berkeley: University of California Press, 2007.

Aumont, Jacques. *Du visage au cinéma*. Paris: Éditions de l'étoile, 1992.

Balázs, Béla. *Theory of the Film*. 1952. Reprint. Oxford: Berghahn Books, 2017.

Bao, Weihong. *Fiery Cinema: The Emergence of an Affective Medium in China, 1915–1945*. Minneapolis: University of Minnesota Press, 2015.

Barber, X. Theodore. "Phantasmagorical Wonders: The Magic Lantern Ghost Show in Nineteenth-Century America." *Film History* 3, no. 2 (1989): 73–86.

Barthes, Roland. *Camera Lucida*. New York: Farrar, Straus and Giroux, 2010.

———. *A Lover's Discourse: Fragments*. Trans. Richard Howard. 1977. Reprint. New York: Hill & Wang, 2010.

———. "Upon Leaving the Movie Theater." In *The Rustle of Language*, trans. Richard Howard, 345–49. New York: Hill & Wang, 1986.

Baudry, Jean-Louis. "Ideological Effects of the Basic Cinematic Apparatus." *Film Quarterly* 28, no. 2 (Winter 1974–1975): 39–47. Reprinted in *Narrative, Apparatus, Ideology*, ed. Phil Rosen, 286–98. New York: Columbia University Press, 1986.

Baumbach, Nico. "All That Heaven Allows: What Is, or What Was Cinephilia?" *Film Comment* 48, no. 2 (March–April 2012): 47–53.

Bazin, André. *What Is Cinema?* Vol. 1. Trans. Hugh Gray. Berkeley: University of California Press, 2004.

Beckman, Karen. *Vanishing Women*. Durham, NC: Duke University Press, 2007.

Belton, John. "Digital Cinema: A False Revolution." *October* 100 (Spring 2002): 98–114.

———. *Widescreen Cinema*. Cambridge, MA: Harvard University Press, 1992.

Benjamin, Walter. "The Work of Art in the Age of Its Technological Reproducibility: Second Version" (1935–1936). In Walter Benjamin, *The Work of Art in the Age of Its Technological Reproducibility and Other Writings on Media*, ed. Michael W. Jennings, Brigid Doherty, and Thomas Y. Levin, 19–55. Cambridge, MA: Belknap Press of Harvard University Press, 2008.

Benson-Allott, Caetlin. *Killer Tapes and Shattered Screens: Video Spectatorship from VHS to File Sharing*. Berkeley: University of California Press, 2013.

Berger, James. *After the End: Representations of the Post-apocalypse*. Minneapolis: University of Minnesota Press, 1999.

Berlant, Lauren. *Desire/Love*. Brooklyn, NY: Punctum Books, 2012.

Bordwell, David. "Never the Twain Shall Meet: Why Can't Cinephiles and Academics Just Get Along?" *Film Comment* 47, no. 3 (May–June 2011): 38–41.

———. *Pandora's Digital Box: Films, Files, and the Future of Movies*. Self-published, 2014. http://www.davidbordwell.net/books/pandora.php.

Brenez, Nicole. "For an Insubordinate (or Rebellious) History of Cinema." *Framework: The Journal of Cinema and Media* 50, nos. 1–2 (Spring–Fall 2009): 197–201.

Brinkema, Eugenie. *The Forms of the Affects*. Durham, NC: Duke University Press, 2014.

Bruno, Giuliana. *Surface: Matters of Aesthetics, Materiality, and Media*. Chicago: University of Chicago Press, 2014.

Casetti, Francesco, ed. *Early Film Theories in Italy 1896–1922*. Amsterdam: Amsterdam University Press, 2017.

———. *The Lumière Galaxy: Seven Keywords for the Cinema to Come*. New York: Columbia University Press, 2015.

——. "Why Fears Matter: Cinephobia in Early Film Culture." *Screen* 59, no. 2 (Summer 2018): 145–57.

Cavell, Stanley. *The World Viewed: Reflections on the Ontology of Film*. Enlarged ed. Cambridge, MA: Harvard University Press, 1979.

Cherchi Usai, Paolo. *The Death of Cinema: History, Cultural Memory, and the Digital Dark Age*. London: British Film Institute, 2002.

Christian, Aymar Jean. *Open TV: Innovation Beyond Hollywood and the Rise of Web Television*. New York: New York University Press, 2018.

Chun, Wendy Hui Kyong, and Sarah Friedland. "Habits of Leaking: Of Sluts and Network Cards." *Discourse* 26, no. 2 (2015): 1–28.

Combs, C. Scott. *Deathwatch: American Film, Technology, and the End of Life*. New York: Columbia University Press, 2014.

Cowan, Michael. "Learning to Love Movies: Puzzles, Participation, and Cinephilia in Interwar European Film Magazines." *Film History* 27, no. 4 (2015): 1–45.

Crafton, Don. *The Talkies: American Cinema's Transition to Sound, 1926–1931*. Berkeley: University of California Press, 1997.

Crary, Jonathan. *Techniques of the Observer: On Vision and Modernity in the Nineteenth Century*. Cambridge, MA: MIT Press, 1990.

De Baecque, Antoine, and Thierry Frémaux. "La cinéphilie, ou l'invention d'une culture." *Vingtième siècle: Revue d'histoire* 46, no. 1 (1995): 133–42.

Del Rio, Elena. "The Body of Voyeurism: Mapping a Discourse of the Senses in Michael Powell's *Peeping Tom*." *Camera Obscura* 15, no. 3 (45) (2001): 115–49.

De Valck, Marijke. *Film Festivals: From European Geopolitics to Global Cinephilia*. Amsterdam: Amsterdam University Press, 2007.

De Valck, Marijke, and Malte Hagener, eds. *Cinephilia: Movies, Love, and Memory*. Amsterdam: Amsterdam University Press, 2005.

Diawara, Manthia. "Black Spectatorship: Problems of Identification and Resistance." *Screen* 29, no. 4 (Autumn 1988): 66–79.

Dixon, Wheeler Winston. *Visions of the Apocalypse: Spectacles of Destruction in American Cinema*. London: Wallflower Press, 2003.

Doane, Mary Ann. *The Desire to Desire: The Woman's Film of the 1940s*. Bloomington: Indiana University Press, 1987.

——. *The Emergence of Cinematic Time: Modernity, Contingency, the Archive*. Cambridge, MA: Harvard University Press, 2002.

Dombrowski, Lisa. "Not If, but When and How: Digital Comes to the American Art House." *Film History* 24, no. 2 (2012): 236–37.

Dulac, Germaine. "Aesthetics, Obstacles, Integral Cinégraphie" (1928). In *French Film Theory & Criticism*, vol. 1: *1907–1929*, ed. Richard Abel, 389–97. Princeton, NJ: Princeton University Press, 1988.

——. "The Essence of the Cinema: The Visual Idea" (1925). In *The Avant-garde Film: A Reader of Theory and Criticism*, ed. P. Adams Sitney, 36–42. New York: New York University Press, 1978.

——. "The Expressive Techniques of the Cinema" (1924). In *French Film Theory & Criticism*, vol. 1: *1907–1929*, ed. Richard Abel, 305–14. Princeton, NJ: Princeton University Press, 1988.

Eisenstein, Sergei, V. I. Pudovkin, and Gregori Alexandrov. "Statement on Sound (1928): Eisenstein, Pudovkin, and Alexandrov." In *The Eisenstein Reader*, ed. Richard Taylor, 80–81. London: British Film Institute, 1998.

Elsaesser, Thomas. "Cinephilia, or the Uses of Disenchantment." In *Cinephilia: Movies, Love, and Memory*, ed. Marijke de Valck and Malte Hagener, 27–43. Amsterdam: Amsterdam University Press, 2005.

——. *Film History as Media Archeology*. Amsterdam: Amsterdam University Press, 2016.

Epstein, Jean. "Cinema and Modern Literature" (1921). In *Jean Epstein: Critical Essays and New Translations*, ed. Sarah Keller and Jason N. Paul, 271–73. Amsterdam: Amsterdam University Press, 2012.

——. "The Cinema Seen from Etna" (1924). In *Jean Epstein: Critical Essays and New Translations*, ed. Sarah Keller and Jason N. Paul, 287–92. Amsterdam: Amsterdam University Press, 2012.

——. *"Ésprit de cinéma"* (various articles). In *Jean Epstein: Critical Essays and New Translations*, ed. Sarah Keller and Jason N. Paul, 330–80. Amsterdam: Amsterdam University Press, 2012.

——. "The Slow Motion of Sound" (1948). In *Jean Epstein: Critical Essays and New Translations*, ed. Sarah Keller and Jason N. Paul, 381–82. Amsterdam: Amsterdam University Press, 2012.

Fee, Annie. "Gender, Class, and Cinephilia: Parisian Cinema Cultures, 1918–1925." PhD diss., University of Washington, 2015.

Feldman, Seth. "What Was Cinema?" *Canadian Journal of Film Studies* 5, no. 1 (Spring 1996): 3–22.

Field, Allyson Nadia. *Uplift Cinema: The Emergence of African American Film and the Possibility of Black Modernity*. Durham, NC: Duke University Press, 2015.

Fischer, Lucy. "The Lady Vanishes: Women, Magic, and the Movies." *Film Quarterly* 33, no. 1 (Fall 1979): 30–40.

Flitterman-Lewis, Sandy. *To Desire Differently: Feminism and the French Cinema*. New York: Columbia University Press, 1996.

Fosatti, Giovanna. *From Grain to Pixel: The Archival Life of Film in Transition*. Amsterdam: Amsterdam University Press, 2018.

Frank, Hannah. *Frame by Frame: A Materialist Aesthetics of Animated Cartoons*. Berkeley: University of California Press, 2019.

Frazer, James G. *The Golden Bough*. New York: MacMillan, 1950.

Freud, Sigmund. *Beyond the Pleasure Principle* (1920). Trans. James Strachey. New York: Liveright, 1961.

——. "The Uncanny" (1919). https://web.mit.edu/allanmc/www/freud1.pdf.

Frey, Mattias. *The Permanent Crisis of Film Criticism: The Anxiety of Authority*. Amsterdam: Amsterdam University Press, 2015.

Fried, Michael. *Absorption and Theatricality: Painting and Beholder in the Age of Diderot*. Chicago: University of Chicago Press, 1980.

Garnier, Phillippe. "Dorothy Arzner: Une femme dans un monde d'hommes." N.d. http://www.cinematheque.fr/cycle/dorothy-arzner-378.html.

Gautier, Christophe. *La passion du cinéma: Cinéphiles, ciné-clubs et salles spécialisées à Paris de 1920 à 1929*. Paris: Association française de recherche sur l'histoire du cinéma, 1999.

Ghosh, Abhija. "Memories of Action: Tracing Film Society Cinephilia in India." *BioScope: South Asian Screen Studies* 9, no. 2 (January 2019): 137–64.

Gilbert, Andrew. "The Death of Film and the Hollywood Response." *Senses of Cinema*, April 2012. http://sensesofcinema.com/2012/feature-articles/the-death-of -film-and-the- hollywood-response.

Gorky, Maxim. "The Lumière Cinematograph (Extracts)." In *The Film Factory: Russian and Soviet Cinema in Documents 1896–1939*, ed. Richard Taylor and Ian Christie, 25–26. New York: Routledge, 1988.

Grant, Catherine. "The Audiovisual Essay: My Favorite Things." *[in]Transition* 1, no. 3 (2014). http://mediacommons.futureofthebook.org/intransition/2014/09/14 /audiovisual-essay-my- favorite-things.

Grieveson, Lee. *Policing Cinema: Movies and Censorship in Early Twentieth-Century America*. Berkeley: University of California Press, 2004.

Gunning, Tom. "An Aesthetic of Astonishment: Early Film and the (In)Credulous Spectator." In *Viewing Positions: Ways of Seeing Film*, ed. Linda Williams 114–33. New Brunswick, NJ: Rutgers University Press, 1995.

——. "The Cinema of Attractions: Early Film, Its Spectator, and the Avant-Garde." *Early Cinema: Space, Frame, Narrative*, ed. Thomas Elsaesser, 56–62. London: British Film Institute, 1990.

——. "Embarrassing Evidence: The Detective Camera, the Revelation of Daily Life, and the Documentary Impulse." In *Collecting Visible Evidence*, ed. Jane Gaines and Michael Renov, 46–64. Minneapolis: University of Minnesota Press, 1999.

Hagener, Malte. "Cinephilia in the Age of the Post-cinematographic." *Photogénie*, February 10, 2015. https://cinea.be/cinephilia-the-age-the-post-cinematographic/.

Hansen, Miriam Bratu. *Babel & Babylon*. Cambridge, MA: Harvard University Press, 1994.

——. "Benjamin and Cinema: Not a One-Way Street." *Critical Inquiry* 25, no. 2 (Winter 1999): 306–43.

——. "Fallen Women, Rising Stars, New Horizons: Shanghai Silent Film as Vernacular Modernism." *Film Quarterly* 54, no. 1 (Autumn 2000): 10–22.

——. "'Of Lightning Rods, Prisms, and Forgotten Scissors': *Potemkin* and German Film Theory." *New German Critique* 95 (Spring–Summer 1995): 162–79.

——. "Room for Play: Benjamin's Gamble with Cinema." *October* 109 (Summer 2004): 3–45.

Hastie, Amelie. *Cupboards of Curiosity: Women, Recollection, and Film History*. Durham, NC: Duke University Press, 2007.

Herrera, Javier. "Almodóvar's Stolen Images." In *A Companion to Pedro Almodóvar*, ed. Martin D'Lugo and Kathleen M. Vernon, 345–63. New York: Wiley, 2013.

Hilderbrand, Lucas. "Cinematic Promiscuity: Cinephilia After Videophilia." *Framework: The Journal of Cinema and Media* 50, nos. 1–2 (Spring–Fall 2009): 214–17.

hooks, bell. "The Oppositional Gaze: Black Female Spectators." In *Black Looks: Race and Representation*, 115–32. New York: Routledge, 2015.

Hoskins, Janet. "The Camera as Global Vampire: The Distorted Mirror of Photography in Remote Indonesia and Elsewhere." In *The Framed World: Tourism, Tourists, and Photography*, ed. Mike Robinson and David Picard, 151–67. Burlington, VT: Ashgate, 2009.

Jacobs, Lea. *Film Rhythm After Sound: Technology, Music, and Performance*. Berkeley: University of California Press, 2015.

Jenkins, Henry, Sam Ford, and Joshua Green. *Spreadable Media: Creating Value and Meaning in a Networked Culture*. New York: New York University Press, 2012.

Johnson, Martin. *Main Street Movies: The History of Local Film in the United States*. Bloomington: Indiana University Press, 2018.

——. "The Places You'll Know: From Self-Recognition to Place Recognition in the Local Film." *The Moving Image* 10, no. 1 (Spring 2010): 23–50.

Jullier, Laurent, and Jean-Marc Leveratto. "Cinephilia in the Digital Age." In *Audiences: Defining and Researching Screen Entertainment Reception*, ed. Ian Christie, 143–54. Amsterdam: Amsterdam University Press, 2012.

Kaes, Anton, Nicholas Baer, and Michael Cowan, eds. *The Promise of Cinema: German Film Theory 1907–1933*. Berkeley: University of California Press, 2016.

Kaplan, E. Ann. *Climate Trauma: Foreseeing the Future in Dystopian Film and Fiction*. New Brunswick, NJ: Rutgers University Press, 2016.

Keathley, Christian. *Cinephilia and History, or The Wind in the Trees*. Bloomington: Indiana University Press, 2006.

Keller, Sarah. "Cinephobia: To Wonder, to Worry." *Lola* 5 (2014). http://www.lolajournal.com/5/cinephobia.html.

———. "Jean Epstein's Documentary Cinephilia." *Studies in French Cinema* 12, no. 2 (July): 91–105.

Keller, Sarah, and Jason N. Paul, eds. *Jean Epstein: Critical Essays and New Translations*. Amsterdam: Amsterdam University Press, 2012.

Kim, Soyoung. " 'Cinemania' or Cinephilia: Film Festivals and the Identity Question." In *New Korean Cinema*, ed. Chi-Yun Shin and Julian Stringer, 79–92. Edinburgh: Edinburgh University Press, 2005.

Klinger, Barbara. *Beyond the Multiplex: Cinema, New Technologies, and the Home*. Berkeley: University of California Press, 2006.

Kracauer, Siegfried. *Theory of Film: The Redemption of Physical Reality*. New York: Oxford University Press, 1960.

Kristeva, Julia. *Black Sun: Depression and Melancholia*. Trans. Leon S. Roudiez. New York: Columbia University Press, 1989.

Lacan, Jacques. *Écrits, a Selection*. Trans. Alan Sheridan. Abingdon, UK: Routledge Classics, 2001.

Lastra, James. *Sound Technology and the American Cinema: Perception, Representation, Modernity*. New York: Columbia University Press, 2000.

Loew, Katharina. "Techno-romanticism: Special Effects in German Fantastic Films of the Silent Era." PhD diss., University of Chicago, 2011.

MacDougall, David. *The Corporeal Image: Film, Ethnography, and the Senses*. Princeton, NJ: Princeton University Press, 2006.

Makhmalbaf, Samira. "The Digital Revolution and the Future of Cinema." In *Film Manifestoes and Global Cinema Cultures: A Critical Anthology*, ed. Scott MacKenzie, 580–85. Berkeley: University of California Press, 2014.

Mannoni, Laurent, and Richard Crangle. *The Great Art of Light and Shadow: Archaeology of the Cinema*. Exeter, UK: University of Exeter Press, 2000.

Marks, Laura U. "Loving a Disappearing Image." *Cinémas*, Fall 1997, 93–112.

———. *The Skin of the Film*. Durham, NC: Duke University Press, 2000.

Martin, Adrian. "Cinephilia as War Machine." *Framework: The Journal of Cinema and Media* 50, nos. 1–2 (Spring–Fall 2009): 221–25.

Martin, Adrian, and Jonathan Rosenbaum, eds. *Movie Mutations: The Changing Face of World Cinephilia*. London: British Film Institute, 2003.

Mayne, Judith. "Scandale! Dorothy Arzner in Paris." *Film Quarterly*, Quorum, posted July 12, 2017. https://filmquarterly.org/2017/07/12/scandale-dorothy-arzner-in-paris/.

Merleau-Ponty, Maurice. "The Film and the New Psychology." In *Sense and Non-sense*, ed. Hubert Dreyfus and Patricia Dreyfus, 55–57. Evanston, IL: Northwestern University Press, 1968.

———. *Phenomenology of Perception*. Trans. Donald A. Landes. New York: Routledge, 2012.

Metz, Christian. *The Imaginary Signifier: Psychoanalysis and the Cinema.* Bloomington: Indiana University Press, 1977.

Michelson, Annette. "Gnosis and Iconoclasm: A Case Study of Cinephilia." *October* 83 (Winter 1998): 3–18.

Mulvey, Laura. *Death 24x per Second: Stillness and the Moving Image.* London: Reaktion Books, 2006.

——. "Some Reflections on the Cinephilia Question." *Framework: The Journal of Cinema and Media* 50, nos. 1–2 (Spring–Fall 2009): 190–93.

——. "Visual Pleasure and Narrative Cinema." In *Feminism and Film*, ed. E. Ann Kaplan, 34–47. Oxford: Oxford University Press, 2000.

Ng, Jenna. "The Myth of Total Cinephilia." *Cinema Journal* 49, no. 2 (Winter 2010): 146–51.

Nye, David. *American Technological Sublime.* Cambridge, MA: MIT Press, 1996.

Ostherr, Kirsten. *Medical Visions: Producing the Patient Through Film, Television, and Imaging Technologies.* Oxford: Oxford University Press, 2013.

Perez, Gilberto. "Toward a Rhetoric of Film: Identification and the Spectator." *Senses of Cinema* 5 (April 2000). http://sensesofcinema.com/2000/society-for-cinema -studies- conference-2000/rhetoric2/.

Promkhuntong, Wikanda. "Cinephiles, Music Fans, and Film Auteur(s): Transcultural Taste Cultures Surrounding Mashups of Wong Kar Wai's Movies on YouTube." *Participations: Journal of Audience and Reception Studies* 12, no. 2 (November 2015): 255–74.

Rae, Ian, and Jessica Thom. "The Rise and Fall of the Stratford International Film Festival." *Canadian Journal of Film Studies* 25, no. 1 (Spring 2016): 67–87.

Rampo, Edogawa. "The Horrors of Film." In *The Edogawa Rampo Reader*, ed. and trans. Seth Jacobowitz, 137–42. Kumamoto, Japan: Kurodahan Press, 2008.

Rancière, Jacques. *The Emancipated Spectator.* London: Verso, 2009.

Remes, Justin. *Motion(less) Pictures: The Cinema of Stasis.* New York: Columbia University Press, 2015.

Rennebohm, Kate. "Re-vision: Moving Image Media, the Self, and Ethical Thought in the 20th Century." PhD diss., Harvard University, 2018.

Richards, Rashna Wadia. *Cinematic Flashes: Cinephilia and Classical Hollywood.* Bloomington: Indiana University Press, 2012.

Ríos-Cordero, Hugo J. "Permutations of Cinephilia: Aesthetics, Technology, and Social Consciousness." PhD diss., Rutgers University, 2016.

Rogers, Ariel. *Cinematic Appeals: The Experience of New Movie Technologies.* New York: Columbia University Press, 2013.

Rosen, Elizabeth. *Apocalyptic Transformation: Apocalypse and the Postmodern Imagination.* New York: Lexington Books, 2008.

Rosen, Phil. *Change Mummified: Cinema, Historicity, Theory.* Minneapolis: University of Minnesota Press, 2001.

Schopenhauer, Arthur. *The World as Will and Representation.* Trans. E. F. J. Payne. New York: Dover, 1969.

Sellier, Geneviève. *Masculine Singular: French New Wave Cinema.* Durham, NC: Duke University Press, 2008.

Shambu, Girish. *The New Cinephilia.* Montreal: Caboose Books, 2014.

———. "Taken Up by Waves: The Experience of New Cinephilia." Project New Cinephilia, May 23, 2011. https://projectcinephilia.mubi.com/2011/05/23/taken-up-by -waves-the-experience-of- new-cinephilia/.

Silverman, Kaja. *The Acoustic Mirror: The Female Voice in Psychoanalysis and Cinema.* Bloomington: Indiana University Press, 1988.

———. *The Subject of Semiotics.* New York: Oxford University Press, 1984.

Singer, Ben. *Melodrama and Modernity: Early Sensational Cinema and Its Contexts.* New York: Columbia University Press, 2001.

Slide, Anthony. *Nitrate Won't Wait: A History of Film Preservation in the United States* Jefferson, NC: McFarland, 1992.

Sobchack, Vivian. "Phenomenology and the Film Experience." In *Viewing Positions: Ways of Seeing Film,* ed. Linda Williams, 36–58. New Brunswick, NJ: Rutgers University Press, 1997.

Sontag, Susan. "The Decay of Cinema." *New York Times,* February 25, 1996.

———. "The Imagination of Disaster." In *Against Interpretation and Other Essays,* 209–25. New York: Farrar, Straus and Giroux, 1966.

Spengler, Christine. *Screening Nostalgia: Populuxe Props and Technicolor in Contemporary American Film.* New York: Berghan Books, 2009.

Sperb, Jason. *Flickers of Film: Nostalgia in the Time of Digital Cinema.* New Brunswick, NJ: Rutgers University Press, 2015.

———. "Specters of Film: New Nostalgia Movies and Hollywood's Digital Transition." *Jump Cut,* no. 56 (Winter 2014–2015). https://www.ejumpcut.org/archive /jc56.2014- 2015/SperbDigital-nostalgia/index.html.

Steimatsky, Noa. *The Face on Film.* Oxford: Oxford University Press, 2017.

Stewart, Garrett. *Closed Circuits: Screening Narrative Surveillance.* Chicago: University of Chicago Press, 2015.

Strother, Z. S. "'A Photograph Steals the Soul': The History of an Idea." In *Portraiture and Photography in Africa,* ed. John Peffer and Elisabeth L. Cameron, 177–212. Bloomington: Indiana University Press, 2013.

Thompson, Kristen Moana. *Apocalyptic Dread: American Film at the Turn of the Millennium.* Albany: State University of New York Press, 2007.

Turvey, Malcolm. *Doubting Vision: Film and the Revelationist Tradition.* Oxford: Oxford University Press, 2008.

Vidal, Belén. "Cinephilia Goes Global: Loving Cinema in the Post-cinematic Age." In *The Routledge Companion to World Cinema*, ed. Rob Stone, Paul Cooke, Stephanie Dennison, and Alex Marlowe-Mann, 404–14. New York: Routledge, 2017.

Wasser, Frederick. *Veni, Vidi, Video: The Hollywood Empire and the VCR*. Austin: University of Texas Press, 2001.

Whissel, Kristen. *Spectacular Digital Effects: CGI and Contemporary Cinema*. Durham, NC: Duke University Press, 2014.

Wong, Cindy Hing-Yuk. *Film Festivals: Culture, People, and Power on the Global Screen*. New Brunswick, NJ: Rutgers University Press, 2011.

Yumibe, Joshua. *Moving Color: Early Film, Mass Culture, Modernism*. New Brunswick, NJ: Rutgers University Press, 2012.

Zhang, Ling. "Shen and Cinema in 1930s Shanghai." *CLCWeb: Comparative Literature and Culture* 15, no. 2 (2013). https://doi.org/10.7771/1481-4374.2226.

Zhen, Zhang. *An Amorous History of the Silver Screen: Shanghai Cinema 1896–1937*. Chicago: University of Chicago Press, 2005.

Index

Page numbers in italics refer to figures

anxieties (*cont.*)

39, 44, 46, 137–39, 194; loss, 27; love, 3–4, 27; and modernity, 60; 1970s-1980s, 81; organic bodies, 202; postmillennial apocalyptic films, 26, 181–82, 185, 188–94, 197–99, 202, 205, 208, 209–11, 214, 218–19, 223; *Psycho* (Hitchcock, 1960), 102; science fiction films, 181; self-images, 100, 103, 127–29; sound cinema, 27, 145–54; spectators, 26, 265n21; subjectivities, 126–27; surveillance, 116; technologies, 27, 134, 135–45, 147, 153–54, 165, 168, 193–94, 202, 223, 236n61; temporality, 235n51; as term, 3, 26; virtual realities, 228; wide-screens, 27

anxious cinephilia, 26–27, 135–80, 225–30; authorship, 156; *Broken Embraces* (*Los abrazos rotos*) (Almodóvar, 2009), 33; cinephiles, 3; death, 3; digital exhibitions, 144, 169, 176; digital technologies, 36; Elsaesser, 11–12, 144; Epstein, 240n36; *50 Years On* (Keathley), 21; film festivals, 76; film histories, 27, 34, 88, 227; futures, 227; geographies, 34, 88; Germany, 58; Hollywood, 12; images, 3, 129, 227, 230; innervation, 57; loss, 11, 86–87, 143, 228; love, 3–4, 180; media, 12, 34–35, 227–28; new cinephilia, 13–14; past vs. present, 226–27; postmillennial apocalyptic films, 36, 181–83, 186–87, 223–24; self-images, 107, 129; sound cinema, 35; spectators, 5, 27, 86–87, 88–97, 107; technologies, 5, 34, 87, 139–40, 143–44, 155, 168; as term, 3, 15, 26–27; theories, 27, 89–93

Apocalyptic Dread: American Film at the Turn of the Millennium (Thompson), 186, 193, 264n2

apocalyptic films. *See* postmillennial apocalyptic films

apparatus theory, 90–91

Apple, The (Makhmalbaf, 1998), 110

Arnheim, Rudolf, 146

Aronoff, Kate, 191

L'arrivée d'un train en gare de la ciotat (Arrival of a Train at the Station) (Lumière Brothers, 1896), 43–44

Artaud, Antonin, 62

art cinema, 72, 74, 84, 85, 121–22, 182, 263n94. *See also* cinema as art

Artist, The (Hazanavicius, 2011), 141, 142, 146–47

Arzner, Dorothy, 68–69, 245n86

Assayas, Olivier, 9, 146–47

At Land (Deren, 1944), 122

audiences. *See* spectators

Aumont, Jacques, 4

auteurism, 2, 7, 33, 37, 55, 63–64, 74, 77–78, 161, 260n60

authorship, 156, 158–62, 165. *See also* copyrights

avant-garde cinema, 6, 56, 79, 121–22, 126, 173

Baby's Lunch (Lumière Brothers, 1895), 130

Balázs, Béla, 4, 137, 149

Bao, Weihong, 243n62

Barney, Matthew, 122

Barthes, Roland, 14, 17, 31, 104, 134

Baumbach, Nico, 10, 244n80

Baumbach, Noah, 75

Bazin, André, 24–25, 45, 63, 150, 154, 236n55, 258n27

Beckett, Samuel, 129

cine-clubs: alternative film clubs, 79; Club des amis du septième art, 54, 241n43; Club français du cinéma, 54; countries, 54, 56; Dulac, 54, 241n43; Fédération française des ciné-clubs, 54; French postwar cinephilia, 62, 63, 67; International Federation of Film Clubs, 68; prewar cinephilia, 49, 50

cinégraphie, 54–55

cinema: addiction, 27, 58–59, 90; anxieties, 5, 26–27, 46–47, 137, 153–54; apparatus theory, 90–91; *Bonjour, Cinema* (Epstein), 52; censorship, 45–47; close-ups, 130; color, 132, 144; colorization, 35, 165; commercialism, 28, 34–35; computer-generated imagery (CGI), 4; death, 3, 13, 45–46; desire, 28; digital exhibitions, 35, 174, 177, 262n88; digital special effects, 4; digital technologies, 4–5, 144, 168–69, 170, 228; dualities, 104; Dulac, 54, 55; elite vs. nonelite, 49–50, 86; futures, 227, 230; identifications, 97; images, 135–36; independent cinemas, 35; *The Intelligence of a Machine* (Epstein), 201; landscapes, 133; loss, 3, 28, 143, 178–80; and modernity, 57–59, 139, 267n51; nostalgia, 24, 143, 179–80; obsolescence, 144, 174, 198; paranoia, 227; past vs. present, 45, 76, 227; places, 3, 79–80, 81; politics, 49, 54; as relational, 9–10, 77–78; scholarship, 27; self-identifications, 35; spectators, 34, 130–31; technologies, 5, 27, 87, 136, 143–45, 153–54, 169, 173, 174, 193, 198,

227–28; temporality, 3, 24–25, 28, 235n51; volatility, 5, 14, 36, 143, 198; women, 48. *See also* anxious cinephilia; early cinema; national cinemas; *individual countries' cinemas*; *individual titles*

"cinéma, Le" (Tournier) (column), 54–55

Cinema 16 (exhibition venue), 79

cinema as art: Canudo, 55–56; cinephilia, 59, 149; cinephobia, 59; close-ups, 149; colorization, 157–63, 165; Dulac, 54, 56, 148–49; Epstein, 52; Fee, 62; French postwar cinephilia, 48–49, 50; images, 148; narrative films, 46; 1920s, 48–49, 56, 148–49; postmillennial apocalyptic films, 214–18; prewar cinephilia, 48–50; silent cinema, 145–46, 148–50, 151–52; sound cinema, 151–53; technologies, 59. *See also* art cinema; auteurism

cinema closures and decline, 7, 11–12, 176–80, 183. *See also* cinema-restoration projects; independent cinemas

Cinémagazine, 19

cinema lexicon, 54–56

Cinema mon amour (Belc, 2015), 109, 111–12

cinemania, 40, 44, 54–56. *See also* cinephiles

cinema-restoration projects, 81–87, 231n8, 247n117. *See also* preservation; *individual cinemas*

"Cinema Seen from Etna, The" (Epstein, 1926), 17, 234n38, 250n24

Cinémathèque française (film organization), 68–69, 243n70

cinephiles: anxious cinephilia, 3; celluloid, 171, 175; cinema as art, 149; commercialism, 21–22, 23; communalism, 20; Confessions of a Cinephile (online community), 86, 248n125; digital exhibitions, 171, 173, 175, 178; digital technologies, 25; elite vs. nonelite, 51; fans v., 22–23, 50–51, 62–63, 235n48, 246n107; film festivals, 21–22; filmmakers as, 9–10, 51–52; home spectatorship, 79–80; images, 88; love, 3, 11–12; media, 79, 81, 228; Metrograph cinema (New York City), 82; 1920s, 49; subjectivities, 15–16; technologies, 11, 140; as term, 54. *See also* cinemania; *individuals*

cinephilia, 14–27, 37–87; actions, 15, 20–23; affects, 15–20; anxieties, 7, 12, 26–27, 34, 81, 243n70; avant-garde cinema, 6; blogs, 6, 19, 86; *Broken Embraces* (*Los abrazos rotos*) (Almodóvar, 2009), 30–33; *Cahiers du cinéma* (magazine), 6; celluloid, 175; cine-love, 7, 39, 51, 89; cinema as art, 59, 149; cinema closures and decline, 7, 11–12, 176–80; cinema-restoration projects, 81–86, 247n117; cinephobia vs., 227, 242n54; colorization, 155–56, 164–65; commercialism, 15, 21–22; communalism, 15, 19–20, 21–22, 23, 49, 81, 133; countries, 48–49, 56–61, 62–63, 64, 70, 242n52, 243n70, 244n71; cross-cultures, 12; death, 6, 13; debates, 22; desire, 27, 33, 34; digital technologies, 12, 84, 145; early cinema, 39–44; elite vs. nonelite, 2, 6–7, 22, 23, 49–51, 58–59, 86; fans vs., 22–23, 50–51, 77, 235n48; film festivals, 21–22, 68–76, 81; film

histories, 2, 6, 34, 38, 68–69, 76, 86, 88; filmmakers, 2, 6–7, 38, 49; first and second cinephilia, 10–12; futures, 81–87; geographies, 38, 60–61, 69; home spectatorship, 79–81; identifications, 95; images, 11, 15, 20–21, 22–23, 33, 35, 95, 133; immersion, 94–96; independent cinemas, 178, 246n106; independent features, 78; individualities, 15–16, 131, 132, 133–34; landscapes, 33, 130; life-and-death, 44–49; loss, 6, 176–77; love, 1, 2–3, 9, 10–12, 14–17, 22–23, 27–33, 34, 36, 77–78; media, 7, 12, 24, 59, 61, 80–81, 238n5; as metacinematic, 9, 15; narrative films, 44–49; nature, 130; *The New Cinephilia* (Shambu), 13, 38; 1970s-1980s, 76–81; 1920s, 49, 56, 240n30, 240n32; nostalgia, 7, 8–9, 11, 19, 24, 86, 143–44; online communities, 12–13, 69, 81, 86; past vs. present, 6–7, 8–10, 12, 15, 33, 34, 45, 86, 231n8, 233n19; politics, 2, 12, 14, 62, 86; postmodern cinephilia, 22, 233n19; prewar cinephilia, 49–61; scholarship, 6, 8–9, 12, 18–19, 48–49, 61, 80, 240n30, 243n70; self-images, 97, 126; spaces, 24–26; spectators, 1–3, 19, 35, 38–39, 89, 97, 126, 131–32, 250n23; subjectivities, 7, 15–20; technologies, 1, 6–7, 12, 35, 81, 136, 145, 153–54, 155, 227–28; temporality, 6, 15, 24–26; as term, 1, 3, 14, 38, 54–56, 63; theories, 7–9, 15–16, 17–18, 89–93; video essays, 6; volatility, 1, 5, 10, 14, 15, 37–38; women, 48, 68–69, 240n30. *See also* anxious cinephilia; French postwar cinephilia; *individuals*

digital exhibitions (*cont.*)
176; film industries, 170–71, 172; filmmakers, 171, 172, 262n89; futures/Hollywood, 177–78; images, 170–73; independent cinemas, 169, 175–79, 263n94; loss, 172, 174, 176, 178; mediums, 173; *New York Times*, 172; *The Phantom Menace* (Lucas, 1999), 172–73; preservation, 171; scholarship, 173, 175; spectators, 169–71, 174–75, 177, 263n98; 3D technologies, 263n98

digital special effects, 4, 136, 185, 193, 195, 203, 210, 219

digital technologies: *All the Money in the World* (Scott, 2017), 163; anxieties, 27, 144, 169; anxious cinephilia, 36; celluloid, 142–43, 263n91; cinema, 4–5, 144, 168–69, 170, 228; cinema-restoration projects, 81; cinephiles, 25; cinephilia, 12, 84, 145; *Dawson City: Frozen Time* (Morrison, 2017), 226; debates, 4–5; film industries, 141, 169, 258n32; futures, 169; Hollywood, 141; home spectatorship, 169, 173; images, 5, 194; Lola VFX (company), 4; loss, 168; media, 169; *New York Times*, 169, 172; nostalgia, 141, 169, 185; *Pandora's Digital Box: Films, Files, and the Future of Movies* (Bordwell), 4–5; past vs. present, 141; postmillennial apocalyptic films, 36, 185–87, 189, 193, 195–96, 197, 203, 204, 208–9, 215, 219; scholarship, 168–69; spectators, 4–5, 13; *Star Wars* films, 261n65; temporality, 25. *See also individuals*

Directors Guild of America (DGA), 155, 162, 163, 166, 260nn61–62

Directors Guild of Great Britain, 154, 155, 162

disaster films, 182, 186–87, 188, 189, 193, 219–20, 222. *See also* postmillennial apocalyptic films

Dixon, Wheeler Winston, 187–88

Doane, Mary Ann, 92–93, 235n51

documentaries, 108–15, 125, 165–68. *See also individual films*

Dombrowski, Lisa, 263n94

Dorsky, Nathaniel, 173

Douchet, Jean, 8

Douthat, Ross, 188–89, 190–91, 265n13

Dreamers, The (Bertolucci, 2003), 250n23

Dreyer, Carl Theodor, 66

dualities, 98–99, 101, 103–8

Duchamp, Marcel, 250n24

Du Cinema (journal), 241n49

Duck Soup (McCarey, 1933), 101–2

Dulac, Germaine, 19, 49, 51, 54–56, 93, 148–49, 241n43, 241n49

Dunst, Kirsten, 214

Durand, Marguerite, 54

DuVernay, Ava, 228

Dyketactics (Hammer, 1974), 122

early cinema, 39–44, 47–48, 109, 116–17, 238n13, 239nn18–19, 239n24. *See also* narrative films; *individuals; individual films*

Edge of Tomorrow (Liman, 2014), 218–19, 220–22

Edogawa, Rampo, 98–99

Edwards, Henry, 152

Eisenberg, Jesse, 112

Eisenstein, Sergei, 151–53, 258n24

Elba, Idris, 223–24

Electric cinema (London), 84–85

Electrocuting an Elephant (Edison, 1903), 45–46

Friedell, Egon, 153
Friedland, Sarah, 254n65
Friedrich, Su, 173, *174*
fronde, La (journal), 54
Fruitvale Station (Coogler, 2013), 121
Fury (Lang, 1936), 119–21
futures, 81–87, 169, 177–78, 182, 185, 188, 195, 218–24, 227, 230

Gainsbourg, Charlotte, 215
Gance, Abel, 52, 241n43
Garnier, Philippe, 68–69, 245n86
Gene Siskel Film Center, 175
Gently Down the Stream (Friedrich, 1981), 173, *174*
geographies, 34, 38, 60–61, 69, 88. *See also* global cinema; *individual countries*
Gephardt, Richard, 158
German expressionist cinema, 149
Germany, 49, 56–59, 69, 72, 119, 229, 239n24, 242nn52–53
Gibson, Mel, 192
Gilbert, Andrew, 141–42
Giornate del cinema muto, Le (film festival), 21–22, 71
glace a trois faces, La (*The Three-Way Mirror*) (Epstein, 1927), 250n24
glaneurs et la glaneuse, Les (*The Gleaners and I*) (Varda, 2000), 110
Glick, Earl, 157, 163
global cinema, 67–76
Godard, Jean-Luc, 9, 63, 66, 74, 232n15
Godzilla (Edwards, 2014), 184
Golden Bough, The (Frazer), 114–15
Gomery, Douglas, 145
Good, the Bad, and the Ugly, The (Leone, 1966), 18
Gopnick, Adam, 167–68

Gorfinkel, Elena, 9–10, 235n49
Gorky, Maxim, 44
Grand theory, 10
Granik, Debra, 132
Grant, Catherine, 21, 231n6. *See also* video essays
Great Train Robbery, The (Porter, 1903), 132
Grey Gardens (Maysles, 1976), 109
Grieveson, Lee, 46–47
Griffith, D. W., 239n19, 248n126
Gunning, Tom, 41, 43–44, 53, 109, 116, 120
Guy-Blaché, Alice, 41–42

Hagener, Malte, 8–9, 10, 13, 61, 250n23
Hall, Sheldon, 77
Hammer, Barbara, 9, 122–24
Hansen, Miriam Bratu, 47–48, 57, 60
haptic visuality, 118, 132–33, 255n90
Harvard Film Archive, 175
Hass, Robert, 189–90
Hawks, Howard, 65–66, 246n107
Haynes, Todd, 146–47
Hazanavicius, Michel, 141
Hemmings, David, 135
Hendershot, Heather, 177–78
Herrera, Javier, 33
Herzog, Werner, 255n85
high vs. lowbrow culture. *See* elite vs. nonelite
Hilderbrand, Lucas, 14
Histoire(s) du cinéma (1988–1998) (Godard), 9, 232n15
historical traumas, 3, 26. *See also* 9/11
Hitchcock, Alfred, 9, 77, 102–3, 130, 152, 247n111

Slide, Anthony, 163–64

Smith, Will, 31–32, 74–75, 205

Snowpiercer (Bong, 2013), 36, 187, 188, 190–91, 194–95

Sobchack, Vivian, 101, 103, 252n39, 253n59

social media, 13, 69, 79, 86, 248n126, 254n65. *See also* online communities

Society for Cinema and Media Studies, 62

Sontag, Susan, 6, 13, 94–95, 181, 183, 189, 264n3

Sorrentino, Paolo, 74

sound cinema, 144–54; anxieties, 27, 145–54; anxious cinephilia, 35; Belton, 257n20; Bordwell, 170; cinema, 35, 149–50; cinema as art, 151–53; Clair, 258n28; close-ups, 147; *Dawson City: Frozen Time* (Morrison, 2017), 225; Epstein, 145, 146; film histories, 145; film industries, 150–51, 258n31; filmmakers, 151–53, 258n24; Gomery, 145; images, 152; Kaeriyama, 257n22; Lastra, 139; loss, 144, 147; montage, 152, 153, 258n24; national cinemas, 151; *New York Times*, 147–48, 151; 1920s, 145; Shub, 153; silent cinema, 143, 145–54, 170, 174, 175, 226, 257n20; *Singin' in the Rain* (Donen and Kelly, 1952), 146–47; spectators, 145–46, 151; Sperb, 258n32; technologies, 136, 139

soundtracks, 21, 53–54, 182

souriante Madame Beudet, La (*The Smiling Madame Beudet*) (Dulac, 1923), 93

South Korea, 71

Soviet cinema, 59–60, 61, 109. *See also individuals*

spaces, 24–26, 31, 36, 53, 139, 196–200, 207, 221, 241n39, 255n85

special effects, 36, 142, 185, 197–98, 218, 223, 237n68. *See also* digital special effects

spectators, 88–97; affects, 16; anxieties, 26, 265n21; anxious cinephilia, 5, 27, 86–87, 88–97, 107; apparatus theory, 90–91; auteurism, 77–78; *Blow-Up* (Antonioni, 1966), 138; *Broken Embraces* (*Los abrazos rotos*) (Almodóvar, 2009), 31; censorship, 47; cinema, 34, 130–31; cinephilia, 1–3, 19, 35, 38–39, 89, 97, 126, 131–32, 250n23; cinephobia, 48, 104; color, 132; colorization, 163–65; desire, 94; digital exhibitions, 169–71, 174–75, 177, 263n98; digital technologies, 4–5, 13; documentaries, 111–12; dualities, 104; early cinema, 40–44; Epstein, 53, 94, 201–2; film festivals, 88; French postwar cinephilia, 65, 67–68, 96; *Les glaneurs et la glaneuse* (*The Gleaners and I*) (Varda, 2000), 110; identifications, 89–97, 102–3, 132; images, 33, 35, 88–97, 131, 227, 228; immersion, 90, 94–96; individualities, 131; landscapes, 130; *Le locataire* (*The Tenant*) (Polanski, 1976), 105; narrative films, 45–49, 131, 239n17; postmillennial apocalyptic films, 186, 188–89, 192–93, 195–96, 210–13; postmodern cinephilia, 233n19; revelationism, 137; secondary identifications, 129–30; self-images, 100, 103–4, 126–29; self-reflections, 88, 89–90; sound cinema, 145–46,

151; subjectivities, 96; technologies, 33, 35, 134; theories, 89–93; 3D technologies, 134, 266n26; Warhol, 126; wide-screens, 134; women as, 48. *See also* home spectatorship; *individual titles*

Spengler, Christine, 140–41

Sperb, Jason, 141, 143, 185, 258n32

Spielberg, Steven, 77, 162–63, 168, 187, 202–4, 247n109, 247nn111–112

Star Wars films, 28, 77, 172–73, 237n68, 261n65

Steimatsky, Noa, 4

Stereo D (company), 167

Stewart, Garrett, 118, 120

Stratford International Film Festival (Canada), 72–73

streaming formats, 22, 75, 117–18, 227–28. *See also* Netflix

Strother, Z. S., 113, 253n54

subjectivities, 7, 15–20, 54, 57, 93, 96, 104, 126–27, 228, 232n12

sublime, 103, 130, 196–99, 216–17, 218–19, 251n27, 255n85

Sundance, 71

surveillance, 115–21, 223, 239n18

Susman, Gary, 177

Take Shelter (Nichols, 2011), 209–14

Tarantino, Quentin, 171

Tarkovsky, Andrei, 255n85

Taussig, Michael, 113

technologies, 135–80; Almodóvar, 32; anxieties, 27, 134, 135–45, 147, 153–54, 165, 168, 193–94, 202, 223, 236n61; anxious cinephilia, 5, 34, 87, 139–40, 143–44, 155, 168; Bazin, 150, 258n27; *Blow-Up* (Antonioni, 1966), 135–39; cinema, 5, 27, 87, 136, 143–45, 153–54, 169, 173, 174, 193,

198, 227–28; cinema as art, 59; cinema closures and decline, 11–12; cinema-restoration projects, 81–83, 86; cinephiles, 11, 140; cinephilia, 1, 6–7, 12, 35, 81, 136, 145, 153–54, 155, 227–28; close-ups, 136, 137; commercialism, 80, 147; *Dawson City: Frozen Time* (Morrison, 2017), 226; early cinema, 40–41, 43–44, 238n13; Elsaesser, 144; Epstein, 53–54, 251n27; ethnographies, 113–14; film histories, 136, 144, 168; filmmakers, 140–42, 162–63, 168; images, 150, 201, 232n12, 238n13; landscapes, 130; loss, 140, 143–44, 150; love, 140, 144; media, 139, 169; nature vs., 183–84, 186, 196–98, 203, 218, 223, 224; nostalgia, 140–45, 147; obsolescence, 141, 144; optimism, 135–45, 223; organic bodies, 193, 198, 200–209; postmillennial apocalyptic films, 36, 183–86, 190, 193–98, 200–209, 218, 219, 221–24; self-images, 128–29; spaces, 139; spectators, 33, 35, 134; Sperb, 141, 143, 258n32; surveillance, 116; temporality, 139, 140; *They Shall Not Grow Old* (Jackson, 2018), 167–68; *The Tree of Life* (Malick, 2011), 142; "The Work of Art in the Age of Its Technological Reproducibility" (Benjamin), 57; Zinnemann, 154. *See also* digital technologies; *individual technologies*

tempestaire, Le (Epstein, 1947), 53

temporality: anxieties, 235n51; *Broken Embraces* (*Los abrazos rotos*) (Almodóvar, 2009), 33; cinema, 3, 24–25, 28, 235n51; cinephilia, 6, 15, 24–26; *The Clock* (Marclay), 234n43;

FILM AND CULTURE

Shivers Down Your Spine: Cinema, Museums, and the Immersive View
Alison Griffiths

Weimar Cinema: An Essential Guide to Classic Films of the Era
Edited by Noah Isenberg

African Film and Literature: Adapting Violence to the Screen
Lindiwe Dovey

Film, a Sound Art
Michel Chion

Film Studies: An Introduction
Ed Sikov

Hollywood Lighting from the Silent Era to Film Noir
Patrick Keating

Levinas and the Cinema of Redemption: Time, Ethics, and the Feminine
Sam B. Girgus

Counter-Archive: Film, the Everyday, and Albert Kahn's Archives de la Planète
Paula Amad

Indie: An American Film Culture
Michael Z. Newman

Pretty: Film and the Decorative Image
Rosalind Galt

Film and Stereotype: A Challenge for Cinema and Theory
Jörg Schweinitz

Chinese Women's Cinema: Transnational Contexts
Edited by Lingzhen Wang

Hideous Progeny: Disability, Eugenics, and Classic Horror Cinema
Angela M. Smith

Hollywood's Copyright Wars: From Edison to the Internet
Peter Decherney

Electric Dreamland: Amusement Parks, Movies, and American Modernity
Lauren Rabinovitz

Where Film Meets Philosophy: Godard, Resnais, and Experiments in Cinematic Thinking
Hunter Vaughan

The Utopia of Film: Cinema and Its Futures in Godard, Kluge, and Tahimik
Christopher Pavsek

Hollywood and Hitler, 1933–1939
Thomas Doherty

Cinematic Appeals: The Experience of New Movie Technologies
Ariel Rogers

Continental Strangers: German Exile Cinema, 1933–1951
Gerd Gemünden